THE CAMBRIDGE CULTURAL HISTORY OF BRITAIN

VOLUME 5 EIGHTEENTH-CENTURY BRITAIN

The Cambridge Cultural History

The Cambridge Cultural History of Britain

edited by
BORIS FORD

VOLUME 5

EIGHTEENTH-CENTURY BRITAIN

CAMBRIDGE
UNIVERSITY PRESS

Published by the Press Syndicate of the University of Cambridge
The Pitt Building, Trumpington Street, Cambridge CB2 1RP
40 West 20th Street, New York, NY 10011–4211, USA
10 Stamford Road, Oakleigh, Victoria 3166, Australia

© Boris Ford 1991, 1992

First published 1991 as *The Cambridge Guide to the Arts in Britain:
The Augustan Age*
First paperback edition 1992

Printed and bound in Great Britain by
BPCC Hazells Ltd
Member of BPCC Ltd

A catalogue record for this book is available from the British Library

Library of Congress cataloguing in publication data

Cambridge guide to the arts in Britain.
The Cambridge cultural history/edited by Boris Ford.
 p. cm.
Previously published as: The Cambridge guide to the arts in Britain. 1988–1991.
Includes bibliographical references and indexes.
Contents: v.1. Early Britain – v.2. Medieval Britain – v.3. Sixteenth-century
Britain – v.4. Seventeenth-century Britain – v.5. Eighteenth-century Britain –
v. 6. The Romantic Age in Britain – v. 7. Victorian Britain – v.8. Early
twentieth-century Britain – v.9. Modern Britain.
ISBN 0-521-42881-5 (pbk.: v.1). – ISBN 0-521-42882-3 (pbk.: v.2). – ISBN
0-521-42883-1 (pbk.: v.3). – ISBN 0-521-42884-X (pbk.: v.4). – ISBN 0-521-42885-8
(pbk.: v.5). – ISBN 0-521-42886-6 (pbk.: v.6). – ISBN 0-521-42887-4 (pbk.: v.7). –
ISBN 0-521-42888-2 (pbk.: v.8). – ISBN 0-521-42889-0 (pbk.: v.9)
1. Arts, British. I. Ford, Boris. II. Title.
[NX543.C36 1992]
700′.941–dc20
 91–43024
 CIP

ISBN 0 521 30978 6 hardback
ISBN 0 521 42885 8 paperback

VN

Contents

Notes on Contributors

Nicholas Anderson has been for many years a Producer in the BBC Music Department, and is a frequent radio broadcaster. He contributed to *A Companion to the Concerto* and *Grove's Dictionary of Music and Musicians*, and is now completing a concise history of Baroque music.

Geoffrey Beard was, until he retired in 1982, Director of the Visual Arts Centre at the University of Lancaster. He is Chairman of the Furniture History Society, and author of *Georgian Craftsmen, The Work of Robert Adam, Craftsmen and Interior Decoration in England 1660–1820*, and *English Furniture 1500–1840*.

T.J. Edelstein is Director of the David and Alfred Smart Museum of Art at the University of Chicago. Her publications include articles in the *Burlington Magazine* and *Victorian Studies*, and the exhibition catalogues *Vauxhall Gardens* and *Donald Cooper: Photographs of the Classic British Theatre*.

Arthur Humphreys, who died in 1988, was Professor of English at the University of Leicester. He was the author of *The Augustan World*; and editor of the Arden editions of Shakespeare's *Henry IV Parts 1 and 2* and *Much Ado About Nothing*, and of the Penguin editions of *Henry V* and *Henry VIII*.

Sally Jeffery is an architectural historian at the Corporation of London, researching the history of the Mansion House. She has published articles on eighteenth-century architecture in *Country Life* and *Architectural History*.

Bryan Little is the author of books on the history and architecture of Bath, Cheltenham, Bristol, Exeter, Cambridge and the county of Somerset, and of biographies of Gibbs and Wren.

David Mannings lectures on the history of art at the University of Aberdeen, and was Visiting Fellow at the Yale Center for British Art and Visiting Scholar at St John's College, Oxford. He is preparing a *catalogue raisonné* of the works of Sir Joshua Reynolds, and contributed over 70 entries to the catalogue of the major Reynolds exhibition in Paris and London 1985–6.

Raymond O'Malley was Senior English Teacher at Dartington Hall and, for a time, Acting Head of the school. He was subsequently, until retiring in 1976, a lecturer at the Southampton and Cambridge Departments of Education and, for a while, Director of Studies in English at Selwyn College, Cambridge. He collaborated with Denys Thompson on a number of anthologies and books on the teaching of English.

Pat Rogers was Professor of English at the University of Bristol and is now the DeBartolo Professor of the Liberal Arts in the University of South Florida at Tampa. He is the author of *Grub Street, Henry Fielding*, a critical study of *Robinson Crusoe*, and *Literature and Popular Culture in Eighteenth-Century England*. He also edited *The Oxford Illustrated History of English Literature*.

Cinzia Maria Sicca is a member of the Faculty of Architecture and History of Art, University of Cambridge, and Senior Research Fellow in History of Art at the University of Pisa. She has published numerous articles on neo-Palladianism, on William Kent and on Lord Burlington. She is the author of *Committed to Classicism: The Building of Downing College, Cambridge*.

Michael Symes lectures on garden history at the Centre for Extra-Mural Studies, Birkbeck College, the University of London. His books include *The English Rococo Garden* and one on Surrey gardens. He contributed to *The Oxford Companion to Gardens*.

General Introduction

BORIS FORD

If all people seem to agree that English literature is pre-eminent in the world, the same would not often be claimed for Britain's arts as a whole. And yet, viewed historically, Britain's achievements in the visual and decorative arts and in architecture and music, as well as in drama and literature, must be the equal, as a whole, of any other country.

The Cambridge Cultural History of Britain is not devoted, volume by volume, to the separate arts, but to all the arts in each successive age. It can then be seen how often they reinforce each other, treating similar themes and speaking in a similar tone of voice. Also it is striking how one age may find its richest cultural expression in music or drama, and the next in architecture or the applied arts; while in a later age there may an almost total dearth of important composers compared with a proliferation of major novelists. Or an age may provide scope for a great range of anonymous craftsmen and women.

The nine volumes of this *Cambridge Cultural History* have been planned to reveal these changes, and to help readers find their bearings in relation to the arts and culture of an age: identifying major landmarks and lines of strength, analysing changes of taste and fashion and critical assumptions. And these are related to the demands of patrons and the tastes of the public.

These volumes are addressed to readers of all kinds: to general readers as well as to specialists. However, since virtually every reader is bound to be a non-specialist in relation to some of the arts under discussion, the chapters do not presuppose specialist knowledge.

The arts of the eighteenth century until 1785 are the subject of the fifth volume of this series. They are the arts of a society that believed in rationalism on the one hand and cultivated elegance and liveliness on the other. The wealth of handsome portraits and resplendent buildings and gardens seemed to embody society's ideals of harmony and order. Poets and essayists, architects and sculptors in this age drew a great part of their inspiration from Greece and Rome, and also from Renaissance Italy.

At the same time, one of the main functions of the arts was to correct vulgar taste and expose social ills, as in Hogarth's and Swift's biting satires

and Pope's vision of the chaos that would engulf the petty world of dunces and charlatans. At the same time society was also much given to lively entertainment as in Fielding's novels or in Vauxhall Gardens, and to a taste for the sentimentality of Richardson or much funerary sculpture. It had a great love for the very positive, vigorous and affecting music of Handel. And the enormously popular *Beggar's Opera* drew on a store of folk-songs of incomparable beauty.

This volume, with a considerably more detailed bibliography, was originally published in a hardcover edition as *The Augustan Age*, under the series title *The Cambridge Guide to the Arts in Britain*.

I would like to dedicate this volume to that most humane of scholars, Arthur Humphreys, who sadly did not live to see it in print.

Part I
The Cultural and Social Setting

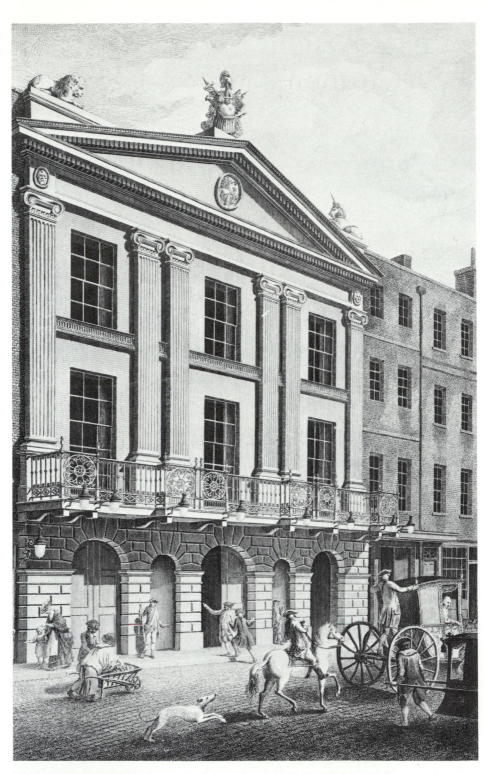

The Theatre Royal, Drury Lane, London. Engraving by P. Begbie (1775).

The Arts in Eighteenth-Century Britain

ARTHUR HUMPHREYS

Preliminaries

We can but imperfectly explain why at one moment theology, poetry, and science burst forth with the fulness of spring, and afterwards subside into the saddened calm of winter.

Leslie Stephen's caveat in his *History of English Thought in the Eighteenth Century* applies equally to the arts, though they incubate rather than hibernate. When, provocatively, J.M. Keynes once 'explained' Shakespeare by the Elizabethan economic boom which could 'afford' him, a critic (Lionel Knights) countered demurely by asking whether, after the 1930s depression, we might not 'afford' another. Prefacing the *Critique of Political Economy* Marx proclaimed the general character of social and spiritual processes to spring from conditions of material life: 'it is not the consciousness of men that determines their social being but their social being that determines their consciousness'. But what does 'determines' mean? The word raises as many questions as did Hume's quizzing of the concept of 'cause'.

The following account examines Augustan Britain specifically as she sought self-improvement. The term 'Augustan', as applied to Restoration and eighteenth-century Britain, originated around 1700 and claimed kinship with the high civilisation of Augustan Rome. The age was concerned to define, and refine, its codes of living. First will be considered its aspirations towards humane consensus, that which makes for a harmonious community, next the practical life which nourished its flowering arts. 'Culture' will mean the outcome of fertilising forces related to social conditions, insofar as these aesthetically tone collective life; more narrowly it will mean (to cite the dictionary) 'refinement the result of cultivation'.

Some magisterial words from Sir Christopher Wren offer a starting-point. *Parentalia* (1750), his observations assembled by his son, also Christopher, proclaims challengingly:

Architecture has its political uses; public buildings being the ornament of a country; it establishes a nation; draws people and commerce; makes the people love their native country, which passion is the original of all great actions in a Commonwealth.

Forty words could hardly offer more relevant themes. 'Architecture' may stand generally for the arts, which – certainly in the eighteenth century – do serve 'political uses'. They express pride in cultural prowess, encourage definition of national character, ensure perspectives longer and meanings deeper than those of the daily round and common task, and establish intelligent love of country. Wren's 'Commonwealth' become 'common wealth'.

Around 1700 liberating influences made themselves felt. Already, in *Astraea Redux* (1660), Dryden hailed Charles II's return as heralding 'Time's whiter series', a prophecy confirmed by the modernisation of scientific, philosophical and literary ideas, and by advances in painting, sculpture and architecture. There continued, certainly, a large carry-over from the past; evolution was not revolution. Work, trade and exchange naturally continued, though with major developments. Traditions ran deep in faith, moral and social habits, rule and obedience. Granted continuities, however, alert eyes discerned a new age, that which, in its European–American totality, is termed 'The Enlightenment'. Insofar as this implies a radical critique of established order it applies principally to the France of Voltaire and the Encyclopedists; yet in Britain, from Restoration days onwards, accelerating material expansion, scientific discoveries, the search for temperate discourse and harmony after decades of turbulence, and Locke's clear-eyed epistemology and political and religious guidance – these promised a finer future. They gained for Britain a reputation for intellectual, political and social sanity which has in some measure persisted. Admittedly there were alarmists; few ages have been ampler in moral reproof, none richer in satire. But generally the moralists reinforced responsible conscience, and satirists castigated folly to further good morals and taste.

In the arts much needed doing. France had shown the way when, by ardent effort, she had rivalled Italy's achievement and indeed under Louis XIV had become the arbiter of European civilisation, though Italy remained the artistic centre. Britain distinguished herself in letters, music and philosophy, and was advancing in architecture, portraiture and sculpture. But still she felt an offshore inferiority; compared with France she had, to quote Pope's *Essay on Criticism* (1711), 'kept unconquer'd, and unciviliz'd'. The third Earl of Shaftesbury, philosopher of fine taste and morals, in *Characteristics of Men, Manners, Opinions, Times* (1711), rated his countrymen, despite their practical prowess, 'the *least civiliz'd* or *polish'd* people of Europe'. If, as he observed, 'the Taste of Beauty and the Relish of what is decent, just, and amiable perfects the Character of the Gentleman and the Philosopher', Britain seemed sadly short of these paragons. He strove to redeem her, giving a lead to Addison, Jonathan Richardson the propagandist for painting, and philosophers like Hutcheson, Hume and Adam Smith; no age or land, it has been said, received more aesthetic advice than Augustan Britain. Shaftesbury addressed such superior spirits as 'are rejoic'd to gather Views, and receive Light, from every Quarter', those whom his poetic disciple James Thomson would apostrophise in *The Seasons* (1730) as 'th'enlightened few / Whose godlike minds philosophy exalts'.

Combining these themes – the heightened national consciousness voiced by

Wren (and others), the new era glimpsed by Dryden (and others) and the persons of virtue and taste hailed by Shaftesbury (and others) – the way in which Augustan Britain conceived of civilisation unfolds itself. A good account is Martin Price's *To the Palace of Wisdom* (1973), the subtitle of which – *Studies in Order and Energy from Dryden to Blake* – gives an appropriate lead. 'Order' and 'Energy' stress the way the age allied control and clarification with drive and innovation. An alternative formula might be the Nature-given 'Life, Force, and Beauty' which, the *Essay on Criticism* assures us, form 'At once the Source, and End, and Test of Art'. Such signposts directed the Augustans towards 'the Taste of Beauty, and the Relish of what is decent, just and amiable'.

Augustan 'Order'

'Order' exacted thoughtful conduct, clear intellect and organised design. Its correlatives were political and religious balance instead of frenzy, efficient style and idea instead of complexity, discipline of vision instead of spasmodic tentatives. Architecture offers an example. The Gothic came for many (though not all) to be restless, unscholarly, 'crinkle crankle', in Christopher Wren junior's phrase. Under Charles I Inigo Jones had rejected it for lucid Palladian classicism in Whitehall, Wilton, the Queen's House at Greenwich and other models of classical form. When in the 1720s this precocious Palladianism was re-established under the Earl of Burlington's advocacy ('Beneath his eye declining Art revives', wrote John Gay in *Trivia*), Wren's intervening baroque splendours became unfashionable. Yet in their day they too appealed, as the *Guardian* No. 70 said in 1713 of St Paul's Cathedral, as being 'just, plain, and majestic Architecture, . . . Divine Order and Economy' enshrined in Anglican faith, since both – faith and building – showed 'a great Variety of Parts united in the same regular Design according to the truest Art and most exact Proportion'.

That literary styles had similar aims needs no reiteration. Steele, like many others, complained of seventeenth-century wit – fashion's own crinkle crankle – 'you find a new design started almost in every line, and you come to the end without the satisfaction of seeing any one of them executed'. From Bacon, from scientists needing the 'close, naked, natural way of speaking' defined in Thomas Sprat's *History of the Royal Society* (1667), from divines advocating charitable understanding (in 1670 Samuel Parker mooted an Act of Parliament against 'fulsome' metaphors provoking – as they still do – 'distempers'), from thinkers wanting to be understood, from literary men prepared to redraft Shakespeare for clarity's sake – from all these the ordering of discourse proceeded so that the understanding, rightly guided by Hobbes and Locke, might clearly grasp what it was offered.

Hobbes had prescribed the mind's 'steady direction to some approved end' and this suited the arts as well as philosophy or letters. If, as Hobbes also said, 'the light of human minds is perspicuous words', the corresponding light in the arts was ordered design in those regular figures which, Wren held, are 'naturally more beautiful than other irregular: in this all consent as

to a law of nature'. 'Nature' seemed to dictate judiciousness and rationality. Championed by Hobbes and Locke, judgement restrained imagination's vivacity, guided proportions and relationships and clarified literary and visual idiom. Rules and traditions, the precedents of the best authorities, became frequent critical currency, though far less frequent creative practice. Classical art declares 'its preference for one thing at a time, an unwillingness to entertain conflicting elements'. (James Sutherland; *Preface to Eighteenth-Century Poetry*): 'Within a Wren church or a Georgian dwelling-house, everything works in the same direction'. F.R. Leavis comments similarly: 'Every word in a piece of Augustan verse has an air of being able to give the reasons why it has been chosen and placed just there'. Writers observed, or at least genuflected before, approved 'kinds' – epic, pastoral, elegy, ode. Poetic inspiration sought standard forms, octo- or decasyllabic couplets, trim quatrains, Miltonic blank verse, Pindaric ode. The essay was freer but still tidily shaped. The novel was freer still (Sterne wonderfully exploited the fact) but still, in general, steered coherently towards plausible ends, and under Fielding achieved masterly form and proportion.

There were parallels in other arts – 'right' patterns for accepted ends. Painters, sculptors and architects tried for 'correctness' by ancient or Renaissance precedents, for grace, harmony, dignity – while still adapting these to their own inspirations. And the 'science of man' (Hume's phrase) was impressively pursued in the hope of ordering its personal and social bearings.

Order assures us that things make sense. From Greek stoicism onwards the idea has associated human rationality with cosmic rule. For the Augustans, Newtonian astronomy and the revelations of the microscope confirmed God's supreme designs: Pope's contemporary, the philosopher-divine Samuel Clarke, widely noted for his rationalised Christianity, in his *Unchangeable Obligations of Natural Religion* (1706) cited the 'exquisite Regularity' of stellar motion as confirming the eternal divine goodness and steadfastness hailed by the Psalmist and the Stoics. Pope's critical rival John Dennis summoned the arts to

restore the decays that happened to human nature by the Fall, by restoring order, [for] nothing in Nature . . . is great and beautiful without Rule and Order The universe owes its admirable beauty to the proportion, situation, and dependence of its parts.

'Order is Heav'n's first law', the *Essay on Man* proclaimed, and through that majestic work the theme resounds – 'The gen'ral Order, since the Whole began, / Is kept in Nature, and is kept in Man'; 'So, from the first, eternal Order ran'; and so on.

A multipurpose term, 'Order' served many Augustan ends. Guaranteeing God's impeccable presidence it freed enlightened souls from 'Those superstitious horrors that enslave / The fond sequacious herd' (*The Seasons*, 'Summer'). It validated the Chain of Being which appointed all creatures to their proper spheres, promoting mankind's 'higher' faculties over the 'lower' (the terms still imply gradation). It pointed to the 'orderly' civil processes divinely meant for the common good. Intellectually it replaced that 'glaring Chaos and wild Heap of Wit' which confused seventeenth-century minds. It

clarified conduct, ideas and style so that, however the details of created work might vary, the whole should be well-formed and intelligible. Thus, the *Essay on Criticism* declared, taking as its symbol Rome's Pantheon,

> Thus when we view some well-proportion'd Dome,
> (The World's just Wonder, and e'en thine, O Rome!)
> No single Parts unequally surprise;
> All comes united to th'admiring Eyes;
> No monstrous Height, or Depth, or Length, appear;
> The Whole at once is bold, and regular.

Order connoted unity, harmony, balance, correctness, rationality ('The names Man and Rational are of equal Extent': Hobbes) – and, consequently, beauty, that 'Nature methodiz'd' which surpassed the raw reality and became Art by disciplining creative energy.

Energy and liberty

Still, creation involves force. As Pope impressively perceived:

> Nor God alone in the still calm we find,
> He mounts the storm, and walks upon the wind.

Overcontrolled, art is 'Correctly cold, and regularly low', a result not unknown among the Augustans. It must (one cannot resist quoting Pope) seek those 'nameless Graces which no Methods teach, / And which a Master-Hand alone can reach'. For the inexplicable magic ingredient a French term was imported, the *'je ne sais quoi'*, which prescribed what was wanted without throwing any light at all. Later, Goethe's *Annalen* for 1805 would challenge the disciplinarians: 'What is the use of curbing sensuality, shaping the intellect, securing the supremacy of reason? Imagination lies in wait as the most powerful enemy'. The nameless Graces needed energy and daring.

Around 1700 styles in all the arts could be exuberant. In music the nobly creative Purcell had only recently died, in 1695. In literature Dryden had shown how strong ideas and trenchant wit could sound a personal and public voice of enviable authority. Colourful fiction sprang from Aphra Behn, Congreve and others: knockabout verse followed Butler's *Hudibras*: comedy was ostentatiously forceful. Political and religious tensions prompted verbal vivacity of which Swift was the ablest exponent. In painting the swagger of aristocratic portraiture, in architecture the dignified opulence of Wren and his school, these all shared the adventurousness of the sciences; Judith Hook's study, *The Baroque Age in England* (1976) covers this well. Perhaps literature should be, as Rapin's *Réflexions sur l'Eloquence* (1672) said in Thomas Rymer's translation, 'Good sense reduced to Method'. But 'reduced' (even in Rymer's sense of 'adapted') implies enervation, and as Addison remarked of literary style, 'the Endeavour after Perspicuity prejudices its Greatness'. Rapin's contemporary, Boileau, while equally championing sense and method, translated Longinus's *Treatise on the Sublime* (1694; English 1711) and energised criticism with that imaginative exultance which Longinus admired

in the Hebrew scriptures and elsewhere. Jonathan Richardson echoed Longinus in exhorting his fellow-artists to cultivate sublimity, that which is 'marvellous, and surprising, it must strike vehemently'. This was forty years before Burke's treatise on *The Sublime and Beautiful* (1757) examined the imaginative power of grandeur and mystery.

As many voices spoke for Energy as for Order. The Bible, Homer, Shakespeare and Milton pointed to fervency of spirit, that *vivida vis animi* which Pope revered in the *Iliad*. Common critics, Pope protested, may prefer a methodical genius to a great and fruitful one but Homer, like the Bible, 'taught the language of the gods to men', his boldness resembling the bravura of 'great masters . . . touched with the greatest spirit' (*Iliad*; Preface) – the praise is germane to noble painting. The Bible too was cited for impassioned thought and rich imagery, and these qualities enriched the century's splendid hymns. The Augustan arts abound in force and boldness – *Gulliver's Travels*, *The Dunciad*, *The Beggar's Opera*, *Tom Jones*, *Clarissa*, *Tristram Shandy*, Hogarth's *Marriage à la Mode*, the works of Handel, Wren, Vanbrugh, Robert Adam, Reynolds, Raeburn and many more. In architecture the basis might be that 'geometrical Beauty . . . consisting in Uniformity and . . . Proportion' of Wren's prescription, but what counted was powerful invention and grand imagination.

Energy was joined with pride in liberty, the age's frequent boast (whatever qualifications hindsight may offer). An invigorating air blew nationally, explained as the breath of political freedom. Addison's *Letter from Italy* contrasted Mediterranean warmth and artistic wealth with Britain's sterner clime and soberer culture, entirely to the latter's advantage since Britons suffered no 'proud oppression'. In Thomson's *Liberty* the eponymous goddess rouses Britannia's 'Native Genii' so that the country 'shines supreme, / The land of light and rectitude of mind', with cities full

> Of wealth, of trade, of cheerful toiling crowds;
> Add thriving towns; add villages and farms
> Where bold unrivall'd peasants happy toil.

Many a patriotic verse exulted similarly, like the 'Rule, Britannia' from James Thomson and David Mallet's *Masque of Alfred*, set to music by Thomas Arne:

> The nations, not so blest as thee,
> Must in their turn to tyrants fall;
> While thou shalt flourish great and free,
> The dread and envy of them all.

Ironically, the supreme outcome of British energy and liberty was the American colonies' attainment of independence, but that proved an incalculable gain on the stage of the world.

At home, energy in the arts needed energy in the infrastructure. An unprecedented boom, though with fluctuations, carried Britain through the century, enhancing material and cultural life alike: *The Birth of a Consumer Society* (1982) by Neil McKendrick, John Brewer and J.H. Plumb provides ample evidence. Poverty could press disastrously, yet economic growth released energy into a society well-enough ordered (granted good judgment

and luck) to make enterprise rewarding. 'Improve' is, indeed, an exhortation reiterated almost by Pavlovian impulse. Crusoe, returning home in the *Farther Adventures*, starts 'cultivating, managing, planting, and improving' his farm, 'the most agreeable life that Nature was capable of directing'. J.H. Plumb's chapter 'The Acceptance of Modernity' in the above-mentioned work finds 'improvement' the century's hardest-worked word, applied universally to manufactures, science, arts, agriculture, landscapes and gardens. Energy working within Order was confident that proper gains, material and cultural, would accrue to whoever laboured diligently in his vocation.

The ideology of consensus: politics

Any programme for civilisation must include social harmony. Augustan Britain has been called 'a society intensely eager to cultivate itself, to find out, first about things, then about general ideas'. The cultivation of general ideas may be taken first, in political and religious thought. In both areas Britons desired sensible agreement, though not without hearing dissentient voices; sensible agreement must always be fought for. In politics, evolution towards the balanced powers of crown, lords and commons worked for a co-ordinated realm. Respecting human nature generally, Britons sought wider participation in ideas, events, tastes and the 'common sense' (shared rationality) which Johnson expected in a right-minded public.

At first agreement seemed unlikely. The importation of foreign kings – William III in 1688, George I in 1714 – devalued monarchy since they depended on the politicians who installed them. Though later prized as a key to temperate politics, the very idea of party government, arising under Charles II with the distinction of Whigs and Tories (names derived from Scottish and Irish factions), could seem to invite tragic division. 'We are' wrote Defoe in 1701, 'the most divided quarrelsome nation under the sun.' The goddess of Thomson's *Liberty* bids her hearers 'all parties fling aside, / Despise their nonsense, and together join' – a plea not unheard since. Pope, while leaning towards Tory Bolingbroke and away from Whig Walpole, claimed to be neutral –

> In Moderation placing all my Glory,
> While Tories call me Whig, and Whigs a Tory.

In the *True Patriot* of 1745 Fielding, though strongly anti-Walpole, said he was 'of no party' and hoped to eradicate the very idea out of political life. He wrote during the second Jacobite incursion from Scotland, directed to restoring the Stuart line in the person of the *soi-disant* James III (exiled in France since 1688), an incursion which climaxed decades of threatened insurrection. Earlier as, without surviving descendant, Queen Anne lay dying in 1714, Tory and Whig contention over the succession grew very dangerous, and the first Jacobite rising followed in 1715 against the importation of Hanoverian George I. Swift's *Enquiry into the Behaviour of the Queen's Last Ministry* (1715–20) could declare that most men were filled with doubts, fears

and jealousies, or else with hatred and rage, to a degree that there seemed to be an end of all amicable discourse between people of different parties. Nothing so threateningly divisive occurred later, though the 1745 invasion caused great alarm. Yet out-of-office Tories bitterly opposed Walpole in his long premiership (1721–42) and dangers arose – to choose major instances – over the American War (1776–83), the Warren Hastings impeachment (1788–95) and radical movements from the 1780s onwards. Alarmists incessantly protested, as Horace Walpole did to Sir Horace Mann on 30 March 1784, that Britain faced 'all the distractions of a ruined country'.

Yet ruined she never was. Temperate men urged moderation, citing cherished predictions which spoke for Christian fraternity. Hooker's admired *Laws of Ecclesiastical Polity* (1594) had based society on 'composition and agreement, . . . peace, tranquillity, and happy estate'. More recently, Locke's influential *Second Treatise of Civil Government* (1690) had given old tradition a newly cogent force; authority must prevail by agreed laws upheld by just judges and 'directed to no other end but peace, safety, and public good'.

Nevertheless, temperate politics seemed for long a mirage. George Savile, Marquis of Halifax, in his *Character of a Trimmer* (1688: 'trimmer' means stabiliser), deplored political factions 'that raise angry apparitions to keep men from being reconciled, like wasps that fly up and down'. Mid-seventeenth-century periodicals mainly for commercial and foreign news were followed in the 1690s by partisan political journals, the Whig *Flying Post* and Tory *Post-boy* in 1695, the *Daily Courier* (Whig) in 1702, in Scotland, Edinburgh's *Evening Courant* (1718; Whig) and *Caledonian Mercury* (1724; Tory). Political debate throve on exacerbation; as a correspondent wrote to *The Freeholder* (22 August 1722),

Unless you Journalists now and then cut a bold stroke we give you over; cry you are grown insipid . . . and have not one grain of spirit, wit, or moral honesty left –

an aspersion no newswriter dare risk. At their peak, the political sheets probably sold about ten thousand per issue. Britain, *The Freeholder* commented, 'which was formerly called a nation of saints, may now be called a nation of statesmen'. As against divisive partisanship, one great service of non-political journals from *The Tatler* (1709) onwards was to speak for social amity. Swift's *Examiner*, Bolingbroke's *Craftsman* and the like might exert themselves in attack, but 'to minds heated with political contest', as Johnson remarked, *The Tatler* and *The Spectator* 'supplied cooler and more inoffensive reflections'. Time needed to elapse, experience to develop, before politicians realised that 'Opposition, when restrained within due bounds, is the salubrious gale that ventilates the opinions of the people', 'bracing ministers as the breeze braces mariners', as Goldsmith wrote in his essay on 'National Concord'. The intention is still imperfectly realised, in many lands not realised at all.

In *The Citizen of the World* (Letter L), Goldsmith portrayed Britons proclaiming freedom but dumbfounded when asked what it meant. It means, he explained, 'all the advantages of democracy' moderated by the sovereign's prerogatives to produce tempered authority. Bolingbroke's *The Spirit of Patriotism* (1749) argued similarly that government and liberty must support

each other, government guaranteeing just liberty, liberty guaranteeing just government. The system was not ideal, with bribery, small electorates, rotten boroughs (not all were so, however), and often rigged and unruly polls (exuberantly rendered in Hogarth's *Election* series). But aspirants to political office had to win public support. Able men could well feel, as Admiral Rodney said, that 'to be out of Parliament is to be out of the world', and indeed many, some very distinguished, and unprivileged by family or wealth, exercised in the Lords or Commons abilities and oratory much to the national advantage.

The political order, it was held, derived from some patriarchal primeval family, analogous to communities in the natural world, like *Henry V*'s honey-bees parable. The patriots of 1688, revoking (in Pope's epigram) 'The right divine of kings to govern wrong', rescued 'that ancient constitution formed by the original contract of the British state' (Burke; *Appeal from the New to the Old Whigs* (1791)). 'Our country', Burke maintained,

is not a thing of mere physical locality. It consists . . . in the ancient order into which we are born. . . . The place that determines our duty to our country is a social, civic relation.

Pope's celebration of this in the *Essay on Man* (1733–4) develops a musical analogy; political partnership, redeemed from tyranny,

> Taught Pow'r's due use to People and to Kings,
> Taught nor to slack, nor strain, its tender strings;
> The less, or greater, set so justly true
> That touching one must strike the other too;
> 'Til jarring int'rests of themselves create
> Th'according music of a well-mix'd state.

Sensible men sought consensus, and Britons in general, whether or not electors or office-seekers, felt that their society ensured liberty without licence, each individual belonging to the social family. Fittingly to the sense of national union it is to the mid-century that Britain owes the world's first National Anthem (words and music published anonymously in *Thesaurus Musicus*, 1744), in time to become propaganda against the 1745 rebels; Thomas Arne's version was sung at Drury Lane Theatre every night that year while the danger lasted.

The ideology of consensus: religion

Religious evolution offered parallels, though divergences too. Ever since Aristotle in the *Ethics* called man a social animal, and in the *Politics* either a beast or a god if he spurn life in the 'city', human sociability had seemed a law of nature. In religious precept it was strongly so; the *Epistle to the Ephesians* (iv. 16) takes the body of the faithful to be 'fitly joined together and compacted by that which every joint supplies'. In Western tradition the doctrine had rung through the centuries; in Augustan Britain it was increasingly audible. Medieval aspiration had been heavenwards, Renaissance

outwards to the classical world and humanism, yet still magnetised towards
the soul's destiny. In Britain, as the Augustans assessed their experience, the
result was no lack of religious intention but insistence on social harmony
fulfilling God's plan. If 'The proper study of mankind is Man' (what earlier
post-classical age would have said so?) this, the *Essay on Man* prescribed, was
to be in a religious context, with Man not as egotist but as ally, in his own
station harmonising with those in others:

> God, in the nature of each being, founds
> Its proper bliss, and sets its proper bounds:
> But as he fram'd a Whole, the Whole to bless,
> On mutual Wants built mutual Happiness.

Religion a century earlier had been, in Hume's phrase, 'a very intractable
principle'. Yet a Restoration Anglican development was the benevolent
tolerance voiced by Broad-Church spokesmen, encouraged by the Cambridge
Platonists and their disciple John Tillotson, Archbishop of Canterbury
(1691–4). 'Universal Charity is a thing final in Religion', the Platonist
Benjamin Whichcote affirmed, and Locke's *Letters on Toleration* (1689–92)
represented the theme. The age-old twinning of the good and the beautiful,
common to Platonism and the Bible, was tirelessly re-asserted, goodness
becoming moral aesthetics. Isaac Barrow, a leading Restoration theologian, in
his sermon 'Of the Love of Our Neighbours' proclaimed social virtues 'no
less grateful and amiable to the mind than beauty to our eyes, harmony to our
ears, fragrance to our smell, and sweetness to our palate'. The *Guardian* No.
21 (1713; Berkeley's) recommended 'the beauty of holiness' (that lovely
Biblical phrase) as being 'the best taste and best sense a man can have' – the
connoisseur tone belongs charmingly to the age. Bigotry and agnosticism were
ugly, and many evaluative terms for the arts – harmony, balance, proportion,
decorum and the like – came to serve also for morals and religion; aesthetics
and ethics were fraternally interrelated.

'Religion is the basis of civil society', Burke would inform the French
revolutionaries, and it should be attractively so. Much was heard of God as
not only Supreme Designer but Supreme Benefactor, his benevolence
communicating itself to humanity. So the *Essay on Man* summed up the sense
of divine and human benignity:

> In Faith and Hope the World will disagree,
> But all Mankind's concern is Charity;
> All must be false that thwart this One great End,
> And all of God, that bless mankind or mend.

Like the Vicar of Wakefield 'an admirer of happy human faces', the true
believer surveyed a world where, Pope instructed him, 'Virtue alone is
Happiness below'. Halifax had reminded his fractious contemporaries that
religion should be 'so far from being always at *Cuffs* with *Good Humour* that
it is inseparably united to it', and good humour and the good heart became
leading themes of Broad-Church sermons, by no means an Anglican
monopoly. Enlightened faith pointed to 'the Happiness and Exaltation of
Human Nature' (*Guardian* No. 70), 'The Soul's calm Sunshine, and the

heartfelt Joy' (*Essay on Man*), and those 'Heights of Science and of Virtue
. . . / Where all is calm and clear' (*The Seasons*, 'Summer'). In new-rising,
clear-glazed, light-filled churches of simple or ornate dignity and classical
distinction appropriate to the desired mood of humane cultivation, instead of
Gothic awe and doom-laden warnings the typical Anglican worshipper was
regaled with decent exhortations to neighbourly goodness delivered by the
kind of parson who, Pope jested, 'Never mentions Hell to ears polite'. Before
long Voltaire's Dr Pangloss would improve on the *Essay on Man*'s 'Whatever
IS, is RIGHT' by proclaiming all for the best in the best of possible worlds.

Not, of course, that Pangloss went unchallenged. *Candide* itself satirised his
euphoria, and concurrently (1759) Johnson's *Rasselas* tempered any undue
jubilation. Not everyone could, with Pope, feel 'Safe in the hand of one
disposing Pow'r', or 'behold the Chain of Love / Combining all below and all
above'. Ancient fears persisted; Methodists could agonise with the conviction
of sin, Quakers could quake. Vice and crime provoked prophecies of doom;
Johnson and Cowper were far from alone in dreading damnation; and even
non-alarmist theology like Joseph Butler's *Analogy of Religion* (1736) found
much in natural and revealed faith alike 'beyond our comprehension'.

Nevertheless, trust in a God desiring his world's happiness stirred a swell
of philanthropy. Less was heard of dogma, more of social ethics. In the good
man, the *Essay on Man* concludes,

> Wide and more wide, th'o'erflowings of the mind
> Take ev'ry creature in, of ev'ry kind,
> Earth smiles around, with boundless bounty blest,
> And Heav'n beholds its image in his breast.

Faith undertook its mission of charity as, awakened by gospels of sympathy
and beneficence, men and women of good will strove to comprehend higher
and lower ranks in a more caring society.

Good nature and good taste: virtue and the virtuoso

Society should be humane and cultured alike. Two trends offer themselves,
twin halves of enlightened character. They are philanthropy revealing true
sympathy, and taste revealing true judgment.

Though much worked for humane consensus, the socially defenceless could
suffer with a violence which provoked many a protest. Yet since hardship and
brutality were common, currents flowed towards charity. The sense of social
responsibility grew and remedies were increasingly promoted for social ills.
Fielding's *Proposal for Making an Effectual Provision for the Poor* (1753)
noted that the sufferings of the indigent were less observed than their vices
'not from any want of compassion but because they are less known'. Faithful
Christians, rationalist philosophers and moral-sentiment enthusiasts alike
could, with Pope in the *Essay on Man*, ally self-love and social, or exclaim
with Richardson in *Sir Charles Grandison* 'How much more glorious a
character is that of the friend of mankind than that of the conqueror of
nations!', or echo Parson Adams in *Joseph Andrews* (1742) telling churlish

Trulliber that whoever lacks charity is 'no Christian'. Francis Hutcheson's influential *Original of our Ideas of Beauty and Virtue* (1725), followed Shaftesbury and bracketed good aesthetics with good morals and good nature in its two treatises, on 'Beauty, Order, Harmony, and Design' and on 'Moral Good and Evil'; its centre is sympathy, both as community of feelings and as outgoing of response. Hume also assimilated morals and aesthetics, relating benevolence to the charms of painting and music (*Essays Moral and Political* (1741); 'The Stoic'):

As harmonious colours mutually give and receive a lustre by their friendly union, so do these ennobling sentiments of the human mind. . . . What satisfaction in relieving the distressed, in comforting the afflicted, in raising the fallen . . .! What satisfaction . . . to find the most turbulent passions tuned to just harmony and concord.

The *Treatise on Human Nature* (1739) likens kindly feelings to the sympathetically vibrating strings of violins. For Adam Smith's *Theory of Moral Sentiments* (1759) sympathy is the keystone, man identifying himself by benign projection with the best ideals of humanity. So were allied philanthropy and imaginative enlargements.

That the campaign for better feelings and better taste achieved nothing like the ideal needs no stressing. But from a modest start Britain rose several degrees in good will and many more in artistic sophistication. In the former regard, with much to deplore there is much to respect. Fielding commented in *The Champion* (1740) that charity 'hath shone brighter at our time than at any period which I remember', and his *Covent Garden Journal* (1752) challenged the world to rival Britain in 'this noble, this Christian, virtue'. When misery is discovered, Johnson remarked in *The Idler* (1758), 'every hand is open to contribute something, . . . and every art of pleasure is employed for a time in the cause of virtue'. Fielding and Johnson were not given to euphoria. Three years earlier Britain had sent £100,000 in aid after the Lisbon earthquake; this, Smollett's *History of England* observed (*Continuation*, (1760–1)), happened when, herself short of food, she yet spared corn, rice and beef not for compatriot co-religionaries but for another nation of different Christian allegiance. Smollett noted the hospitals maintained by voluntary aid as signs that benevolence was creditably prevalent. Besides hospitals (the Foundling Hospital among them; Hogarth and Handel were governors and generous supporters) there were charity-financed dispensaries, schools and societies for helping the needy, sending boys to sea, apprenticing waifs, fighting the slave trade, promoting Christian knowledge, propagating the Gospels and fostering other good causes, not only in London but far afield. Many ills lacked remedy, but to show oneself a friend of mankind became increasingly commendable.

The vogue of the virtuoso paralleled that of virtue. 'My charges', Shaftesbury told a friend, 'turn wholly towards the raising of arts and the improvement of virtue', and in *Advice to an Author* (1710) he asserted that 'to be a Virtuoso (so far as befits a Gentleman)' – a telling qualification – leads one 'towards the becoming a Man of Virtue and Good Sense'. The ideal citizen, as the *Guardian* No. 34 (1713) defined him, embraces religious benevolence along with 'the whole course of the polite arts and sciences'. And Pope advised his friend Ralph Allen of Prior Park, Bath, that in choosing

works of art a man 'not only shows his taste but his virtue'. The rule of taste, then, claims attention.

Taste was not dilettantism in the pallid modern sense but the deep appreciation of artistic quality. The sense of many evaluative words was stronger then than now – politeness, elegance, refinement, delicacy and the like (though not imagination, which the Romantics intensified). To have taste, to be a dilettante, connoted informed and vigorous discrimination. Among the best of Augustan clubs was the Society of Dilettanti, formed in 1732; Reynolds later painted groups of its members. This assembled connoisseurs, recorded the antiquities of Greece and the Near East in handsome folios like *The Antiquities of Ionia* (1769, 1797: other volumes later), and helped found the Royal Academy in 1768. A dilettante was indeed a friend of mankind.

In 1700 Britain's graphic arts needed encouragement; Louise Lippincott's *Selling Art in Georgian London* (1983) shows them dominated by Continental paintings, prints and antiquities. Home-bred painters, lacking art schools, trained by apprenticeship, and often hackworking, trailed behind their foreign contemporaries, finding their main chance of improvement in study abroad. Most Britons, Jonathan Richardson's *Theory of Painting* (1715) lamented, think art 'a pleasing superfluity', and though Britain shone in music, letters and science, his *Argument in Behalf of the Science of a Connoisseur* (1719) found 'a very few lovers and connoisseurs in painting'. By contrast, half a century after Sir Godfrey Kneller opened the earliest academy in 1711 (followed in 1735 by Hogarth's St Martin's Lane Academy), Reynolds's first *Discourse* (1769) rejoiced that British artists had become outstandingly good, supported by wealthy patrons and a king favourable to artistic culture; George III, himself a fair painter, was the finest royal collector after Charles I, with a penchant for Canalettos. From 1746 art-seekers could visit the Foundling Hospital's collections, organised on Hogarth's initiative, from 1760 those of the Society of Artists, and from 1768 those of the Royal Academy; these were so popular that, Walpole told Sir Horace Mann, they caused unmanageable traffic jams.

Jonathan Richardson called on his fellows to entertain 'great and beautiful sentiments', to 'converse' (a pleasant term) with the best masters, to cherish 'the dignity of their country and their profession' and to enhance the high thought, fine taste and love of liberty which should prove Britain the heir of Greece and Rome. Hogarth, too, fought hard for British art, admiring Italian painters but deriding connoisseurs obsessed by Italian tastes. The arts, all agreed, testify to national character and civility. 'In Leo's Golden Days', the *Essay on Criticism* asserted (Leo X became Pope in 1513),

> Rome's ancient Genius, o'er its Ruins spread,
> Shakes off the Dust, and rears his rev'rend Head!
> Then Sculpture and her Sister-Arts revive;
> Stones leap'd to Form, and Rocks began to live;
> With sweeter Notes each rising Temple rung;
> A Raphael painted, and a Vida sung!

The Renaissance seemed to have given life new value for, as Reynolds declared, great art enriches human nature. The idea of 'taste' emerged first, perhaps, with Inigo Jones, though the *Oxford Dictionary*'s earliest relevant

citation is from *Paradise Regained* (1671) – 'Sion's songs, to all true tastes excelling'. In *The Rule of Taste* (1936) John Steegman observes that the word embraced both collective and individual judgment and distinguished its possessor from the common herd – 'Persons of Quality must now become Persons of Taste'. The qualities it bestows, Archibald Alison remarked in his *Essay on Taste* (1790), 'increase the Splendours of the National Characters [and] exalt the Human Mind'.

Like any true judgment, taste recognises rules and traditions without depending on them. The Augustans were trying two things, often contradictory – to speak both for 'the general sense and taste of mankind' (*Spectator* No. 29) and for the individual sensibility. If judgment had often been dogmatic, now, though not eccentric, it should be personal, mediating between the inspected work and a public eager for guidance by fresh intelligence working within intelligently shared experience. In his *Large Account of the Taste in Poetry* (1702) John Dennis anticipated Jonathan Richardson; not only are 'Parts, Education, and Application' necessary, along with dignity and intellectual control, but the reader must emulate the writer's imaginative activity. 'To have what we call Taste', Leonard Welsted posited in his *Dissertation concerning . . . Poetry* (1724), 'is having . . . a new sense or faculty, . . . the prerogative of fine Spirits', and such a sense, Addison had declared, 'looks upon the world in another light and discovers in it a multitude of charms that conceal themselves from the generality'. Hume's essay 'Of Delicacy of Taste' recommended the arts, sensitively studied, as conferring good judgment and true values (a claim still heard): it added, more debatably, 'nothing is so improving to the temper'. And as the century closed, Uvedale Price, theorist of the picturesque, offered landscape gardening as highly suited to 'a liberal education'.

'Taste' became a key word, even – satirists mocked – a cant word. Later, its prestige waning, Wordsworth protested that, as 'a *passive* sense', it was unapt for intellectual operations. But earlier it was felt decidedly as active, its owner seeking the best in human cultivation. It meant true valuation appreciating the beauty God implants in creation, 'a natural good taste . . . established in the nature of things' (Shaftesbury), validated by 'general uniformity and agreement in the minds of men' (Reynolds). To study authorities helped but did not automatically confer it – 'Jones and Le Nôtre have it not to give.' Rule-mongering was useless; bad critics, Johnson told Fanny Burney, judge by rule, less bad ones by instinct, good ones by instructed individual sense.

What, then, was 'true' taste? Hogarth wrote his *Analysis of Beauty* (1753) hoping, his title-page avers, to fix fluctuating ideas of it; true taste should not fluctuate. Shaftesbury ridiculed as false taste the vanity of curio-collecting, and Pope's *Epistle to Augustus* derided the ignorant prodigal:

> For what has Virro painted, built, and planted?
> Only to show how many Tastes he wanted.
> What brought Sir Visto's ill-got wealth to waste?
> Some Dæmon whisper'd, 'Visto! Have a Taste.'

In the *Epistle to Burlington* Pope develops his comedy of Timon's villa with

its tasteless pomp and 'huge heaps of littleness'. But Time brings in his revenges, and Pope's targets are now universally extolled – monumental buildings, marble floors, splendid library, lavish chapel, formal gardens, landscaped prospects. What was legitimate display? Versailles, certainly, spelt megalomania, but how distinguish Timon's 'false' taste from Burlington's 'true', or Cobham's at Stowe?

> Expense and Vanburgh, Vanity and Show,
> May build a Blenheim, but not make a Stowe,

Cawthorn pontificated. Bramston's *The Man of Taste* (1733) satirised the upstart despising Inigo Jones and Wren, lauding Vanbrugh, and improving landscapes by flattening hills and exalting valleys. Pope sided with the Burlingtonians who deplored the baroque ('that dam'd gusto', William Kent called it) and honoured Palladian refinement where 'Splendour gathers all her Rays from Sense'. But since gaining the approval of Reynolds and Robert Adam the baroque revived; Chatsworth, Blenheim, Castle Howard and St Paul's matched all comers, and confidence in 'true' taste evaporated.

Nevertheless, the vogue of taste, as intuitive yet informed evaluation, raising its possessor into finer experience, developed as the Augustans broke with prescription and sought individuality. Creators moved into new fields; critics should do likewise. 'A poet, they say, must follow *Nature*', declared Hurd's *Letters on Chivalry and Romance* (1762), its very title marking an emergent interest:

by *Nature*, we are to suppose, can only be meant the known and experienced course of affairs in this world. Whereas the poet has a world of his own, where experience has less to do than consistent imagination.

The conclusion must be that taste, however defined, should be fresh-minded, guided by enlightened culture, and directed to 'the higher and nobler species of humanity' (Shaftesbury). Not least, it should belong not to the cognoscenti alone but to what, writing of music, Addison called 'a man of an ordinary ear'. For, in Burke's words, 'the true standard of the arts is in every man's power'.

The social arts

The arts were to improve life not only by moral elevation but by straight-forward pleasure, pleasure not, in general, from startling originality as with much modern art but from the lively rendering of desired experience. Jacobean magnates had been hailed in estate-poems for practical paternalism; what Augustan patricians sought was aesthetic display. But the arts embellished not only high-born life; good style became the normal expectation, not the prerogative of privilege. Literature in particular served an extending public with better book production, better printing, and contents for intelligent enjoyment. Seldom were its subjects specialised beyond plausible experience; writers needed Johnson's 'common reader', and in his surroundings that reader wanted seemliness. For pomp or security

buildings, but not their furnishings, had always expressed prestige; now their furnishings caught up. Solid oak yielded before fine mahogany, heavy panelling before gay wallpapers and sporting or conversation pictures; pottery and silverware grew elegant. Music, light or serious, readily intelligible, offered itself for enjoyment and, as has been said, 'as evidence of that measure on which society depended', its makers extending but never bursting the bounds of their art.

Of all the arts music is the most social. Music-making was popular and Handel's London was among Europe's liveliest centres. Especially among the well-to-do there was much skilful cultivation in clubs and private assemblies, and London's concert-goers spread their tastes to holiday resorts. Music is indeed as revealing a measure of Augustan culture as any of the arts, as the social poise of painting, the formal and masterly sophistication of architecture, or the verve, intelligence and good order of literature. An era once thought, by some, 'an age of prose and reason' responded as by natural disposition to the grace, passion and dignity of Purcell, succeeded as it was by the dramatic grandeurs, subtle sensitivities and Italianate refinements of Handel, and then by the lesser but still finely controlled and melodiously crafted graces of Arne, Boyce, Avison, and the succession of continental composers attracted to musically hospitable Britain. An age which could welcome the new-found splendours of oratorio as Handel developed them, the graces of chamber music, the engaging artificialities of Italian opera, and the native freshness of ballad opera and traditional folk-song, and could find in music at many social levels its most widespread form of participatory entertainment, had an admirable vivacity of spirit. As clearly as in any other medium, energy working within order, eloquent and richly expressive, is the essence of Augustan musical styles, finely managed to arouse and fulfil expectations with melodies, harmonies, rhythms and forms which, while gratifying the hearer by fresh invention, have an air – to recall Leavis on the words of Augustan verse – of knowing exactly where they are and why. Such qualities combine with the accomplishments of Augustan painting, furnishing and architecture to express a wholly positive pleasure in humane, ingenious and controlled form.

The most striking developments were the varying fortunes of opera. After early productions of Purcell's *Fairy Queen* and a few other works English opera faded. In 1705 came Thomas Clayton's *Arsinoe, Queen of Cyprus*, 'the first opera that gave us a taste of the Italian music', according to Addison. 'Italian' meant its Italy-derived tunes; the text was in English. The first mainly Italian work was *Almahide* in 1710, doubtfully attributed to Marcantonio Bononcini; then in 1711 came Handel's success with *Rinaldo*. Thereafter a series of works offered 'an exotic and irrational entertainment, which has been always combated, and always has prevailed', to quote Johnson's *Life of Hughes*. The plots were trivial but what enthralled audiences was the superb singing of the heroines and *castrati* heroes – Niccolini, Senesino, Farinelli and others, derided though they were in lampoons and caricatures like Hogarth's *Marriage à la Mode*, The Countess's Levée. John Dennis's *Operas after the Italian Mode* deplored 'Arts which Nature has bestow'd on effeminate Nations', but their vogue was maintained

by the Royal Academy of Music (1719–28), a company of patrons under George I; this sponsored over thirty works, thirteen by Handel, he and Giovanni Bononcini being director-composers.

The Royal Academy expired in 1728, overshadowed by the century's greatest musical-theatrical success, Gay's *Beggar's Opera*, with music arranged by J.F. Pepusch from folk-songs and airs by Purcell and others. Swift said it specifically attacked Italian tastes, but its main thrust and popularity lay in its satirical-political zest and irresistible musical freshness. 'The taste for Italian *friandises* was palled', Charles Burney commented in his *General History of Music* (1776–89), 'the English returned to their homely food'. Though Italian works persisted, *The Beggar's Opera* prompted a succession of ballad-operas further popularising the English tradition. Another sign of growing pleasure in traditional music, though much more specialised, was the Academy of Ancient Music (founded early in the century), which revived Renaissance motets and madrigals. (Further details of musical life appear in this chapter under 'Patrons and public' and 'Provincial life and communications'.)

As the century advanced, 'the science of man' became subtler; writers and artists began cultivating life's hazier outlands rather than the well-lit centre. But for long, while Britons sought consensus, what they liked was to find enjoyment in social communion. For the first time to any great extent in Britain artists recorded familiar attractions – travel views, sports, picnics, street scenes. Leading architects and painters might serve high society, furnishing it with fine portraits and magnificent publications like Knyff and Kip's *Britannia Illustrata* (1707–20), Leoni's *Architecture of A[ntonio] Palladio* (1715), Campbell's *Vitruvius Britannicus* (1717–25), Castell's *Villas of the Ancients* (1728), Stuart and Revett's *Antiquities of Athens* (1762–1816), Robert Adam's *Ruins of the Palace of the Emperor Diocletian* (1764, dedicated to George III), or, supremely, the *Works in Architecture of Robert and James Adam* (1778–9). However, lower down the social strata a wide public happily recognised its daily needs and interests in familiar writing, seemly buildings, companionable pictures and sociable music, comprising a fuller record of normal life than survives from any earlier period, a record mostly of human comedy, sometimes tart but often genial.

The century produced some shocking masterpieces – Pope's portrait of Sporus, Swift's of the Yahoos, Hogarth's *Cruelty* series, for instance – and some puzzling ones – Berkeley's philosophy, Sterne's *Tristram Shandy* (Johnson foretold it would fail the test of time), Gray's *Odes* (Garrick expressed comic dismay and Johnson disliked their 'cumbrous splendour'). But predominantly art aimed, in Johnson's words, 'to please many and please long'. 'A picture', said his friend Reynolds, 'should please at first sight'.

The corollary is important. The arts must please, but the pleasure lies in the recipient, and artistic receptivity cannot be passive; what it takes in needs translating into value. 'We receive but what we give, / And in our life alone doth Nature live', Wordsworth would declare. As with Nature, so with the arts. Addison's 'Pleasures of the Imagination' *Spectator* (Nos 411–21) popularised Shaftesbury's doctrines of imaginative response. 'The Eye', Hartley wrote in *Observations on Man* (1749; Proposition 60),

approaches more and more, as we advance in Spirituality and Perfection, to an Inlet for mental Pleasure, and an Organ suited to the Exigencies of a Being whose Happiness consists in the Improvement of the Understanding.

Physical science, taking colour, sound and taste to be fallible sense-impressions, might seem to relegate subjective experience to an inferior status; things seen 'only in their proper figures and actions', Addison admitted, would be unappealing. True, Newton's *Optics* (1704) had inspired new interest in light and colour, 'that great modern discovery'. But, Philonous asks in Berkeley's first *Dialogue* (1713),

Are then the beautiful red and purple we see on yonder clouds really in them? Or do you imagine they have in themselves any other form than that of a dark mist or vapour?

Sense impressions are subjective, imaginary (and Hobbes had disparaged imagination as only the transient reception of images). So, are we naively deluded by 'pleasing shows and apparitions'? No, Addison declares, as Berkeley assures us that, if sane, we are not solipsistically locked within our impressions because God underwrites their connection with reality. Our delight in sense pleasure is God's drawing us to love him through his creation and such delight is subjective, yet the mind, actively recipient, validly creates values from what the senses convey. 'Our eyes', William Gilpin the 'picturesque' enthusiast would observe, 'are only glass windows; we see with our imagination'. The principle applied generally; even Claude's landscapes, Handel's music, and Milton's poetry, Archibald Alison argued in his *Essay on Taste*, would be meaningless did not imagination amplify our physical reactions. The Romantic theory of perception was evolving.

There is a footnote to this. To quote Hartley's *Observations* again (Proposition 61), 'The Ideas of [sight] are far more vivid and definite than those of any other [sense]', and light and colour are prime stimulants. Painters of course needed no Newtonian promptings about colour, and poets (indeed, the human, animal and vegetable kingdoms) have always responded to it. But as Augustans opened increasingly sophisticated eyes, a heightened fascination with colour and illumination followed. John Hughes's *Ecstasy* (1720) hailed Newton's astronomy and optics alike. Pope, himself a painter by inclination and by the artist Charles Jervas's help, made the most of prismatic discoveries, especially in the scintillating account of *The Rape of the Lock*'s sylphs:

Some to the Sun their Insect-Wings unfold,
Waft on the Breeze, or sink in Clouds of Gold;
Transparent Forms, too fine for mortal Sight,
Their fluid Bodies half-dissolv'd in Light.
Loose to the Wind their airy Garments flew,
Thin glitt'ring Textures of the filmy Dew;
Dipt in the richest Tincture of the Skies,
Where Light disports in ever-mingling Dyes,
While ev'ry Beam new transient Colours flings,
Colours that change whene'er they wave their Wings.

Less sparkling, yet enchanted by chromatic effect, is Thomson's elegy *To the Memory of Sir Isaac Newton* (1727), telling how, from light's 'whitening undistinguished blaze', Newton 'To the charmed eye educed the gorgeous train / Of parent colours' – colours of fire, sky, plants, frost, clouds, rainbow, raindrops, 'infinite source / Of beauty, ever flushing, ever new'. Since 'all colours depend on *light*', Burke considers the emotional effects deriving from light's qualities, sublimity needing brilliance, chiaroscuro or 'melancholy' darkness, beauty needing clear, fair, mild tones (*The Sublime and Beautiful*). Gilpin finds mountainside lights 'a sort of floating silky colours, . . . playing with a thousand changeable varieties into each other. They are literally colours "dipped in heaven"' (*Observations on Cumberland* (1786)). In *Newton Demands the Muse* Marjorie Nicolson explores how such sensitivity sharpened interest in the visible world; Bonamy Dobrée's pages on 'Scientific Verse' in *English Literature of the Eighteenth Century* are another good guide. If, as Blake, Wordsworth and Keats were to protest, science could diminish man's sense of kinship with nature and of subjective experience as valid, this aspect worked otherwise, and writing increasingly rivalled painting in rendering the world's colour and detail.

Patrons and ~~Europ~~

Generalisations about the Augustan arts can only be loose. But generally speaking the audience for them extended markedly; what was originally a relatively small circle (larger for letters than for the other arts) expanded towards the nineteenth-century's far wider participation.

Originally the best support came from cultured and wealthy patrons. Recurrent names include Bathurst, Bolingbroke, Burlington, Chandos, Dorset, Frederick, Prince of Wales, Halifax, Harley, Lyttelton, Montagu and Somers. From these and their like, commissions flowed to architects, garden-designers, painters, sculptors and musicians. They supported writers often as political allies but often also from an intelligent interest in literature, and they enjoyed the homage of many of the country's liveliest minds.

Yet aristocratic taste was not exclusive taste. What it provided was high authority for an educated consensus through middle levels ready for aesthetic experience. At these levels the mansion, gentry house and parsonage could transmit learning and taste. Not solely from the heights did stimuli flow towards good achievement, any more than in economic life did they flow solely from high-placed entrepreneurs, in religious life solely from leading prelates, in social life solely from the court. In *The Seventeenth Century* (1929) G.N. Clark remarks of Holland and France that while artists and architects served powerful masters 'they brought with them skills and aptitudes acquired here, there, and everywhere, . . . Beneath the coherent arts was the unschooled energy of swarming life'. This was true too of Britain. In respect of literature, more readers made writing a possible if hazardous profession. Authors might still need employment beyond that of their pens, but gradually, through Grub-Street struggles, they found public support ('Grub-Street . . . in London, much frequented by writers of small histories,

dictionaries, and temporary poems': Johnson's *Dictionary* (1755)). A Copyright Act in 1709 gave them a bargaining counter with publishers competing for manuscripts; Lintot beat Tonson for Pope's Homer and rewarded Pope well – Pope, though, was exceptional. 'A man goes to a bookseller and gets what he can', Johnson remarked at St Andrews in 1773. 'We have done with patrons'. His famous letter rejecting Lord Chesterfield's belated support for the *Dictionary* asked whether a patron were not 'one who looks with unconcern at a man struggling for life in the water, and when he has reached ground encumbers him with help'. Dedicators who 'Spatter a Minister with fulsome praise', patrons 'Fed with soft dedication all day long', who 'keep a *bard*, just as they keep a *whore*', were derided by Pope (*Epistle to Arbuthnot*), Gay, Churchill and others. Dramatists, with luck, could profit from benefit nights, when they kept the takings. Popular religious or political writers could sell widely. Temporarily, under George III and his prime minister Lord Bute, aristocratic patronage revived: Bute supported scientists and writers, including Macpherson for *Ossian*, and George III's accession, Boswell commented, offered men of letters 'a brighter prospect'. Royal favours went to Johnson, Mallet, Beattie, Robertson the historian, Hume, and others. But support came mainly from the public, and by 1760 the days of Grub Street and Hogarth's *Distressed Poet* were receding.

Music drew only marginally on patronage. The leading representatives like William Croft, Handel, Maurice Greene, Thomas Arne and William Boyce depended on church or stage appointments and certain court offices and might profit, as Handel notably did, from publishing their works (Croft's *Musica Sacra*, Greene's *Forty Select Anthems*, Boyce's *English Cathedral Music*); Greene was also Professor of Music at Cambridge. Sometimes patrons helped; the Duchess of Newcastle supported Greene, and the visiting Italian, Nicola Haym, Handel's opera collaborator, received £200 annually from the Duke of Bedford. Giovanni Bononcini, sponsored in England by Burlington in 1720, received a commission for the Duke of Marlborough's funeral anthem in 1722 and was pensioned by the second Duchess, but he subsisted largely on his operas and other compositions.

Handel – 'the great and good Mr Handel', in John Byrom's phrase – may stand, though in a uniquely grand way, for eighteenth-century musical fortunes. Arriving from Hanover in 1710, scoring a resounding success in 1711 with *Rinaldo*, gaining Burlington as patron and host (1713–16), he undertook an astounding sequence of public and private ventures, with operas, oratorios and ceremonial commissions, starting in 1713 with a Treaty of Utrecht *Te Deum* and a *Birthday Ode* for Queen Anne. This latter earned him a £200 pension from the Queen, which George I, though initially displeased by his forsaking of Hanover, confirmed and in fact doubled, his favour reputedly regained by his delight with Handel's *Water Music*. In 1717 Handel entered the Duke of Chandos's service, composing for him a *Te Deum*, the twelve Chandos anthems, his first masque *Esther*, and the charming pastoral *Acis and Galatea* to Gay's words. Naturalised in 1727, he became composer to the Chapel Royal, wrote George II's coronation anthem (1727), the Princess Royal's wedding anthem (1734 – she was among his best pupils), Queen Caroline's funeral anthem (1737), the Dettingen *Te Deum* and

the music for the royal fireworks (1749), celebrating the Treaty of Aix-la-Chapelle. He visited Dublin in 1741–2 for concerts supporting local hospitals; *Messiah*, first performed there in 1742, realised large sums for charity. He was also a benefactor of London's Foundling Hospital, where annual performances of *Messiah* established its popularity. For other musicians, as for Handel, some support came from patronage but such advantages were, on the whole, incidental, and their main subsistence lay in the church, theatre, publishing, and concert-giving. Public support, however chancy, greatly extended that of patrons.

The greater artists and architects, though their work too could figure in churches, colleges, and public places, were largely the concern of the wealthy, not necessarily as patrons but certainly as clients and purchasers. 'No gentleman', Louise Lippincott observes, 'was fully prepared for polite society until he could tell a Raphael from a Michelangelo, or, better yet, owned an example of each' – which is why fakes abounded. It was of such – Shaftesbury's 'Lovers of *Art* and *Ingenuity*; such as have seen the *World*' – that were constituted the Roman Club (1723–42: John Dyer the artist-poet dedicated to it his *Ruins of Rome*) and the Dilettante Society (1732 onwards). Many collectors confined themselves to imported paintings (whence Hogarth's scorn) and to imported painters, like Kneller, Amigoni, Verrio, and Laguerre (whose saints, in the *Epistle to Burlington*, 'sprawl' over Timon's chapel: Laguerre's finest murals, scenes from Virgil, have recently – 1983 – been discovered in Frogmore House at Windsor). Fielding's *Joseph Andrews* complains that the poor starve while money is lavished on 'Ammyconni', 'Varnish' (Veronese), and 'Scratchi' (Carracci). But the championship of British art which Jonathan Richardson inaugurated, the growing cultivation of 'taste', and the determination of the wealthy to celebrate in paint themselves, their households, and their houses (and horses), produced those happier circumstances Reynolds described in his first *Discourse*, the nobility's wish 'to be distinguished as lovers and judges of the arts [and] the greater number of excellent artists than were ever known before at one period in this nation'. Admittedly, home-produced landscapes might lag in favour; as Ellis Waterhouse remarks in *Painting in Britain 1530–1790*, Richard Wilson's masterpieces were neglected by connoisseurs worshipping Claude, and imitating on their estates, those very qualities which his landscapes expressed. But despite fashion's vagaries the movement, dependent mainly on wealth, culminating in Reynolds and the Royal Academy, was a triumph for Britain's culture.

As with the purchase of books, middle society too was not unimportant. Artists could mingle with other professions, provide family portraits for the well-to-do, and teach drawing. Satirical prints, book illustrations, and other commercial desiderata could make money; many artists worked for booksellers. Hogarth's 'pictured morals' sold cheaply to buyers wanting the life around them vividly recorded. There were popular demands for reproductions of portraits, buildings, town and country views, native and foreign scenes. Walpole noted a 'rage' for engraved portraits, prices exploding from a shilling or two to a crown or even a guinea (to Mann, May 1770). Every man of taste, declared Joseph Strutt's *Dictionary of Engravers* (1775),

collected prints. Paul Sandby's engravings have been credited with doing more than anything earlier to popularise the scenery of Britain, especially that of Wales, of which from 1775 he published four sets of views. Around 1750 there existed, in Louise Lippincott's words, 'a solid professional and commercial base on which the later eighteenth-century art world would thrive'.

'The grand affair of business'

Augustan practical life might have been surveyed earlier were it not that, while the arts certainly need a practical basis, they view life in an imaginative rather than a material context. But of course what was materially done underpinned what was imaginatively conceived.

In 1754 the Society for the Encouragement of Arts, Manufactures, and Commerce was founded in London; similar societies existed in Dublin and Edinburgh . The date all but signalises the century's chronological heart, and equally near its heart were the Society's concerns. Twenty years later, appropriately, it found its home in Robert Adam's Adelphi at Westminster, the Great Room of its meetings adorned with James Barry's vast murals depicting the progress of human culture from ancient times, the last scene showing the assemblage in Elysium of the greatly virtuous of all lands and ages. The great maxim, Barry explained – in the full spirit of the Enlightenment – is that 'the obtaining of happiness, individuals as well as public, depends on cultivating the human faculties'. In 1768 the Society helped found the Royal Academy, George III assisting too. The mid-century has been called insatiably curious, its activities flexibly responsive to fresh influences, and the Society expressed that spirit. Sophie von la Roche, the observant wife of a German nobleman, visited it in 1786; its projects, she reported, embraced the improvement of industry, agriculture and the arts, the encouragement of tree-planting (five acres of oak saplings earned a silver medal, ten a gold), the extension of drainage and reclamation, the furtherance of education (a gold medal for easy ways of teaching Latin), and schemes for reducing industrial injury.

Defoe's *Tour Thro' the Whole Island of Great Britain* (1724–6) had celebrated 'the grand affair of business', and one year before the Society's birth the *Adventurer* No. 67 (Johnson's) observed, of London's swarming activities, that

He that will diligently labour, in whatever occupation, will deserve the sustenance which he obtains and the protection which he enjoys; and may lie down every night with the pleasing consciousness of having contributed something to the happiness of life.

Johnson knew all about hardship yet his affirmation of honest work rewarded by happiness (a touch typical of the time) chimed with common assumptions that, whatever the evidence to the contrary, divine rectitude had appointed happiness as the intended end of diligence. Pope's *Essay on Man* explains that by God's plan mankind's infinitely varied activities unite in global harmony, and Adam Smith's *Wealth of Nations* (1776) would, however

untenably, assure readers of an 'invisible hand' co-ordinating multitudes of economic individualisms into a beneficial whole. Robinson Crusoe's *Farther Adventures* introduces its hero to an English merchant in Bengal who, questioned about his labours remote from home, replies that life means travel and work:

The whole world is in motion, rolling round and round; all the creatures of God, heavenly bodies and earthly, are busy and diligent; why should we be idle?

A rolling stone, evidently, did gather moss.

The encouraging orthodoxy was that the more arts, manufactures and commerce developed, the more they would serve a well-rewarded national and international whole. 'We merchants', Steele's aptly-named Mr Sealand observes in *The Conscious Lovers*, 'are a species of gentry that have grown into the world this last century'. Their better representatives had 'grown' not only in monetary thrust but in sociability and culture, and many commendations praised self-made men who did honour to life. William Hutton's *History of Birmingham* (1781) voiced the general view that 'civility and humanity are ever the companions of trade; the man of business is the man of liberal sentiments; a barbarous and commercial people is a contradiction'.

Society was in many ways hierarchical yet it admitted vertical mobility. Trading families, Defoe asserted in *The Compleat English Tradesman*, produce statesmen, prelates and judges as readily as do those of blue blood, and 'Merchants', Adam Smith was to observe 'are commonly desirous of becoming country gentlemen' and in his *Plan of the English Commerce* he claimed to know five hundred estates within a hundred miles of London taken over by rich merchants from impoverished gentry. Conversely, 'the declining gentry sinks into trade'. 'Sinks' implies degradation, yet the process was not necessarily regrettable. That tradesmen rose invigorated the gentry; that gentry traded was good for society. The Turks, Defoe noted, scorn trade and are poor: the Venetians court it and are rich. Nathaniel Forster's *Enquiry into the Present High Price of Provisions* (1767) lauded competitive enterprise:

In England the several ranks of men slide into each other almost imperceptibly. . . . Hence arises . . . the perpetual restless ambition in each of the inferior ranks to raise themselves to the level of those immediately above them.

The quotation comes from Neil McKendrick's chapter, 'Commercialization and the Economy', in the *Birth of a Consumer Society*: its spirit is that rather of the present New World, or the developing world, but the Augustans early responded to its promptings.

Practical success should earn moral honour. 'No doubt', Boswell reflected in 1765 when recording Johnson's introduction to Mr and Mrs Thrale (Mr Thrale a thriving brewer), 'Honest industry is entitled to esteem.' The remark fitted Johnson and Thrale alike. On the other hand, corrupt wealth was scathingly satirised; success must be honest success. *The New Whole Duty of Man* (1722; often re-issued) declared that God, letting one man thrive more than another, 'doth thereby . . . advance him into a higher sphere.' This was not tautology; it meant that success is God's endorsement of ethical worth. The ideal of the man of enterprise was defined in Thomas Mortimer's *Elements of Commerce* (1772); it included religious principles, a

firm attachment to truth and honour, 'prudent generosity', 'dignity and moral rectitude' and willingness to shoulder public responsibilities. Such was the approved commercial ethic.

Nonconformists, barred in England (though not Scotland) from universities and the learned professions, exerted themselves in trade and industry. Their dissenting academies were generally better than Church schools, providing modern studies for modern minds, those, for instance, of Defoe, John Howard the prison reformer, John Roebuck the leading industrial scientist, and Thomas Malthus the economist and demographer. Quakers, Baptists, Unitarians and Presbyterians were powerful in banking, milling, brewing, cotton spinning and iron and steel. They often distinguished themselves in the late-century provincial Literary and Philosophical Societies and in groups like Birmingham's Lunar Society, adorned by Joseph Priestley, Unitarian divine and outstanding chemist, James Watt the inventor, Matthew Boulton ('princely Boulton'), metallurgist and captain of industry, and, ablest of all, Josiah Wedgwood the potter, whose artistic enhancement of his industry was as remarkable as his phenomenal enlargement of its scope. But though Dissenters had strong motives for enlightened progress the impulse was not theirs alone; for men of all tenets such God-approved virtues as diligence and sobriety pointed to success. They would concur with *The Tradesman's Calling* (1684) by Richard Steele (Restoration London rector, not the essayist), that 'Prudence and Piety were always very good friends. . . . You may gain enough of both worlds if you would mind each in its place'.

Gaining the world should mean more than gaining its substance. Enlightened men could serve not only practical gain but also welfare, science and the arts – men like Ralph Allen of Prior Park (Benjamin Boyce's *The Benevolent Man* (1967) gives an admirable account), Johnson's friend Henry Thrale, Richard Arkwright, cotton spinner, and the already-mentioned Matthew Boulton and Josiah Wedgwood. Such men, a French visitor commented, were 'level with the greatest in the land'. So themes already heard – the desire for humane co-operation, freedom within law for personal exertion, readiness to explore the worlds of man and nature, and zest for Britain's prowess in culture, as in trade and war – these find echoes in practical life. 'No study', wrote Thomas Mortimer, 'seems more important than that which tends to convey proper ideas of . . . Commerce, Politics, and Finances', and while denouncing masters who exploited their labourers he commended the Chinese (widely considered paragons of wisdom) for conferring on worthy businessmen 'the honour of a mandarin, or noble of the ninth class'.

The individual pursued his initiatives, the community devised laws and organisations for the general good. Of individual initiatives Robinson Crusoe is the great symbol. Rejecting his father's cautions he seeks new worlds, the most compulsive of pioneers who exert themselves and return with cargoes of useful or luxurious imports, striving – to quote Mallet's *Amynta and Theodora* –

> With ev'ry wind to waft large commerce on,
> Join pole to pole, consociate sever'd worlds,
> And link in bonds of amity and love
> Earth's universal family.

The catalogue of Defoe's library contained 'several hundred Curious, Scarce Tracts . . . on Husbandry, Trade, Voyages, Natural History, Mines, Minerals, &c.' A characteristic parable occurs on his *Review* (21 June 1711), the story of Invention, born of Necessity and Poverty, from whom flow 'Improvement of Land, Art [that is, skill], and various Contrivances for their Advantage'. Invention begets Industry, Ingenuity, Honesty; from ingenuity descend Barter and Trade, source of monetary values and 'Improvements of Navigation'.

Already under Queen Elizabeth the Levant and similar companies had organised foreign trade. In 1670 a medal was struck inscribed *Diffusus in Orbe Britannus* – the Briton dispersed through the world; the slogan was representative. In 1675 Charles II instituted the Greenwich Royal Observatory to further astronomy and navigation. Matthew Prior's *Carmen Seculare for the Year 1700*, one of many patriotic paeans, inaugurated the new century:

> Through various climes, and to each distant pole,
> In happy tides let active commerce roll;
> Let Britain's ships export an annual fleece,
> Richer than Argo brought to ancient Greece;
> Returning loaden with the shining stores
> Which lie profuse on either India's shores

(the Indies, East and West). Parliamentary and extra-parliamentary groups exerted themselves for the general benefit. The legislature, Arthur Young remarked in his *Tour of Ireland* (1780),

has for a century bent all its energies to promote the *commercial system*. The statute-book is crowded with laws for the encouragement of manufactures, commerce, and colonies.

When Sir Robert Walpole took office in 1721 as, effectually, Britain's first prime minister (the term for long was unofficial), he announced his policy to foster commerce 'upon which the riches and grandeur of this nation chiefly depend'. Voltaire noted the alliance of collective and individual business in that while Walpole governed Britain his younger brother directed a trading post at Aleppo. Joint-stock financing tempted a generally inexpert public into speculation, and the most reverberant crash in British economic history occurred with the bursting of the South Sea Bubble in 1722, when, after rocketing, the South Sea Company's shares plummeted, leaving fortunes for a few, ruin for the many. But while the public took risks, it also felt the excitement of enterprise.

If Britain sought the world, the world sought Britain. London's Royal Exchange inspired the *Spectator* No. 69 (Addison's) about its manifold business and the international assembly gathered for trade – Britons, Russians, Armenians, Dutch, Jews, Japanese; Mr Spectator feels himself a citizen of the world. A similar prospect, but cynically rendered, had prompted Bernard Mandeville's squib *The Grumbling Hive* (1705): this portrayed society as a swarm whose prosperity springs from 'vice' ('vice' being, teasingly, any indulgence over the barest minimum). Churchill's *The Ghost* (1762) turned Addison inside out, presenting London as a place

Where to be cheated, or to cheat,
Strangers from ev'ry quarter meet;
Where Christians, Jews, and Turks shake hands,
United in *commercial* bands,
All of one *faith*, and that, to own
No God but interest alone.

But Addison's view was the more persuasive, his themes those of the time –
pleasure even to tears (the Augustans not being phlegmetic) at mankind's
shared happiness and at the God-given dispensation whereby different
nations supply different needs. Overseas settlements spread, in 1700 only
Jamaica, the American colonies and some Indian footholds, but multiplying
during the century by conquest and colonisation. Between 1700 and 1750
England's foreign trade and shipping nearly doubled.

Such practical activity impinged markedly on the arts and social life.
Though trade flourished most with Europe or America, its gratifications came
rather from the East. Coffee, tea, silks and perfumes affected social habits.
Decorative styles accommodated the exotic; European morals were quizzed
by fictional Oriental visitors exercising the slanted eyes of Asiatic wisdom.
Horizons broadened with accounts, real or fanciful, of fantastic scenes.
Mediterranean or Levantine travellers, or masqueraders at Vauxhall,
Ranelagh, and Oxford Street's Pantheon, promenaded in eastern finery.
Indian muslins and chintzes affected design. Chinese styles – chinoiserie –
transfigured furniture, screens, porcelain, buildings and gardens. As for
home-bred preoccupations, zestful celebrations of enterprise figure in verse
eulogies and in prose accounts like Defoe's *Essay upon Projects* or *Tour*. A
hilarious antidote to them, yet itself reflecting the prevalent mood, is Swift's
derision in *Gulliver's Travels* ('Voyage to Laputa') of those 'schemes of
putting all arts, sciences, languages, and mechanics upon a new foot' which
mesmerize the Ladago projectors (parodying the Royal Society). The climate
of opinion is clear in the quite unsatirical schedule which Richard Savage
prefixed to his poem *Of Public Spirit in Regard to Public Works* (1737),
addressed to the Prince of Wales. This treats, Savage declares

Of reservoirs and their use; of draining fens and building bridges; cutting canals,
repairing harbours, and stopping inundations; making rivers navigable, building
lighthouses; of agriculture, gardening, and planting for the noblest uses; of commerce;
of public roads; of public buildings, viz. squares, streets, mansions, palaces, court of
justice, senate-houses, theatres, hospitals, churches, colleges; variety of worthies
produced by the latter; of colonies. The slave trade censured, &c.

That last item is a reminder that, with much in commerce commendable,
there was also much deplorable – corruption, exploitation, cruelty. For over a
century the slave trade was both profitable and outrageous.

Production, exports and imports increased, and living standards rose not
only at the upper levels commissioning luxuries and artworks but at all levels
above the poorest. Moralists fumed. Gay's *Trivia* yearned for old, simple
Britain 'Ere pride and luxury her sons possess'd'. Defoe protested that what
impoverished the poor was self-indulgence (*Giving Alms no Charity*). Fielding
deplored 'a vast torrent of luxury' (*Enquiry into the Late Increase of Robbers*).
Smollett referred in the *Continuation* (1760–1) of his *History* to excess

'breaking down all the bounds of civil morality'. And John Byng complained in his *Torrington Diaries* (5 June 1781) that good roads spread London sophistication, and country milkmaids adopted 'the dress and looks of Strand misses'. Yet, Boswell notes, when Goldsmith inveighed against extravagance, Johnson retorted that Britain appeared healthy, that luxury might do the poor good, and that increased consumption benefited society.

The debate continued: life raised by affluence? debased by excess? To the optimist, like Defoe in his *Tour*'s Preface, England was 'the most flourishing and opulent country in the world'. Whig zealots believed this self-evident, and modern research tends to support them. As money spread, so too did literary and artistic cultivation; this was that 'superfluity of wealth among the people to reward the professors' (artists and craftsmen) on which Reynolds congratulated his countrymen.

Savage dealt with 'public works'. These increasingly gave Britain a creditable or indeed handsome face. Economic growth could introduce or intensify social ills but its happier results were to encourage not only personal enrichment but civic display, the hallmark of self-aware nationhood. To quote Savage again,

> Hail, arts! where safety, treasure, and delight
> On land, on wave, in wondrous works unite.

He was, probably, echoing the *Epistle to Burlington*: Pope had praised the Earl for restoring 'fallen arts' and then, nudging George II, had mentioned such projects as 'become a Prince' – harbours, roads, churches, bridges. Parliament was then, in 1731, debating the construction of Westminster Bridge, for which Burlington would be a commissioner. Opened in 1750 (and superbly depicted by Canaletto and Samuel Scott), it was the first classical bridge of its size in Britain, followed twenty years later by Blackfriars. Pope's *Epistle* ends by glorifying ideas central to his time's aspirations – the admiration fine buildings evoke, Britain's pride in peace and embellishment, and the royal patronage which should support such lofty aims:

> These Honours peace to happy Britain brings;
> These are Imperial Works, and worthy Kings.

The Act for building fifty new churches in London (1711) gave important commissions to Hawksmoor and others, though only twelve new churches resulted: others, already existing, were part-aided. An Act of Parliament established the British Museum (1753–9). St Paul's Cathedral, Chelsea Hospital, Greenwich Hospital, Somerset House, Blenheim, and other great schemes including the classical splendours of Dublin, Bath, Edinburgh and elsewhere bid for Britain's architectural renown, many of them public projects and all of them such 'Imperial Works' as gratified the national desire for distinction.

In other areas economic organisation advanced. The Bank of England founded in 1694, basically a Whig-merchant invention for financing William III's wars, curbed the Crown's control over money and fertilised business. The Bank of Scotland followed in 1695, the Royal Bank of Scotland in 1727, the Bank of Ireland in 1783. In 1714 a prize was offered for a method of fixing longitude at sea, won by John Harrison in 1765. In the latter half of

the century coal production doubled and pig-iron output quadrupled. Insurance companies developed. Commercial periodicals appeared, like *Lloyd's List* which from 1726 spread market and shipping news. As in Savage's prospectus, lighthouses, harbours, canals, and highways appeared. Rural innovation broadcast its benefits. The Royal Society from its foundation had encouraged agriculture, and experiments extending far beyond the Society improved harvests and stock, a happy result being much appreciative painting of fine animals. The Society of Improvers of Agriculture started work in Scotland in 1723. Swift is again satirical in the 'Voyage to Laputa', contrasting newfangled 'unaccountable methods' of farming, unproductive of crops, with Lord Munodi's old-fashioned but flourishing estate. Yet even Swift approves the King of Brobdingnag's view that whoever makes two ears of corn grow where only one grew before does more good than the whole race of politicians together – tongue-in-cheek praise, doubtless, but heartfelt: that was precisely the improvers' aim. Enclosures, initiated by enterprising landowners, enriched the countryside, if not, necessarily, all countrymen. Agriculture gained its mouthpieces; *The Farmer's Magazine* started in 1776, the Board of Agriculture in 1793.

Many labourers certainly suffered the poverty Goldsmith lamented in *The Deserted Village* (1770) and Crabbe in *The Village* (1783). But increased output averted starvation during the Napoleonic wars, and Britain's enhanced beauty encouraged notable advances in sensibility – scenic appreciation, touring enthusiasm, landscape painting. Such enterprises, home-bred and foreign, urban and rural, developed her, often through difficulties and hardships, yet as Savage wrote, in a spirit confident that,

> Thus Public Spirit, Liberty and Peace,
> Carve, build, and plant, and give the land increase.

London

'He who is tired of London is tired of life.' Johnson was expressing the gratification he felt – inconceivable, he said, to non-Londoners – that, Boswell recorded on 30 September 1769, 'there is more learning and science within the circumference of ten miles from where we now sit than in all the rest of the kingdom.' Dublin and Edinburgh had much to boast of, and the main provincial towns were centres of cultural activity. Yet the capital was indeed a powerful magnet. 'I am glad I am got into brave old London again', Horace Walpole told George Montague, and to Boswell it comprehended 'human life in all its variety, the contemplation of which is inexhaustible'. Defoe thought it outstanding –

The most glorious sight . . . that the whole world at present can show, . . . made glorious by the splendour of its shores gilded with noble palaces, strong fortifications, large hospitals, and public buildings; with the greatest bridge [London Bridge] and the greatest city in the world.

From 1700 to 1800 the annual shipping tonnage using Britain's ports multiplied sixfold, and of this London bore the major share; a German traveller in 1782 observed 'a little forest of masts' whenever the Thames was in view.

In central London the Great Fire of 1666 had swept away many of the diseased areas of the 1665 Plague, roaring, said the diarist Anthony Wood, with 'a noise like the waves of the sea'. Originating in a baker's shop in Pudding Lane, near St Paul's Cathedral, where the Monument now commemorates it, it raged for five days destroying four hundred acres or nearly two-thirds of the City, of the old close-packed timber-framed houses, along with churches and public buildings like St Paul's itself, the Guildhall and the Royal Exchange. There was immense loss of property, though fortunately very little of life. As Wood further commented, the combined plague and fire left London 'much impoverished, discontented, afflicted, cast down'.

As a result the face of London was radically changed, though Sir Christopher Wren's far-sighted design for a new city with rectilinear street plans centring on circuses and piazzas in Continental style was defeated by vested interest. Streets were widened and buildings, brick- or stone-built instead of wood, followed orderly designs. Regulations unified cornice heights and other details; John Summerson's *Georgian London* (1945) is a fascinating commentary. Wren's new St Paul's, though not finished until 1710, as compared with the Gothic old one, said John Evelyn, struck 'the understanding as well as the eye with the more majesty and solemn greatness'. Wren was also involved in the rebuilding of fifty-one of the eighty-six burnt-out churches. In fashionable areas formal squares, crescents, and terraces displayed, as Dyer remarked in *The Fleece*, the 'beauteous shapes / Of frieze and column'. Inigo Jones had set the precedent in the 1630s:

> Where Covent Garden's famous temple stands,
> That boasts the work of Jones' immortal hands,
> Columns with plain magnificence appear,
> And graceful porches lead along the square.

The tribute is Gay's, in *Trivia* (1716); the 'temple' is St Paul's, Covent Garden, a design of severe and masterful power; it figures in Hogarth's *Morning*.

London's growth seemed marvellous, by 1800 nearly doubling the half million inhabitants of 1700. Walpole told Sir Horace Mann in 1776 that even thirty years earlier, when after losing office his father Sir Robert paid social calls (as prime minister he had been spared them), 'he could not guess where he was, finding himself in so many new streets and squares'. Since then, Walpole added, London seemed to have 'imported two or three capitals' and could tuck Florence (where Mann was) into its fob-pocket; like overgrown Babylon, Memphis, and Rome, he prophesied, the rage of building would explode under 'the exuberance of opulence'.

Defoe's guidance is indispensable, even if his superlatives need qualifying. 'So many noble streets and beautiful houses as are in themselves equal to a large city' stretch along the Thames. Theatres, hospitals, mansions,

new squares and new streets rising up every day to such a prodigy of buildings that nothing in the world ever does or ever did equal it.

St Paul's Cathedral and the City churches, white Portland stone, their steeples brilliant classical translations from Gothic originals, symbols of the

newly embellished capital as shown in Canaletto's panorama from the Duke of Richmond's house, or his drawings of river scenes (Westminster, Westminster Bridge, the City) – so appeared that 'mighty heart' of 'Ships, towers, domes, theatres, and temples' which, as the next century dawned, Wordsworth hailed from Westminster Bridge as equalling earth's fairest sights.

A diametrically opposite portrait of London could certainly be drawn, of poverty among swarming populations in the extensive insanitary warrens of slum parishes. Even in the better areas disease, squalor, and crime were never far off. This London is the scene of *Moll Flanders* and *Colonal Jack*, *The Dunciad*, *Jonathan Wild*, Fielding's sociological pamphlets, *Roderick Random*, Johnson's *Life of Savage*, together with the end-of-the-century radical writers, and Hogarth's *Idle Apprentice*, *Gin Lane* and *Rake's Progress*. If the main impression transmitted by the better-known writers and artists is that of a lively social round for both sexes in handsome clubs, theatres, pleasure grounds, and rural retreats, that is because social comedy is more appealing than social misery – and because, also, that is where their interests centred. Still, Augustans predicated their civilisation on awareness of depths and dangers, and this awareness animated not only their philanthropy but also the vigour with which they defined and realised their best codes. Had their sense of life been confined to elegant display they would have lacked spirit and muscle; a bulwark needs strength. A German visitor, Friedrich August Wendeborn, in his *View of England* (1791), commended the range and vigour of London's character, not its stylishness:

The friend of arts and sciences, the friend of religious liberty, the philosopher, the man who wishes to be secure against political and ecclesiastical tyrants, the man of business, the man of pleasure, can nowhere be better off than in this metropolis.

Ireland and Scotland

Ireland (most notably Dublin) and Scotland (most notably Glasgow, Aberdeen and Edinburgh) strikingly varied England's steadier development. Both, long unimproved, underwent dramatic renaissance. Ireland's was achieved through a sudden galaxy of talent – the Boyles, Archbishop King, Swift, Congreve, Farquhar, Berkeley, Burke, Goldsmith, Steele, Hutcheson, Sterne and Sheridan (to cite only outstanding names). Admittedly they shone mostly in England – Swift and others hardly thought themselves 'Irish'; nevertheless they formed a powerful Irish dimension, and Dublin, second city of Britain, was noted for intelligence, wit and elegance. Swift's friend Mrs Pendarves (later Mrs Delany) recorded during her 1731–2 visit 'great sociableness [and] great civilities', with concerts, receptions, balls, plays and excursions into delightful landscapes along roads 'much better . . . than in England' – though she noted also the wretchedness of the rural poor. Arthur Young's *Tour in Ireland 1776–9* (1780), while observing poverty and oppression, found Dublin comparing well with London in agreeable society, its Rotunda rivalling Ranelagh in 'gaiety, pleasure, luxury, and extravagance'. The city's fine musical tradition was enhanced when in 1742 *Messiah* was

first performed there. The Royal Dublin Society (founded in 1731 – 'the father of all the similar societies now existing in Europe', Young called it, though in fact there were precedents) and later the Royal Irish Academy (1785) fostered practical and 'polite' learning.

Though Ireland suffered the exploitation which Swift became a folk hero for denouncing, the wealth which landlords gathered from vast estates scattered Palladian mansions with gardens and art collections through the land. Young's pages abound with beautiful landscapes, handsome houses, improved roadways, and agricultural developments. 'The badness of the houses', he observed, 'is remedying every hour throughout the whole kingdom, for the number of new ones just built, or building, is prodigiously great'. The Irish he commended for hospitality and 'eloquent volubility', as 'a brave, polite, and liberal people' among whom 'a new spirit, new fashions, new modes of politeness exhibited by the higher ranks are imitated by the lower'. Dublin, its Vice-regal court focusing fashion and intellect, displayed fine mansions, terraces and public buildings – St Patrick's Hospital (built from Swift's bequest), the Blue Coat School, Parliament House (now the Bank of Ireland), the Royal Exchange (now the Mansion House), Trinity College Provost's Lodge and Library ('very beautiful, . . . a very fine room, and well-filled'; Young), the Custom House and Four Courts, the wealthier residences, as in England, adorned with paintings and superb rococo plasterwork. Mrs Pendarves judged St Stephen's Green equal to the best London squares, and by 1760 Dublin's better areas rivalled anything in the capital. As for literary production, H.R. Plomer's *Dictionary of Booksellers and Printers 1726–75* (1922) lists over 250 names in Ireland, 540 in Scotland, and though many were small jobbing contractors others were of more consequence; there were readers in both countries for a considerable publishing trade.

The Scottish story is still more remarkable. After Scotland's fifteenth to sixteenth-century cultural efflorescence, King James's accession in 1603 to the British throne drew many leading Scots south. Politico-religious strife hindered development; Calvinism encouraged dogmatic disputation but discouraged the arts. Before the 1707 parliamentary union with England and Wales, Scotland's economic progress was negligible. A population of around a million was widely dispersed; communications were undeveloped; many regions were little known, visitors were few, and landscapes were treeless and unenclosed.

The 1707 union meant political subservience but brought compensations, particularly in opening contacts with America; in 1700 Scotland had a hundred sea-going ships, in 1800 two thousand. Glasgow took strong hold on New England commerce and the Virginia tobacco trade. Development gained an astonishing momentum; by mid-century – to quote Phillipson and Mitchison's *Scotland in the Age of Improvement* (1970) – the country's economic growth was 'little short of miraculous'. Symptomatic of the 'wonderful change' (Macaulay's phrase) was the already-mentioned Society of Improvers of Agriculture; by 1800, advanced though England's farming was, Scotland's was in some ways better. There was much mismanagement of Highland estates but enlightened managers strove for progress; visiting

Raasay in 1773 Johnson and Boswell recorded how fruitfully their host, Captain Malcolm Macleod, had remedied his precursors' neglect. There were developers who radically improved their estates, like Lord Kames the eminent lawyer-philosopher-landowner, the third Duke of Argyll who rebuilt Inverary Castle and did much for trade, communications and education, and the fifth Duke who presided over the Highlands Agricultural Society and the British Fisheries Society and founded Tobermory in Mull as a fishing port in 1788. There were similar developments in the mid-century under Daniel Campbell of Islay, who established Bowmore for the distilling trade. Thomas Pennant's *Tour in Scotland* (1774) noted much poverty but many signs of amelioration.

Communications improved by military road-building and turnpike construction; in 1786 two coaches daily did the Edinburgh–London run in sixty hours. Local banks multiplied for local enterprises. From 1727 the Board of Trustees for Manufactures developed linen spinning and weaving. Ironmasters opened Stirlingshire's Carron works (whence 'carronade', a short, large-bore cannon). Coalpits and cotton mills began operating. In 1778 the Forth–Clyde canal linked east and west coasts. By contrast with earlier poverty at least the Lowlands (the Burns and Scott country) reached decent subsistence: merchants, landowners and industrialists could prosper and their workers gain a fair living. Between 1700 and 1800 the population doubled but governmental revenues increased fiftyfold.

Culturally Scotland's renown spread impressively; the process is well covered by Roderick Watson in *The Literature of Scotland* (1984; Chapter 5). Education was often better than in England, and poor families sacrificed heroically for learning. Touring in 1773 Johnson commented that, though often backward materially, Scots 'attained the liberal, without the manual, arts', and that students, though starting university over-young, were well-trained and motivated. Recently, he recognised, material life too had improved – 'Progress in useful knowledge has been rapid and uniform'. Determined to prove civilised, Scotland embarked on fruitful self-projection with her writers, philosophers, theologians, lawyers, artists, architects, economists, inventors, engineers and natural scientists. Preservation went along with development; G.S. Fraser, introducing his selection from Burns (1960), stresses how characterful was the communal life in which Burns grew up, a store of folk memories and traditions – 'the life of small market towns, villages, farms, kirk sessions, cattle fairs, hiring fairs, bastardies, penances, marriage, convivialities, and responsibilities'.

Poets anticipated Burns in practising familiar styles. William Hamilton of Bangour (1704–54) wrote popular verses in demotic idiom; he contributed to Allan Ramsay's *Tea-Table Miscellany* (1723–37), widely popular throughout Britain, which preserved (while 'improving') old songs and ballads. Ramsay's *Ever Green* (1724) collected 'Scots Poems wrote . . . before 1600', commending their 'Strength of Thought and Simplicity of Style', and his *Gentle Shepherd* (1725) was rustic-life pastoral, first performed in 1729 by a schoolboy cast as a ballad-opera with all-Scots songs, prompted by the Edinburgh success in 1728 of *The Beggar's Opera*. (Five *Beggar's Opera* airs have been attributed to *The Tea-Table Miscellany* or its derivative, William

Thomson's *Orpheus Caledonius*, 1725.) London was in fact familiar with Scottish music; there were, for instance, Scots-fiddle collections by William Playford (1700) and John Young (1726). In 1725 Ramsay opened Britain's first circulating library in Edinburgh, fifteen years ahead of London. The poet Robert Fergusson (1750–74) preceded Burns (who celebrated 'Ramsay and famous Fergusson') in asserting the vitality of Scottish language and tradition. With much cross-fertilisation of social classes, traditional songs and stories circulated among all ranks. James Kinsley's essay, 'The Music of the Heart' (in D.A. Low's *Critical Essays on Robert Burns*, 1975), judges the prevalence of folk-song and music to be, after historiography and philosophy, 'the most striking feature of eighteenth-century Scottish culture'. Johnson on the island of Raasay, like other visitors elsewhere, was captivated by airs, dances, and 'the sound of words which I did not understand'. Highlanders and islanders strongly resisted efforts to suppress Gaelic; they spoke it universally and sang its songs. The year 1741 saw the first *Galick and English Vocabulary*, the 1750s the first printed Scottish texts and 1767 the first Gaelic *New Testament*, and in 1784 the Highland Society was founded to foster Gaelic studies.

There was also, as likewise south of the border, spirited cultural antiquarianism. Interest mounted in earlier poetry, heralded by James Watson's *Choice Collection of Scottish Poems* (1706), the first – it claimed – 'in our own Native *Scots* Dialect'. Allan Ramsay revived Henryson and Dunbar; Thomas Ruddiman's glossary (1710) to Gavin Douglas's *Aeneid* translation (1553) promoted interest in Middle Scots. Folk poetry was assiduously gathered, notably in Ramsay's collections, Lord Hailes's *Ancient Scottish Poems* (1770), and, supremely, David Herd's *Ancient and Modern Scottish Songs* (1769, 1770), and, folk-singing being a living tradition, folk-tunes were extensively recorded. So, comments Ian Grimble's *Scottish Islands* (1985), Scots characteristically, however poor, guarded 'a rich, aristocratic culture'. The 1747 Act proscribing the tartan after the 1745 uprising was repealed in 1782; by then the Highlands were a tourist attraction, 'a grand and timeless setting' – they have been called – 'for caterans and Fingalian heroes' (Highland marauders and legendary warriors). The enthusiasm greeting John Home's historical tragedy *Douglas* (1757) and his friend James Macpherson's Ossianic poems (1760–3), with incantatory names and rhythms anticipating Blake's spell-binding, reflected pride in a copious national inheritance which Burns and Scott were to climax.

Scottish feelings could be ambivalent. Better prospects might beckon abroad; 'Scotland is too narrow a place for me', Hume once told Adam Smith. Yet Scotland needed home-centred patriotism, and Hume, Boswell and others kept a foot in both camps. Expatriates or not, Hume claimed in 1757, Scots were 'the People most distinguish'd for Literature in Europe'. He could have named Gilbert Burnet, Arbuthnot, Ramsay, Francis Hutcheson (Irish-born but eminent in Glasgow for philosophy), James Thomson, David Mallet, Hugh Blair, Robert Blair, John Home, Tobias Smollett, William Robertson, Lord Kames and others. The next three years – 1758–60 – saw Robertson's *History of Scotland*, Gerard's *Essay on Taste*, Smollett's *History of England*, Adam Smith's *Theory of Moral Sentiments*, Macpherson's

Fragments of Ancient Poetry – and Burns's birth. 'I have often considered, with some sort of envy,' Gibbon wrote in 1779 to Robertson, 'the valuable society you possess in so narrow a compass.' Scottish achievements were outstanding in biography (Boswell is still unrivalled), historiography (Burnet, Lord Hailes, Hume, Roberts and Smollett), and philosophy (from Hutcheson to Dugald Stewart). Modern sociology, Max Weber asserted, sprang from such works as Adam Ferguson's *History of Civil Society* (1767) and, with John Millar, *The Origin of the Distinctions of Rank* (1771). And the Foulis brothers – 'the Elzevirs of Glasgow' as Boswell called them in his *Tour* – began their superb editions of Greek and Latin classics and other works in 1741.

Much notable work admittedly appeared beyond Scotland's borders, but Scottish writers were still Scots, even in England. As for periodicals, while some sprang up in Glasgow, Aberdeen and Dumfries, the main centre was Edinburgh, with the *Courant* (1705), *Evening Courant* (1718), *Caledonian Mercury* (1721), *Scots Magazine* (1739), *Advertiser* (1760), Ruddiman's *Weekly Magazine* (1768), and Henry Mackenzie's *Mirror* (1777) and *Lounger* (1785); several carried important literary contents. Accounts of Scotland found an English–Welsh public. Tastes for romantic tales and landscapes travelled south; English writings, fashions and artistic styles travelled north. Scotland, in G.M. Trevelyan's words, 'burst into sudden splendour'.

In 1700 her universities were generally undistinguished (though Edinburgh, in 1690, pioneered the teaching of Newton's *Principia*) but poised for advance. They have always favoured studies which sharpen the mind – theology, philosophy, medicine, law; among the most distinguished legal works are Lord Stair's *Institutes of the Law of Scotland* (1681), Sir George Mackenzie's *Laws and Customs of Scotland* (1678) and *Institutes of the Laws of Scotland* (1684), and John Erskine's *Principles of the Law of Scotland* (1754) and *Institutes of the Law of Scotland* (1773). Scholars rose to eminence – at Glasgow Hutcheson and Adam Smith; at Edinburgh Colin Maclaurin the (Glasgow-trained) mathematician, Hugh Blair the rhetorician, Robertson the historian, Dugald Stewart the philosopher; at Aberdeen Maclaurin (before transferring to Edinburgh), James Beattie the poet-philosopher, Alexander Gerard the theorist of taste, Thomas Reid the philosopher (later succeeding Smith at Glasgow). Dr Johnson found congenial company everywhere, was greeted at Glasgow with courteous awe, at St Andrews 'entertained with all the elegance of lettered hospitality', at Aberdeen (where he received the freedom of the city) enjoying 'the kindness of communication', at Edinburgh finding 'great respect and great kindness' and being, Boswell reported, 'quite in his element. All was literature and taste'. Scots philosophy, in Hutcheson, Hume, Smith and Dugald Stewart, presented man as 'a passionate, socially-minded animal, who derived happiness, ease, and a sense of identity as well as security and sustenance from society' (N.T. Phillipson, in David Daiches's *Companion to Scottish Culture* (1981)).

Smollett wrote *Humphry Clinker* (1771) partly to commend his native land, and his Matthew Bramble calls Edinburgh 'a hot-bed of genius', city of 'the two Humes [David Hume, John Home], Robertson, Smith, [Robert] Wallace [divine and mathematician], Blair, [Adam] Ferguson [sociologist], Wilkie

[author of *The Epigoniad*], etc.' That same year Henry Mackenzie made his name with his sentimental novel *The Man of Feeling*. The city of Bramble's praises, 'Athens of the North', ranked with Europe's intellectual capitals, its university among the world's best, served – remarked Benjamin Franklin in his *Autobiography* – by 'a Set of truly great men, Professors of Several Branches of Knowledge, as have ever appeared in any Age or Country'. Appropriately Edinburgh originated the *Encyclopedia Britannica* (1768–71). Clubs gathered those of intellectual tastes. Ramsay read his poems at the Easy Club, of which he was co-founder (1712 onwards). The Rankenian Club, at Rankin's Inn (1716 onwards), included Maclaurin and Sir John Pringle, later president of London's Royal Society. The Society for the Improvement of Medical Knowledge (1731) became, more succinctly, the Philosophical Society; Hume was joint secretary. The Select Society (1754) and Cape Club (1764) included writers and artists. Edinburgh's Royal Society was founded in 1783. Moreover, though the Kirk reprehended theatre-going, Home's *Douglas* was enthusiastically received, other plays could be well supported, and indeed there were capable school theatricals.

Music, Scottish and other, was a perennial attraction. As for portraiture, nowhere else outside London, Ellis Waterhouse remarks in *Painting in Britain 1530–1790*, was so strong a tradition maintained, from Sir John Medina around 1700 (he painted a comparable series to Kneller's Kit-Cat portraits in London), through his pupil John Aikman (though he left for London in 1733), the poet Allan Ramsay's son, also Allan (he too left for London but often returned for such spectacular productions as his 'Norman, Chief of Macleod' at Dunvegan, 1748), Gavin Hamilton, John Kay the caricaturist, David Allen 'the Scottish Hogarth', Alexander Nasmyth, and others, the line culminating in the century's closing decades with Raeburn.

In architecture, the classical tradition was inaugurated by the King's Surveyor and Master of Works Sir William Bruce (d. 1710). He rebuilt Holyrood (1701) and did several large houses including his own at Kinross, Drumlanrig Castle, Dumfriesshire, and Hopetoun, Linlithgow, which was remodelled in the eighteenth century on grand Vanbrughian lines by William Adam and finished by William's son Robert. The lead in the building of country-houses was taken by William Adam who in the century's early years developed the rich classicism of the Wren tradition, as at Haddo House in Aberdeenshire. James Gibbs, among the finest classical architects, worked almost entirely south of the border, and Colen Campbell, after early work in Scotland, left around 1715 to distinguish himself in London's Palladian circles. But Scotland's finest architect, Robert Adam, though engaged mostly in England, built handsomely at Pollok House and Dumfries House in the 1750s, left marvellous crenellated piles at Mellerstain, Wedderburn, and, supremely, Culzean, and with superb authority adorned Edinburgh with the Register House, the University's old quadrangle, and Charlotte Square. Scotland's late-Augustan era was her artistic and intellectual Golden Age, 'the Scottish Enlightenment'.

Provincial life and communications

London far from eclipsed the rest of Britain. She was herself within easy reach of rusticity; in *The Seasons* ('Spring') Thomson proposes to climb some hill within her bounds to view 'the country far-diffus'd around / . . . / One boundless blush, one white-empurpl'd shower / Of mingled bloom'. In Hogarth's *Evening* a citizen family returns from rural Sadler's Wells, commended by Sophie von la Roche as 'very lovely; large meadows alive with excellent cattle; lakes and trees in front of the house'. From Westminster Bridge Wordsworth saw London 'Open unto the fields and to the sky'. Metropolis and countryside were neighbours.

As for travel, perhaps the century's most prized improvement was in communications. Around 1700 wheeled traffic in many regions was often impracticable. Even later, conditions could be primitive, as Defoe found in Wales and the Pennines, Arthur Young in Lancashire (the Wigan–Preston road was 'infernal'), Gilpin in the Lake District, and William Hutton in Midland clay country – 'impassable roads, no intercourse with man to humanise the mind, no commerce to smooth rugged manners' (*History of Birmingham*). Defoe often complained – the Epsom road 'deep, stiff, full of slough, . . . impassable', the Downs 'deep stiff clay', western Essex 'scarce passable in winter', Kent 'the deepest, the dirtiest country', and so on. There were, moreover, highwaymen.

Still, things improved. 'The safe road through rocks shall winding tend, / And the firm causeway o'er the clays ascend,' Savage prophesied. Between 1700 and 1750 more than four hundred road Acts were passed, and by 1800 far more again. By 1757 Dyer reported in *The Fleece* roads crowded with carts, rivers with barges. Evidence varied from observer to observer and region to region, but except for conservatives solicitous for rural 'virtue' a chorus of approval swelled. Coaches formerly made five or six miles an hour, fifty or sixty a day, stopping at dusk; by 1780 they doubled that speed and continued overnight. Henry Homer, chaplain to Lord Leigh who supervised Warwickshire turnpikes, wrote his valuable *Enquiry into . . . the Public Roads* (1767) on the 'astonishing revolution'. Farming and inland trade had previously languished; now, coaches travel 'with almost winged expedition between every town of consequence in the kingdom and metropolis [and] every article of our produce becomes more valuable'. The spirit of enterprise is 'released from treading the cautious steps of our forefathers'.

Better roads galvanised trade, news and touring. Deepened rivers and extending canals carried industrial cargoes cheaply. The process began the century before with improvement of the Aire and Calder rivers for Yorkshire's wool trade. It developed around 1700 with work on the Trent and Derwent for Nottingham and Derby, in 1720 on the Mersey and Irwell for Liverpool and Manchester, and thereafter increasingly. The first canal was proposed in 1755 to link the Duke of Bridgewater's coal mines at Worsley to Manchester; in 1778 the Forth–Clyde canal connected east and west Scotland; and by 1800 about four thousand miles of inland waterways were in use.

'Good roads and postchaises' was Horace Walpole's recipe for civility and

enlightenment. The cultural effects were marked. As William Hutton
observed, 'the intercourse occasioned by traffic gives a man a view of the
world, and of himself; . . . expands the mind; . . . removes his prejudices; and
polishes his manners'. He celebrated the intelligent spirit of well-connected
Birmingham (its Lunar Club has been mentioned) as compared with less
accessible Midland towns; 'I had been among dreamers,' he commented in
1741, 'but now I saw men awake'. Improvement went fastest near London;
Defoe noted 'rich habitations of gentlemen of quality' along the Thames, and
a 'strange passion for fine gardens'. Horace Walpole was reminded of Roman
luxury when he wrote to Richard Bentley (5 July 1755) of villas around
Strawberry Hill 'as abundant as formerly at Tivoli or Baiae', those renowned
Italian beauty spots. Gilpin found the country from Leatherhead to
Guildford 'richly adorned [with] elegant houses'. Farther afield, prosperity
was amplest in East Anglia and the south and west but other regions too
offered their charms, notably the vale of York. The prevalent view of rural
improvement was that of *The Gentleman's Review* in 1754; visitors seeing
Britain after thirty years' absence discover 'a land of enchantment'.
Travellers kindled to landscape delights; hayfields, cornfields, orchards, and
ample flocks blessed much of the rural scene. Foreigners found a landscape,
one remarked, 'a large and majestic garden'. Smollett's *Travels Through
France and Italy* (1766) saw England

smiling with cultivation; . . . parcelled out into beautiful enclosures, cornfields, hay
and pastures, woodland and common, . . . her meadows well-stocked with black cattle;
her downs covered with sheep; . . . her teams of horses and oxen, large and strong,
. . . her farm-houses the habitations of plenty.

Such euphoria sounds uncritical yet it finds parallels. Arthur Young's *Six
Months Tour Through the North of England* (1770), no rose-coloured
impressionism but shrewd agricultural analysis, concludes that England is
'rich and flourishing', her farming 'good and spirited, and every day
improving'. Young admired the 'stately as well as useful buildings,
ornamented parks, lawns, plantations, waters, &c., which all speak a wealth
and happiness not easily mistaken'. 'How is the whole face of the country
changed, in about twenty years!' John Wesley wrote of Staffordshire in 1770,
'and the country is not more improved than the people'. The traditions of the
great estate persisted; Howard Erskine-Hill defines them admirably in *The
Social Milieu of Alexander Pope* (1975). Mansions needed maintaining, estates
cultivating, and many small towns lived on the employment thus created.
Pope's *Epistle to Burlington* is the climactic celebration of the aristocratic aim
his *Epistle to Bathurst* defines as being

> The Sense to value Riches, with the Art
> T'enjoy them, and the Virtue to impart, . . .
> To balance Fortune by a just Expense,
> Join with Economy, Magnificence,
> With Splendour, Charity; with Plenty, Health.

From what has been called 'the Whig Arcadia' – the ideal of culture,
liberty, pastoralism and classical taste – aristocratic example percolated down
the social scale. So, the *Epistle to Bathurst* adds,

> . . . all our Praises why should Lords engross?
> Rise, honest Muse! and sing the Man of Ross:

– that is, such as John Kyrle, Herefordshire gentleman characterised as a model of benevolence in Pope's note for the poem – 'possessed of debts and taxes clear, Children and wife – five hundred pounds a year (public buildings, alms houses, walks, roads; the Man of Ross divides the weekly bread; public tables twice a week for Strangers, etc.)'. Fiction provided Addison's Sir Roger de Coverley, *The Guardian*'s good-natured Sir Harry Lizard, Richardson's Sir Charles Grandison, Goldsmith's Squire Thornhill, and Fielding's Squire Allworthy (reflecting Ralph Allen) 'replete with benevolence'. The ideal was that of Horace's virtuous countryman cherishing his estates far from city strife (Epode II. i; 'Beatus ille'). As *Tom Jones*'s Squire Western evinces, not every squire was all-worthy, not every magnate a Maecenas; in *The Deserted Village* Goldsmith protested that 'trade's unfeeling train / Usurp the land and dispossess the swain'. But many literary and pictorial records support Defoe's appreciation of well-managed countrysides; even as he saw his pages through the press, he remarks, he needed 'supplemental accounts of fine houses, new undertakings, buildings, &c.' His appraisals comprise thriving rural estates, farms, mills, workshops, resorts and all that constitutes the full engagement of daily life and society.

A balanced account of rural as of urban life would need heavy shadings of poverty, starvation and riot. In *The Rambler* No. 202 (1752) Johnson reminded readers how 'distress, complaint, anxiety, and dependence' constitute that penury which idealists equate with innocence and the 'sleep that sheds his balsamic anodyne only on the cottage'. In *The Village* (1785) Crabbe exposed the 'weighty griefs' of labouring life, countering the nostalgia of Goldsmith's *Deserted Village*, yet Goldsmith himself idealised past happiness to dramatise present misery. John Barrell's *The Dark Side of the Landscape* (1980) remarks that, though Dutch paintings made rural realism familiar, poets and artists had conventionally sentimentalised rusticity, presenting country society as cheerful and harmonious (this, however, was less true of the novel), until a truer record eventually appeared in the shabby clothes and unkempt children portrayed by Gainsborough, Morland, and Wheatley, and the closer scrutiny focussed upon – in Crabbe's words – 'What form the real pictures of the poor'.

Yet such was not the main tenor of rural existence, and save for writers and artists like Stephen Duck 'the thresher poet', Fielding, Goldsmith, Crabbe or Morland it bore little on the spirit of provincial life. What counted was local taste and money. Defoe guides his readers to Bristol, commercially prosperous, Shrewsbury rich and sociable, Lichfield enjoying 'good conversation and good company', Yarmouth with 'magnificent buildings [and] little palaces', Salisbury 'large and pleasant', her citizens 'gay and rich, York where 'a man may converse with all the world as effectually as at London', and so on. William Wilberforce, born in 1759, counted Hull in his youth one of the gayest places out of London, its theatre, balls and card parties 'the delight of the principal merchants and their families'; in 1790 Arthur Young too found its amenities greatly advanced. Health resorts and watering places developed; spas had long existed wherever mineral springs

were sufficiently nauseous. Bath opened its first Pump Room in 1704, its first theatre in 1707, its first Assembly Rooms in 1708. Epsom, Tunbridge Wells, Harrogate, Buxton, Richmond (its company, Defoe testified, 'illustriously bright') caught the swell of fashion. Scarborough pioneered seaside recreation early in the century, and by the 1750s 'Brighthelmstone' (Brighton) was, Richard Pococke reported in *Travels through England*, greatly improved for visitors coming 'to bathe and drink the sea waters' – a stimulant by repute outstandingly healthful there and, one hopes, outweighing in eupeptic benefits its revolting taste.

By 1800 most towns of any consequence would boast a theatre and Assembly Rooms for dances and concerts. Thomas Sheridan, the playwright's father, divided his career between acting and elocution lessons in Bath, Bristol, Cambridge, Oxford and Edinburgh, as well as London. Capable musicians served the provinces – Charles Burney at King's Lynn (1751–60), Charles Avison at Newcastle upon Tyne, Joseph Gibbs at Ipswich, William Jackson at Exeter (whereby helped to found the Literary Society), Thomas Linley at Bath (where his daughter Elizabeth, the singer, married Richard Brinsley Sheridan) before becoming musical director at Drury Lane in 1775. At Gloucester the Three Choirs Festival developed early in the century from concerts by the cathedral choirs of Gloucester, Worcester and Hereford; its conductor from 1737 was William Boyce.

Michael Tilmouth's essay, 'The Beginnings of Provincial Concert Life in England' (in Hogwood and Luckett's *Music in the Eighteenth Century* (1983)), describes conditions in the age of Pope. Provincial aristocrats and gentry were capable of informed musical appreciation, indeed music-making, often reinforced by professionals disengaged outside the London concert season. The libretto of Handel's *Messiah* (as also of *Saul* and *Belshazzar*) was composed by a Leicestershire country squire, Charles Jennens of Twyford, and its first parish church performance was at the nearby village of Church Langton. Local booksellers often stocked music. Where Assembly Rooms were lacking, taverns had halls. The larger towns developed music societies, often the outgrowth of glee clubs for which successive editions of Thomas D'Urfey's *Pills to Purge Melancholy* (1699, enlarged 1719) provided songs by Purcell and others; many of *The Beggar's Opera*'s airs occur in it. Festivals sprang up; cathedral cities gave a lead, often commemorating St Cecilia's Day (22 November). Assizes, race-meetings, victories, and other notable events could generate concerts. Garrick's Shakespeare Jubilee at Stratford-upon-Avon in 1769, though innocent of Shakespeare's works, offered musical odes and the like, a striking sign of provincial involvement even though organised from London. As for painting, William Gandy (Reynolds's admired first master), William Hoare, and Philip Mercier practised successfully in Devonshire, Bath and York, respectively; much of Gainsborough's painting life was spent in Ipswich and Bath, much of Joseph Wright's in Derby; and landscapists like Paul Sandby, Richard Wilson, Joseph Farington and William Gilpin toured extensively in England, Wales and Scotland.

News and views were increasingly disseminated. Before 1700 few regular provincial journals are recorded but under Queen Anne political and social

papers like *The Tatler* and *Spectator* circulated from London and others appeared locally, first in Norwich and rapidly elsewhere, some with wide social and cultural coverage. In London *The Gentleman's Magazine* (1731), *The Monthly Review* (1749), and Smollett's *Critical Review* (1756), and in Edinburgh *The Scots Magazine* (1739) instructed subscribers about literature and, briefly, other arts. H.R. Plomer's aforementioned *Dictionary of Booksellers and Printers 1726–75* names over 750 concerns in England and Wales outside London, and though, as in Ireland and Scotland, many were of only minor consequence the rest ensured a spread of significant publication throughout the provinces. In the *Adventurer* No. 115 (1753) Johnson amusingly discerns such enthusiasm for authorship that the village smith or ploughman free at evening from his labours settles down to 'providing intellectual pleasures for his countrymen'.

Great houses could have private libraries as well as fine paintings. The average purse ran to humbler collections, but circulating libraries, denounced by Sir Anthony Absolute in *The Rivals* as 'an ever-green tree of diabolical knowledge', enlarged reading opportunities. They seem to have originated around 1700 in Berlin (though from the 1660s some London booksellers informally rented books out) and they found a British foothold in Edinburgh in 1725, spreading by 1740 to Bath, Birmingham, Bristol, and London, and by 1800 widely throughout the country. John Shebbeare, writing as 'Batista Angeloni', a supposed Italian in London, remarked in *Letters on the English Nation* (1756) that English country folk were far better informed than their Continental counterparts, and in 1782 visiting Pastor Moritz recorded that the national authors, in Germany read only by the educated, in England were 'in all hands' (an exaggeration, surely?). His landlady, a tailor's widow, won her husband, she told him, 'because she read Milton with such proper emphasis'. This bizarre circumstance might seem exceptional, Moritz admitted, but other humble folk too apparently 'knew all their national authors', an assertion supported up to a point by James Lackington's *Memoirs* (1791); Lackington was a prominent London bookseller. 'Country curiosity', he declared, 'was once satisfied with tales of ghosts and fairies. But now you may see *Tom Jones, Roderick Random* and other entertaining books stuck up on their bacon-racks, and if John goes to town with a load of hay he is charged to be sure not to forget to bring home *Peregrine Pickle's Adventures*, and when Dolly is sent to market to sell her eggs she is commissioned to purchase *The History of Pamela Andrews*' – the uses of literacy indeed. As the century closed, rural theatre-visits, social calls, card-parties, and refinements in language and manners were bringing Jane Austen's world into view.

Landscape and touring

One fertile extra-metropolitan interest was response to scenery. For Walpole's *Anecdotes of Painting* (1762) landscape viewing is connoisseurship:

How rich, how gay, the face of the country! . . . Every journey is made through a succession of pictures! . . . Enough has been done to establish such a school of

landscape as cannot be found on the rest of the globe. If we have the seeds of a Claude or a Gaspar amongst us he must come forth

– a most percipient prophecy. His words prompt three reflections. First, the countryside is newly beautiful. Second, Britain's painters have a captivating subject – less the divinisation of Nature (though Shaftesbury had sounded that theme) than (in Blake's happy phrase) 'England's green and pleasant land'. Third, landscape has become picture-like; 'an open country is but a canvas on which a landscape might be designed'. Currently, Richard Wilson, Paul Sandby, Gainsborough and others were – twisting Walpole's sense – already designing landscapes on canvas. And between 1769 and 1782 Crome, Constable, Turner, Girtin and Cotman were born, along with Wordsworth, Scott and Coleridge.

A very English development was proceeding, what in 1763 Shenstone called 'landskip or picturesque gardening'. Shenstone, with moderate means, was one of its best exponents at The Leasowes near Halesowen in Shropshire; Gilpin praised his grove and cascade 'from which the stream plays in irregular meanders among the trees and passing under a romantic bridge forms itself into a small lake' (*Observations on . . . Cumberland*). Wealthier owners, with brilliant designers like Charles Bridgeman, William Kent, and Lancelot ('Capability') Brown (who detected 'capabilities' wherever he looked), cultivated an idealised naturalism. The conception was twofold: gardens should resemble landscapes of poetic and associational charm, with vistas, temples, ruins real or sham, and other stimuli to pastoral inspiration. Landscapes should resemble gardens of varied harmony – or, if too wild for that, of Salvatorian drama. And both should resemble pictures, idyllic or melodramatic as the case might be. So, through enterprise and imagination, evolved many treasures of Britain's heritage, Nature exquisitely cherished by Art.

Observant eyes had long valued landscape beauty, and place-names like Belvoir and Beaulieu are old-established. Yet pastoral charm is one thing, connoisseur appreciation of 'scenery' another. Landscapes are Nature's art but her hand is fallible, and the enthusiast could help by imagination, vision or, more practically, by using 'Claude glasses', those slightly darkened convex pocket mirrors which composed and toned scenes compactly. Gray did so, touring the Lakes and Highlands, though even unaided he could describe beautifully what he saw. Landscape painting, Jonathan Richardson had held, lacked 'noble sentiments': now, noble sentiments were just what landscapes inspired. Nature was, Shaftesbury had vouched, 'supremely fair and sovereignly good', and Gibbon in his *Memoirs* prescribed just what the spectator needed, 'a correct and exquisite eye which commands the landscape, . . . discerns the merits of a picture, and measures the proportions of a building', such an eye being 'closely connected with the finer feelings'.

Tourists and tour-writers fell into three groups. Some concentrated on practical matters; Arthur Young, for instance, did so, appreciating scenery and buildings but always making agriculture his prime concern. Others covered everything, scenery, occupations, history – Celia Fiennes, Defoe, Pococke (*Travels through England . . . during 1750, 1751*), Pennant (*Tours in Scotland 1771, 1774*; *Tour in Wales, 1778*; *Journey from Chester to London,*

1782; and so on), John Byng (*Torrington Diaries*), and others. The rest sought scenery, art and intellectual-emotional satisfactions, like Gray and Walpole, or else they practised 'picturesque' viewing. Gilpin's various *Observations*, sketchy about what the locals actually do, abound in history, views, aesthetic analysis and aquatints. Tour-writing was, John Byng commented, 'the very rage of the times'.

Scenery became virtually a cult, though a commendable one. Admirers of Dutch realism sought homely rusticity; romantic enthusiasts yearned for Salvatorian drama; votaries of Italian enchantment strove to see like Claude or the Poussins; partisans of the picturesque ('a new object', said Gilpin in 1770) behaved like Henry Tilney in *Northanger Abbey* harping on scenic desiderata until Catherine Morland dismisses the whole of Bath as unworthy of depiction. Gilpin pontificated about rock- and tree-forms and the grouping of suitably shaggy cattle, idle peasants, and off-duty banditti, or at least gypsies; the scene should never, he warned, 'degenerate . . . into cultivation'. (Combe and Rowlandson's *Tour of Dr Syntax in Search of the Picturesque* (1809–11), happily guyed the whole movement.) Mountains gained favour; whereas to Thomas Burnet's *Theory of the Earth* (1681) they were punishments for Adam's sin, Burnet's younger contemporary John Dennis considered them 'bold strokes . . . wrought in a fury' – as by a supreme artist (letter from Turin, 1688). Shaftesbury elevated rocks, caverns and waterfalls above 'the formal mockery of princely gardens'; Addison approved 'the most rude uncultivated parts of Nature' (*Spectator* No. 411); and Berkeley's first *Dialogue* acclaimed irregular oceans, forests and highlands.

For wild, even sublime, prospects one sought the Peak or Lake District (in 1788 Wilberforce thought Windermere as crowded as the Thames), Wales (beautifully rendered by Paul Sandby and Richard Wilson), or Scotland (whose peaks, Gray told William Mason in 1765, were 'ecstatic' symbols of beauty and 'horror' – 'horror' meaning awe-inspiring ruggedness). Pennant's *Tour in Scotland* (1771) offered fine descrptions of romantic landscapes; as a result, he claimed, the country was '*inondé* with southern visitors'. Where Defoe found 'howling wilderness' in Derbyshire and 'unhospitable horror' in Cumberland, the Duchess of Northumberland in 1759 exulted in Dunstanburgh Castle on its storm-swept precipice as 'a scene of glorious Horror and terrible Delight'. *Humphry Clinker*'s Matthew Bramble rated Loch Lomond above Italy or Switzerland for sublimity, silence and solitude. Johnson travelled the Highlands, he said, for 'wild objects – mountains – waterfalls – peculiar [that is, characteristic] manners'. His journeys there and to Wales show a temperament not usually associated with romantic sensibility appreciating (in his piquant phrase) the 'turbulent pleasure, between fright and admiration', inspired by Hawkestone's 'striking scenes and terrific grandeur' or, at Slanes Castle in Aberdeenshire, by the 'terrific grandeur of the tempestuous ocean'. Even when drenched by a storm near Inveraray he responded like a connoisseur:

The wind was loud, the rain was heavy, and the whistling of the blast, the fall of the shower, the rush of the cataracts, and the roar of the torrent, made a nobler chorus of the rough music of nature than it had ever been my chance to hear before.

Reverent before ancient buildings, moved by sublimity, Johnson memorably

expressed what the venturesome tourist travelled to feel, admiring in pre-Byronic fashion such scenes as Alison's *Essay on Taste* recommended for nature's 'savage majesty'.

Not scenery alone beckoned. Medievalism struck a chord long before Walpole championed it, and medieval buildings were more often admired than the supposed disrepute of Gothic would suggest. Great houses, medieval or classical, with their paintings and gardens, recognised a duty to admit interested visitors and, for artists unable to visit the Continent, their possessions were a main source of study before the time of art exhibitions and galleries. Road-maps and guide-books showed the way; even before Blenheim was complete visitors came in droves; Wilton received two thousand in a single year. The discovery of Britain was proceeding apace.

There was discovery also of the European Continent, rich in Shaftesbury's rocks, caverns, waterfalls and princely gardens, with art collections and social-intellectual excitements. The Grand Tour was the supreme experience, the preserve of the wealthy, of artists and of tutors acting, Burke explains in *Reflections on the Revolution in France*, 'as friends and companions of a graver character'. The term reached England in Richard Lassels' *Voyage of Italy* (1670) – 'the *Grand Tour* of France, the *Giro* of Italy' – and as a '*Giro*' Pope satirised it brilliantly in *The Dunciad*. Irresponsibly though some took it, intelligent tourists found it invaluable; Paris, Rome, Venice, Alps, Apennines, even (in time) Greece and the Near East – these immeasurably enriched life. Josiah Tucker's *Instructions for Travellers* (1757) listed the benefits – collection of curios and paintings, experience of the arts, superior sense of fashion, and – 'most commendable' – 'that impartial View of Men and Things which no single Country can afford'. Boswell, whose Continental touring produced some of the century's most diverting documents, struck the right note to Rousseau (in French, in 1764) – 'I left Great Britain a completely insular being. . . . I am travelling with a genuine desire to improve myself'. Writers, artists, philosophers, statesmen could be met; Adam Smith, accompanying the Duke of Buccleuch in 1763–5, recast his ideas of political economy in Toulouse and discussed them with Turgot in Paris; Boswell's conversations with Rousseau and Voltaire are famous.

Travellers thrilled to the glories of great collections and incomparable scenery, among the finest responses to which are the letters Walpole and Gray wrote after visiting the Grande Chartreuse. First, Walpole to Richard West (28 September 1739):

But the road, West, the road! winding round a prodigious mountain, and surrounded with others, all shagged with hanging woods, obscured with pines, or lost in clouds! Below, a torrent breaking through cliffs, and tumbling through fragments of rocks! Sheets of cascades forcing their silver speed down channelled precipices, and hasting into the roughened river at the bottom! Now and then an old foot-bridge, with a broken rail, a leaning cross, a cottage, or the ruin of an hermitage!

Then Gray to his mother (13 October 1739) – 'the most solemn, the most romantic and the most astonishing scenes I ever beheld' – adding a graphic account of mountain magnificence. Their excitement was only an ecstatic rendering of the Alpine experience of which the climactic expression would be Wordsworth's in *The Prelude*, Book VI:

The unfettered clouds and region of the Heavens,
Tumult and peace, the darkness and the light –
Were all like workings of one mind, the features
Of the same face, blossoms upon one tree;
Characters of the great Apocalypse,
The types and symbols of Eternity.

Treasures of art, distinction of cities, splendour of scenery, exchange of ideas and incidental adventures (charmingly reflected in Sterne's *Sentimental Journey* (1768)), all made, for those qualified, an unforgettable revelation.

Part II
Studies in the Individual Arts

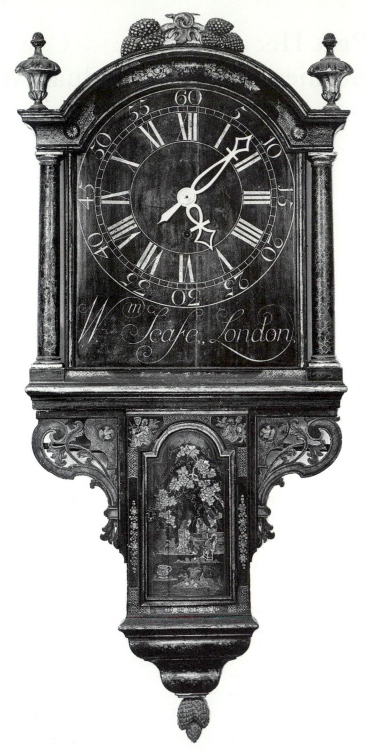

Tavern clock (c. 1760) with carved grape ornament and japanned drinking scene. Temple Newsam House, Leeds.

1 The Decorative and Useful Arts

GEOFFREY BEARD

Introduction

The hundred or so years which followed the Great Fire of London in 1666 and which came to a triumphant climax with the establishment of The Royal Academy by King George III, in 1768, were among the richest in the visual arts in Britain. The European 'Grand Tour', undertaken by each young milord to finish his education, led to a keen interest in architecture, painting, town planning, landscape gardening and to collecting, centred at first on a taste for the Antique and the emulation of Renaissance patterns. It was fashionable to visit the antique sites at Paestum, Pompeii and Herculaneum and to encourage further interest in archaeological remains, not only by their publication in lavish folios, but by expressing their motifs, as in the decorations and architecture of Robert Adam and Sir William Chambers, and in the productions of Matthew Boulton and Josiah Wedgwood in metal and pottery forms of great beauty – the classical frieze, the urn-shaped vase, the ormolu capitals to a cabinet based on those in crumbling stone at Diocletian's palace on the Adriatic.

The eighteenth century was characterised by the 'Man of Taste' and the lure of antiquarianism. Horace Walpole, no mean achiever himself in these arts, was the acute observer of what his contemporaries were doing in spreading knowledge, both of elegant design and, as Lord Shaftesbury put it, of 'the Idea or Sense of Order and Proportion'. It was a dictum which applied as much to the precise elevations by Lord Burlington – Walpole's 'Apollo of the Arts', as to the rococo epergne, or a two-handled silver cup, fashioned for one of the rising merchant class. By their growing wealth and the provision of much that they wanted by architects and craftsmen alike, there was a considerable and steady enrichment of collections. Further, both noblemen and the merchant classes patronised foreign craftsmen who had come to England with skills unfamiliar to the native artisans. In consequence the arts of sculpture and of 'carving' in wood or stucco, of fashioning silver, porcelain and pottery, weaving fine textiles and tapestries, and inlaying furniture with elaborate patterns became well established. The decoration of

the interiors of buildings brought together all these changes and innovations in taste. The effects were dazzling and have been rarely equalled since: the eighteenth-century craftsman worked in an active, questing and complex era, serving masters who had, for the most part, an unerring concern, in Pope's phrase in his *Epistle to Burlington of the Use of Riches*, that:

> Tis Use alone that sanctifies Expence,
> And splendor borrows all her rays from sense . . .

Their support allowed many to rise from mere competence to acts of virtuosity, and to turn, occasionally, a useful object into one of abiding beauty and even frivolity.

Patronage and the rule of taste

In the late seventeenth century interiors in fashionable houses were influenced by the Dutch styles introduced by William III and his Huguenot designer, Daniel Marot (*c.* 1660–1752). But in the early years of the eighteenth century the activities of a younger generation of architects, Nicholas Hawksmoor, Sir John Vanbrugh, Colen Campbell, and James Gibbs encouraged a further, more wide-ranging use of foreign craftsmen. Painters such as Gian Antonio Pellegrini and Marco Ricci covered great areas with colourful murals (Castle Howard), the workers in stucco embellished ceilings, walls, and over doors (Ditchley) with a white exuberant froth of well-modelled decoration; and every tea-table was set with the gold and silver filigree creations of the many Huguenot craftsmen who had fled to England from religious persecution in France.

This eager respect for decoration and a need to satisfy it swept artists into a whirl of activity until by 1750 at least five stylistic moods – Palladianism, rococo, Gothic, Chinese and neo-classical – were in being or had already been eclipsed. Houses became more than mere arrays of ordered precise columns, Crusader-like castles with tumbled battlements, rooms full of frivolous and gay wood and stucco or painted versions of ancient Rome with fresco and gilded martial trophies. They were more because their rooms embodied the distilled essence and evidence of informed patronage and discernment and the best of craftsmanship, even if it was sometimes ill-judged, or outmoded by European or London standards. This impetus was helped along by the appearance of many pattern-books and manuals of instruction and most of all by the patronage of many noblemen, whose early introduction to a formal education had been rounded off by the Grand Tour in Europe.

John Dryden noted in his *Observations on the Art of Painting of . . . Du Fresnoy*, 'The Italians call a man a virtuoso, who loves the noble arts, and is a critic in them.' In England it denoted students of natural history or experimental philosophy and led on occasion to their being satirised, as in Thomas Shadwell's *The Virtuoso*. However, the virtuoso was also regarded as an informed amateur who collected works of art with care 'and attempted to develop a natural culture comparable to that of ancient Rome'. In 1719 the

Detail of stucco ceiling in the Saloon at Ditchley House, Oxfordshire, c. 1725.

painter and virtuoso, Jonathan Richardson the elder (1655–1745), in his 'An Essay on the Art of Criticism as it relates to Painting', lamented what was true equally for all the arts, that 'so few here in England have considered that to be a good connoisseur is fit to be part of the education of a gentleman . . .' and that painting, other than as furnishing pieces or portraits, was 'an art capable of entertaining and informing their minds'. There may have been special pleading in his case, not least support for his essay on the subject, because it ignored the achievements of many noblemen such as the 3rd Earl of Burlington who were avidly acquiring paintings, statuary, drawings, and works of art of all kinds.

Given that the Baconian theme of acquaintance with arts being part of the accomplishment of a gentleman is acceptable, some elements, to do with taste, were less rational. James Brydges, 1st Duke of Chandos, wrote in September 1719 to his friend, Robert Benson, Lord Bingley, that by the time the latter returned from his travels his little building would be far advanced, but if it was 'such an one as is displeasing to your Lordship I shall pull it down with more satisfaction than I carry it up . . .'. In a century typified by great learning and fine craftsmanship, but also by nauseating smells and bugs in bed or chair, a scribe in *The Connoisseur* (1756) could write that 'in this amazing super-abundancy of Taste few can say what it really is . . .'. However, there were always those few who knew unerringly when it was

absent. In the main these were the patrons and their architects.

The patrons also based their patronage on their ability to afford, or to delay, the payments. When the 1st Duke of Devonshire, the great builder of Chatsworth but an avid gambler, died 'deep in debt' in 1707, John Macky recorded that he was 'of nice honour in everything, but the paying his tradesmen'. The magisterial statement of Sir Edward Knatchbull in January 1771 to the Yorkshire-born furniture maker, Thomas Chippendale: 'as I receive my rents once a year, so I pay my Tradesmens Bills once a year . . .' was typical of many made by those who rewarded industry tardily, if at all. In consequence ability as a craftsman sometimes had to take second place to a greater ability to extend credit to those well able to make payments more promptly. Occasionally the record was set straight, as in the case of the building of the Radcliffe Camera at Oxford designed by James Gibbs; in the preface to his *Bibliotheca Radcliviana* (1747) Gibbs thanked the Trustees on behalf of 'all Persons employed by you' who 'honour you for your punctual payments'.

Training

One of the prime functions of craftsmen was to use, to contort, and to exploit materials in embellishing buildings or in providing items for pleasure or use. For the most part they followed a classical system of proportions and orders. This caused problems for the compilers of pattern books and manuals of instruction; for their publications to succeed, they had to continue to appeal to the underlying conservative system while applying the fashionable flourishes of a contemporary but more bizarre style. In this ambition they succeeded but rarely, mainly because they had little real understanding of the manner in which such styles had originally been used, and plagiarism was, in any case, widespread. It was perhaps a failure of the methods by which English craftsmen trained, and an indication (as John Evelyn had pointed out as early as 1664) that they were unwilling to be taught their trade further 'when they had served an apprenticeship and worked for gentlemen who were satisfied with their endeavours'.

The apprenticeship system, set out by statute allowed masters to take apprentices for periods of instruction of seven or eight years. The virility of local centres, apart from London, meant that the various trade guilds in towns such as York, Bristol, Chester, Durham, Newcastle and Edinburgh occupied important positions in social activity. Having sought out a suitable master, the parents of an intended apprentice paid an apprenticeship premium and were issued with an indenture setting out the conditions of training, and the boy or girl moved into the family circle. It was hoped that during their seven years of training they would not only be taught their master's trade but be set an example of good workmanship. They assisted on commissions and, as they progressed in ability and knowledge in the several branches of their 'mystery', they were entrusted with more specialised tasks. Many were allowed to measure work, make out accounts and sign receipts against payments made, through them, from patrons to their masters.

When the apprenticeship was finished, the test work undertaken was examined carefully by representatives of the Livery Company. Then at three successive meetings, the apprentice was 'called'; if no one objected to his election, he was sworn in as a member of his guild – before the mayor at the borough court, in the case of Durham freemen.

The ordinances of most guilds were very similar. Those at York and Durham give guidance as to the regulations to which a master needed to adhere: he was not to absent himself from guild meetings and was to see that apprenticeship indentures were available to the 'searchers'; he could be put out of his occupation and not be allowed to work within the city if he took or used any goods which did not belong to him; he could take no apprentices until he had been a freeman or brother of the 'mystery' himself for seven years and, after, he was not allowed to take apprentices for a term less than seven years. There were also fines for default in workmanship and for the use of inferior materials, but many guilds were lax in their oversight of such matters. Whilst it could be claimed that the system had the framework for a rigid oversight of men and work, a great deal depended on the integrity of the guild officers. The seventh injunction, also found in those regulating London Companies, 'not to have any more apprentices but two' was openly disobeyed; to take undue notice of it would have limited the capacity of a business to expand and become more efficient. However, training more than two apprentices at a time was a difficult task.

Thus guild members were ill-equipped for competition from foreign craftsmen, who enjoyed more freedom to learn by example and experiment and could travel to train in sophisticated centres of artistic activity such as Rome. In addition, the official policy of expanding English trade led to tolerant naturalisation orders; all protests went unheeded. Even the powerful Goldsmiths' Company could do little about the inrush of Huguenot goldsmiths leaving the Continent: in the 25 years before 1710, some 120 French goldsmiths came to London. The new styles and engravings they brought with them fitted alongside the reluctant acceptance by English craftsmen of foreign competition. The astute ones invited foreign artists to join their own teams of workmen.

Interior decoration

The interest in collecting works of art exerted a subtle influence on the structure of the house. The long gallery, a feature of Elizabethan and Jacobean house-plans, became a picture gallery or statue gallery in houses such as Holkham, Norfolk, where it was designed for sculpture obtained in Italy (see Chapter 4). The pursuit of knowledge, now fashionable, created libraries with architecturally-designed bookcases surmounted by busts or bronzes. The saloon, adapted from the Italian *salone*, a ball or gambling room, was frequently circular in plan and was one of the state apartments placed on the first floor, or Italian *piano nobile*, opening out one to the other to form an impressive enfilade along the south side of the house.

Wanstead, Colen Campbell's great house in Essex (destroyed in 1824), was

reckoned one of the finest houses in the kingdom with nineteen rooms on its principal floor, 'the hall very magnificent, fifty feet high: to look through the suite of apartments has a fine effect; three hundred and sixty feet the length of the house'. However, the richness of materials – stucco, damask-covered walls, gilded wood doorcases, statuary marble chimneypieces, console brackets bearing the twelve Caesars in bronze – was emphasised at the expense of more essential qualities. The Palladian style in particular depended upon the skill of those craftsmen who understood the architectural orders in detail and how to put them into an environment that made practical, albeit classical, sense.

Towards the middle of the eighteenth century there had to be reckoned the growing concern for fashions from France, the Chinese and the revival of Gothic. All deviated from the classic and sometimes a whole building, such as Strawberry Hill, was carried out in one style, the Gothic, or a single room similarly treated, as at Arbury. The Chinese taste offered the complete alternative to academic classicism: it had no allegiance to the five orders, was vivid in colouring, and served to accustom the eye 'to a freer play of line and a more irregular spacing of masses'. Whilst Chinese architecture was not suited to European purposes, the occasional use in interior decoration, and in furniture, of its motifs – pagoda roofs, figures, birds, wooden railing, and frets – was a welcome diversion.

The vogue for the asymmetrical, exuberant curves of rococo, or French taste, whilst already present in the early eighteenth-century productions of the silversmiths, came to England shortly before 1740 and lasted for some twenty years. The earliest published designs in England are those of Gaetano Brunetti, who in 1736 brought out a book of designs 'very useful to painters, sculptors, stone-carvers, woodcarvers and silversmiths'. The elements forming the style were those found in nature – combinations of fleshy plant-forms, pierced and convoluted rockwork and shells, scrolls and serpentine lines which could be extended without need for repetition or continuity.

Richard Boyle, 3rd Earl of Burlington (1695–1753), was the leader of the classical style; it was Philip Dormer Stanhope, 4th Earl of Chesterfield (1694–1773), who was identified in the 1740s with the French taste. The first had been on two Italian tours before he was twenty-five years old, the latter had not reached Italy on his own Grand Tour. Yet both were typical as early Georgian patrons. Lord Burlington encouraged the Handelian opera and the pursuit of Palladian ideals in plan and form in architecture (his own *villa suburba* at Chiswick for example), had an extensive library, and gave practical support to the painter, architect and designer William Kent (1685–1748). Lord Chesterfield, who regarded his library as the best room in his house, with its poets 'in stucco allegorical frames, painted white' above the bookcases, all surmounted by inscriptions from Horace in a deep frieze, expected opposition to his entirely French house, with its panels based on designs by Cuvilliés and Mansart L'Aîné. It was nevertheless a room in which, as Chesterfield told his son in 1748, in the famous letters on conduct he addressed to him, he expected to find 'uninterrupted satisfaction'. Upon all the cabinets stood 'voluptuous vases and bronzes, antique or Italian, and airy statuettes of opera Nymphs'.

Heveningham Hall, Suffolk (c. 1778). Sir Robert Taylor and James Wyatt.

The principal force in the architecture and decoration of the second half of the eighteenth century was the Scottish-born architect, Robert Adam (1728–92). He had spent four years (1754–8) in Italy, and included in his activity the surveying, with a small team of draughtsmen, of the ruins of the palace of the Roman emperor, Diocletian, at Spalato (Split) in Dalmatia. When he returned his style was not completely formed, but he was convinced of the 'simplicity and elegance of the ancient manner'. Soon, according to the words of Sir John Soane, 'everything was Adamitic; buildings and furniture of every description'. Adam developed a style in which the heavy Palladian mouldings were replaced by smaller, lighter forms, and with painted and stucco ornament drawn from the Italian Renaissance and the school of Raphael. The swirls of French rococo also had no place and were banished before the precise, symmetrical display of what Adam called 'a great diversity of ceilings, friezes and decorated pilasters', the 'beautiful spirit of antiquity' which he claimed to have transfused 'with novelty and variety'.

In the decade 1770–80 interiors grew richer while the exteriors, particularly of the town houses, became plainer. No Adam interior was complete without painted decoration and much was done by the foreign painters such as Angelica Kauffmann, her husband Antonio Zucchi, Giovanni Battista Cipriani (who also painted the door panels on George III's Coronation coach), Michele Angelo Pergolesi and Biagio Rebecca. The paintings were usually done in the studio on paper or canvas, with the subject-matter taken from a wide repertory of mythology and ancient history, chosen with due attention to the function of the room; 'Apollo and the Muses' would be put in a Music Room, and poets' or philosophers' heads in the Library, and so forth. On the walls, 'grotesque' decoration, which Adam defined in his *Works in Architecture* (1773–8) as a beautiful light style of ornament, was a prominent feature. He had seen it in some of the Roman amphitheatres, temples and tombs: 'the greatest part of which being covered with ruins have been dug up and cleared by the modern Italians, who for these reasons give them the name of *grotte*, and hence the word *grotesque*'. Often the large panels (Harewood, Saltram) were filled with paintings of ruins and architectural fantasies, brightly coloured and effecting, with ceiling and carpet, a satisfying synthesis.

Interior features

With the accession of George I in 1714 oak panelling almost entirely disappeared and where panelling reappeared as a feature expensive mahogany was used (as at Houghton, Sir Robert Walpole's Norfolk house) or deal or pine, which were cheap and easy to work. These were painted to simulate more expensive materials, or finished in white and gilding in most Palladian state rooms. Applied carving was much less in favour with the Palladian architects but there are some splendid displays (the state rooms at Woburn Abbey, in the 1750s) and the later rococo, allied with Chinese motifs, finds exuberant expression in Luke Lightfoot's work at Claydon, Buckinghamshire.

A feature of the early years of the century is the shelved recess or cupboard

framed in the wainscot. Such recesses were usually surmounted by a semi-hemispherical head and the pilasters framing the recess relieve the plain wall surface. However, by the middle years of the century they had become less frequent as walls were hung with paper or with silk hangings.

The typical Palladian staircase did not run up beyond the first floor and the ornament of its walls and ceiling was considered carefully, for as Isaac Ware put it in *The Complete Body of Architecture* (1756)

There is no part of a house where the eye is more naturally directed upwards than the staircase . . . in passing upstairs the eye is naturally directed to the sides and top and this justifies the finishings usually bestowed upon these parts of an edifice.

The 'finishings' were splendid when they were, say, paintings by William Kent (Houghton), flamboyant stuccoes and busts on brackets (Fairfax House, York), or a precise array of metal balusters, with alternating palmette and lotus motifs and other decorative flowers contrasting with paintings in various tones and with foliate plasterwork (Harewood House).

The early Georgian architects turned back to Inigo Jones as 'the first who arrived at any great degree of perfection' in the art of designing chimney-pieces. *The Chimney-piece Maker's Daily Assistant* (1766) gives a table to show the true size that a chimneypiece ought to be in various rooms. They were divided into the architrave type, those with trussed pilasters and the caryatid or terminal supports, or columns to support the mantel-shelf. Chimneypieces were also made of one or two storeys, or, to adopt Isaac Ware's term (1756), were of the 'simple' or 'continued' type. The former

The Saloon at Houghton Hall, Sir Robert Walpole's Norfolk house, c. 1730.

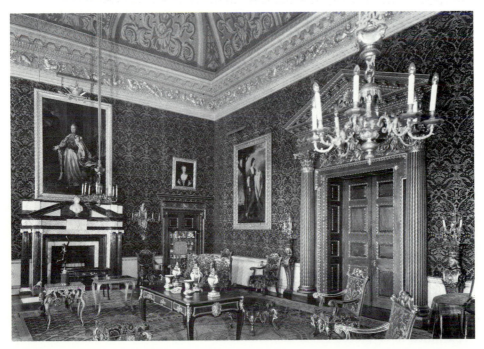

terminated at a cornice or pediment and was thought best suited for rooms hung with paper or silk. The continued chimneypiece had an upper structure of wood or stucco, containing a picture or sculptured panel. The upper part was set off by an open pediment, often 'broken' to contain a bust or figure.

The chimneypiece, according to Ware, should correspond to the overdoors in the room. The principal sculptors, Peter Scheemakers and John Michael Rysbrack, both provided chimneypieces in this continued style (Ditchley, Houghton) and there were many, such as Joseph Wilton, John Devall, Thomas Carter and Sir Henry Cheere who specialised in fine 'simple' chimneypieces (Woburn, Syon, Wallington). Variegated marbles were considered best suited to these and plain to the continued types; and Ware gives an extensive list of the plain and variegated marbles from Spain, Egypt, Italy, and many English sources. The French rococo style was well used in chimneypieces created by woodcarvers, and all but one of the designs for chimneypieces in Abraham Swan's *British Architect* (1745) are rococo. The wooden chimneypiece was, like the panelling of the day, painted in various colours, green, cream, light blue and brown.

In the first years of George III's reign in the 1760s some massive Palladian chimneypieces were still in use but after the half-century a lighter treatment prevailed. Adam used several continued styles but with a stucco panel in the upper stage, and his later designs show his love for colour and the use of coloured, scagliola-type compositions as inlays in marble. The use of yellow streaked Sienna marble was common and tablets and blockings were enriched with classic subjects. The application of ormolu or gilded bronze was introduced by Robert Adam in the white marble Red Drawing-Room chimneypiece at Syon, and cast tin or pewter ornaments, stamped in relief as a substitute for carving, were made by Matthew Boulton. The most splendid of the neo-classical chimneypieces are, however, those which incorporate carved and modelled bas-reliefs in jasper-ware from Josiah Wedgwood's Etruria factory. Flaxman was designing bas-reliefs for chimneypieces for the firm in 1776. Wedgwood wrote on 6 October 1778,

I know they are much cheaper than marble, and every way better, but people will not compare things which they conceive to be made out of moulds, or stamped at a blow like the Birmingham articles, with carving in natural stones where they are certain no moulding, casting or stamping can be done.

Nonetheless, Wedgwood's confidence in his wares remained unshaken.

It was not Robert Adam's practice to give undue space to a staircase hall, often providing modest ones fitted carefully around the state rooms (Syon, Kedleston). However, his concern for spatial organisation finds no finer representation than in the staircase at Home House (21 Portman Square) where it rises through the full height of the house, lit by a top skylight. The application of wrought iron for the staircase balustrade dates from the late seventeenth century (Chatsworth), but in the eighteenth century the use of wrought and cast iron was preferred for its strength, beauty and ability to follow the stair in its upward gliding curves.

Throughout the principal floor of the eighteenth-century house doors continued to be placed as far as possible in a line, but an excessive use of

feigned doors (to give symmetry in a room), whilst enjoying a brief revival in Adam's interiors, was given up. The English climate dictated that the fewer doors a room had the more comfortably habitable it would be. In the Palladian house the doorcase was often treated with an order – the 'Corinthian' double doors at Houghton and Woburn are splendid examples of the joiner's art – but in Adam's early work he merely used consoles to support the cornice above the door. As the eighteenth century progressed the general treatment called for a marked flatness, the architrave being surmounted by an entablature with frieze and moulded cornice of light projection. Sometimes a centre tablet with bas-relief or painted decoration is inserted, breaking through the lower members of the cornice. The door itself, whether of finely figured mahogany or of painted deal, was normally six-panelled. The *Builders' Magazine* (1774) noted that the best form of panel was the plainest: 'that is, a long square, the two or four larger should be long upwards and the other crosswise'. They opened on to displays of increasing diversity and richness made so by lavish expenditure on movable furniture.

Door in the Red Drawing-Room at Syon House, Middlesex, c. 1768.

Plasterwork and stucco

Using plaster for modelling and ornamentation had been well explored in the Tudor and Jacobean periods. When Henry VIII was building his (now-vanished) palace of Nonsuch in the 1520s he used Italian stuccoists who worked with somewhat different materials and used different techniques from the many members of the Worshipful Company of Plaisterers. The last years of the seventeenth century had allowed, by the elusive development of taste, a finer plasterwork (in technical terms) to appear in England than ever before. However, ceiling and wall painting on the grand decorative scale was always a threat: a patron only had so much money to spend and his house only so many walls and ceilings to embellish. The very successful London plasterer Edward Goudge was lamenting by 1702 that: 'for want of money occasioned by the war, and by the use of ceiling painting, the employment which hath been my chiefest pretence hath been always dwindling away, till now its just come to nothing'.

In the first few years of Queen Anne's reign a small group of Italian stuccoists had reached England and were soon employed in the decoration of houses throughout the country. They were born in Italian-speaking Switzerland in the villages near Lugano, and, working in England as partners, were invariably referred to as 'Italians'.

The Italians are credited with a number of schemes, of which the principal were those where they worked for the architects James Gibbs and Francis Smith. They include the London church of St Martin-in-the-Fields (1725), Ditchley, Oxfordshire (1725), Mawley Hall, Shropshire (*c.* 1730) and, in later years, Hagley Hall, Worcestershire (1758) and Shugborough Hall, Staffordshire (1763). However, their activities were in decline by 1760 when they were old and had long since passed their best years, and when neoclassical interiors were about to be the latest fashion.

The best kind of plaster was obtained from burning gypsum or plaster of Paris. In this and various other forms it was added to sand and water; animal hair (ox, horse, goat) was added in chopped lengths to give tensile strength and to act as a binding agent. This was then applied in successive coats, usually three, over a ceiling area which had been prepared by having oak or other laths nailed to the joists. Scaffolding had been erected on the floor joists of the room below the ceiling to be decorated.

When the three-coat ceiling of plaster was dry it was ready to be ornamented with moulded relief work. Frequent confusion arises over the use of moulds and modelling work in situ. There were some ornaments which were more quickly and accurately realised by turning them out of an iron or wood mould on a table at ground level. The usual division of labour was for repetitive work to be moulded, and single features such as coats-of-arms, full-size figures, or *putti* to be modelled in situ. Complicated ornaments could not be created in some moulds because a great deal of undercutting was needed, but the ratio of moulded to free modelled work is probably in the order of three to one.

In his *Lives of the Most Eminent Painters, Sculptors and Architects* (1550), Giorgio Vasari, the Italian architect and painter, indicated a basic difference

between plaster and stucco, namely, the addition to the slaked lime of marble dust instead of animal hair:

the powdered marble is taken and is finely sifted and mixed in with the lime in the proportion of two parts of lime to one of powdered marble. The mixture can be made coarser or finer according to the needs of the work being done.

One further difference was that the best work in stucco was strengthened with various forms of armature.

The relationship between sources and the final design is a close one, if at times difficult to untangle. A vast repertory of engraved designs by such masters as Francis Barlow, Gaetano Brunetti and Grignion was available to most eighteenth-century plasterers. Plasterwork, with a few exceptions, was usually finished white or off-white. In the eighteenth century this practice continued until about 1760, with the occasional addition of gilding or colouring. After the introduction of complete decorative schemes by the neo-classical architects, colour became more apparent from about 1760 onwards. The extensive series of Adam drawings (Sir John Soane's Museum, London) are the best guide as to what was allowable. In addition, the advice of Sir William Chambers in May 1770 to Gilbert Mason, a merchant at Leith, is worth quoting:

In regard to painting your Parlours, if they are for Common use Stone Colour will last best & is Cheapest but if you mean them to be very neat pea green & white, Buff Colour & White, or pearl or what is called paris Gray and White is the Handsomest.

In addition to plaster and stucco for decorating internal surfaces there was also a brief vogue for papier mâché. Pre-numbered pieces were available to form scrolls, garlands, and other ornaments. The principal suppliers were René Duffour at The Golden Head in Berwick Street, Soho, and Peter Babel in Long Acre. It has been noted that such foreigners 'posed a threat to native plasterers and carvers' and that the title-page of Thomas Johnson's *One Hundred and Fifty New Designs* (1761) has a flying *putto* setting fire to a scroll inscribed 'French Papier Machée'. One of the principal decorative schemes to use papier mâché on a large scale was that carried out in the Gallery at Horace Walpole's Strawberry Hill, *c.* 1752. The Gallery has a fan-vaulted ceiling based on that in Henry VII's Chapel in Westminster Abbey, but instead of stone each rib and ornament was formed from the light ductile paper.

The principal neo-classical plasterer, who headed a large firm, was Joseph Rose, junior (*c.* 1746–99). He had travelled to Italy in the mid-1760s and at his return turned an already successful business (his uncle, Joseph Rose had been, with Thomas Perritt of York (his master), one of the most successful of the rococo plasterers, working in particular for the architect James Paine) to work on most of Robert Adam's interior schemes. This work may still be seen, among many attractive settings, at, for example, Kedleston, Kenwood, Newby, Nostell and Syon, a precise array of white and gold neo-classical ornament carried out in one of Adam's patented light 'compositions' composed mostly of gypsum and size. It was capable of being pressed out from boxwood moulds with its very precise outlines intact.

Woodcarving

When a patron was weary of sombre wood wainscoting stretching from floor to ceiling he could cover it with tapestry, hang full-length pictures over it, or embellish it with applied carvings in soft-wood.

The first craftsman to hold the title of 'Master Sculptor and Carver in Wood' to the Crown was Henry Phillips, who at his death in 1693 was succeeded by the better-known Grinling Gibbons (1648–1721). Gibbons had been born of English parents in Rotterdam and had come to England *c.* 1667. His career of forty years in royal service and his extensive private patronage have received due attention: however, much of it was carried out, with great bravura, before 1700. All of his work was within two main categories: woodcarving, in soft lime-wood (or occasionally oak) of an amazing dexterity and truth to natural forms, and large marble monuments with full-size standing figures. Whilst of uneven quality his woodcarving, at its best – for example, the panel presented to the Grand Duke of Tuscany by Charles II (now at the Pitti Palace, Florence) – remained unsurpassed by his contemporaries. By 1700 Gibbons was 52 years old and his output thereafter declined: we know he did a small amount of work in 1705, either for the new Castle Howard, rising from Sir John Vanbrugh's plans, or for Lord Carlisle's London House, and some unspecified carving, *c.* 1715, for Nicholas Hawksmoor's church of St Alphege, Greenwich.

When Gibbons died in 1721 at his house at Bow Street, Covent Garden, he was succeeded in his royal post by James Richards (?–1759). Richards became one of the most accomplished carvers of the Palladian years, working in particular for the architects Colen Campbell and William Kent. His

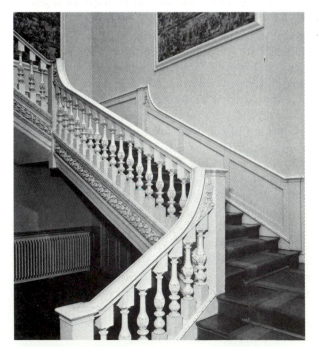

Stair banister by James Richards at Compton Place, Sussex (1728–9).

association with the first brought him work at the great houses of Houghton and Mereworth, as well as for Lord Burlington at his London house and at his villa at Chiswick. The greatest display of Richards's virtuosity as a carver can be found, however, on the gilded enrichments of the Royal State Barge (National Maritime Museum) which William Kent designed for Frederick, Prince of Wales, in 1731–2. It is work of consummate craftsmanship, with a riotous display of sea-creature motifs similar to those he had used on some of the overdoors at Chiswick.

Involvement by Richards in jobs supervised by William Kent for the Board of Works – Kent was Master Carpenter to the Board – was a mainstay of his daily activity. He was concerned, for example, with carving chimneypiece surrounds and doorcases in the new Treasury, in Whitehall, designed by Kent (building 1733–7) and he worked there alongside many competent men as part of a trusted team. The liaison between architect and craftsman continued throughout Kent's life, with Richards doing the carving at Henry Pelham's house in Arlington Street (1742) and at the Horse Guards, which was erected in the main after Kent's death in 1748.

By 1754 Richards was judged 'by Age and Infirmity render'd incapable of performing the Duty of his office' and he was succeeded as Master Carver by his assistant George Murray, who had worked alongside him at the Pelham house and at the Horse Guards. At least Murray presumably did the actual job from 1754, but it was not until Richards's death in 1759 that he could be confirmed in the post. He enjoyed its perquisites for but one year, dying in 1761.

In the north activities centred on the Etty family of York. The most important members were John Etty and his son William. John was born in 1634, and by the time of his death in 1709 he had earned enough fame for it to be stated on his monument at All Saints, North Street, York, that he had acquired 'great knowledge of mathematics, especially geometry and architecture in all its parts, far beyond any of his contemporaries in this city'. William Etty (d. 1734) acted as Sir John Vanbrugh's clerk of works at Castle Howard and Seaton Delaval.

Another talented York joiner and carver was William Thornton. On his memorial tablet at St Olave's, York, it is recorded that by 'the ablest judge in the former kind of work' – meaning joinery – 'he was looked upon as the best artist in England for architecture: his reparation of Beverley Minster ought to give him a lasting memorial'. This is not idle flattery but refers to the very elaborate timber structure that Thornton constructed under the supervision of Nicholas Hawksmoor for restoring to the vertical the north front of Beverley Minster (1716–20).

Thornton was equally felicitous in carving, and it may be assumed that it was he who worked at the delightful Yorkshire villa of Ebberston, designed by Colen Campbell in 1718. However, his 'monument' was the carving (as well as the design and erection of the house) he did at Beningbrough Hall, in north Yorkshire (1716–20), now a property administered by the National Trust. The carved wood overdoors and friezes are of excellent quality, an exemplar of work arising from the training and talents of the large group of York carvers active in the eighteenth century.

In Westminster Abbey the carved woodwork screen and organ gallery (1729) needed to be splendid, as did the reredos (1732) at Canterbury Cathedral. The work was given to John Boson (who also made a number of pieces of important Palladian furniture: Chatsworth, Stourhead), who with his partner John How worked at four at least of Wren's city churches. He was presumably more successful and affluent than the carver John Dawson, who complained when asked to make a mahogany chimney surround for Okeover, Staffordshire, at a cost of £115, that the payment was insufficient 'because the stuff is excessive dear'. Supplies of timber were pouring into Bristol and an enlightened group of patrons and architects were becoming more demanding and careful. The spacious days when the owners of Burghley, Petworth and Chatsworth scarce knew how much they would have to lay out for rich carved work were fast receding and the trades had become even more sub-divided. Isaac Gosset, who did woodcarving, was better known as a wax-modeller; Jacob Gosset was a carver and picture-frame maker, and many earned their living more by gilding than carving.

The most enigmatic and strangest of the rococo school of carvers was undoubtedly Luke Lightfoot (*c.* 1722–89), whose most amazing work was done for the Verney family at Claydon, Buckinghamshire. A visitor to the house in 1768, whose diary survives, described the lesser rooms as being 'furnished in all tastes, as the Chinese Room, the Gothick Room, the French Room etc'. Lightfoot's carvings were carried out for the 2nd Earl Verney who spent some fifteen years from the late 1750s in decorating his house. When the architect Sir Thomas Robinson saw the work in progress in 1769 he wrote to Lord Verney to complain about 'such a Work as the world never saw'. The carved ho-ho birds, the scrolled crestings and the 'c' and 's' scrolls round the niches in the North Hall, influenced by the engravings of the carver, Thomas Johnson, are amazingly like plasterwork and all the more remarkable for being in carved wood.

Johnson's patterns circulated to other carvers, but actually to carve them required no mean talent. No doubt many competent carvers, like Thomas Paty of Bristol, glanced at them and perhaps subscribed to them, but rarely troubled to master their intricacies. Paty, born in 1713, was at the height of his powers by the late 1750s (he died in 1789) and a contemporary note records that he was 'generally esteemed one of the best carvers in England, either in wood or stone' and that all the ornaments in the (surviving) Redland Chapel at Bristol 'were designed and carved by him'.

One of the most important neo-classical carvers, and a member of the Alken family of sporting painters, was Sefferin Alken, who had earned a good reputation by the late 1740s, working in particular for the architect Henry Flitcroft. In 1759 Alken produced five gilt picture frames for the Breakfast Room at Kedleston to a Robert Adam design. This was based on a love of forms derived from the Antique – scrolls, festoons, vases and urn-shapes, often white with gilt mouldings and of an exaggerated sophistication and delicacy. Alken's long connection with Adam and with neo-classical decoration had begun, and it continued with Adam's important commission at Croome Court, Worcestershire, for the 6th Earl of Coventry. With John Hobcraft as joiner, Alken provided most of the carved mouldings in the

Rococo carving by Luke Lightfoot in the north hall at Claydon House, Buckinghamshire, c. 1760.

house and the adjacent church, and in the London house in Grosvenor Square, and also he did carved work on furniture supplied by William Vile and John Cobb and by John Bradburn and William France.

Perhaps the finest piece of carving on furniture with which Alken was connected is that on the medal cabinet designed in 1767 by Sir William Chambers, formerly at Charlemont House, Dublin and since 1984 the property of the Courtauld Institute of Art of the University of London. What Alken's work in the late neo-classical years demonstrates is the unending attention to quality and detail which characterised eighteenth-century work. It had to be done to satisfy patrons, the best of whom had a concern for taste and correctness.

Wrought ironwork

While the decorative workers in iron contributed less to a house than the plasterers or carvers, their activities enhanced staircases, balconies and gave fitting and dignified approaches through huge gates with coats of arms in the overthrow. The principal worker in the first few years of the eighteenth century was Jean Tijou. His first recorded appearance in England was in 1689 when he was working at Hampton Court. He alternated work there, over several years, with commissions under Wren at St Paul's and went out

to Chatsworth, Burghley, Stoneyhurst, Ampthill and Kiveton. He published his *A New Booke of Drawings* in 1693, and as was the case with other publications in the latter part of the century, it had a considerable improving effect. Tijou left England in about 1712; in November 1712 Mrs Tijou was paid £109 'in full of my Lord's note for the Iron Balusters and Railes for the stair case made by her Husband'. This was probably payment for the work carried out at Ampthill for Lord Ashburnham in 1706–7.

Tijou stated on the title-page of his book that he hoped it would be used by 'them that will worke Iron in Perfection and with Art' and his influence can be traced in many workers, such as Robert, Thomas and John Davies, Robert Bakewell, John Gardom, Thomas Robinson and Thomas Warren. The work of the Welsh smith, Robert Davies, and his two younger brothers, with its use of eagle heads and *repoussé* masks – particularly in Erdigg gates (1720) and the Chirk Castle gates (dated 1719) – is similar to Tijou's work at Hampton Court. Perhaps the finest works by Robert Davies are the White Gates and Screen at Leeswold, Mold. In a hundred-foot length it incorporates a series of broken pediments with solid cornices. Each section has the Wynne dolphin in the centre, with the cupolas of the piers bearing vases of flowers. They take their place among the finest pieces of ironwork in Europe and were probably erected in 1726–7 for Sir George Wynne, who is notable more for his patronage of the artist Richard Wilson and for leading the sort of life Hogarth was to satirise in the paintings and engravings of his *Rake's Progress*.

Entrance gates by Robert Davies at Chirk Castle, Clywd (1719).

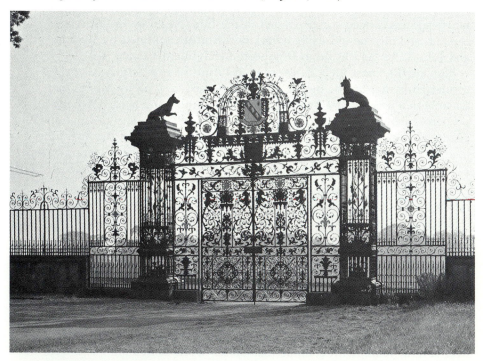

The dominant Midlands smith was Robert Bakewell of Derby. The earliest document referring to his principal work – the arbour or 'Bird Cage' at Melbourne House, Derbyshire – is a bill made out in his hand dated 27 June 1706 – 'Iron work done for ye Rt. Honr Thomas Cooke, Esqe'. The iron arbour, charged at £120, may not have been complete at this date but was done by 1708 at the latest. The arbour shows a resemblance, without cupola, to a plate of an arbour in *La Théorie et la Pratique du Jardinage* which suggests that its author and Thomas Coke drew upon a common source. The arbour at Melbourne, likened to a 'bird-cage', is more akin to a small temple, fashioned from vertical and horizontal bars, decorated lavishly with stylised leaves and patterns, and surmounted by a pierced cupola. Considerable advances have been made in knowledge of the work of English wrought ironsmiths in recent years. Bakewell's work may be seen, easily, at Melbourne, in the Chancel screen and gates (*c.* 1724) at All Saints Church, Derby, designed by James Gibbs, and the seven ornamental gates to fill the outer arcades at Gibbs's Radcliffe Camera, Oxford (1744–6). He also worked the gates at Okeover, Staffordshire (based partly on plates in Gibbs's *A Book of Architecture* published in 1728), and the communion rails in the chapel at Foremark, also in Derbyshire, with a near replica at St Ann's in Manchester. Throughout his long life Bakewell's reputation continued to grow, until at his death in 1752 he was famous all over England for his ironwork. He had married Mary Cokayne, the daughter of the Mayor of Derby, and lived to see his brother-in-law, Francis Cokayne, become Lord Mayor of London in 1751. He was buried, without memorial, in St Peter's Church, Derby, and his business was carried on by his erstwhile pupil, Benjamin Yates.

The fact that there was more than one member of a family at work in the same trade can lead to confusion. The fine gates at the church of St Mary Redcliffe, Bristol, are by William Edney (d. 1715). He was the brother of the Simon Edney (d. 1726) who had provided the 'iron rails before the hous' at Dyrham, a few miles from Bristol, in 1694. William's gates at St Mary Redcliffe were made originally in 1710 to separate the nave and chancel, and he received £110 for his work. William Edney has also been credited with work in several Bristol churches (St Nicholas, the Temple Church) and with the gates of Tewkesbury Abbey. Attributions, however, are easy to make in the absence of established fact.

A worker in the Tijou style in the north Midlands was John Gardom of Baslow in Derbyshire. He worked with Tijou at Chatsworth and at Kiveton in the 1690s and was also employed at Castle Howard, *c.* 1708. More research continues on his activities – after his death his widow married his pupil, Richard Oddy – and on other smiths like Thomas Warren. He worked to provide the screen balustrades in the hall at Vanbrugh's Grimsthorpe Castle, Lincolnshire, *c.* 1724.

Tijou's book in 1693 was seminal to the development of English wrought ironwork and there was little else published until William and John Welldon's *The Smiths Right Hand* published in 1765. This, however, had rather weak designs – a mixture of Gothic and chinoiserie patterns.

One of the important economic factors in Robert Adam's success was the control the family had over its building supplies: it had its own company to

provide it with stone, timber, sand, etc. In metalwork Adam used several skilled artificers for stair balustrades and skylights, such as Thomas Tilston and William Kinman, but he also had shares in the Carron Iron Company of Falkirk, set up in 1759. They provided, to his design, many cast-iron grates bearing moulded neo-classical ornament, and heating stoves (the two in the Saloon at Kedleston are superb) in the main years of his activity, 1760–85.

Chippendale and the furniture-makers

By the early years of the eighteenth century the best English cabinet-work was comparable with anything produced on the Continent. During the reign of Queen Anne a sharp contrast developed between everyday domestic furniture and richly decorated pieces in Venetian Baroque style commissioned for the great Palladian houses of the ruling Whig oligarchy. William Kent's name has been given to this grandiose furniture of strong architectural character. Massive side tables with marble tops, scrolled supports, and aprons decorated with gilded scallop shells, masks or naturalistic swags epitomise this class of furniture. Pedestals and brackets of elaborate sculptural form suggestive of stone or plaster were placed in reception rooms (Longford Castle) together with gilt 'dolphin' or 'eagle' console tables (Temple Newsam, Leeds), and walls were hung with large mirrors having broken pediments and floral pendants (the series by James Whittle and Samuel Norman, 1755–60, at Woburn Abbey is spectacular) similar to doorways and overmantels. These monumental pieces, several of which were engraved by John Vardy in 1744 in his *Some Designs of Mr Inigo Jones and Mr William Kent*, survive to a considerable degree and may be attributed to a

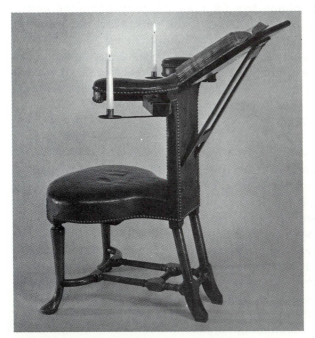

Reading chair (c. 1750).

handful of carvers (James Richards, James Moore the younger, William Linnell and Matthias Lock) well versed in the Kent style.

In ordinary domestic furniture there was, during Queen Anne's reign (1702–14), a movement away from the exuberance of baroque styling to a use of finely veneered walnut furniture displaying modest proportions and restrained but effective ornament. Chair backs were lowered, the stretchers disappeared and the rectangular design was replaced by a graceful curvilinear style in which the flowing line of the cabriole leg was copied in the smooth contours of the back and seat rails; carving was confined to an unobtrusive shell or frond on the top-rail or the 'knee' of the leg. Lightly constructed bureaux-bookcases, tallboys, commodes, cabinets, card and writing tables in figured walnut with cross-banded veneers and simple mouldings were made in large numbers for small town houses where monumental baroque pieces would be out of place. Conversation pictures (see Chapter 3, 'The Visual Arts') show that the average room was fairly sparsely furnished at this period.

There was a steady demand for neat looking-glasses on stands fitted with drawers, and great mirrors in walnut and gilt-gesso frames with classical mouldings and pedimented tops. The most elaborate of these came from the London shops of Gumley and Moore and there are towering examples at Chatsworth and Hampton Court. However, in remote country districts something more modest would do, even in outmoded oak.

The sober 'Queen Anne' style walnut furniture – the best of it with fine choice of matching veneers – and bold versions of continental baroque began to wane in popularity about 1740. This was due in part to the introduction of mahogany – Sir Robert Walpole had lifted the import tax on it in 1722 – and to the growing influence of the rococo style. Together, these two factors gave both a strong timber of good figure and a restless stylistic system of ornaments in which contorted and fanciful motifs could be combined in an asymmetrical but tense, balanced composition. Mirror frames, sconces, stands and console tables were among the first pieces to reflect the new rhythms.

This frivolous idiom was suited, admirably, to the art of woodcarving and many seemingly outrageous designs were produced by Matthias Lock and Thomas Johnson. However, the most accomplished series of designs was produced by Thomas Chippendale (1718–79) in 1754 under the title *The Gentleman and Cabinet-Maker's Director*, which contained 277 engravings illustrating the entire range of domestic furniture. By this publication rococo motifs became firmly integrated into English furniture manufacture. Serpentine lines and sinuous ornament were employed with more restraint in England than on the Continent (in fact the more conservative furniture makers such as William Vile (d. 1767), who executed commissions for the Crown, showed little awareness of the latest fashions and continued to work in the tradition established by William Kent). Although few enough pieces from Chippendale's workshop can now be identified with certainty (what there is may be assessed in Christopher Gilbert's two-volume study, 1978) his name is used, habitually, to describe English mid-eighteenth century furniture in the rococo manner.

Chippendale, in common with his contemporaries, often combined rococo ornament with pseudo-Gothic and Chinese details. The vogue for chinoiserie

*Armchair, gilded oak and beech, one of a set of six from Osterley Park House, Middlesex (*c. 1778*).*

*Windsor armchair, beech and yew (*c. 1750*).*

which had emerged at the close of the seventeenth century enjoyed a revival during the 1750s since the mandarins, ho-ho birds, dragons, pagoda-like structures and lattice work could be amalgamated, easily, with stock rococo elements. The pattern of intricate wood lattice-framing known as Chinese paling was used, extensively, for chair-backs and glazing bars, while Oriental frets appeared on chair and table legs and pierced galleries. The style was favoured, particularly, for bedroom furnishings.

The mid-eighteenth-century Gothic revival, confined solely to England, forms an attractive interlude in the history of taste. No attempt was made to copy ancient furniture, but late-medieval ornaments such as finials, tracery, columns, roundels, cusps and bosses were grafted on to traditional forms. The pseudo-Gothic manner was considered appropriate for library tables, bookcases and chairs.

During the 1760s there was a firm reaction against the rococo taste. This stemmed, as I have noticed earlier, from the work of Robert Adam. In contrast to the naturalistic and curvilinear idiom of rococo, Adam's style was based on a repertoire of ornament derived from the interior decoration of ancient Roman villas and *thermae*. Classical motifs such as urns, *paterae*, husk-chains, running scrolls of foliage (*rinceaux*), rams' heads and stylised

honeysuckle (*anthemion*) were used in formal arrangements to create an effect of 'delicacy, gaiety, grace and beauty'. In contrast to Kent's use of large-scale architectural features for furniture and the serpentine lines of rococo, he favoured straight lines, simple curves and forms based on classical tripods, altars and so on, enriched with delicate neo-classical devices in marquetry or carved in low relief.

The revolutionary new style – Sir John Soane in his eleventh lecture to the students of the Royal Academy in 1812 said that Adam had effected changes which were 'the electric power of this revolution in art' – influenced, speedily, every branch of the decorative arts. By 1770 the leading furniture-makers were embodying his ideals in their work. Although Adam has left an important series of designs for furnishings supplied to the great houses that he built or decorated (mostly at Sir John Soane's Museum, London), the best-remembered disseminator of neo-classical fashion was George Hepplewhite. Whilst George Hepplewhite's name has been given to a form of chair, he is an elusive figure, who died intestate in 1786. Obviously he trained as a furniture-maker but never practised. His widow issued his influential *The Cabinet-maker and Upholsterer's Guide* in 1788. Perhaps the finest exponents were the fashionable firms like those of Chippendale, John Linnell and Ince and Mayhew.

Thomas Chippendale was born in 1718 at Otley, Yorkshire, and after training under his father and the York joiner, Richard Wood, left the north in the early 1740s for the wider opportunities of London. We know little of Chippendale's early years apart from a small commission – the first recorded – from Lord Burlington (1747), and his marriage, a year later to Catherine Redshaw. By 1753 the young man had prospered enough to take premises in St Martin's Lane, and a year later, as noted, his important pattern-book was issued. Its many engravings illustrated the entire range of domestic furniture in which varied rococo motifs became fully integrated into the English tradition of furniture-making.

Chippendale's ability as a designer, the success of his pattern-book (a second edition was called for within a year, 1755), coupled with the competence of his large workforce, enabled the business to expand. From the mid-1760s he was producing his finest neo-classical furniture, and in the early 1770s superb marquetry pieces made for Edwin Lascelles of Harewood House, Yorkshire, and elsewhere. The praise which came to Chippendale in his lifetime continued well into the nineteenth century and even his rivals Mayhew and Ince called him 'a very ingenious Artificer'. What elements in his work led to this high esteem, apart from the success of the *Director*, in a third edition by 1762?

Both Adam and Sir William Chambers had studied in Italy and had returned to England in the late 1750s intent on introducing a new repertory based on classical precedents. Chippendale, however, had no first-hand knowledge of foreign collections and had to make do with a later visit to France and with looking at engravings. The introduction of neo-classical designs into the third edition of the *Director* (1762) is therefore the more remarkable. He was able, over the next few years and into the 1770s, to recast the flourishes of rococo shown in the first edition. Chippendale worked

for Adam's patrons in many of the houses designed by the architect; some, for example Newby, Nostell, and Harewood in his native Yorkshire, contain furniture by him. It is of unrivalled excellence, with large-scale ornament, some inlaid into richly veneered surfaces and flanked by elaborate gilded ormolu mounts. The Nostell library table is a particularly impressive piece in his early robust style. It has massive corner trusses in the form of lion-masks and incorporates two pedestal cupboards, one enclosing drawers, and the other vertical divisions for folio books. The top was finished in black leather and was invoiced on 30 June 1767 'of very fine wood' for £72 10s.

Chippendale's output of furniture in the 1770s included some splendid pieces of marquetry furniture. The pier tables commissioned for various rooms at Harewood House, Yorkshire, together with the sumptuous 'Diana and Minerva' commode there, *c.* 1773, may indicate that he employed a specialist marquetry worker. London could provide the most accomplished craftsmen, who subcontracted their time and skills to established makers. The evidence for Chippendale's use of specialists is too sparse to permit firm conclusions, but with or without them he produced some of the finest examples of English marquetry furniture.

When Thomas Chippendale reached semi-retirement, a few years before his death in 1779, an increasing share of the administration and supervision of the London workshops and at various houses was taken on by his eldest son, Thomas Chippendale the Younger (1749–1822). It is probable that the younger man designed some of the firm's late neo-classical work, but after his father's death the firm became 'Chippendale and Haig' – Thomas Haig, his father's partner from 1771, did not retire until 1796, seven years before his death in 1803.

A few words about some of the leading eighteenth-century furniture-makers will relate furniture to their creators, and, indirectly, to the ever-important patron. That there were over 50,000 makers active in England between 1660 and 1840 (listed in dictionary form in 1986) indicates how little can be said here and how arbitrary any selection must be.

Some of the leading makers were those employed by the Crown. In the early eighteenth century James Moore the elder (*c.* 1670–1726) worked in

Chippendale library table from Harewood House, now at Temple Newsam House, Leeds, c. 1770.

royal service and is known, particularly, for furniture with incised gesso tops or details, some of which bear his name. He would work with the looking-glass supplier, John Gumley, and alongside Richard Roberts, 'Chairmaker to His Majesty' and the son of Thomas Roberts who had supplied furniture to the royal palaces during the reigns of William III and Queen Anne. He also worked at Chatsworth and furniture at Knole is assigned to him.

When Moore died in 1726 (and his son, James, who provided some furniture to designs by Kent, only outlived him by eight years) his erstwhile apprentice, the talented Benjamin Goodison (d. 1767), succeeded him in royal service. Goodison was one of the most outstanding makers, with a fine control over the use of mahogany. He was also probably a main supplier of Kentian-style furniture characterised by Greek frets and gilt enrichments, also the province of carvers such as John Boson, James Richards and Matthias Lock. Goodison's furniture at Longford Castle, Wiltshire shows him at his best: deeply carved mahogany frames of ample dimensions, upholstered in green damask or cut-velvet together with candle-stands having fish-scale carving on the pedestals and cherubic putto heads at the top. Standing aloof, with the largest London workshop and the greatest number of apprentices, was Giles Grendey (1693–1780). He had an active export business, particularly in scarlet-japanned furniture, and his label is often found on pieces he made.

Goodison was rivalled throughout his career and succeeded in royal service in 1761 by William Vile (d. 1767) and his partner John Cobb (d. 1778). They had set up in 1751, and provided furniture of the highest quality (even if it was a little old-fashioned) to George III and Queen Charlotte, outstanding pieces of which survive in the royal collections. Their principal work for Queen Charlotte included a mahogany bureau-cabinet with intricate fret-work carving in the upper stage, a jewel cabinet of 'many different kinds of fine woods . . . all the Front Ends & Top inlaid with Ivory' – the 'fine woods' included olive, padauk, amboyna, tulip and rosewood.

The main competitors to Vile and Cobb – the latter produced some very fine marquetry furniture (Corsham Court) after Vile's death – were Mayhew and Ince, John Linnell and, pre-eminently, Thomas Chippendale.

In 1759, the business of 'Mayhew and Ince' was set up in Soho, near Carnaby Market. Ince was the designer and Mayhew acted as manager and dealt with the upholstery side of their business.

Once established they decided, in 1759, to issue designs 'in weekly Numbers'. They imitated Chippendale's *Director* both in the intended number of plates (160) and in the use of Matthias Darly as engraver. Unfortunately they underestimated the amount of work required, and they had to compete with the build-up by Chippendale of the third edition (1762) of the *Director*; their venture foundered in the autumn of 1760, after the late appearance of part 21. Rococo, with Gothic and Chinese overtones, formed the main style of the designs. Some were unashamedly copied from the 1754 edition of the *Director*, and explanatory notes were printed in both English and French.

The supreme achievement of Mayhew and Ince was in providing a series of marquetry-decorated commodes to Robert Adam's design. One is

fortunately documented – that they provided to the 12th Earl of Derby in 1775 – 'a circular Commode of fine and curious Woods very finely inlaid with Etruscan Ornaments' charged at £88. In its semi-circular form it was an enduring furniture type in their output and implies a close 'partnership' with Adam.

The firm's label on a mahogany china cabinet (Museum of Decorative Arts, Copenhagen) proclaims that they had 'an Assortment of French furniture consigned from Paris'. The partners' output was considerable and of very high quality. Therefore their charges were high and the rate for being apprenticed to them was also the highest of any comparable London business. For the 6th Earl of Coventry twenty bills were rendered in the 1760s for their comprehensive service at Croome Court, Worcestershire, and the Earl's London town house, 29 Piccadilly. These included papering walls, laying carpets, and the ever-necessary disinfecting and stuffing of mattresses.

The bills document the supply of some outstanding pieces of furniture including two settees and six armchairs covered with petit-point Gobelins tapestry in two shades of pink-red (*rose du barri*) and a Boucher-Neilson set of wall tapestries depicting the Four Elements (all are now in the New York Metropolitan Museum of Art). The provision of tapestry-covered furniture to complement suites of Gobelins wall tapestries was a feature of a number of commissions to Mayhew and Ince and other makers in the 1770s.

The range of furniture provided by a successful firm might be very extensive. Chippendale's patrons were encouraged to 'order either a standard, refined, or *de luxe* version', with subtle changes to each design. Mayhew and Ince provided parlour chairs or 'deal benches covered with green baize' (in

Marquetry commode and torchères by John Cobb, at Corsham Court, Wiltshire, c. 1772.

Gobelins tapestry, Pomona being wooed by Vertumnus *(1775)*, *at Osterley Park House, Middlesex*.

1778, for the 4th Duchess of Beaufort) and, at the other extreme, a cabinet (probably to Robert Adam's design) to display eleven intarsia panels created at Florence in 1709, in which the inlaid pictures were formed with semi-precious stones. Commissioned by the Duchess of Manchester in 1775, the cabinet (now in the Victoria and Albert Museum, London) is in mahogany, veneered with satinwood and rosewood, and decked with ormolu mounts provided by Matthew Boulton. The quality of work is outstanding, with classical sources providing ideas for the decoration of the capitals and friezes.

When William Vile retired in 1763 the post of royal cabinet-maker went to his former assistants, John Bradburn and William France. There were, however, many other able contenders for a patron's interest and purse, in particular William and John Linnell, and the French *ébéniste* resident in London, Pierre Langlois (d. 1767).

William Linnell served his apprenticeship as a joiner but specialised in carving. By 1729 he had set up his own general business, and from the early 1750s he was assisted by his eldest son John (b. 1729) at such important commissions as the carving at James Gibbs's Radcliffe Camera at Oxford. John headed the firm, based in Berkeley Square, until his own death in 1796, and became noted not only as a talented designer but as a competent businessman. Many of his designs and workshop drawings survive (Victoria and Albert Museum, London) and give a good idea of the scope of the firm's activities. The names of over a thousand clients of the firm have been listed. One of their most important commissions was to supply, in the early 1750s, the 4th Duke of Beaufort with a japanned bed, eight armchairs, two pairs of standing shelves, and a commode *en suite*, for the Chinese bedroom at Badminton House, Gloucestershire. The quality of this suite (now dispersed, some at Badminton, the bed at the Victoria and Albert Museum) once led historians to assume it was made by Thomas Chippendale, who did on occasion make superb lacquer furniture (as at Nostell Priory, Yorkshire).

One of the joint Adam–Linnell commissions was the work they did for the Child family at Osterley Park, Middlesex. The pedestal desk they made for the Library, 1768–9, and two superb commodes bearing marquetry roundels of Diana and her hounds and Venus entreating Cupid are of a quality few could attain.

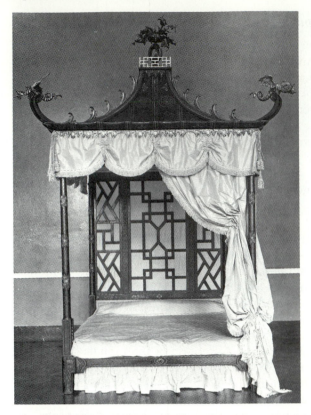

Japanned bed by John Linnell (c. 1755) for the fourth duke of Beaufort, to furnish the Chinese bedroom at Badminton House, Gloucestershire.

Headboard of the State Bed, commissioned by the Child family at Osterley Park House, Middlesex (c. 1776).

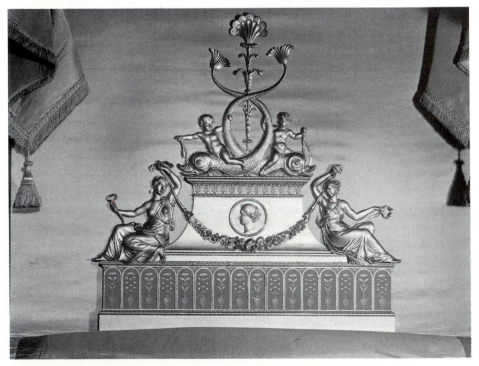

Silver, gold and Sheffield plate

Gold and silver have been regarded from early times as the most precious of metals, capable of being formed into functional shapes by beating thin and able to take decoration in engraved, embossed or enamelled form. In their pure states both gold and silver are too soft for use in metalwork: gold is alloyed with other metals (copper, silver or platinum) and silver is usually alloyed with copper. The working properties of both metals, and the rarity in particular of gold, have given them almost mystical properties; they were used for the making of sacred vessels and for pieces of secular plate which denoted status, such as salt-cellars. The variations in quality and ductility allowed them to be used to good aesthetic effect by generations of skilled gold- and silver-smiths.

The arrival of William III in England in 1688 gave approval to the French style which had been practised by the small group of French Huguenot refugee goldsmiths who had set up in London. Within two decades they had taken the initiative and although the changeover to new techniques and fashions was not without difficulties raised by the deprived native-born goldsmiths, French taste was generally dominant after 1700.

The Huguenot style in silver was based on the considerable number of ornamental designs produced by Jean Berain, Jean Lepautre and Paul Androuet du Cerceau. While their engravings covered a far wider range than that of goldsmiths' work alone, Berain produced a number of drawings with designs for silver, and Lepautre included in his vast output of some 2200 etchings a set of designs for silver andirons.

One significant Act of Parliament affecting silversmiths had been passed in 1697 to introduce a 'new sterling' or 'Britannia' standard. This meant that no one 'shall work or make or cause to be wrought or made any silver vessel or manufacture of silver, less in fineness than that of 11 oz 10 dwt of fine silver in every pound Troy'. The previous standard was at 11 oz 2 dwt. Marks were changed so that the new and former standards of silver could be distinguished with 'the figure of a woman, commonly called *Britannia* and figure of a *lion's head erased*, and a distinct variable mark to be used by the warden of the said mystery, to denote the year in which such plate is made'.

Some workers thought the metal of the old standard was harder and gave vessels a longer life, but others held the new to be 'of much finer Colour, and better adapted for curious Work'. A solution came finally with the Wrought Plate Act of 1719 providing that no one was restrained from working the old standard if he so chose: the standard became, as it still is today, free. However, the 1719 Act imposed a duty of sixpence per ounce which was not removed until 1758.

These changes, early in the eighteenth century, led to many innovations in design, not only in the form of the vessel but also in the ways of making it. The Carolean style had called for lavish embossed ornament (which meant working the metal sufficiently thin to be stretched to the shapes required), whereas the new style needed an extravagant use of silver by the use of heavy mouldings and ornament cast in high relief and applied to the walls of the vessel. Admittedly gadrooning or fluting (the first is the inverted form of the

latter: shallow rounded parallel grooves) was still hammered out of the body, but the so-called 'cut-card' work became a prominent feature, eclipsing almost all other ornamentation – cut-card work was a method of decorating with foliage patterns cut from flat sheets of silver.

Just as some of the leading Huguenot makers worked in the plain English manner when occasion demanded – the famous Huguenot goldsmith Paul de Lamerie (1688–1751) produced his early works, *c.* 1711–20, in plain form, but soon turned to elaboration – there were, by contrast, some English makers who adopted the grand manner. This is particularly true of the work of the brothers George and Francis Garthorne and of Benjamin Pyne, who may of course have employed Huguenots in their workshops. Queen Anne employed the Garthorne brothers as well as Benjamin Pyne, but she was also supplied with a basin and ewer (1702) by the Huguenot David Willaume. During George I's reign commissions were spread more widely among the Huguenots, with an order for a complete service of plate. A complete toilet-service of plate – which might comprise at least thirty items, including a silver-framed mirror – was the customary gift for a woman at the time of her wedding. They were, however, also varied in content for the use of men and an order for a complete service of plate for the use of the Prince of Wales (later George II) went to Pierre Platel; and Sir Robert Walpole ordered plate in the 1730s from three makers, Paul de Lamerie, Paul Crespin and William Lukin.

The principal articles of early Georgian domestic plate were standing cups and covers, two-handled cups and covers, tankards, monteiths and punch bowls, tea pots and tea kettles, bottles, coffee and chocolate pots, tea caddies, ewers, inkstands, and in some rare instances silver furniture. 'Flat plate'

Salver by Paul de Lamerie (1727), for Sir Robert Walpole. Made from the second Exchequer seal of George I; engraving attributed to William Hogarth.

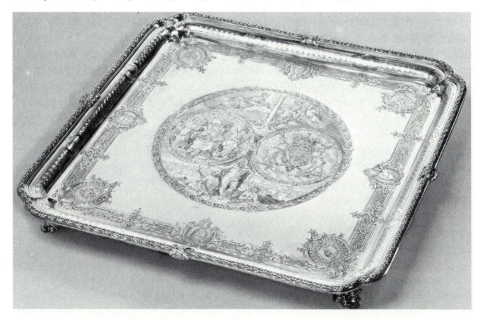

consisted of spoons, forks, marrow scoops, and there were necessary but miscellaneous items such as dishes and plates.

The standing cup, an important form in the seventeenth century, declined in use before the advent of the two handled cup. The finest examples of these were produced in the early eighteenth century, of elegant line, with engraved armorials, cut-card work on the lower bowl and with gadrooned covers centring on a finial. Some in gold or silver-gilt were presented as race-cups; the shallower ones were used in a more utilitarian way to contain soup or vegetables.

Throughout the seventeenth century the ever-useful tankard had usually had a flat lid with a thumb-piece and tapered slightly in the body towards the top. In the early eighteenth century the height increased, handles were more gracefully fashioned, and the top was heightened into a dome. The monteith, introduced in the 1680s as a variant of the punch bowl, had a scalloped rim which allowed glasses 'to hang there by the foot so that the body or drinking place might hang in the water to cool them'. This rim was, however, simplified in the early Georgian period and made detachable. In this simple way the punch bowl evolved and monteiths were effectively obsolete by about 1730. Bottles or flasks were made to hold wine, and with a stopper and chain were of oval section and often of considerable height and weight.

As fashions in dining and eating changed, the forms of tableware changed too. At the centre of the table was an epergne which incorporated casters, cruets, candlesticks to light the table at night, and dishes for serving dessert. Additionally soup was served with serving spoons from tureens, sauce boats were easily circulated around the table, salts were displaced by condiment vases, and bread was dispensed from a bread-basket. However, many items for dining were more acceptable in porcelain, which was competitive in price even if imported from Dresden or France.

Equipage for tea is often depicted in conversation pictures: tea kettle, tea pot, sugar bowl, tea canister and a jug for hot water; tea was drunk from a dish or shallow bowl rather than a cup. Cream or milk jugs were not normally supplied until about 1730. The tea kettle was set on a simple stand or waiter until the rococo style affected its shape. A lamp was necessary to heat the kettle. The tea was kept in canisters, one for Bohea or black tea, the other for green tea. A spoon to lift the coarse tea-leaves from the narrow-necked canister was essential. Its pointed end was used, probably to clear leaves from the spout of the teapot; however, about 1760 the canister was given a wider opened end and a tea-caddy spoon became popular. Hot water was now dispensed from a hot water urn which supplanted the tea-kettle on a stand. The drinking of chocolate seems to have fallen out of fashion in the 1730s or was simply preferred from a porcelain vessel. Chocolate pots are not found in silver from the 1740s.

After the provision of silver for eating or drinking, the men of the household had need of silver vessels for washing and shaving and women had a complete set of 'dressing plate' with caskets for pomades, brushes, pins, small jewels, and various small pots and basins. Demand for these elaborate sets continued until the late eighteenth century with a frequent use of the same moulds.

By the time George III came to the throne in 1760 English silver was undergoing considerable change. Silver plating was being introduced at Sheffield and elsewhere and there was a concern to consider the new neo-classical shapes. Some of these were effected by the die-stamping method where steel dies were used to produce relief ornament on sheet silver and to make larger wares such as small baskets and candlesticks. With this technical improvement the Birmingham silversmiths launched into the wholesale provision of 'toys' or small fancy goods. The dies allowed the use of less metal and could readily produce hundreds of design variations for a mass market.

Across the eighteenth century the system continued of proving the quality of silver by assaying it (by melting a portion of metal scraped from different parts of the article), and as well as in London, assay offices were set up in 1700 at York, Bristol, Chester, Norwich and Exeter, Newcastle (1702) and Birmingham and Sheffield (1773). At Birmingham the successful business entrepreneur Matthew Boulton had campaigned for seven years for an office. However, his 'career' as a silversmith is notable more for the quality than the quantity of his wares. This was also true of his trade in producing ormolu wares. The word 'ormolu', from the French term *or moulu*, means literally 'ground gold'; that is to say, gold made into a powder so that it can be easily amalgamated with mercury for use in the gilding process. In England, since Boulton's day, it has come to be used both as an adjective meaning 'made of gilt brass, bronze or copper' and as a noun denoting brass, bronze or copper which has been gilt by fire-gilding or mercurial gilding.

Between 1768 and 1782 Matthew Boulton, at his Soho, Birmingham, manufactory, produced many ormolu ornaments, candelabra, door knobs, escutcheons, sconces, inkstands, clock-cases, and ornamental vases. He took a keen interest in the firm's production, a natural development of Birmingham's involvement with metal-working and the 'toy' trades. It gave Boulton a foundation on 'which to build the edifice of his later ventures', particularly the eventual success of the steam engine business. However, in spite of his enthusiasm the ormolu trade was a financial failure, merely allowing him to advertise his name in the most useful circles in England and abroad.

By 1770 or so the taste for rococo ornament had largely disappeared and the first signs of a change seem to have come in the architecture and interior design of architects such as Robert Adam, Sir William Chambers and James Wyatt. Some of Adam's designs for silversmiths (Sir John Soane's Museum, London) show the growing popularity of the urn shape, particularly for important race-cups such as those awarded at Doncaster and elsewhere. Relief ornament on these and other vessels was embossed or applied, with delicate fluting, palmettes, acanthus leaves, *paterae* and various forms of beading as common decorative features. Most vessels were also embellished from about 1775 by bright-cut engraving, a new development in technique, where various curved grooves were cut with sides of varying profile so that the facets produced a bright effect. There was also continued competition with the cheaper 'Sheffield plate'.

In the early 1740s a Sheffield cutler, Thomas Boulsover, had established

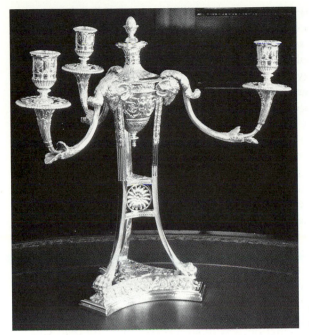

Silver candelabrum by John Carter, c. 1774.

that if a sheet of silver was fused with a thicker copper one the mass could be rolled so that the copper was covered with a layer of silver. The idea was exploited by others and Matthew Boulton also took a leading position, obtaining a near monopoly in its manufacture at his Soho factory from 1762. The quality of his work was very high, and coupled with improvements in rolling, stamping and embossing machinery, and with the introduction of the steam engine, Boulton and his partner, John Fothergill, began to reproduce shaped parts for sale in quantity to smaller firms. It was an activity that encouraged a demand for fashionable, inexpensive objects as well as being an indication of Boulton's considerable skills at staying ahead of his many rivals. Alas, he could rarely stay ahead of an avaricious Government: by an Act of 1784 a duty of eight shillings was imposed on each ounce of gold plate and sixpence on each ounce of silver plate. Additionally, by another Act of the same year, two standards of gold plate of eighteen and twenty carats were added to promote work because 'various manufacturers of Gold require gold of different degrees of hardness and purity'. It was a sign of the continuing involvement of authority with the regulation of trade in the precious metals; one applied uniquely, and regrettably absent, in terms of quality control, from furniture or pottery and porcelain items.

Josiah Wedgwood and the potters

All ceramics begin as lumps of common clay and to make earthenware was, in essence, always a simple process. In England the Midlands county of Staffordshire has been at the centre of manufacture and development,

particularly in the process of glazing with salt, a process introduced from Germany in the seventeenth century. The kiln was brought to a high temperature (up to 1400°F) and common salt (sodium chloride) was shovelled in. At the intense heat the salt decomposed into sodium oxide gas and hydrochloric acid. The heavy gas swirled around the hot ceramic body and combined with its alumina and silica to form a glazed coating, thin, and without colour. However, after solving the problems of attaining the whiteness, the potters began adding colour in the form of various metallic oxides. Saltglazed wares also took relief decoration well and reached their peak in the jasper wares of Josiah Wedgwood. The addition of colour necessitated a second firing, at a lower temperature than the first, which vitrified the coloured glazes. The majority of the early pieces were decorated in imitation of Chinese porcelain.

There are no marked pieces of saltglazed stoneware so that attribution to makers is difficult. According to the Staffordshire historian Simeon Shaw (1829), John Astbury made the first white saltglaze 'about 1720' with the use of white clay from Devonshire added to calcined flint. However, there were conflicting claims – Josiah Wedgwood claimed the method for Thomas Heath – but all that can be stated with any certainty is that every pottery works in Staffordshire between about 1730 and 1760 made stoneware, and pirated each new idea with alacrity. Its production was dealt a major blow by the inventive skill of Josiah Wedgwood (1730–95).

Josiah began in a similar way to his father and forefathers, all Staffordshire potters, being apprenticed to his brother and learning hard throughout his years of training. At the end of his time he entered into two trade partnerships, the second of which was with one of the greatest potters of his day, Thomas Whieldon (1719–95). Wedgwood's terms of reference allowed him some freedom for personal experiment: the business needed some improvement 'as well in the body as the glazes, the colours and the forms'. His experiment book for 1759–60 survives and shows his interest in new glazes, but the restless urge for improvements caused him to dissolve his partnership with Whieldon and to set up at his own first factory, The Log House works. Here, with the assistance of a modeller, William Greatbatch, he experimented with many naturalistic forms, and Pine Apple ware and Cauliflower ware, using green and yellow glazes, were issued. Whilst unmarked, the surviving examples may, by their refinement of form and detail, be regarded as early products of Wedgwood.

With his technical experience now firmly grounded, Wedgwood turned to the considerable task of refining the cream wares. He obtained a lighter and better-controlled colour, which led to his appointment in 1763 as potter to the Queen and his cream ware being renamed 'Queen's ware'. Throughout Josiah Wedgwood's lifetime it was a staple product of his factory and became a fashionable, well-decorated ware in demand internationally. In fact in 1768 and 1775 Wedgwood made two enormous dinner services for Catherine the Great of Russia, the 'Husk' and the 'Frog': the latter was decorated with English landscapes, and a frog in a shield was marked on each of the 952 pieces.

To help along his trade Wedgwood set up new showrooms in London and

much of his success, as indeed that of his friend, Matthew Boulton, was due to the understanding he displayed of how both to make and market his products. This business side of the pottery needed a business partner and in 1769 Wedgwood joined up with a Liverpool merchant, Thomas Bentley. Even before the formation of the partnership the two were active in promoting a parliamentary Bill for the Trent and Mersey canal. The canal made it possible to move their wares safely and economically in order to compete in a world market. Bentley also assisted in the growing search for new shapes as the neo-classical taste took hold. In particular, the glazed black wares of a previous age became refined as the unglazed basalts that came from the success of the partnership. There were also many experiments with imitations of red-figured Greek vases – in encaustic glazes for which a patent was granted in 1769.

At the time Wedgwood was entering into the fruitful liaison with Bentley he had purchased an extensive Staffordshire estate near Burslem where his 'Etruria' factory was built. It was arranged in sections, each with its own kilns, and with workmen who specialised in one operation. The first firing took place on 13 June 1769, and it inaugurated also the most creative years of Wedgwood's life. New bodies, forms and glazes appeared and the latest archaeological treatises were searched in order that the designs could be

Black basalt urn made by Wedgwood in 1774 in memory of Henry Earle. The fine-grained black stoneware is decorated with unusual green and white encaustic enamels.

turned into commercial products. Agate wares, which Wedgwood had improved in his Whieldon years, were altered to 'marbelized' and 'pebbled' wares about 1770. There was also a continuing search, sharpened by classical prototypes in cameo form, for an improved white body. Only in 1775, after years of experiment with various spars and minerals, did he begin to produce medallions in the style of classical cameos in a body he named 'jasper'. When the problems of incorporating or setting it against coloured grounds were solved, he began a very active production of relief-ornamented jasper wares in the forms of intaglios and cameo medallions. The variety and size of these was improved from 1775 when Bentley persuaded John Flaxman to be the firm's modeller. This association continued beyond Bentley's death in 1780 and jasper ware was used for teapots and tea and coffee services as well as for plaques, figurines, vases and candlesticks. There were, of course, many imitators of his innovative wares, but in 1768 Wedgwood told Bentley, with assurance: 'we are far enough before our rivals and whenever we apprehend they are treading too near our heels, we can at any time manage them better . . .'.

It is accepted that Wedgwood was England's most famous potter, a man of great creative ingenuity and tireless energy. He was active at a time when expanding trade could be backed by the development of mechanical and technical resources. As one of the early pioneers of the Industrial Revolution he stayed ahead by the quality of his creative mind and the knowledge gained early at the potter's wheel.

One of the abiding characteristics of early Staffordshire pottery is the concern of makers with figurines. They made their appearance there about 1720, as simple ornaments for cottage and chimney shelves, after some early examples had been made in the 1670s by John Dwight at Fulham. John Astbury may have been their originator in the Staffordshire pottery area but he had to share his ideas with a small group. Initial attempts were in solid agate ware formed from a two-part press mould and included figures of Dr Sacheverell and Queen Anne. It is not known who made these figures – Astbury is assumed – but reckoning needs to count the later activities of Aaron Wood whose name is associated with saltglaze figures in the 1740–5 period, particularly 'pew groups' in which two or more quaintly dressed figures, often playing instruments or fondling dogs, are backed by the representation of a stylised church pew with piercings of quatrefoils and applied relief 'Gothic' ornament. The later figures – Astbury died in 1743 – are often called 'Astbury–Whieldon', allusive of the most creative potter of the next generation (and Wedgwood's master), Thomas Whieldon. It is of course regrettable that more accurate information cannot be established about the early Staffordshire figures. Future excavations in the Burslem area may help, but in the meantime the Astbury figures and the derivatives remain as enchanting samples of a true folk-art, individually moulded, modelled, stained and glazed.

Very little information concerning Thomas Whieldon's activity can be gleaned from his one surviving account-book, 1749–53 (City Museum, Stoke-on-Trent). No signed piece is extant and excavations at Fenton Low and Little Fenton have proved unsatisfactory since it is known Whieldon had

A 'pew group' of salt-glaze figures, attributed to Aaron Wood (1740–5).

premises on other sites too by 1747. I have mentioned Wedgwood's notice of his partner in his own 1759 experiments book: 'white stoneware (viz. with salt glaze) was the principal article of our manufacture . . . the article next in consequence to stoneware was an imitation of tortoise-shell . . .'. What Wedgwood introduced was an imitation of agate, but with improvements, 'in the body as the glazes, the colours and the forms'. In fact, with a careful choice of journeymen or apprentices (all of whom made later reputations) Whieldon was able to encompass 'the whole range of wares currently in favour in Staffordshire' – saltglaze, agate ware, tortoise-shell and black-bodied wares.

 Another significant force was the Wood family, Ralph and his sons Ralph, Aaron and Enoch. Together they spanned the years from 1715, the date of Ralph senior's birth, to the death of Enoch in 1840. The two Ralphs specialised in pottery figures and in mask and Toby jugs, achieving the bright colours by the use of controlled staining of particular sections by adding oxides to their glazes. Ralph junior and his younger brother Aaron were very capable mould-makers (Aaron also worked for Whieldon), relying on many refined sources for inspiration – Apollo, Ophelia, Neptune, Venus and Jupiter were some of the subjects made in the 1760–70 period. Aaron's two sons, William (1746–1808) and Enoch (1759–1840), were also accomplished modellers, William working for Josiah Wedgwood and Enoch, the 'Father of the Potteries', setting up in partnership with his cousin as Enoch Wood and Company.

*Colour-glazed earthenware
figure of St George, impressed
by Ralph Wood (1789–1801).*

Ceramics: porcelain

A comparable industry to pottery, that of porcelain, developed in England
from the middle of the eighteenth century. There are two types of porcelain,
hard paste and soft paste. The first, or true porcelain is made from white
china clay (*kaolin*) and chinastone (*petuntse*), a silicate of aluminium and
potassium. When fired at a high temperature (1250–1350°C) the material
fuses into a glassy matrix. If left unglazed it is called 'biscuit porcelain', but
glazes made from powdered feldspar were usually applied prior to firing.
Sometimes the body was decorated under the glaze in a cobalt blue or
manganese, or, after the last firing, over the glaze with metallic oxide colours,
which melt at a lower temperature (about 750°C).

 This hard-paste porcelain was first made in China in the seventh or eighth
century AD, enjoyed the first revival at Meissen, near Dresden, in 1710, was
produced on a great scale in France at Sèvres in 1768 and in the same year
was made in England by William Cookworthy at Plymouth.

 The variation, soft paste, was an imitation of true porcelain and was first
produced in Florence between about 1575 and 1587 at the Medici factory,
founded by the Grand Duke, Francesco de' Medici. The French factories of
Rouen and Saint-Cloud took it up in the 1670s but thereafter it became the

paste used by many other European factories, and in England at Bow, Chelsea, Derby, and Worcester until the end of the eighteenth century.

Lead glazes were used to decorate soft-paste porcelain after it had been fired and needed a second firing at a lower temperature. Those pieces decorated with enamel colours needed even a third firing in order that the colours would sink into the glaze. Production was difficult, kiln losses frequent and commercial production was thereby limited. For these reasons soft-paste porcelain is comparatively rare and, coupled with great skill in the modelling, appeals more to collectors.

The Bow factory obtained a patent to manufacture porcelain in 1744 but as no wares have been found dated prior to 1748 it shares with Chelsea (surviving pieces from 1745) the distinction of being the first English porcelain factory. It was sited in the East End of London and was founded by Thomas Frye, an Irish painter, and Edward Heylyn, a glass-merchant. Their 1744 patent stated that they intended to make 'a certain material whereby a ware might be made . . . equal to, if not exceeding in goodness and beauty, China or Porcelain ware imported from abroad'. They imported their china clay from the American potter of Huguenot origin, Andrew Duché, who had discovered an equivalent for the Chinese *kaolin* and feldspathic rock, used for making porcelain, in about 1738, when he was living at Savannah.

In 1748 Thomas Frye entered details of a second patent and Bow pieces dated within a year or two of this show that he reached a high standard of production, using a white body, or with underglaze blue or enamelled decoration applied. The factory was active for over ten years, until Frye's retirement in 1759, and had been innovative in using transfer printing from 1754 – the year after its first use at the Battersea enamel factory. This method of decoration involved inking an engraved copper plate with a ceramic colour, printing-off the image on thin paper and pressing this to the surface of the object being decorated. It could be applied before or after glazing, and some of the finest work was done by Robert Hancock who worked both at the Battersea Enamel Factory and after it closed (1756) at Bow. In 1775 the Bow factory was bought up by William Duesbury (1725–86), a good porcelain painter and owner of the Derby factory as well as that at Chelsea, which he had acquired in 1770.

Despite Bow's earlier start Chelsea became the best-known and perhaps the best of the English porcelain factories. Its early history is complex and obscure, with early pieces – 'triangle period' and the 'Girl in a Swing' figures – perhaps coming from two separate Chelsea factories. The first manager, Charles Gouyn, left Chelsea in 1749 and was succeeded by a skilled silversmith, Nicholas Sprimont, a Huguenot who was admitted to the Goldsmiths' Company in 1742. His speciality in modelling was in creating representations of natural forms decorated with shells and crabs, perhaps cast from nature, and it is significant that the outstanding early productions at Chelsea were salt-cellars in the form of crayfish on rocks.

Sprimont's patrons were influential and included, for silver, Frederick, Prince of Wales and at Chelsea the Duke of Cumberland, whose secretary, Sir Everard Fawkener, owned the factory. The Chelsea mark of a raised

anchor was put on to many vessels which were based on Meissen prototypes: from an aesthetic standpoint those of the 'red anchor period' (the anchor in underglaze red), from about 1752–8, are the most appealing. A good ceramic factory is only as good as its modellers, and apart from Sprimont's overall supervision Chelsea was served by Joseph Willems, a Belgian sculptor who was in England by 1748 and maintained a distinguished standard.

A further variation of the anchor mark, the gold anchor, was used from 1758 when the factory, closed for a year because Sprimont fell ill, re-opened. Improvements had been made to the paste with a thicker glaze and elaborate versions of French rococo Sèvres vases were made, together with the evocative and well-known bocage groups such as 'The Music Lesson' and 'The Dancing Lesson' in which modelled leaves and flowers were used as background to a figure or group – the French word *bocage* denotes a copse or grove. In 1769 the astute William Duesbury, active at the Derby factory from 1756 (after work in his London studio painting for Bow, Chelsea, Derby and the short-lived Longton Hall factory) bought Chelsea and for the next fifteen years, until 1784 when it closed, Chelsea wares were indistinguishable from the Derby products: indeed they are usually called 'Chelsea-Derby' and bear the same mark – an anchor and the letter 'D'.

The middle years of the eighteenth century were the most active for porcelain manufactories. Derby had been established in a tentative way in the late 1740s by Thomas Briand from Chelsea and a partner, James Marchand. But by 1756 William Duesbury had joined with a banker friend, John Heath, and André Planché, a Derby china-maker, to start the first regular Derby Porcelain Factory, with the first of its wares generally imitative of those from Meissen and Chelsea. Particularly successful was Derby's production of biscuit figures, that is, those made of unglazed white porcelain. They were modelled to perfection and subjects included George III (*c.* 1773) and members of his family. The popular 'Crown Derby' period began in 1784, but Duesbury died two years later and was succeeded by his son.

The longest-lived of the good English factories is that at Worcester, founded in 1751, which profited in increase of business when it took over Benjamin Lund's Bristol factory in 1752. Lund had been involved with William Cookworthy, the entrepreneurial potter who probably first made porcelain in England, and had licences to mine soapstone in Cornwall. This enabled him to make a variation of a soft-paste porcelain and Worcester, wisely, used his formula until 1784. It enabled them to make thin, durable vessels, able to withstand hot liquids better than other soft-paste vessels, which were formed, usually, from a feldspathic rock.

One of the founders and shareholders of the Worcester factory was Dr John Wall who, after his Oxford training as a physician, practised in Worcester for some forty years. With William Davis as manager, the factory made a name for itself with black and blue transfer-printed wares from prints adapted from French sources and engraved by Robert Hancock who became a shareholder in 1772. However, in the 1760s white porcelain made at Worcester was decorated by the very talented freelance decorator, James Giles, who, in his advertisements of 1768, stated that he had for sale goods 'curiously painted in the Dresden, Chelsea and Chinese Tastes'. He also had

close business links with William Duesbury in the early 1770s, applying overglaze enamels and gilding to undecorated porcelain he obtained from Derby, but at a time when the rococo style in ceramics was waning in favour of the neo-classical.

Glass

At the end of the seventeenth century English glassmakers were in a strong position based on the perfecting of glass-of-lead in 1676 by George Ravenscroft. They were ready to experiment and in the realm of drinking-glasses to advance rapidly from the thick baluster stems of early Georgian glasses, almost drawn up from the foot, into a trumpet bowl, and then the stem was given an attractive bubble in the form of an imprisoned 'tear' of air. The second step was to 'twist' the stem so that several tears were elongated around it, and this led finally to the air-twist stem glasses in which the trapped air was twisted into a shining spiral pattern. This kind of drinking glass was popular into the 1750s but the development of enamel glass (which was opaque) allowed the air-twists to be replaced by threads of white opaque glass. These remained fashionable until 1780, with the imposition of a tax on enamel glass (1777) causing a gradual decline for them. At least a hundred varieties of opaque-twist stemmed glasses are known.

Baluster silesian, or pedestal stem wine glass (1730).

Perhaps the best-known, but comparatively rare, group of glasses is that which includes acknowledgement of the Jacobite cause. A wealth of sentiment had been settled on the adventures of Bonnie Prince Charlie and the failed cause. In 1715 the leadership had failed and in 1745 the Stuarts had few reliable supporters. Standard Jacobite glasses are engraved with a rose with one or two buds, although other emblems such as a thistle, oak leaf, star and the word *Fiat* may be present. The rose represented the English crown, but after the battle of Culloden Moor in 1746, which effectively concluded the Stuart claim to it, there was perhaps little raising of glasses. The 'Jacobite glasses' had enabled adherents to express their personal loyalty to the 'Old Pretender', James III, and to Charles Edward, the 'Young Pretender', for a few brief years, secure in their knowledge of what all the engraved motifs meant and having still a sentimental and historical appeal.

One of the neglected areas of English glass, mainly because it has been regarded, carelessly, as porcelain – is that of enamelled opaque-white glass. Most of it has, unreliably, been attributed to Michael Edkins who seems to have settled in Bristol after completing only some of his apprenticeship in Birmingham. One of his ledgers survives and lists many forms which are repeated in both enamel and blue glass. Edkins covered his vases, candlesticks, tea caddies and plates with assured painting in enamel colours: roses in full flower, obsequious Chinamen, sedate birds and gold lettering. Some of this work may have been unfired and much was certainly exported: therefore little survives, but all of it demonstrates great decorative skills.

These attributes were also enjoyed by the Beilby family of Newcastle on Tyne. At least four of them are noted as enamellers on glass. William Beilby was the most important: he was apprenticed in Birmingham in 1755, an excellent area in which to train, as there were many enamel and silver box makers resident there. The first datable pieces by him are the goblets enamelled in celebration of the birth of the Prince of Wales in 1762. Despite the fact that the stems of glasses had become so elaborate, rendering it less necessary to decorate the bowls, the decorated armorial glasses by the Beilby family are among the most highly prized products of the late rococo period.

Textiles: tapestries and carpets

Partly as a result of French competition the supremacy of Flanders as a textile weaving country had been lost by the opening of the eighteenth century. French weavers were in Munich, Berlin and Dresden as well as France, and Italian weavers were active despite the closing in 1737 of the Medician tapestry workshops. In England, until 1727, John Vanderbank was still weaving his Soho chinoiserie tapestries, rich, with dark backgrounds which imitated lacquer and showing great style in the disposal of figures, buildings and animals. This interest in the Orient apart, it was French designs which were to inspire the somewhat tardy English production of tapestries after the closure of the Mortlake atelier in 1703. In particular the flower paintings of John Baptiste Monnoyer and the paintings of Watteau were important influences.

One of the most important weavers of wool and silk tapestries in early

eighteenth-century England was Joshua Morris, who had premises in Frith Street, near Soho Square, from 1720 to 1728. What we know of his activity is crowded into these few years. Arabesque tapestries, in which Morris specialised, are so named because scrolling acanthus leaves frame panels of flower-filled urns, exotic birds and full-mouthed tulips. The designs may have been provided by a Frenchman, Andien de Clermont, who worked in England for some forty years, 1716 to 1756. A number of sets survive (Victoria and Albert Museum, London; Boston Museum of Fine Arts; Metropolitan Museum, New York; Hagley Hall, Worcestershire; Grimsthorpe Castle, Lincolnshire), and with their bright red, blue and beige colourings are attractive ensembles of proportioned, yet asymmetrical, patterns.

On 1 December 1726 Morris's stock was put up for auction and his premises were taken over by the upholsterer and tapestry weaver William Bradshaw. It was not long before he was issuing similar works in partnership with Tobias Stranover, a painter of birds and flowers. They were presumably partners in the 1730s, since a tapestry on a settee from Belton House, Lincolnshire, is signed by both of them. Bradshaw and Stranover may also have worked together on the Watteau tapestries for the Cabal Room at Ham House, Richmond, although only Bradshaw's signature is on them. They seem to have separated about 1732.

A major London upholsterer of the 1750s and 1760s was Paul Saunders, who had a fashionable clientele, as well as holding the position, from 1757, of 'Yeoman Arras-Worker' to the Royal Wardrobe of George III. In partnership with George Smith Bradshaw, Paul Saunders had already supplied tapestries to Holkham Hall and Petworth House. He was known for his depictions of Oriental-style landscapes with soft trees and picturesque ruins, his most famous design being 'The Pilgrimage to Mecca' (examples of which survive at Alnwick Castle, Petworth and Holkham) in which a great procession of turbaned figures threads its way on camels through a rocky landscape bounded by a rich floral border. In 1761 Saunders received a second appointment in the Great Wardrobe as 'Yeoman Tapestry Taylor' and held the two appointments concurrently until his death. Both jobs were concerned with repairing and cleaning royal tapestries, but new hangings were also supplied.

Knotted carpet weaving in England was revived in the 1750s by the defrocked Capuchin friar, Pierre Parisot, who found an early patron in the Duke of Cumberland, and a tradesman who would help them to set up in Fulham, the successful Thomas Moore of Chiswell Street, who was shortly to become a key figure in carpet weaving in England. In 1756 Thomas Moore, who won a prize for carpet making given by the Society for the Encouragement of Arts, Manufactures and Commerce, advertised 'Royal Velvet Tapestry after the manner of the Persians'. Perhaps the supreme example of his skill is the great carpet he wove to Robert Adam's design in 1769 for the Dining Room at Syon House (although it is now in the Red Drawing Room there). At Saltram, Devon, on the other hand, Adam's designs, also dating from 1769, were executed by Thomas Whitty. As at Saltram, the carpets sometimes echoed the ceiling designs. English carpets

were at last successful and orders for them flooded in from America, Italy and France.

In the areas of silk design, embroidery, and the printing of textiles from engraved copper plates, French influence was also strong. However, the publication of books incorporating Chinese designs, such as Edward Darly's *New Book of Chinese Designs* (1754), provided alternative sources to enhance the sinuous lines of rococo styling. Important designs for woven silks were made by Anna Maria Garthwaite, and in the cheaper material of cotton important advances were made after the printing of all-cotton cloth or 'fustian' became legal in 1774. Prior to that date the 'sale, use and wear of all cotton cloth' was illegal from 1721–36 and fustian had to be woven with a linen warp. This took the dye less well and created a speckled effect. Nevertheless large quantities were exported, especially to the American colonies and throughout Europe, and English cottons had a prosperous run in popularity until the American Civil War in the 1860s brought 'famine' to Lancashire.

Textiles: costume

Along with their snuff boxes and cane or parasol, eighteenth-century elegants might equip themselves with gloves and handkerchief, a watch, a fan, a sword, for as Dr Johnson observed: 'Every man of any education would rather be called a rascal than accused of deficiency in *the graces*'. Prominent people spent a great proportion of their income on personal finery. Overseas wares were in great demand – lace from Flanders, silk and satins from various Italian cities, Indian cottons and Dutch linen. Correct appearance, as Lord Chesterfield reminded his son, was a very important matter, and payments to a London tailor a necessary expense to being equipped with resplendent embroidered outfits.

Of course eighteenth-century people did not sacrifice comfort and warmth for the sake of fashion in the clothes they wore. During much of the eighteenth century women's skirts were long and sleeves covered the elbows, and bodies were pulled in by corsets or 'stays'. In the summer months men wore unlined coats and thin waistcoats and woman favoured lustring, a crisp light silk, over more layers of underwear than is now common. Gowns were made with the skirts open at the front to reveal a matching or contrasting petticoat, and the bodice was shaped to be worn with an insert called a 'stomacher' which was pinned or laced in place. By selecting different petticoats and stomachers many variations in one dress could be effected.

Men wore less underwear than women but the wealthy owned enough dress shirts of fine bleached linen or cotton to wear a clean one each day if desired. Shirts worn by working-class men were made of coarse unbleached linen or cotton. By a little after 1700 men's suits had assumed the three-piece format still worn today, although the eighteenth-century suit had a long coat, a waistcoat, and knee-length breeches buttoned at the centre front. Suit coats had full sleeves and wide skirts ending just below the knee.

After mid-century the waistcoat was shortened and finer suits were often made of silk fabrics embellished with applied braid and decorative buttons.

Waistcoats were of elaborate colourful fabrics brocaded on a loom or hand-worked by professional embroiderers. The latter produced most elaborate designs using silk threads, often adding gold, silver and precious stones on the elaborate suits worn at court or other formal settings. Their work was at a considerable remove from the farmer's smock made of a sturdy fabric.

Finishing the wardrobe for men, women and children was a ready source of employment for many, from silversmiths, shoemakers, milliners, handkerchief- and waistcoat-makers, hat-pin-, glove-, buckle- and watch-makers.

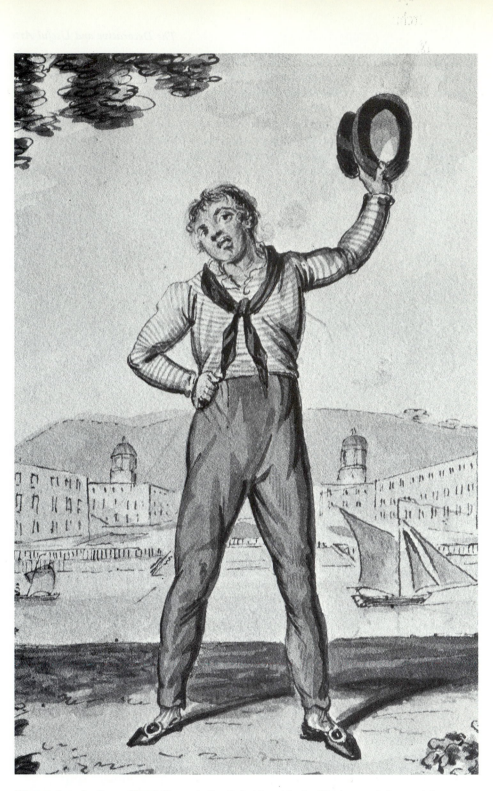

Watercolour by Isacc (?and George) Cruikshank, with the Thames and Greenwich Hospital in the background.

2 Flowers in the Valley: Folk-Songs in Britain

RAYMOND O'MALLEY

There exists a poem, 'The Quiet Grave', which says, in its own verse idiom, very much what I shall be attempting to say in prose in the present chapter. It is printed as a coda to this chapter on pages 104–5 with the consent of the author, Ursula Fanthorpe. It is true, as she says, that the songs went unnoticed by most village priests; true also that it was a kingdom of great riches that survived only in the memories of the ageing singers; and true that the tradition ended in the dying air of irreversible social change. The termination might have gone unremarked, English folk-song might have passed into utter oblivion, but for the work of Cecil Sharp, Ralph Vaughan Williams and other distinguished musicians at the turn of the last century.

They knew that the frail and aged countryfolk, many of them ending their lives in workhouses, neglected and even scorned, had access to values in no way accessible through the familiar channels of progress. In particular Sharp, to whom Ursula Fanthorpe subscribes her poem, devoted his life to seeking out the old singers in cottages, lanes and fields, earning their trust, and (without help from modern recording devices) meticulously noting down their songs (his notebooks may be studied in the library of Clare College, Cambridge). He edited the songs and persuaded the Education authorities of the day to have them taught in the schools. No-one – not even Sharp – could revive a tradition that had died along with rural Britain; but we owe it to the collectors that we have, in imperishable form, accurate knowledge of many hundreds of exquisite songs, and insight into a neglected part of our national history. My own chance discovery of 'The Flowers in the Valley' among some sheet music, in 1933, had the force of a revelation. This chapter owes much to the writings of Sharp and concludes with some of his words which themselves quote one of the old singers he so deeply respected.

For folk-songs and ballads draw on the accumulated experience – personal, musical, verbal – of whole generations of people; they draw on wisdom that can rarely be attained by persons acting singly. The title of Ursula Fanthorpe's poem, 'The Quiet Grave', alludes to 'The Unquiet Grave', a ballad that illustrates the point well. Ballads have much in common with folk-songs, though they developed somewhat earlier and were often recited

without tune. 'The Unquiet Grave' has for theme what is perhaps the most disturbing human experience, bereavement, with the possibility of despair and the need for resignation:

'The wind doth blow today, my love,
 And a few small drops of rain;
I never had but one true-love;
 In cold grave she was lain.

'I'll do as much for my true-love
 As any young man may;
I'll sit and mourn all at her grave
 For a twelvemonth and a day.'

The twelvemonth and a day being up,
 The dead began to speak:
'Oh who sits weeping on my grave
 And will not let me sleep?' –

''Tis I, my love, sits on your grave,
 And will not let you sleep;
For I crave one kiss of your clay-cold lips
 And that is all I seek.' –

'You crave one kiss of my clay-cold lips;
 But my breath smells earthy strong;
If you have one kiss of my clay-cold lips,
 Your time will not be long.

''Tis down in yonder garden green,
 Love, where we used to walk,
The finest flower that e'er was seen
 Is withered to a stalk.

'The stalk is withered dry, my love,
 So will our hearts decay;
So make yourself content, my love,
 Till God calls you away.'

It may well be that Emily Brontë had this ballad in mind when writing the poem 'Remembrance'. Its tune was taken down by various collectors in several counties.

Similar largeness of spirit is expressed in the song 'Bedlam', picked up in Somerset. It concerns a girl demented by the unkindness of her lover, shut in an asylum, and chained. One verse runs:

My love he'll not come near me
To hear the moan I make,
And neither would he pity me
If my poor heart should break;
Yet though I've suffered for his sake
Contented will I be;
For I love my love because I know
He first loved me.

The last two lines, repeated as a refrain, show great maturity of attitude; and the expression of gratitude for proffered affection occurs in other songs; for example in 'The Foggy Dew', from Suffolk:

> When I was a bach'lor I lived all alone
> And worked at the weaver's trade,
> And the only only thing that I ever did wrong
> Was to woo a fair young maid.
> I woo'd her in the winter time
> And in the summer too,
> And the only only thing I did that was wrong
> Was to keep her from the foggy foggy dew.
>
> One night she came to my bedside
> When I lay fast asleep.
> She laid her head upon my bed
> And she began to weep.
> She sighed, she cried, she damn near died,
> She said what shall I do?
> So I hauled her into bed and I covered up her head
> Just to keep her from the foggy foggy dew.
>
> O I am a bach'lor and I live with my son
> And we work at the weaver's trade,
> And every single time that I look into his eyes
> He reminds me of that fair young maid.
> He reminds me of the winter time
> And of the summer too,
> And of the many many times that I held her in my arms
> Just to keep her from the foggy foggy dew.

Yes, wit and humour, but complete seriousness too. The song goes deeper than propriety.

Songs are a fusion of words and tune. Many of the retrieved folk-songs have tunes that match the words in their level of interest. The 'Foggy Dew' is a good example of this. Such tunes are evidence of the wealth of the vanished 'kingdom'.

The Foggy Dew

One more song will be quoted at this point, the song often known as 'Waly Waly' – 'Waly' is a cry of lamentation:

> The water is wide, I cannot get o'er,
> And neither have I wings to fly.
> Give me a boat that will carry two,
> We both shall row, my love and I.
>
> O, down in the meadows the other day,
> A-gathering flowers, both fine and gay,
> A-gathering flowers, both red and blue,
> I little thought what love could do.
>
> I put my hand into one soft bush
> Thinking the sweetest flower to find.
> I pricked my finger right to the bone,
> And left the sweetest flower behind.
>
> I leaned my back up against some oak
> Thinking that he was a trusty tree;
> But first he bended and then he broke;
> And so did my false love to me.
>
> A ship there is and she sails the sea,
> She's loaded deep as deep can be,
> But not so deep as the love I'm in;
> I know not if I sink or swim.
>
> O, love is handsome and love is fine,
> And love's a jewel while it is new,
> But when it is old it groweth cold,
> And fades away like morning dew.

Once again the theme is the place of love at the heart of living, as source of the utmost joy – and the utmost misery: 'I little thought what love could do.' The third verse in particular gains its power through the use of unusual symbols.

Waly Waly

There is of course no final way of *proving* the worth of a tune (or for that matter a poem), but it is incontrovertible that these folk-tunes and others from the same source have been of deep concern to composers of the calibre of Holst, Vaughan Williams and Britten, and to such eminent singers as Kathleen Ferrier, Peter Pears and Ewan McColl.

The number of authenticated songs is enormous; to name only two of the collectors, Vaughan Williams noted down six hundred tunes, and Sharp nearly five thousand from England and New England (for the Pilgrim Fathers took their songs as well as their language with them). And the songs are extremely varied; an attempt will be made later to show something of their range. The songs so far quoted have been selected to give a first idea of the quality of the vanished culture. The peasants of whom Sharp's stone-breakers and bird-scarers were the survivors were no illiterate yokels, but the originators of the ballad and the songs we have been considering, and of thousands like them.

In what sense the originators? That is, of course, the crucial question.

It is tempting to suppose that only musically trained persons could have composed such exquisite tunes as 'Dabbling in the dew', 'The trees they do grow high' and 'The Chesapeake and Shannon'; that the songs must have been the work of professionals, overheard by the villagers and remembered by them, though forgotten by the original composers; and that the songs are, it has been said, garden escapes. There are, however, convincing objections to such a view, both general and technical. The world of the folk-songs is utterly different from that of madrigals, operas and Court music, whose Phyllidas have no milk in their pails. Folk-songs do not modulate, and though they exist commonly in the major (which is identical with the ionian mode) they are seldom or never in the minor; the aeolian mode, though close

to the minor, is in fact significantly different in character, and is not uncommon in folk-song. The dorian and mixolydian modes are fairly common. All the modes have their distinctive 'flavour', reflected in the respective songs. There are other musical difficulties that make the 'garden escapes' theory untenable.

There is a more credible explanation, however. This assumes a society with certain features – which in fact were those of the villages and market towns of Britain when it was rural. (Britain, now overwhelmingly urban, was overwhelmingly rural in the Middle Ages; the balance tipped early in the nineteenth century). The social unit then was small, cohesive (no commuting!), and somewhat but not wholly isolated. Social mobility was minimal, and so talented persons were not systematically filtered out; and in the almost complete absence of provided entertainment there was strong incentive for villagers to make their own. Social gatherings were frequent; winter evenings were unlit. At the heart of every village was the church – and the churchyard, constant reminder of transience. Perhaps the most important fact of all: very few people could read and therefore everything depended on memory.

Conditions like these would foster the growth of the various folk-arts, and especially folk-song. A person with a musical idea to try out could sing it at the next gathering. If hearers did not care for it, it would be forgotten; if they liked it they would remember it, but (despite the known good memories of the unlettered) with varying degrees of inaccuracy; for nobody could write it down, even its originator. The song or fragment would be repeated by the listeners to other groups of hearers, and so on indefinitely, with mounting 'inaccuracy'. Since folk-songs lived for centuries, there would be ample scope for change. But the direction of change would not be random; inevitably the shared taste of the community would impress itself, and the 'eventual' shape of a given song might bear little resemblance to the original shape. There is, however, no eventual or definitive shape to a living folk-song. In this respect it is different from a 'composed' song – say, one of Schubert's. It exists only in the separate memories of the separate members of the community, and may develop further.

Every small change in the tune or the words of a song, then, is, whether intentional or not, the creative act of an individual, and yet the song itself is truly communal. The notion sometimes encountered today that one person with a guitar can compose a folk-song is entirely false. The living tradition of folk-song inevitably ended with the spread of literacy and other such changes. For better and for worse, Britain has changed beyond recognition. This does not mean that the folk-songs in their static condition have become unimportant – far from it. Some of them are immeasurably beautiful, and they give evidence of a past society of great interest.

English folk-song developed along with the English language itself in the later Middle Ages and the development continued until fairly recent times. Throughout, there has been remarkably little contact between the two cultures, that of the majority – the folk – and that of the cultivated minority. In every parish there has always been at least the one educated man, who must often have heard the singing in the fields, but whose education seems to

have closed his ears to the significance of the alien idiom. Sharp mentions the incredulity, followed by astonishment, of some parish priests when shown his transcripts of songs taken down from their own parishioners. There is, it is true, some contrary evidence from the creation of the Ballad Operas in the eighteenth century. There were several dozen of these, beginning with the most successful, *The Beggars' Opera*, in 1727. John Gay was responsible for the words and Johann Pepusch for the music, which is derived largely from English folk-songs. Pepusch, however, was not English himself, and it seems that Gay sang the tunes for Pepusch to write down. At least, therefore, Gay had heard the songs. But he had heard them with the ears of an educated townsman and (probably without conscious distortion) he denatured the tunes – put them in silk knee-breeches. In *English Folk Song – Some Conclusions* (pp. 113–14), Sharp quotes both the folk-song 'Constant Billy' and what it becomes in the opera, 'Cease your funning', with many changes – even a modulation to the dominant: the opera version belongs to a different world (though still a good tune). The example is characteristic; the Ballad Operas therefore give further proof of the divide, if not of its completeness.

It is not possible to give in one short chapter an adequate account of the range of songs we have inherited. A considerable number of them indeed are not in English but in Gaelic and its related languages. Social change has been in some ways slower in the Highlands and Islands of Scotland, in Wales and in Ireland, and the old songs are closer at hand. Many songs with a special haunting, haunted quality were taken down in the Hebrides by Mrs Kennedy-Fraser, but the tunes need their words and could only be discussed here with the help of translations. It is interesting that, not infrequently, the tunes are pentatonic – as is 'Auld Lang Syne', incidentally, though that is a Lowland song, with words by Burns. There is a wealth of Lowland songs with, of course, words in the English of the Lowlands, which is substantially different from southern English. (Not all revellers recognise 'auld lang syne' as referring to 'old' times that have 'long since' passed away.) Songs such as 'Leezie Lindsay', 'Jock o' Hazeldean', 'Robin Adair' and 'Ye Banks and Braes' are widely known and sung at ceilidhs (spontaneous or the reverse). The familiar words of these songs are often poems substituted for the original words in order to widen the popular appeal of the songs; of the four just mentioned, the words of the second are by Sir Walter Scott and of the last two by Burns. The ballad 'Barbara Ellen' begins 'In Scotland I was born and bred' and is often thought of as Scottish, but (as with many folk-songs) its currency in different versions was wide and it was recorded as far south as Somerset.

The Border Ballads are known for their energy and pathos; they reflect the troubled history of the region – for long one area, the Debatable Land, was given over to outlaws, since neither Scottish nor English law ran there. In 'The Twa Corbies', two carrion crows have spied a new-slain knight:

> 'Ye'll sit on his white hause bane,
> And I'll pike out his bonny blue een:
> Wi ae lock o' his gowden hair,
> We'll theek our nest when it grows bare.

> Mony a one for him makes mane,
> But nane sall ken where he is gane;
> O'er his white banes, when they are bare,
> The wind sall blow for evermair.'

Or there is this from further north – Dunfermline of course is beyond Edinburgh. A bride has to be fetched from Norway, but no-one would expect the king to wait for less perilous weather:

> The king sits in Dunfermline town,
> Drinking the blood-red wine;
> 'O whare will I get a skeely skipper
> To sail this new ship o' mine?' . . .
>
> O laith, laith were our gude Scots lords
> To wet their cork-heeled shoon;
> But lang or a' the play was played
> They wat their hats aboon.

The border Ballads call for at least a chapter to themselves; it seems best to refer the reader to the admirable book by James Reed, entitled simply *The Border Ballads*.

Some of the songs from the English counties concern the daily occupations of the singers, such as carting, ploughing, milking, lambing and shearing, and others are about familiar animals and birds – fox, goose, blackbird, nightingale; one set of words about the cuckoo has no less than three independent tunes, all of them memorable. A verse of one song runs:

> The lark in the morn she will rise up from her nest
> And mount into the air with the dew all on her breast;
> And like the pretty ploughboy she will whistle and will sing,
> And at night she will return to her own nest back again.

However, one would expect it to be the townsman rather than the country-man who sang of the delights of the countryside, and in fact another verse of the ploughboy song runs:

> 'I wish I were a scholar and could handle the pen,
> I would write to my lover and to all roving men.
> I would tell them of the grief and woe that attend on their lies,
> I would wish them have pity on the flower when it dies.'

Love is a more characteristic theme (we have already seen several examples), especially unhappy love. The theme may occur in dialogue songs, as in 'My man John' and 'Oh no John', both of which have an amusing twist; it occurs very differently in the many versions of 'Lord Rendall'. Many songs have a refrain, repeated with every verse; it may be just an evocative list, such as *Parsley, sage, rosemary and thyme*; it may occupy much of the verse as in:

> There was a woman and she was a widow,
> *Fair are the flowers in the valley,*
> With a daughter as fair as a fresh sunny meadow,
> *The red and the green and the yellow.*

> *The harp, the lute, the pipe, the flute, the cymbal,*
> *Gay goes the treble violin,*
> The dame so rare and the maid so fair,
> Together they dwelt in the valley.

(Knights clad in the three colours figure in the narrative.) One song starts
like this:

> Robin he married a wife in the West,
> *Moppety, moppety, mo-no,*
> And she turned out to be none of the best,
> *With a high jig-jigetty, tops and petticoats,*
> *Robin-a-Thrush cries mo-no.*

Capstan-shanties, such as 'Clear the track', noted down in London, would
help to co-ordinate the continuous pulling of a group of men, whereas
pulling-shanties like 'The dead horse' had accented notes for rhythmical
work. H.E. Hammond collected in England 'I will give my love an apple', a
riddling song that is obviously related to, and yet substantially different from,
'The riddle song' collected by Sharp in Kentucky. 'The moon shines bright',
a song from Warwickshire, is possibly influenced by outbreaks of the Plague,
or of violence:

> The life of man is but a span,
> It's like a morning flower;
> We're here today, tomorrow we are gone,
> We are dead within one hour.

If space permitted, the tunes also of the songs mentioned could be given,
and a great number of other songs could be quoted, all essentially different;
together they illustrate the freshness and variety of the national inheritance.

The tradition continued without a break from Plantagenet times or earlier
until the nineteenth century. Young people learned the old songs from their
elders, committing them to memory, and in due course themselves passing
them on. But the pace of social change was always increasing, and in the
nineteenth century in many parts of the country change became critical.
About the time of the railway-building mania, most of the singers, for
whatever immediate reason, ceased to sing their songs, of which some had a
large repertoire; they may have felt that the new age of steam was hostile to
them and their values. Music-hall songs and the like took over. Children
were no longer hearing the old songs and learning them; so, by the 1890s, the
songs existed in the memories of ageing people and nowhere else. The songs
would die with the people. We know how that disaster was averted.

The old singers, says Sharp, had accepted with quiet dignity the eclipse
and even scorn of their songs.

One old singer, once said to me, 'Our tunes be out o' vashion. They young volk come
a-zinging thicky comic songs, and I don't know they, and they won't hearken to my
old-vashioned zongs.' Imagine, then, their joy when the collector calls upon them and
tells them of his love for the old ditties. He has only to convince them of his sincerity
to have them at his mercy. They will sing to him in their old quavering voices until
they can sing no more; and, when he is gone, they will ransack their memories that

they may give him of their best, should, perchance, he call again, as he promised
One old woman once sang to me out in the open fields, where she was working, and
between the verses of her song she seized the lapel of my coat, and looked up into my
face with glistening eyes to say, 'Isn't it beautiful?'

It is the heartfelt comment without which the rest is dry history: 'Isn't it
beautiful?'

The Quiet Grave
(for Cecil Sharp)

Underground Rome waited solidly
In stone patience. Orpheus might lose
A beast or two, cracked apart by roots
Of brambled centuries, but still
Foundations lasted, knowing, like the princess,
That one day a ferret and a boy
Exploring a rabbithole would find an empire.

But this was a kingdom that lived

Some kinds of earth are reliable. The black
Peat of Somerset, and Norfolk mud
That tenderly cradled the deathship's spectral
Longrotted timbers. Some kinds of dryasdust
Air, too, responsibly cherish papyrus.

But this was a kingdom that lived
In the living air

Who held the keys of the kingdom?
Unfriendly old men in workhouses;
Bedridden ninety-year-olds terrorized
By highhanded grandchildren; gipsy women
With the long memories of the illiterate;
Old sailors who could sing only
Within sound of the sea. These
Held the keys of the kingdom.

Where was the kingdom?
The kingdom was everywhere. Under the noses
Of clerics devoted to folklore it lived
Invisibly, in gardens, in fields and kitchens,
In the servants' quarters. No one could find it
But those who were in it already.

When was the kingdom?
The kingdom was while women washed
And men broke stones. It was
Intervals in birdscaring; between
A cup too low and a cup
Too high; what a great-grandfather
Sang like a lark. Then
Was the kingdom.

Who cared for the kingdom?
An old woman gathering stones,
Who seized Sharp by his gentle-
Manly lapels, blowing her song into his mind
Through wrinkled gums. A surly chap
In Bridgwater Union, holding
Sharp's hand between his own grim bones,
Tears falling on all three. These
Cared for the kingdom.

What were the treasures of the kingdom?
Scraps of other worlds, prized
For their strangeness. A derrydown and a heyho,
And a rue dum day and a fol the diddle dee.
These were the treasures of the kingdom.

Who were the heirs of the kingdom?
The kingdom had no heirs, only
A younger generation that winked
At senility's music, and switched on the gramophone.

What was the end of the kingdom?
Massed choirs of the Federation
Of Women's Institutes filling
The Albert Hall; laconic
Improper poetry improved
For the benefit of schools;
Expansion of the Folk Song Industry. These
Were the end of the kingdom.

For this was a kingdom that lived
In the dying air

 Ursula Fanthorpe

Michael Rysbrack's monument to Sir Isaac Newton, in Westminster Abbey (1731).

3 The Visual Arts

DAVID MANNINGS

Introduction

When in 1753 William Hogarth's *Analysis of Beauty* appeared in the bookshops it drew a critical, mildly puzzled response from a reading public which was, if not totally unaccustomed to books about art, not over-provided with them and certainly not with books in English. True, there were practical treatises on how to paint and draw and there were a few compilations of 'Lives' along the lines of – and usually plagiarised from – Italian authors like Vasari, but there were very few serious books on painting or sculpture written from a critical standpoint. Furthermore, all earlier writers who addressed the British public shared one fundamental assumption – sometimes tacit, sometimes openly stated – which particularly irritated Hogarth. That was the *foreignness* of the visual arts.

The Renaissance had, after all, been an Italian not a British phenomenon. For Lord Burlington – architect, connoisseur and wealthy patron – art was still something to be imported from Italy. Since the time of James I, oil paintings and marble statues had been purchased abroad by the court and aristocracy, and praised by a learned élite – men who were often, like Franciscus Junius, author of *The Painting of the Ancients* (1638), foreigners themselves. The problem was therefore twofold: the wider public might be taught to appreciate art, but first it had to be convinced that art was something worth appreciating, or even taking seriously at all. The British had to be convinced that there was a place for art in *their* world, and that having produced a Shakespeare and a Milton they might also produce a Raphael or a Titian.

Even in Hogarth's time British artists were weakly dependent upon foreign styles and critics continually deferred to foreign standards. Sculpture was dominated by European-trained masters – Guelfi (brought to England by Burlington *c.* 1714), Rysbrack (arrived from Antwerp *c.* 1720), Roubiliac (from France *c.* 1732) and Scheemakers (finally settled here in the early 1730s) – and even in portrait painting, already in the eighteenth century considered a British speciality, the Frenchman J.B. van Loo was able to set

up in London in 1737 with little to fear from local competition. When in 1741 Hogarth painted the portrait of a man in a red coat which now hangs at Dulwich, he signed the back of the canvas with the words 'W. Hogarth Anglus', as a form of defiance.

Hogarth was the first British-born painter since the miniaturist Samuel Cooper (d. 1672) to produce a body of work that could be discussed in European, not just in British terms. He was also the first to escape from the restrictions of patronage, whereby artists were continually at the beck and call of some nobleman or other. By advertising his engravings in the press he was able to appeal straight to the public at large, including people of relatively modest means who could nevertheless spare a shilling or two for prints. His success in this respect was comparable to Pope's earlier achievement of financial independence through his translations of Homer. In 1735 Hogarth protected his interests and those of his fellow-artists by promoting a copyright act, and in the same year re-opened the St Martin's Lane Academy. This was not the first academy of art to be established in London but it was far and away the most important before the foundation of the Royal Academy in 1768. Hogarth's academy was distinguished by its practical, workmanlike approach. There were to be no presidents, no professors, no official Discourses, none of the 'foolish parade' (as Hogarth saw it) of the French. It was essentially a life class, where artists could learn to draw from the model – undoubtedly one of the weaknesses of British when compared to Italian or French art, as Hogarth must have realised.

Another weakness was the lack of any place where artists could show their work to the public. In 1740 Hogarth presented his portrait of Captain Coram to the Foundling Hospital and from 1746 he encouraged others to do likewise. As a result the elaborately panelled and plastered Court Room of that institution was hung with history pictures on appropriate themes like Hogarth's own *Moses before Pharaoh's daughter*. In addition, small circular views of London hospitals were dotted around the panelled walls, including a delicate study of the Charterhouse painted in 1748 by a virtually unknown young man called Thomas Gainsborough. The public was intrigued, and the Foundling Hospital became a place to visit and to see works of contemporary art, just as Hogarth intended. Not long afterwards, in April 1760, there opened in the Strand Great Room of the Society of Arts the first temporary public exhibition of work by living British artists, and the direct forerunner of the annual exhibitions of the Royal Academy.

Meanwhile, in the second quarter of the eighteenth century, a minor renaissance had taken place in British sculpture. It can best be described in terms of a response to two powerful forces coming from abroad: an increased awareness of Italy – ancient Rome, but also the baroque – and the arrival in London of a number of first-rate Flemish sculptors.

Isolated Italian influences had occurred here and there in the seventeenth century, especially on tombs, but the classical renaissance in eighteenth-century sculpture took place within a new frame of reference. In the early years of the century the English upper classes were more and more encouraged – for example by writers like Addison – to see themselves as emulating, in the struggle against Popery at home and French tyranny

abroad, the virtues of Republican Rome. By the 1720s Roman costume –
cloak, body armour and buskins – was more or less *de rigueur* for whole-
length figures on tombs and there was an increased demand for classical-style
busts to decorate houses which were themselves designed now according to
the principles of Palladio. Montfaucon's encyclopedic *Antiquité Expliquée*,
published 1719 and translated into English by 1721, provided artists and
patrons with a mine of information about the ancient world. Illustrated with
hundreds of engravings – costume, armour, furniture, tombs – it proved to be
a veritable quarry for sculptors.

Patrons, too, were generally better informed. The Grand Tour was more
popular now than ever and young gentlemen and their guides could avail
themselves of a new publication by the two Richardsons, father and son,
entitled *An Account of the Statues, Bas-Reliefs, Drawings and Pictures in Italy,
France, etc.* (1722), which quickly became a standard guide book telling them
what to look out for. Nor did the enthusiasm of the Grand Tourist
necessarily stop at merely seeing the treasures of Italy. He had no qualms
about shipping as much as he could afford back home. The galleries and
corridors of Castle Howard, Holkham, Houghton, Newby and Petworth are
lined with classical sculpture – some genuine, much of it heavily restored,
some pieces outright fakes – just as the picture-galleries were (and
occasionally still are) filled with Renaissance paintings. All of which testifies
to a tremendous boom in collecting in this period.

Roman baroque sculpture, particularly the design of tombs, was another
source of inspiration. The sculptor Francis Bird made at least two trips to
Italy, studying in Rome under the Frenchman Pierre Legros whose work in
the Jesuit church of Santo Ignazio evidences a dazzling and refined stylishness,
while the Scottish architect James Gibbs, who had also studied in Rome – in
fact in the studio of one of Bernini's pupils, Carlo Fontana – included a
number of distinctly Italianate designs for monuments in his best-selling
Book of Architecture (1728). William Kent, too, designed tombs – among his
many accomplishments.

Since the eighteenth century – and even during their own lifetimes – the
critical fortunes of many of the artists with whom we are concerned in this
Guide have shifted. This is bound to happen in the light of wider changes in
taste, but a special plea must be made for the sculptors. Although the skills
of masters like Rysbrack and Roubiliac have always been acknowledged, they
and almost all their fellow-sculptors have been consistently neglected in the
literature. As a result, some of the most distinguished artists and craftsmen of
the period remain largely unknown and unappreciated.

With painters the situation is rather more complicated. Hogarth, the major
figure before the rise of Reynolds, was too down-to-earth for the Victorians
and in the eyes of early twentieth-century critics lacked 'significant form'. It
was not until after World War II that his reputation was re-established on a
secure basis, notably in Frederick Antal's pioneering (and very perceptive)
study which placed him for the first time firmly into the mainstream of
European art. But no artist has seen his star rise more remarkably than
Joseph Wright of Derby. 'The neglect of Wright', says Joseph Burke in his
volume of the *Oxford History of English Art*, 'is the most serious charge that

can be levelled against the Academy under the Presidency of Reynolds'.

The reason for that neglect had nothing to do with Wright's talent as a painter which, like Stubbs's talent for painting horses, was universally acknowledged; it had everything to do with the subjects he chose to paint ('candlelights') and the artistic models he followed (Schalcken, Honthorst). Wright, dismissed by Fuseli as totally lacking in any sense of 'heroic or poetic form', was finally recognised as a major British painter as recently as 1968, in Benedict Nicolson's comprehensive monograph.

The age of Hogarth

William Hogarth (1697–1764) began as a decorative engraver on silver plate, a career he soon abandoned because it was, by his own later account, too tedious and restrictive. Around 1720 he set up in business as an independent printseller and engraver of bookplates, tickets, and shop-cards. His earliest oils were conversation pieces and he began to produce them about 1728.

The Beggar's Opera

Hogarth, a keen theatregoer, found his feet as a painter when the success of John Gay's *The Beggar's Opera* (1728) inspired him to paint what we would now call a theatrical conversation piece. He chose the crucial scene (Act III, scene 2) in which the highwayman Macheath stands in chains in the centre of the stage flanked – like 'Hercules at the Crossroads', an old subject for painters which was obviously well known to Hogarth – by his two 'wives'. Beside Lucy Lockit stands her father the gaoler, whom she implores on her knees to save her beloved, while Polly Peachum similarly begs her father, the informer or 'thief-taker'. Hogarth has already discovered three important principles on which he would subsequently build the success of his narrative art: first, the importance for a picture of choosing the moment of greatest psychological tension; second, the enormous potential offered by the stage, both as a model or mirror of human action, and for the gestures and facial expressions of actors; third, the technique of visual parody as an equivalent to the sort of literary parody employed by his older contemporaries Swift, Pope and Gay.

In fact Hogarth, after making preliminary chalk sketches on paper, explored this motif through no fewer than six oil paintings, all variations on that same affecting scene. The first was bought by – perhaps directly commissioned by – John Rich, the player-manager at whose Lincoln's Inn Fields theatre *The Beggar's Opera* had been performed. Rich then asked Hogarth to paint another, larger version which is dated 1729. It includes another device that Hogarth exploited in the first of his 'comic histories' *A Harlot's Progress* (1732), namely the introduction of recognisable people who were 'in the news'. The actress Lavinia Fenton, playing Polly, looks away from her stage lover Macheath, and past her stage father Peachum, to the figure of the Duke of Bolton – seated in his box at the side of the stage – with whom she was currently having a real-life love affair. Similarly in the

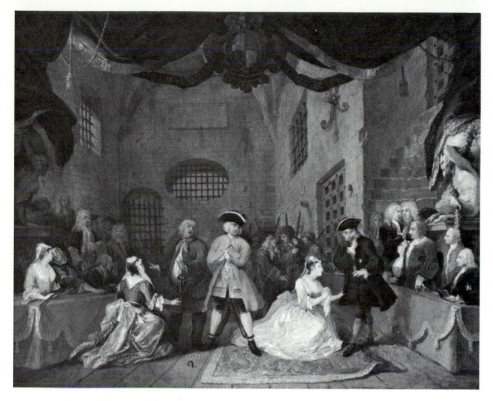

William Hogarth, The Beggar's Opera *(1728)*.

first plate of *A Harlot's Progress* Hogarth introduced the portraits of Mother Needham the procuress and Colonel Charteris, a notorious rapist whose misdeeds provided excellent copy for the newspapers of the day.

Conversation pieces

The special type of small-scale portrait group known as a 'conversation' – which has seemed to some collectors the most characteristic of all forms of early eighteenth-century British painting and is represented so well in the Yale Center for British Art – was not invented by Hogarth. The credit for that must go to the French Huguenot Philip Mercier (1689–1760), an imitator of Watteau, who came to England around 1719 and whose earliest conversations date from 1725–6. The loose, apparently casual arrangement of figures, the paint applied freely with small touches of delicate, rather pretty colours, and the preference for outdoor terrace or garden settings – these features were all inherited directly from Watteau. Hogarth's little picture of the Woodes Rogers family of 1729 (in the National Maritime Museum at Greenwich) shows his early assimilation of all these elements. However, to this French style he added a robust realism and a liking for richly furnished interiors which has obvious Dutch roots, and it is clear that he had looked admiringly at artists like Metsu and Netscher.

These early conversation pieces almost always employ some small dramatic incident to fix the beholder's interest: a gentleman draws a lady's attention to a horse, a child holds up a fishing rod, a seated matron pours tea, a servant holds up a framed picture for the approving gaze of the adults. Compositional arrangements tend, however, to be very slack. There is a tendency to fill up the spaces with various members of the family with their heads turned this way and that, each separately posed and carefully painted, and one feels that one or two figures added or removed would not impair the effectiveness of the grouping. An extreme case is Hogarth's *Assembly at Wanstead House*, painted 1730–1, in which more than twenty figures are more or less equally spaced across the great salon at Wanstead, Lord Castlemaine's Palladian mansion in Essex. The effect is not unlike a school photograph.

The comic histories

If the conversation piece, at least in its eighteenth-century form, was invented by Mercier, 'comic history painting' (the phrase was coined by Fielding by a kind of analogy with his own 'comic epic' novels) was certainly the invention of Hogarth, and he was right to claim as much in his later autobiographical notes. Of course nothing is entirely new, least of all in eighteenth-century art which drew continually on the wealth of the Renaissance and baroque tradition. The downfall of rakes and prostitutes had long been a popular subject in Italian prints, issued in sets not unlike Hogarth's. The fundamental notion that pictures could function rather like literary texts, as stories to be 'read', is rooted in the long tradition of religious frescoes; stories from the lives of Christ and his saints ranged round the walls of churches or pictured in small predella panels on altarpieces.

Neither tradition was alive in Hogarth's England, but the basic conventions had long ago passed into the mainstream of European painting to be refined and enriched by a succession of great masters who were very well known to Hogarth and his fellow-artists, as well as to the connoisseurs whom he so despised. Raphael, Rubens, Poussin and Le Brun, as well as Dürer and the Dutch genre painters of the seventeenth century, all contributed to the making of Hogarth's comic histories. Time and again he borrowed and adapted poses and compositional arrangements from this living tradition. And like the religious and mythological pictures Hogarth admired, the comic histories were intended to work on more than one level. Again literary precedents can be cited, for levels of interpretation were a standard topic of discussion among early eighteenth-century literary critics; Addison, for instance, in an essay on Milton (*Spectator* No. 315, 1712) pondered the relationship between the 'plain literal sense' of a text and its 'hidden meaning'. In a sentence that can equally well be applied (as Ronald Paulson indicated) to Hogarth's pictures, Addison wrote that a story 'should be such as an ordinary reader may acquiesce in, whatever natural, moral, or political truth may be discovered in it by men of greater penetration'.

In a famous series entitled *A Harlot's Progress*, published in April 1732 in the form of six prints engraved by himself, Hogarth initiated the sequence of 'modern moral subjects' (his own phrase, this time) on which his fame has

always most securely rested. It was followed in 1735 by *A Rake's Progress* and several other series were to come, satirising for instance the conduct of elections, or displaying the contrasted fortunes of the idle and the industrious apprentice. These subjects he considered 'as writers do', defining his picture as a stage on which his actors 'were by means of certain actions and expressions to exhibit a dumb show':

I wish to compose pictures on canvas, similar to representations on the stage; and farther hope that they will be tried by the same test and criticized by the same criterion.

The finest of all these comic histories, from the point of view of painterly technique and in terms of subtlety of content, is *Marriage à la Mode*. The six pictures were engraved not by Hogarth himself but, more expertly, by French craftsmen, and were published in June 1745. They tell the story of an arranged marriage, a sordid contract between cynical fathers who, careless of the happiness or the virtue of their offspring, are prepared to barter young lives in exchange for money (in the case of the earl), and (for the merchant) the enhanced social status such an alliance would be expected to bring.

The first scene, 'The Marriage Settlement' reminds us straightaway of the conversation pieces Hogarth had painted earlier in his career. Here are two families in an interior, linked by an incident of domestic life. But instead of innocence and harmony we find ominous signs of discord and portents of

William Hogarth, Marriage à la Mode: The Contract *(1745)*.

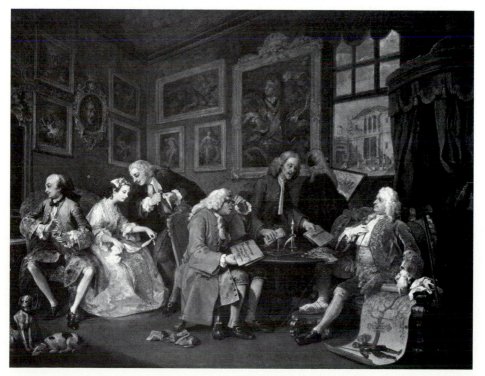

doom. The young couple pay no attention to one another. The viscount admires his own reflection in a mirror, and his bride-to-be is already listening to the seductive tones of Counsellor Silvertongue, while the pictures on the wall above their heads – violent martyrdoms and scenes of torture flanking the head of Medusa – shriek out their warning. The earl's bandaged foot, so prominently displayed, introduces the motif of disease which, as a metaphor for spiritual sickness, runs through subsequent scenes, most notably in the third scene where the viscount takes his very young mistress to consult a quack-doctor about her (and probably his) venereal disease. In the penultimate scene the earl (by this time he has succeeded his father) dies, a wound in the side pouring blood, in an attitude reminiscent of Christ taken down from the cross, a gross parody but also a reference back to the scenes of martyrdom hanging on the wall in the first picture.

As always, Hogarth drew freely and creatively on the stock of Old Master painting, but he also drew on contemporary art, especially on the theatre. With its closed, at times claustrophobic 'stage-setting', the histrionic gestures and facial expressions of the actors and actresses – for instance the steward who 'exits left' in the second scene, 'Shortly after the Marriage', and the melodramatic deaths in the final two scenes – *Marriage à la Mode* perfectly fulfils Hogarth's stated aim 'to compose pictures on canvas, similar to representations on the stage'.

The penultimate scene, 'The Death of the Earl', is worth looking at more closely. Here the husband surprises the lovers in a *bagnio* (as such houses, where couples could hire a room for secret assignations like this, were euphemistically called) and forces a duel in which he is mortally wounded. Apart from anything else, the picture is one of the richest night-pieces of its time, a study in light and shade which looks back to the religious dramas of Caravaggio and forward (just twenty years) to the early candlelight studies of Joseph Wright of Derby. In Caravaggio's pictures light from an unknown source probes the darkness, a symbol of spiritual enlightenment as in *The Calling of Matthew*, or *The Conversion of Saul*. In Hogarth's picture the light sources are obvious (fire, candle, lantern) and very earthbound. The low-placed firelight – very suggestive of the footlights that were being introduced by Garrick to the London theatre at just this time – illuminates the kneeling figure of the horrified and guilt-stricken countess and may well signal her moment of truth, but too late: the earl is tottering to his death, and the men who burst through the door bearing a lantern (the second source of light) will bring doom to her lover, who will be hanged and thereby precipitate her own suicide. The momentary quality of the whole representation, indicated by the earl's sword, suspended in mid-air, is further emphasised by the third source of light – the candle, its flame blown sideways by the sudden draft from the window through which Silvertongue attempts his escape.

Again and again Hogarth, the first British artist thus to paint a split-second, shows in his pictures an acute awareness of exact time. This has been called a fundamental characteristic of the rococo, that flimsy and decorative style which was so fashionable in the 1740s, and Hogarth is to some degree at least a rococo painter. But we can go further, for Hogarth's career spanned the period when clocks and watches, formerly clumsy and inaccurate devices,

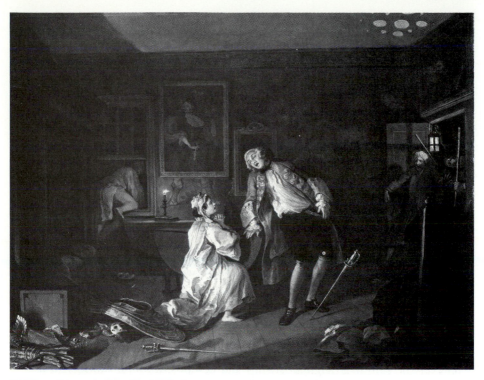

William Hogarth, Marriage à la Mode: The Death of the Earl *(1745).*

became very reliable indeed, as the superb timepieces made by John Harrison for Captain Cook's voyages testify. Clocks are featured in many of Hogarth's pictures, most prominently in *The Graham Children* (1742) and in *The Lady's Last Stake* (1758–9, Albright-Knox Art Gallery, Buffalo, New York). Here the clock on the mantelpiece, a splendid rococo confection topped by a tiny gilt figure of Cupid with a scythe, and bearing the inscription NUNC NUNC, underlines the fact that for the lady time is indeed running out.

Character and caricature

In the preface to his novel *Joseph Andrews* (1742) Fielding tried to define Hogarth's art in a way that distanced it from what 'the Italians call *caricatura*', the aim of which was 'to exhibit monsters, not men, and all distortions and exaggerations whatever are within its proper province'. Hogarth was himself concerned to make this distinction. When customers came to his studio to put down their money for a set of prints, they were given a receipt in the form of a subscription ticket, illustrated with a design by the artist. The subscription ticket issued in April 1743 for *Marriage à la Mode* was entitled *Characters and Caricaturas,* and represents a crowd of men's faces, full of variety and all observed, like the faces in the comic histories, from daily life. Contrasted with these character-heads are examples of caricature taken from Leonardo da Vinci, Annibale Carracci and Pier

Leone Ghezzi, as well as examples of idealised heads taken from the Raphael Cartoons. My art, Hogarth is saying, does not belong with either of these two extremes.

But the whole-hearted pursuit of extremes led, in other hands, to the creation of one of the most popular and powerful art-forms of the century. Caricature, both personal and political, flourished and reached a kind of high-water mark in the hands of artists like James Gillray (1756–1815) and Thomas Rowlandson (1756–1827). It was an art based on disrespect for persons. The caricaturist refuses to doff the cap to anyone, whatever high status he or she (Queen Charlotte was not the only lady to be ruthlessly satirised) might claim to possess; he mocks the pretensions of politicians, lawyers and the professions generally; he ridicules all ideals, however high or worthy some people might think them. And in pursuit of this end he uses any ammunition that comes to hand. In the Augustan age emblems, which had been so popular in the seventeenth century, anti-papal imagery dating from the sixteenth century, such as the reversible head, and even older images like the mouth of Hell, or the fool's cap and bells, were still found to be serviceable. Thus eighteenth-century caricaturists drew upon a stock of signs, all the more useful for being familiar and easily understood. Sophisticated critics might deplore their dull and hackneyed familiarity, but they were not intended – or not originally and primarily intended – to be admired by connoisseurs. A print by Gillray or by James Sayers (1748–1825) has, whatever the skill in draughtsmanship and composition, the subtlety of a punch on the nose, or of the cudgels that are wielded by the bruisers in Hogarth's *Chairing the Member* (Sir John Soane's Museum).

Nor can Hogarth, in spite of his protests, be excluded from the history of caricature in England. On the contrary, he played a formative part in its early development. Among his first published works were two emblematical prints on the subject of the South Sea Bubble (1720), and among the rich gallery of human types that throng the comic histories and occasional prints (*Gin Lane* and *Beer Street* spring to mind) are figures of archetypal significance – corrupt lawyers, quacks, whores, skinny Frenchmen and plump, beer-swigging locals – eagerly snatched up by the caricaturists who followed him.

The long years of the Whig Supremacy were reflected in a surge of political caricature, especially in the 1740s. As Richard Godfrey stresses in his introduction to the exhibition catalogue, *English Caricature: 1620 to the Present* (1984), the imagery could be 'gross and scatalogical':

Ministers of the Crown defecate, vomit up their ill-gotten gains, disperse their enemies by monstrous farts, and grovel for money like hungry mongrels.

Not surprisingly, many prints of this kind were anonymous. They were personal as well as political satires; the same public figures who sat proudly for Reynolds and Gainsborough to be represented so elegantly on canvas were derided in the work of the satirists. Any slight physical defect was exaggerated, and even features which were not defects were enlarged to ridiculous proportions. The results were indeed 'monsters' as Fielding described them.

Although the roots of personal satire go back centuries (as indicated in Hogarth's *Characters and Caricaturas*) the art was really launched in England during the years 1736–42 when Arthur Pond (1701–58) published a series of 26 engravings after Italian caricatures, including 12 after Pier Leone Ghezzi, an artist based in Rome. Then in the mid-1750s caricature was adopted as a weapon by a highly gifted amateur, Colonel George (afterwards first Marquis) Townshend (1724–1807), in his personal war against the Duke of Cumberland and his supporters. Horace Walpole noted that Townshend – an officer who had served under Cumberland – adorned 'the shutters, walls, and napkins of every tavern in Pall Mall with caricatures of the Duke and Sir George Lyttelton, the Duke of Newcastle and Mr Fox', and that he issued some of these in the form of small etchings on pasteboard cards, about two-and-a-half by four inches – 'a new species of manufacture' as Walpole noted. These were rather like modern postcards and could indeed be sent through the post.

Townshend's most successful work, published in April 1757, was an etching coloured by a technique using woodblocks, entitled *The Recruiting Serjeant or Britannia's Happy Prospect*. This print, in which we see ridiculed the efforts of Henry Fox to form (or 'recruit') a government to replace Pitt's ministry, is a key work in the transformation of the older type of emblematical print into a new form of caricature. Very significant is the representation of Henry Fox with a fox's head – not just a visual pun but also a symbol of craftiness – for animal imagery of this sort was to play a big part in the enormous proliferation of personal satire that was to follow in the second half of the eighteenth century.

Later caricaturists would represent Boswell as a monkey, Dr Johnson as a bear, Hogarth (partly his own fault, this) as a pug, Lord North as an elephant, the Duke of Cumberland as an ox, and the Duke of Newcastle as a goose, or sometimes an ass. Not that the force of such satires depended always upon specific reference being made to individuals. The whole swarm of greedy government ministers could be most tellingly represented (in an anonymous print of 1748) as locusts stripping the nation's resources.

An alternative source of animal imagery – which was by no means limited to graphic satire – was the long tradition of heraldry, with its lions, unicorns and other creatures. On the gate-piers at Blenheim Grinling Gibbons (1648–1721) sculpted the British lion mauling the French cock in allusion to the Duke of Marlborough's victories. The image was reversed in certain prints attacking Walpole's foreign policy, in which the cock crows on the back of a sleeping lion. An even older tradition underlies the wriggling medieval dragon of Envy crushed beneath the sarcophagus on Marlborough's tomb.

In spite of Hogarth's protestations, it is difficult to draw a firm distinction between caricature and the sort of character-study on which so much of his own art was based. One can point to numerous caricatured figures in his own paintings and prints, none more memorable than the fat friar in *The Gate of Calais, O the Roast Beef of Old England* (Tate Gallery), said to be a likeness of his friend, John Pine, the engraver. On the other hand, Hogarth's satire, if occasionally personal and always moralising, is very rarely political. After the

success of *A Rake's Progress* he was, according to Dr Johnson's biographer Sir John Hawkins,

(pressed) by the Patriots in Opposition to Sir Robert Walpole to design a series of prints, to be intitled *The Statesman's Progress*, but he, scorning to prostitute his art to the purposes of faction, rejected their offer.

No such qualms affected the generation of caricaturists who came to maturity after Hogarth's death and flourished in the 1770s and 1780s. Not only were they employed to serve the purposes of faction but they were quite happy to change sides in tune with their sponsors. The greatest of them all, James Gillray, evidenced in Diana Donald's words 'a profound cynicism and moral pessimism' in his work. The impeachment of Warren Hastings, after his return from India in 1784, precipitated a deluge of caricatures; Gillray's were the best.

The Political Banditti assailing the Saviour of India, published in May 1786 at a time when charges were being drawn up, represents Hastings in a kind of oriental costume riding a camel and attacked by three 'banditti', clearly identifiable as Burke, North and Charles James Fox. This print has been described as pro-Hastings, but arguably he is represented as only slightly less ridiculous than his assailants. He defends himself with a 'Shield of Honour', but his camel is laden with bulging money-bags, the profits, or rather the plunder, of the East India Company and a clear allusion to the enormous personal fortune he had acquired. Gillray's skill is shown in the clarity of the

James Gillray, The Political Banditti Assailing the Saviour of India *(1786).*

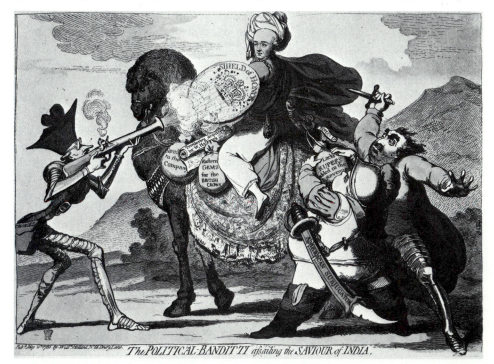

design, in which the skinny figure of Burke in his Jesuit's cap, firing his blunderbuss, is silhouetted – 'like a malignant insect or a burlesqued Don Quixote', as Dorothy George describes him – alone at the left of the composition, confronting the solid mass formed by Hastings on his camel together with the rotund persons of Fox and North.

In abstract terms this is one of Gillray's more 'classical' constructions; on other occasions he could exaggerate the features of his subjects to create monstrous visions that look forward to Goya's *Caprichos* or to the 'Sublime' and Romantic imagery of artists like Fuseli and James Barry. An example is the gigantic bespectacled nose, all we see of Burke as he pounces, in *Smelling out a Rat* (1790), on Dr Richard Price, who had published a sermon in praise of the French Revolution.

Reason and feeling in Augustan sculpture

Of the Flemish immigrants who revitalised sculpture in Britain the most important were Michael Rysbrack (1694–1770) and Peter Scheemakers (1691–1781). Not only were they technically superior to their British rivals but they were able, because of their background and training, to draw imaginatively on the rich resources of the European – specifically Flemish – baroque, and to combine this with Italianate classicism in a way that occasionally (at least in Rysbrack's case) invites comparison with Rubens himself.

Rysbrack: the Marlborough tomb

Arriving in England about 1720, apparently with an introduction to James Gibbs, Rysbrack was soon working for one of the wealthiest and most powerful families in the land, that of the Duke of Marlborough. He seems also to have established very early links with the Burlington circle, especially William Kent (1685–1748), a group very much disliked by Hogarth. The Duke of Marlborough died in 1722 and, in a move that exactly reflected the ascendancy of the new Palladian over the old baroque taste, William Kent was called in to replace Hawksmoor as the designer of his monument in the chapel at Blenheim. Rysbrack was the sculptor, and the elaborate result bears the date 1733. It will be worth looking at in detail for there is no better example of the taste of the time.

The Marlborough tomb is typical of its period – of the 1720s and 1730s – in its tasteful avoidance of any excessively dramatic or emotional content. Unlike the later tombs of Roubiliac, it presents the spectator with no grisly reminders of mortality, no skulls or hourglasses, nor does it carry – as many seventeenth-century tombs had carried – any trace of Christian imagery, no reference to Judgment or to the expectation of a future life. Nor does it, in fact, record the sorrow of those left behind; here are no weeping children, no inconsolable widow. Instead, the relief on the base represents, like a famous tapestry in the palace itself, the surrender of Tallard, and the winged figures are Fame, with his trumpet, and History, writing an inscription on a curly-

Tomb of the duke of Marlborough in the Chapel at Blenheim Palace; designed by William Kent and sculpted by Michael Rysbrack (1733).

framed marble plaque. Unlike the allegorical figures who feature on some later tombs, neither is shown in the actual performance of what is clearly a symbolic act; each turns his head away – the trumpet has sounded, the inscription is complete. Again, this imparts no specifically Christian sentiment, merely recording the fact that the monument was erected by Duchess Sarah to the memory of the Duke and his two sons (both of whom died young). An alternative inscription, never used, announced more tendentiously that the Duke 'who so often Conquered the enemies of his Country, . . . hath conquered his last enemy, Envy.' And we do indeed see the spiky dragon of Envy crushed under the weight of the sarcophagus.

All these elements were conventional, stock-in-trade; more interesting is the upper half of the monument. Instead of the single figure envisaged in the rejected design that had been made by Hawksmoor, we find a family group – an enlarged conversation piece we are tempted to call it – with over-lifesize figures of the Duke himself (in Roman costume), the Duchess and their two sons. Husbands and wives do occur from time to time on early eighteenth-century tombs, and Rysbrack went on to carve a more lively and successful group of father, mother and baby on the Harborough monument at Stapleford, Leicestershire, during that same decade. But the rather loose composition of the Marlborough family and the detachment of the heir who looks away should not be criticised as incompetence of design; such elements are normal in painted groups, a point especially well demonstrated at Blenheim in John Closterman's large portrait of the same family. The contrast between the private or domestic function of painted portraits and the public or commemorative function of tomb sculpture is suggested by the fact that Closterman included Marlborough's four daughters in his picture, females who are nowhere mentioned, let alone represented, on their father's monument.

On 24 May 1732 the Duchess of Marlborough wrote to Sir Phillip Yorke to say that the chapel was finished, and

more than half the Tomb there ready to set up all in Marble Decorations of Figures, Trophies, Medals with their inscriptions and in short everything that could do the Duke of Marlborough Honour and Justice.

Roubiliac's tombs in Westminster Abbey

Soon afterwards Louis François Roubiliac (?1705–62), described by Margaret Whinney as 'probably the most accomplished sculptor ever to work in England', arrived in London. Our first record of him in London concerns his marriage in 1735 to a Huguenot lady, Catherine Hélot, and he must have become acquainted fairly quickly – the London art-world was small – with the Hogarth–Hayman–Gravelot circle, as we find him working for Jonathan Tyers (see the chapter on Vauxhall) and by 1745 he was attending the St Martin's Lane Academy. Roubiliac was not Flemish; he was born in Lyons and had studied under the German baroque master Permoser. What is certain is that he was able, by virtue of this particular background and training, to introduce to British sculpture a vitality unknown to Rysbrack.

The chief difference between the tombs of the 1720s and 1730s – especially those by Guelfi, Scheemakers and Rysbrack – and those of the two following decades (notably those by Roubiliac) is a change in religious feeling. Sir Isaac Newton, reclining on his tomb in Westminster Abbey propped up against a pile of massively bound volumes (another work designed by Kent, carved by Rysbrack, *c.* 1730), has much in common with the Duke of Marlborough on his tomb at Blenheim. Both wear classical, not eighteenth-century, dress; neither shows any particular emotion beyond that tasteful stoic dignity recommended by such influential writers as Lord Shaftesbury. By contrast, a number of important tombs designed in the 1740s include a new emphasis on human emotions and a return to the traditional iconography of death. While

Louis François Roubiliac, monument to General William Hargrave in Westminster Abbey (1757).

the spectator standing before the Newton monument is inspired with admiration for the great man's intellectual achievements (the books), and at the same time recognises his affinity with ancient philosophers (the reclining figure derived ultimately from Etruscan tombs, as illustrated in Montfaucon), the Hargrave and Nightingale monuments by Roubiliac, erected in Westminster Abbey in 1757 and 1759, respectively, make an entirely different impression.

General William Hargrave is represented flinging aside his shroud and emerging from his tomb as the angel sounds the last trump. We see a great pyramid – like the one against which the Marlboroughs posed on their monument at Blenheim – disintegrating behind him. The pyramid symbolises the world: created matter, earthly glory, and time itself conceived (as an eighteenth-century philosopher might say) as the measurement of change. From this instant there can be no change, for Hargrave is shown passing from earthly decay to eternal bliss, to the realm of pure spirituality. The winged and bearded figure of Time is represented breaking his scythe, as he will have no further use for it, and Death, in the traditional form of a skeleton, tumbles headlong, his crown falling from his head. Whereas Marlborough and Newton typify the portrait-like representation of great men on the tombs of the 1720s and 1730s, the ecstatic Hargrave does not pose for his picture – he is caught up in the greatest moment in history and there will be no one to stand and admire him then. Thus, for the tomb of a most wretched sinner (Hargrave made a fortune at the expense of his soldiers and of the taxpayer) the Christian motif of the Resurrection made a spectacular return to British monumental sculpture.

If the theme of the Hargrave tomb is the attainment of eternal bliss, the Nightingale monument seems, at first glance, to represent the Triumph of Death. Lady Elizabeth Nightingale had died many years earlier having suffered a miscarriage (deaths associated with childbirth were of course common, and were commemorated frequently enough on tombs well into the nineteenth century). Roubiliac shows her at the moment when her husband tries to ward off the spear of Death who emerges, a shrouded skeleton, from a massive iron door below. The arrangement of the three figures is simple and effective; everything is focused on the crucial moment of the drama, and one is reminded of the *Death of the Earl* in Hogarth's picture already discussed.

If we refer back once more to the Newton and Marlborough tombs, we can see that in that period the figures of the deceased were not normally represented at any particular moment in their lives, and the timelessness was emphasised by the frequent – almost universal – use of classical dress. In both the Hargrave and Nightingale monuments we are confronted with (as in Hogarth's pictures) a split second. The theme of the Nightingale monument is not, however, one of despair. As David Bindman has pointed out, Death 'is seen as a deliverer whose brief triumph will only serve to bring the devoted couple nearer to their eternal union'. The true message of this brilliant work is therefore consolation, a truly Christian theme recognised and admired, in both this and the Hargrave monument, by John Wesley. Death is inevitable and those left behind will weep, but Christians know that death is not the end but the gateway to eternal life.

Louis François Roubiliac, monument to Lady Elizabeth Nightingale in Westminster Abbey (1759).

Busts

Rysbrack's status as a master of what historians have called 'baroque classicism' is nowhere better evidenced than in his busts. Although he had never been to Rome, he was able to absorb the classicising currents of the early 1720s that were embodied for instance in the architecture of the early Palladians, especially William Kent. A fine work carved as early as 1723 is the marble bust of Daniel Finch, Earl of Nottingham, with its short 'Roman' hair, its loose drapery arranged in broad, simplified folds to give the effect of a classical toga, and above all the strongly-characterised face, obviously intended to remind the spectator of those noble Romans – farmers and landowners and opponents of tyranny – in whose likeness the English were increasingly seeing their own reflection. 'No nation under Heaven', wrote Jonathan Richardson in an oft-quoted passage

. . . so nearly resembles the ancient Greeks and Romans than we. There is a haughty courage, an elevation of thought, a greatness of taste, a love of liberty, a simplicity, and honesty amongst us, which we inherit from our ancestors, and which belongs to us as Englishmen; and it is in these this resemblance consists.

To what extent Rysbrack's bust is a true likeness of the earl himself as he might have appeared in everyday life it is impossible to say, but that was in any case less important than the presentation of a selected *persona*. No better

illustration could be found of the embodiment of the litany of virtues given by Richardson than this.

Portrait busts like that of Lord Nottingham might decorate almost any of the public rooms of a fine house; when it came to the library, however, special considerations applied. Of course, likenesses – or supposed likenesses – of classical philosophers, poets, and orators were very suitable, as they had been on the European continent since the Renaissance, but a new demand now arose for sets of 'British Worthies'. And so, alongside the portrait busts of contemporaries, Rysbrack was called upon to produce likenesses of Queen Elizabeth, Milton, Shakespeare, Spenser, Ben Jonson, Francis Bacon, Newton, John Locke and Oliver Cromwell. At Stowe a set of these decorates William Kent's Temple of British Worthies, and in countless libraries they, or the more 'literary' among them, took their place alongside Aristotle, Cicero and Marcus Aurelius. Rysbrack's marbles were of course fairly expensive, and many gentlemen were happy to settle for the plaster replicas of classical busts turned out in great numbers by the workshops of artists like John Cheere.

The baroque alternative to the strictly classical bust is demonstrated most brilliantly in the work of Roubiliac, but before looking at the portrait he made around 1741 of his friend Hogarth it is interesting to return to Westminster Abbey, to the south transept, to look at its immediate precursor. This is the bust of Matthew Prior, who had been British ambassador in Paris, carved about 1700 by one of Louis XIV's team of sculptors, Antoine Coysevox. It is more than a precursor, it is an almost inevitable source of inspiration, for, from the time it was set up in 1721 for about twenty years, this was the only example of its type – that is, the only *informal* bust – permanently displayed in an accessible and public place. The bust of Prior, incorporated into a baroque tomb designed by James Gibbs and executed in 1723 by Rysbrack, employs what is in fact an ancient Roman device of turning the subject's head away, as if responding to a third person (not, in other words, to the beholder). This gives a lively sense of communication which was taken up by sculptors – and, incidentally, by painters – from about 1740 onwards, and is very well demonstrated in Roubiliac's bust of Hogarth.

The clay model for this bust was seen by George Vertue in 1741 and he described it as 'very like'. It certainly conforms to our expectations of how this peppery little man must have looked. Like the bust of Prior, it represents the sitter *en négligé* with loosely-fitting folded cap and shirt open at the neck, turning his head sharply as if (we imagine) challenging a statement that someone has made or, with slightly furrowed brow and parted lips, listening to a discussion. The suggestion that the subject is not alone, not viewed in isolation, distinguishes portraits like this from the normal type of classical bust – the static image of inner concentration, appropriate to a poet or philosopher. As a mode of presentation Roubiliac's *Hogarth* has something in common with the more animated type of painted conversation piece, in which individuals engage in polite social exchange, but it has at the same time a forceful sense of the individual's alert and active presence which goes beyond the scope of any such comparison.

Subject pictures

Religious and classical subject-matter: Thornhill, Hayman and Hamilton

The example of Sir James Thornhill (1675/6–1734) inspired British painters who dreamed of escaping from the drudgery of 'face-painting'. His baroque ceilings at Greenwich (1708–11) representing William and Mary bringing Peace and Liberty to Europe were the Hanoverian answer to Rubens's glorification of the Stuarts on the Whitehall ceiling seventy years earlier. The educated and travelled Thornhill, a director of Kneller's Academy in 1711, Serjeant Painter to the King in 1720 – the year he was knighted – demonstrated the possibility of political allegory and religious narrative in what Gainsborough was later to call this land of roast beef.

Among the few British-born artists who followed in Thornhill's footsteps, Hogarth's friend Francis Hayman (*c.* 1708–76) was the most important: 'unquestionably the best historical painter in the kingdom', according to Edward Edwards, writing at the beginning of the nineteenth century, 'before the arrival of Cipriani'. Unfortunately very little of Hayman's work in this vein survives. His reputation now rests largely upon his numerous conversation pieces and portraits-in-little. He was exceedingly prolific. In the 1740s he decorated the supper-boxes in Vauxhall Gardens (see Chapter 6); during the same decade he contributed the *Finding of Moses* to the Foundling Hospital, and he painted a number of ceilings and a full-size altarpiece representing *The Good Samaritan*, which is now at the Yale Center for British Art. A black-and-white chalk drawing in the Royal Academy of a nude man is of particular interest in this connexion. Not only is it quite evidently a study for the figure of the robbers' victim in Hayman's altarpiece, it is a rare example of the type of lifestudy that we know was produced at the St Martin's Lane Academy. The pattern of light and shade across the rather lumpy figure is entirely characteristic of Hayman, who was one of the instructors at that important art school, attended by so many of the major artists of the mid-century.

Francis Hayman, life-study in chalk.

Hayman's art was, however, firmly rooted in the rococo era. He was at his best working on small canvases where his rather limited skills, especially in pictorial composition, were not too apparent, his somewhat 'Frenchified' and distinctly unclassical approach to drawing the human figure did not strike the beholder as unseemly, and his decorative placing of small areas of strong local colour gave a feeling of confidence and purpose. Although prolific he was not adaptable, and was unable to adjust to the new currents of taste that we can see pulling in different directions from about 1760 onwards. At the 1765 exhibition of the Society of Artists (of which Hayman was then president) he showed three pictures, noted by Horace Walpole in his copy of the exhibition catalogue as 'all execrable'. In the years that followed, his attempts to keep up with the new world of Reynolds, Gavin Hamilton, Benjamin West and Angelica Kauffmann were harshly criticised and the neo-classical torch passed to other, younger artists.

The most singular of these was the Scotsman, Gavin Hamilton, failed portrait painter but successful excavator of classical sculpture and dealer in old masters, who returned to Rome in 1756 determined to succeed as a history painter in the grand style. He had been to Rome before, a pupil of Agostino Masucci in the mid-1740s. His huge picture of Robert Wood and James Dawkins discovering Palmyra, painted 1757–9 and now on display at Glasgow University (where Hamilton had studied), heralded, with its representation of brave deeds in far-off lands, a new age in British painting. Yet the device of *distance* was, as Edgar Wind showed, a way of preserving academic dignity. Thus Hamilton's *Achilles mourning the death of Patroclus* exploited a subject remote in both time and space. Begun about 1760, this was the first of six great canvases depicting scenes from Homer. Although not well received when exhibited they must have provided a spur to the ambitions of Reynolds, West and the young James Barry.

Gavin Hamilton, Achilles Bewailing the Death of Patroclus *(1760–3).*

Modern history and the Sublime

The real achievement of Benjamin West (1738–1820) was not, however, classical either in style or subject-matter. His *Death of Wolfe* commemorated a famous victory and represented the brave death of a hero far from home, as remote in space as Homer's Troy was remote in time. And it caught the patriotic mood of George III's Britain in a way that the *Death of Patroclus* could not.

It was not the first scene from contemporary history to be painted in contemporary costume – historically 'correct' costumes had recently been introduced on the London stage for certain plays like *Richard III* – but it successfully brought together a number of previously separate strands in British painting. If its array of portrait heads shows its derivation from the sort of enlarged conversation piece painted earlier by Mercier and Hogarth, the composition itself, with figures grouped around the recumbent hero, · dying beneath the flag set cross-like against a stormy sky, invokes a long tradition of Depositions by a succession of Old Masters. The emotional response of the eighteenth-century beholder was shaped partly by this somewhat disconcerting religious affinity. As James Barry wrote,

History painting and sculpture should be the main views of every people desirous of gaining honour by the arts. These are tests by which the national character will be tried in after ages.

Benjamin West, Death of Wolfe *(1771)*.

No wonder the revival of history painting coincided so closely with the outburst of patriotic zeal that followed Pitt's victories over the French during the years 1758–60 and the accession of George III in October 1760. Thus when the Royal Academy was founded in 1768 its primary purpose was to put this newly emerging school of British history painting on to a secure theoretical and institutional footing.

The first President of the Academy, Sir Joshua Reynolds (1723–92), made his own public debut as an historical painter at the Royal Academy in 1773. *Ugolino and his Sons* (Knole, National Trust) was a gruesome subject from Dante's *Inferno*, the choice of which must have been encouraged if not directly inspired by currently fashionable theories about the aesthetic validity of all that causes terror and horror in the human soul. Count Ugolino, starving in the tower with his sons and grandsons, was certainly Sublime in that sense, though the critic in the *Middlesex Journal* (27–29 April 1773) thought it plain disgusting. Nevertheless, Reynolds's picture, scraped as a powerful mezzotint by John Dixon, was one of the most celebrated of its time. Indeed its fame was not limited to these shores, and its direct influence on, for instance, Guérin's *Return of Marcus Sextus* attests to Reynolds's place as an early contributor to European Romanticism.

Yet Barry was fighting a losing battle. In the hands of Hogarth, West, Copley (two Americans, admittedly, but working in Britain), Edward Penny, Philippe Jacques de Loutherbourg (Swiss-born and French-trained) and – above all – Joseph Wright, the old conventions of European history painting were applied to new subjects. It was Hogarth who first took his sketchbook into prisons and hospitals and into the seamiest London streets, and who, in his *March to Finchley* (1746, Coram Foundation), first represented the muddled reality of modern warfare in an unheroic and humorous spirit. In the years after his death the range of subjects was expanded further to include certain aspects of science and industry.

Joseph Wright of Derby

Joseph Wright of Derby (1734–97) began exhibiting his candlelight scenes from 1765 onwards, the first being *Three Persons viewing the Gladiator by Candlelight*. This was followed in 1766 by *A Philosopher giving a Lecture on the Orrery*, a larger, more ambitious picture which was bought by Lord Ferrers, keen amateur astronomer and Fellow of the Royal Society, for 200 guineas (more than Reynolds was charging then for a full-length portrait). The best-known of all is *An Experiment on a Bird in the Air Pump*, exhibited in 1768 (Tate Gallery). A number of variations on the theme of the *Blacksmith's Shop* and an *Iron Forge*, painted during the early 1770s, added a more practical 'industrial' dimension to Wright's subject matter.

There had been a long tradition of night scenes, or pictures which, while set in daytime, used shafts of sunlight to probe the shadows, a metaphor very often for spiritual enlightenment. Moonlight, too, had been explored by seventeenth-century Dutch landscape painters who were well known to eighteenth-century British collectors. In short, the treatment of light was not the most original aspect of Wright's subject pictures. Wright's most original

contribution to eighteenth-century painting was the way he combined the clever use of chiaroscuro effects with the new 'industrial' and 'scientific' subjects.

It is important to locate these pictures in their proper social and intellectual context. During Wright's lifetime Midland towns like Birmingham, Stoke, Lichfield and Derby saw considerable social change. Like the manufacturing centres of Lancashire, like Edinburgh and Glasgow, these towns saw a flowering of intellectual life coinciding with the increased prosperity that accompanied the growth of the early Industrial Revolution. Literary clubs, scientific institutions and circulating libraries testify to what is sometimes referred to as the Midlands Enlightenment. It has frequently been pointed out that Wright's 'scientific' pictures do not represent the sort of experiments or demonstrations that were actually performed by eighteenth-century scientists, and this is true in spite of Wright's friendship with men like Erasmus Darwin, Joseph Priestley and other members of the Lunar Society. What they do represent is the popularisation of learning. The young ladies who sing and play musical instruments in the conversation pieces of Mercier and Zoffany now gather round an air pump to watch as the proposition that all creatures need air to breathe is demonstrated 'scientifically'. The boys who, in Hogarth's pictures, build card houses and play toy drums now attend to the philosopher who expounds the workings of the orrery. Nor are the 'industrial' scenes particularly novel in terms of their subjects. Indeed, Wright could hardly have found a better example of the survival of an older technology into the industrial age than *The Blacksmith's Shop* (1771).

In both the *Gladiator* and the *Orrery* a small group is gathered in a darkened room. A concealed light, against which one of the figures is silhouetted, illuminates the faces and casts great deep shadows. In each case, what is being contemplated is a work of genius – ancient sculpture in the first instance, modern science in the second. At the side of the *Gladiator* an older man, perhaps intended to be the drawing teacher, places a hand on the plinth of the statuette, apparently offering some critical comment. He is a meditative figure, the Thinker who recurs in many of Wright's subject pictures. In the *Air Pump* he sits at the right, elbows on the table, head lowered and deep in thought; in two versions of the *Blacksmith's Shop* he sits, again at the right, hands resting on a stick, his lowered head and furrowed brow attesting to serious meditation.

The *Orrery* is one of the most original pictures of the whole period. The orrery was itself an eighteenth-century invention, a model for demonstrating the movements of the planets round the sun, in which a lamp took the place of the sun and tiny models of the planets, together with their satellites, could be made to turn in their proper orbits. It has all the simple clarity of Enlightenment science, and its three-dimensional geometry of intersecting circular bands has been exploited by Wright to achieve the maximum pictorial effect. The philosopher himself presides, Newton-like, over all. 'Nature, and Nature's Laws lay hid in Night', runs Pope's famous couplet, 'God said, *Let Newton be!* and All was *Light*.' Immediately beneath the philosopher and close to the source of light are two children, a boy and a girl,

Joseph Wright of Derby, A Philosopher Giving a Lecture on the Orrery *(1766)*.

framed by the pattern of the instrument itself and caught like the astrological twins, whose symbol is inscribed along with the rest of the signs of the zodiac on the horizontal circle beneath. Further out the faces of the other watchers are similarly illuminated, and like the children seem to be planets themselves caught momentarily in their orbits. There are no real parallels for this brilliant composition. It may be described as a sort of conversation piece, but it is unlike any conversation piece by any earlier British painter. Nor has it any real parallel in European art.

The *Air Pump*, in spite of its thematic originality, carries unmistakable traces of its origins as an enlarged conversation piece. The portrait-like character of the faces is more marked than it was in the *Orrery* and the literary and anecdotal associations more obvious. The scientist in the centre of the composition is perhaps an excessive piece of melodrama, with his face lit from below like an actor in a horror film. The moon peering wanly through the window completes the Romantic stage-setting. But the most striking feature is the prominent group of the two distressed girls, perhaps sisters, comforted by an older man. Like the children in Hogarth's modern moral subjects, they symbolise innocence; they also serve to complete the characteristic eighteenth-century opposition of reason and feeling. In the *Orrery* reason is everywhere sovereign: indicated by the geometry of the model itself, but also by the attentive faces and by the figure taking notes at the left of the composition. In the *Air Pump* the rule of reason is put in doubt. Not all members of the audience are attending as they should, and

two are visibly upset by what is happening. 'With terrors round', Pope had demanded, 'can reason hold her throne . . .?'

Wright's 'scientific' pictures, while being rooted in the tradition of the conversation piece, thus manage to include serious themes of a kind one would normally look for in history painting. If we compare *The Iron Forge* at Broadlands (1772) with one of the classics of eighteenth-century history painting, Jacques-Louis David's *Oath of the Horatii* in the Louvre (1785), in terms of pictorial structure we shall be struck by the way that in both compositions men are engaged, centre-stage, in purposeful activity while women and children, placed at one side and set back slightly, react emotionally. In both pictures the action takes place in an entirely closed and somewhat claustrophobic space. While the mood is, obviously, very different, the comparison does serve to point up the fact that Wright's subject pictures are more than enlarged conversation pieces, that they raise in the mind of the beholder questions of wide interest, and that they look forward to the Romantic period as well as back to the earlier Augustan age.

About the time that David was painting the *Horatii* Wright was working on a picture which explores the theme of stoicism and duty in a novel way. In *The Indian Widow* (1783–5) a beautiful young woman sits alone in a landscape, in a pose not unlike that of the woman who grieves at the extreme right of the *Horatii*. In fact, with her vaguely neo-classical draperies and bared breast she exemplifies a popular late eighteenth-century motif, and her

Joseph Wright of Derby, The Indian Widow *(1783–5)*.

sisters can be found mourning the deceased on numerous tombs by sculptors like Flaxman and Bacon well into the next century. Behind her, hung on a dead tree, her husband's weapons of war symbolise his Horatii-like bravery and self-sacrifice, while smoke rises from his funeral pyre. In front of her the land falls away to a stormy sea and lightning flickers across the darkening sky, in the midst of which is a bright patch. Against this brightness the woman is silhouetted. If the widow herself is a Noble Savage – already featured widely in the art of the 1770s and 1780s, for instance in West's *Death of Wolfe* – dressed and posed according to the ideas of Wright's own time, the astonishing cloudscape behind her looks forward to the Romantic period, to John Martin and even to Turner himself.

Portraiture

Rank and status, likeness and decorum

Hogarth's *Marriage à la Mode* told a harrowing story of pride and ambition based on fundamental eighteenth-century notions of rank and status. The attempt made by the merchant to buy his daughter a title illustrates vividly the sort of social manoeuvring that was keenly observed by John Millar, the Glasgow professor who in 1771 published a pioneering study of social stratification in which he commented upon the new power of money to increase social mobility. Thus in eighteenth-century Britain there arose a new awareness of how and why distinctions of rank (Millar's phrase) are drawn in particular ways, and the subject was debated for the first time in a recognisably modern spirit.

Portraiture, considered as the public commemoration of greatness, would necessarily give the clearest possible indications of rank. In the most formal whole-length portraits, lords and ladies appear in their full coronation robes, knights proudly display the ribbon and insignia appropriate to their order, sword and crown convey their ancient symbolism – to defend the monarch in time of war, to offer counsel in time of peace. In such portraits the van Dyck tradition is at its strongest.

But it was in its more 'private' capacity, as token of friendship or family affection, that portraiture flourished most excitingly in this period. In the more informal works of Hogarth, Reynolds, Gainsborough and Zoffany what was expected was a sharper sense of likeness, of the portrait not as a social mask but as the recognisable image of a particular person. Contemporaries naturally disagreed as to which painters were best able to 'hit a face' (in the current phrase) and ladies in particular seem to have been quite content to see on the canvas a flattering image rather than an analytic and perhaps excessively truthful representation. And so John Hoppner (1758–1810), a gifted and by no means slavish imitator of the later, more baroque style of Reynolds, would start a lady's portrait by painting an ideal face, in terms of contemporary fashion, and then modify it gradually until observers said they could see a likeness coming – whereupon he stopped. Similar stories are told of other portrait painters in this period.

Likeness is, of course, a relative concept. People who sat for their pictures wanted to be recognised, but recognised *as* something: as a country gentleman, perhaps, with gun and faithful dog, posing against the backdrop of his own fertile estate; or as a dutiful wife and mother, together with her baby son. Judges wished to be represented as just and upright, scholars as learned, soldiers as brave, and so on. The individual was thus always absorbed in some sort of role; the mask, we could say, never really dropped. There was also another factor to be taken into account.

When, on 23 October 1760, Mrs Delany – friend of Swift, Richardson and Fanny Burney – saw Gainsborough's whole-length portrait of Miss Ford posing with her guitar and with one leg over the other, she thought it 'a most extraordinary figure', but 'bold', and she added: 'I should be very sorry to have anyone I loved set forth in such a manner'. It is clear from this, and from the discussions of eighteenth-century critics, that likeness was not everything. As Richardson put it,

A portrait may be very like, though the man may be represented as just come out of his bed, or off a journey, but such a choice would be certainly wrong.

Thus the Renaissance concept of decorum still shaped the public response to portraiture in the Augustan age. It was, however, under attack, most notably by Reynolds. In his portraits of Mr and Mrs Francis Beckford in the Tate Gallery, painted 1755–6, Reynolds switched male and female poses, so that the lady is represented with her hand on her hip and her elbow poking out in a 'bold' way traditionally thought more suitable for soldiers or admirals, while her husband, by contrast, stands quietly at a table, almost demure, the composition taken directly from a well-known portrait of Charles I's queen, Henrietta Maria.

Another rule of decorum required that a sitter's physical defects should not be recorded, or at least not be emphasised, in portraiture. Few of those who, in the 1750s and 1760s, sat to Reynolds or Gainsborough would have welcomed Oliver Cromwell's insistence (in a famous story) that the painter had a duty to represent his subject 'warts and all'. But a glance at Reynolds's remarkable portraits of Lord Mansfield (1776, Scone Palace), Lord Heathfield (1788, National Gallery), or Lord Rodney (1788–9, Royal Collection) will indicate very clearly that the rule of decorum was not necessarily associated with flattery. It was a question rather of what kind of presentation was appropriate to persons of different stations in life.

Single figures

According to Lord Shaftesbury, the 'measures' of eighteenth-century portraiture were fixed and corresponded to different types of poetry:

In the same manner, as to painting, sculpture, or statuary, there are particular measures which form what we call *a piece*: as for instance, in mere portraiture, a head, or bust: the former of which must retain always the whole, or at least a certain part of the neck; as the latter the shoulders, and a certain part of the breast. If anything be added or retrenched, the *piece* is destroyed.

In practice conventions were looser, though the commercial sense of the colour-shops which led them to stock ready-made canvases in the most popular sizes greatly encouraged artists to develop a limited range of compositional patterns and stick to them. Again it was good commercial sense that led painters to pose their sitters in very similar ways, and organise their studios so that backgrounds, draperies, and so on could be filled in by trained assistants following regular procedures. There was, after all, little point in striving too hard for novelty – the overriding pressures were all for sameness. And it is within that primarily social context that the greater variety introduced by Hogarth and – above all – by Reynolds ('Damn him', said Gainsborough, in a famous comment, 'how various he is') must be recognised and understood.

There were of course limits to variety. It was rarely a question of thinking up an entirely new pose, but more often of adapting, in a witty or unexpected way, an old one. We have already observed Hogarth's effective use of this device in his comic histories. When in 1698 Kneller painted the Countess of Orkney he arranged her long loose hair and placed her hands across her bosom and waist in a way cleverly designed (as Douglas Stewart has shown) to evoke in the mind of the spectator both Titian's famous *Mary Magdalen* and a celebrated classical statue known as 'Pudicity'. The countess was a former mistress of William III and these allusions effectively contrive a mood of dignified repentance.

More often ladies hoped to convey to the spectator a different impression, above all one of quiet, effortless movement suspended for a moment. Thus Allan Ramsay (1713–84) – supreme master in this respect – paints his second wife pausing in the act of arranging flowers in a vase, turning her face towards us. The eighteenth-century word for this desirable quality, pursued across countless canvases by all the painters of the time, though with varying degrees of success, was *grace*. Unlike 'mere beauty' (as certain writers referred to it) grace was a spiritual quality, operating on a level higher than the physical, and writers never tired of quoting Milton's description of Eve: 'Grace was in all her steps, heaven in her eye'.

Men of course sought different values. If the ideal for women was a quiet and passive spirituality, men were increasingly *active* in their portraits. The pictures gifted to the newly established Foundling Hospital from 1740 onwards are useful examples. Hogarth's whole-length portrait of the founder, Captain Coram, combines in one image at least three aspects of the sitter's personality and all of them socially significant. First, the globe and distant view of the sea allude to Coram's earlier career as a man of action in the service of trade; secondly, the seal in his hand and the charter on the table attest to his great philanthropic work at the hospital itself; and thirdly, the painter has rendered most effectively the honest benevolence in the old man's face and general bearing. As in the contemporary philosophy of David Hume, utility in action and sympathy with one's fellow human beings are the dominant themes.

Ramsay's whole-length portrait of Dr Mead, gifted to the Hospital in 1747, is sometimes contrasted with Hogarth's *Coram* – a more 'dignified' response to the likeness of a bluff man-of-the-people. There is some truth in this, but

we should not overlook the profound affinity between these two portraits when they are viewed in a social framework. Ramsay represented Mead as a physician with a statue of Hygeia in the background – the motif taken from a portrait by Rubens which was in Mead's own collection. He sits as if in consultation, fixing the beholder with a steady eye and gesturing towards a paper on the table. He is a professional man with a recognised and respected position in society and that was at least as important as the likeness – and Vertue says it was 'very like'.

To sum up: if the feminine ideal was grace, the masculine ideal was greatness. Discussions of greatness tended to overlap and merge with the parallel debate about the Grand Style, and with the concept of the Sublime. Judith F. Hodgson, in her thesis on *Human Beauty in Eighteenth-century Aesthetics*, points to the attempts being made in this period to establish masculine supremacy in the realm of beauty as in most other respects, in accordance with the underlying doctrine of the great chain of being. Women could be granted a monopoly of 'mere beauty' or even of 'grace', but only men could achieve the higher, quasi-religious status of sublimity or greatness. The distinction underlies Walpole's oft-quoted comparison between Reynolds and Ramsay who, he declared,

can scarce be rivals; their manners are so different. The former is bold, and has a kind of tempestuous colouring, yet with dignity and grace; the latter is all delicacy. Mr Reynolds seldom succeeds in women: Mr Ramsay is formed to paint them.

Couples, groups and children

Husbands and wives, fathers and sons, young men with their tutors, artists with their clients, all provided an opportunity for the painter to attempt a more ambitious type of composition than was possible with a single figure. In the majority of husband-and-wife pictures, contact is avoided. Thomas Hudson's 1755 double whole-length portrait of Sir John and Lady Pole at Antony House shows the lady seated – or rather perched – on the left with her husband standing cross-legged on the right, both looking at the spectator and quite detached from one another. Gainsborough's well-known picture of Mr and Mrs Andrews (*c.* 1748–50) in the National Gallery is another study in marital isolation, but later in his career Gainsborough arrived at a – to modern eyes – more appealing solution in his 1785 portrait of Mr and Mrs Hallett out together with their dog in a picture known as *The Morning Walk*.

Double portraits of friends, like Reynolds's *Mr Huddesford and Mr Bampfylde* (1777–9) in the National Gallery, or of two brothers, like *Peter and James Romney* by Romney (1766) at Yale, or sisters, like Gainsborough's *Elizabeth and Mary Linley* (*c.* 1772) at Dulwich, sometimes draw upon the Renaissance tradition of the Friendship portrait. According to this convention the figures, given equal weight, would normally be contrasted in some way, usually as 'active' and 'contemplative' figures. One will look out of the picture, usually at the beholder, in an alert manner, while the other lowers his or her gaze and holds perhaps a letter or a book.

Large groups of people were, for obvious reasons, normally painted smaller than lifesize, and we have already noted the popularity of the small-scale

conversation piece after its introduction to this country by Mercier in the mid-1720s. Although such pictures enjoyed a vogue in the late twenties and early thirties, and were even commissioned by the aristocracy, they soon became the almost exclusive preserve of the gentry, and of the new moneyed classes in the expanding industrial towns of the midlands and north. By the late 1730s the Preston-born painter Arthur Devis (1711–87) was producing a steady stream of pleasant little pictures in which his customers, in their neat blue coats and shiny white dresses, were reduced to the size and given something of the appearance of dolls, and were placed in curiously empty rooms, or set against landscapes. We know that they were in fact largely painted from dolls, and the backgrounds seem to be more or less interchangeable from one picture to the next; but at his best – as in the

Sir Joshua Reynolds, The Marlborough Family *(exhibited 1778); Red Drawing Room, Blenheim Palace.*

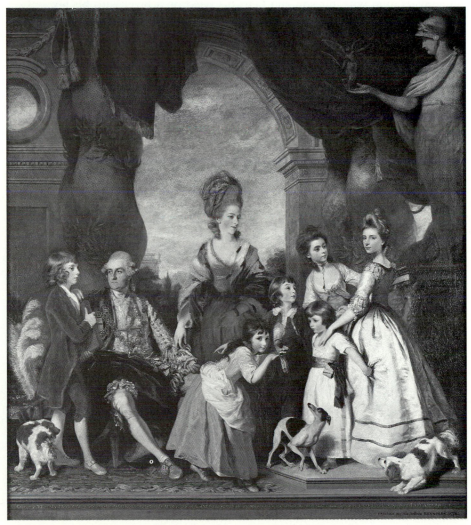

delicately painted *James Family* of 1751 in the Tate Gallery – Devis was an accomplished craftsman with an attractive feeling for colour.

As for groups on the scale of life, few people could afford them and most eighteenth-century houses, particularly in view of the new fashion for rococo plasterwork, lacked the necessary wall-space. When the Society of Dilettanti in London decided in 1777 to commission two group portraits of its members from Reynolds (himself a member) to hang one at each end of their meeting-room, each sitter paid his equal share of the price. That created, of course, a problem for the painter because each sitter expected to be given equal prominence. It was a difficulty that hardly arose in family groups where each member knew, so to speak, his or her place and could be arranged accordingly. It is interesting that in his huge picture of the family of the 4th Duke of Marlborough, exhibited at the Royal Academy in 1778, Reynolds, after a few preliminary trials, decided to make the Duchess the most prominent figure. The Duke is shown seated at one side of the composition, in conversation with his son and heir, his head on a level with his six children. Of course such an arrangement would not have been arrived at without advice from and consultation with the family, but it is clear that within certain limits the artist was encouraged to plan his composition to achieve the best pictorial effect. And so he did, for the *Marlborough Family* is one of the great achievements of British art, and is not surpassed in eighteenth-century European portraiture before Goya's *Family of Charles IV* (1800).

George Romney, Leveson-Gower Children *(1776–7).*

William Hogarth, Graham Children *(1742)*.

Children

The position of children within the institution of the family changed radically during this period. They became, to a greater extent than ever before, the object of investment – both emotional and financial – on the part of their parents. Adults now paid more attention to their offspring, bought them books, better clothes, toys (a growth industry in the eighteenth century), paid to have them educated, spent more time with them, and discussed their progress and their problems in letters and journals. By the end of the century the Spoilt Child appears as the subject of a humorous drawing by Rowlandson.

Not surprisingly the representation of children in their portraits undergoes profound change in this period. Whereas in the seventeenth century they were depicted as solemn little creatures, constricted by their uncomfortable clothes, posing and gesturing like miniature adults, now they break free, and on the canvases of Hogarth and Reynolds they sing and dance, romp and play. Hogarth's conversation piece of the *Cholmondeley Family* (1732, Private Collection) contrasts formally posed adults on the left with two little boys on the right who are in the library, but are not reading; instead they are engaged in kicking over a pile of their father's books. This simple contrast – dignity and impudence – was exploited by other artists, for instance Reynolds in the *Marlborough Family* where the formality of the adults is set against the mischievous girl who frightens her little sister with a grotesque mask – a detail much praised when the picture was exhibited and soon engraved as a separate motif.

Children are also painted alone, or in groups without the supervisory presence of their parents, more often than they had been in the past. This

parallels the emergence of a new concept of childhood as a distinct time of life with its own values and its own legitimate forms of behaviour. Thus Hogarth's *Graham Children* of 1742 presents the children of Daniel Graham, apothecary to Chelsea Hospital, lifesize and full of happiness and energy. The girls are dancing to the music of a bird-organ played by their brother, and on the side of the organ is a relief showing Orpheus Charming the Beasts. This little joke underlines the happy mood of the group, but the composition is not without echoes of an older, darker iconography. For the cat clawing its way up the chair in its attempt to catch the caged bird, and the clock with its little gilt figure of Cupid carrying a scythe, are age-old symbols of transience and death. The children will grow old, the bird of youth will fly away.

Sporting and equestrian portraits

Eighteenth-century portraiture is as much the representation of a way of life as the likeness of individuals, and it is therefore not surprising that horses, guns and dogs were much featured. There is space to mention just a very few examples. Around 1715 Kneller painted whole-length portraits of the Countess of Mar (Scottish National Portrait Gallery) and Lady Huntingtower (Ham House) wearing splendid riding dresses, carrying whips and with grooms holding horses in the background. In an impressive whole-length portrait at Althorp painted in 1745 by George Knapton, the Hon. John Spencer is represented gun in hand with his son mounted on a horse and watching his father with obvious admiration, while a black servant holds back the dog.

Both Reynolds and Gainsborough painted gentlemen in landscapes with gun and dog. Reynolds's first customer for this type of picture, Philip Gell, who posed in 1760–1, preferred to be represented wearing – inappropriately we might think – his best embroidered French suit, white stockings and buckled shoes (Private Collection). Gainsborough's whole-length portrait at Holkham of Thomas William Coke, 1st Earl of Leicester, shows him wearing the costume in which he appeared before George III in 1782 when presenting an address from the county of Norfolk in support of the American colonies: broad-brimmed hat, shooting-jacket, and long boots. Whereas Philip Gell had decisively shunned 'country' clothes Coke chose to wear such costume as an assertion of his privilege to do so as Knight of the Shire.

'After the portraits of himself, his wife, and his children', observed Ellis Waterhouse, 'the English patron of the eighteenth century liked best to have a portrait of his horse' The representation of a gracefully posed rider in effortless control of a mighty charger has been a favourite with the ruling classes since antiquity. As a symbol of social control it could hardly be bettered. However, the lifesize military equestrian portrait is naturally rare and eighteenth-century examples are not, it must be admitted, very inspiring. Among the few exceptions is Reynolds's very baroque portrait of the Prince of Wales, later George IV, exhibited in 1784, and now at Brocket Hall. Against a sky filled with cannon smoke, wearing an entirely fanciful uniform of – apparently – his own design, this most unwarlike prince prepares to mount a splendid grey horse and ride into battle.

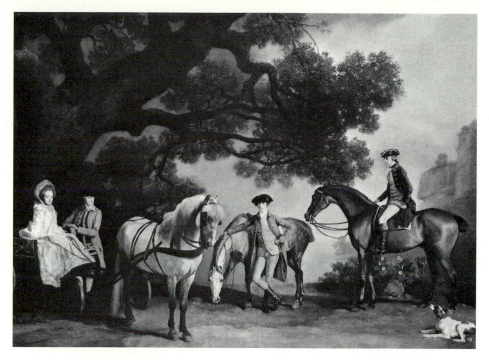

George Stubbs, The Melbourne and Milbanke Families *(1769–70).*

A far greater demand existed for smaller pictures with a sporting rather than a military content. Hunting, racing and breeding horses were, of course, the most popular leisure occupations of the landed aristocracy and gentry, and several gifted painters specialised in subjects drawn from that world. John Wootton was the first notable figure, but the great master of the genre was George Stubbs (1724–1806).

Stubbs, like Wright, never received his due from the Royal Academy because he was always regarded as a 'horse painter', a man working, therefore, in an inferior category of art. A picture like *The Melbourne and Milbanke Families* (1769–70) seems to us to make nonsense of that assessment. Here is a composition that deserves our closest attention, for Stubbs has planned it as carefully as any of the masters of the Grand Style recommended by Reynolds in his *Discourses*. Against a huge dark tree, whose weighty boughs form a natural canopy, Lady Melbourne is seated in a phaeton at the left of the picture. Sir Ralph Milbanke, hands placed on the side of the phaeton, turns his head to look across towards his son-in-law, Lord Melbourne, who sits on a beautiful, shiny brown horse facing towards the centre of the composition. The animal's finely arched neck and graceful head are silhouetted against the light sky. In the centre, Sir Ralph's son John stands cross-legged and facing the beholder, one hand on the reins as his horse crops the grass. The whole arrangement is calm and still, frieze-like, classical we might say rather than baroque, each unit of the design clearly separated from the one next to it. In this respect – and against the background of Stubbs's interest in anatomy – we are reminded of quattrocento art.

In the *Melbourne and Milbanke* group, in the *Grosvenor Hunt* (dated 1763), in the portrait of John and Sophia Musters out riding at Colwick Hall (dated 1777) and in his several pictures of reapers and haymakers (two of which were exhibited in 1786) Stubbs proves himself to be much more than, as the eighteenth-century public would say, a mere sporting artist. His subject was a whole way of life, not only hunting and horse-racing but, as Basil Taylor puts it, 'the more informal conditions and pleasures of rural society' which were now of such importance to the landed classes.

Landscape

European landscape painting can be characterised in terms of a contrast between the garden on the one hand, and the wilderness on the other. The garden, nature tamed by man and brought to order purely to give pleasure, had emerged in Western art as far back as the fifteenth century as a place of safety where the Virgin and Child could sit quietly and read, or listen to angelic music. In the later Renaissance it was often populated by the gods of antiquity; and it was painted in the seventeenth century most notably by the French classical painter Claude Lorraine. The wilderness, where the hostile forces of Nature rage uncontrolled, had an even longer pedigree in art, especially in the form of the rocky desert to which holy men retired to battle against the temptations of the flesh and to contemplate the perfection of God. Towards the end of the eighteenth century Nature emerged once more as a threatening power, above all in the work of Turner, but during the period with which we are concerned the British public preferred to contemplate an ordered world.

Country-house views

No better symbol of order could be found than the country-house, and the country-house nestling at the centre of its well-husbanded estate, represented in the form of the 'prospect' (usually a bird's-eye view), was the most frequent subject for landscape painters working in Britain around the turn of the seventeenth and eighteenth centuries. The great monument to this approach – which clearly owed something to seventeenth-century mapping techniques – was the publication in 1707 of *Britannia Illustrata*, a collection of engraved views of royal residences, together with 'the principal seats of the nobility and gentry', by two Dutch-born artists, Leonard Knyff and Johannes Kip. These essentially topographical views were intended to glorify for posterity the patrician families who had built the houses and established the estates.

Not that all 'prospects' were strictly factual; the view of Hampton Court painted about 1710 by Jan Griffier the Younger is just one of many examples in which topographical accuracy is disregarded and landscapes are cheerfully re-arranged for aesthetic effect. Here Windsor Castle is incongruously included as a picturesque motif overlooking the formal parterre of Hampton Court. Nor were they necessarily aerial views – though that was the most

popular type; many were taken from a more 'normal' eye-level. During the eighteenth century the country-house itself gradually retreats from being the central focus of attention and the landscape around – the view *from* the house rather than the house itself – assumes a greater importance.

To contemplate the landscape from the terrace of a country-house – as Squire Allworthy, replete with benevolence towards his fellow-men and imbued with love for God's creation, does in Fielding's *Tom Jones* (1749) – was to look out upon an orderly vista. Allworthy saw

a very fine park, composed of very unequal ground, and agreeably varied with all the diversity that hills, lawns, wood, and water, laid out with admirable taste, but owing less to art than to nature could give.

(Book I, Chapter 4)

Not surprisingly, scenes of agricultural labour (discreetly distant), of haymaking or ploughing, occur in many landscapes by artists like George Lambert, Edward Haytley and Gainsborough in the period roughly 1730–60. For example, Lambert's *View of Box Hill, Surrey* (1733) presents a wide tract of countryside the most prominent feature of which is an irregularly shaped group of hills dotted with small trees in the centre of the composition, serving both as an eye-catcher (as the country-house had done in earlier 'prospects') and to divide the wide rectangle of the composition into two halves. To the left, the lone reaper and his fellow-labourer in conversation with a girl are almost emblematic features of eighteenth-century landscapes: symbols of industry and idleness. The right half of the picture is populated by figures of a different sort – an artist sketching the view, presided over by a standing gentleman, while another gentleman reclines on the grass against a background of woods and meadows better adapted to leisure pursuits than to farming. A horseman is visible in the distance.

George Lambert, View of Box Hill, Surrey *(1733).*

Richard Wilson and the classical tradition

The agricultural landscape, which declined in the second half of the
eighteenth century before being magnificently revived by Constable, was not
the only type of scene that was appreciated. Of equal importance was the
purely imaginary view, based very largely on the compositions of Claude
Lorraine. Claude's work was now beginning to be collected by the British,
and patrons who were unable to acquire original pictures by Claude – or
were unwilling to pay the price – had copies or imitations cheaply made.
Lambert, whose *View of Box Hill, Surrey* has been discussed, painted some;
so did John Wootton, better known as a sporting artist. George Smith of
Chichester and his brother John worked almost wholly in the style of Claude.
Furthermore, as discussed elsewhere in this volume, gentlemen began, with
the help of landscape gardeners like William Kent and Capability Brown, to
remodel their estates so that the view from the terrace really did resemble a
composition by Claude.

Architecture plays a major role in the landscapes of Richard Wilson
(1713–82). In fact his earliest known picture, the *Hall of the Inner Temple
after the Fire* (1737, Tate Gallery), introduces a motif which recurs in his
later work, namely the contrast of ruins and intact buildings. In this rare
instance, the ruins are the result of a sudden (and modern) catastrophe,
rather than of the slow decline of ancient greatness. Nevertheless the scene is
enough to inspire melancholy reflections on the transitoriness of all human
achievements, and is at the same time a reminder of the destructive power of
natural forces.

Wilson's later ruin-scapes encourage reflections of a more peaceful kind. A
superb example is *Pembroke Town and Castle*, painted about 1765. This 'most
flourishing town of all south Wales' (Defoe's description) has been relegated
to the distance, too far away for much activity to be visible, and the scene is
dominated by the great shadowy mass of the castle ruins. This stands, of
course, for past glories, and may well inspire thoughts on the transience of
human greatness; but the weather is too clement, the sky is too clear, the
people in boats and along the river bank too relaxed for gloomy
prognostications. Wilson is painting an earthly paradise where man and
nature, past and present, co-exist in perfect harmony. A similar mood
prevails in other pictures by Wilson that include castles such as Dolbadarn,
Neath, Okehampton and Caernarvon.

Wilson instils a similar peace, but employs a different compositional
structure, in the numerous views he painted of country-houses. These owe
nothing to the tradition already discussed of the 'prospect' but a good deal to
Claude, and to the classical tradition generally. Thus in Wilson's pictures of
Croome Court, Tabley, Moor Park, Wilton, Woburn and other noble seats
the buildings themselves are reduced in scale and the emphasis is on the
landscaped parks in which they are set. In these years Capability Brown was
employed to redesign many of these parks and it is his sense of great spaces,
sweeping lawns, lakes and carefully placed single trees that we see expressed
in Wilson's country-house views.

Not all Wilson's work is, however, so peaceful. The picture that

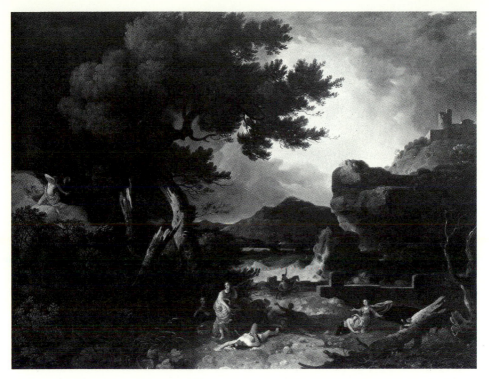

Richard Wilson, The Destruction of the Children of Niobe *(c. 1760)*.

established his reputation in England was *The Destruction of the Children of Niobe*, shown at the first exhibition of the Society of Artists in 1760 and now at Yale. The success of this melodramatic piece, with its echoes of Gaspard Dughet and of Salvator Rosa, was remarkable. Not only were numerous copies and variations made, but the engraving by Woollett earned a small fortune for the print-publisher John Boydell. It would not have been considered 'melodramatic' at the time but an example of the Grand Style, a demonstration of the painter's 'elevation of thought and dignity of composition', in the words of Constable's friend, Sir George Beaumont, who later owned a version himself.

Gainsborough and the picturesque

No such learned and allusive subject-matter occurs in the landscapes of Gainsborough, nor do we find scenes of violence and distress. In spite of some recent attempts to represent him as a consciously propagandist painter, reacting to the social changes affecting rural life, such as the enclosure movement, Gainsborough was by no means sufficiently original in his choice of themes and motifs. That is especially true of his early work. His *Landscape with distant view of Cornard Village* of about 1747 is conceived entirely within the framework of earlier Dutch river views by artists like Jacob van Ruisdael, and has been painted – especially in certain details – with more than a

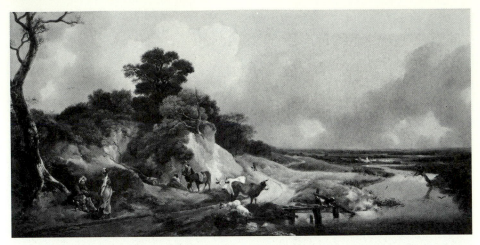

Thomas Gainsborough, Landscape with Distant View of Cornard Village *(c. 1747).*

sideways glance at contemporary French art. First, the composition. The scheme whereby an open panoramic view of a river winding into the distance at the right is contrasted with dark, irregular wooded hills or dunes at the left, the diagonal emphasis from upper left to lower right counterbalanced by a diagonal swathe of stormy clouds running down the other way, from top right corner into the centre of the horizon – all this occurs in numerous Dutch landscapes. We know that Gainsborough studied such landscapes very thoroughly, notably those by Ruisdael, whose pictures were to be seen in the London salerooms. On the other hand the loaded, broken brushwork, the way that Gainsborough has applied his paint in irregularly shaped dabs of rather dry, sticky colour, has more to do with French rococo painting.

However, an account of his artistic debts does no justice to the impact of Gainsborough's picture, the atmospheric distance, the clear reflections in the water, the attractive way that shapes echo one another – trees, clouds and animals, paired light and dark. The unusual horizontal format (it may originally have been painted as an overmantel) has created awkward compositional problems which Gainsborough has solved by a complex and, considering the early date, remarkably mature pattern of low intersecting triangles.

A direct comparison between Gainsborough and Wilson illuminates two further aspects of eighteenth-century British taste. If Wilson, with his emphasis on a few clear shapes, his classical references and his smooth surfaces, can be located under the heading of the 'beautiful' as it was defined by Edmund Burke, we can place Gainsborough confidently enough within the framework of the 'picturesque'. The concept was formulated by various writers slightly later – in fact mainly in the years following Gainsborough's death – but it can be seen as an active principle much earlier. Rough surfaces, sudden instead of gradual variations in tone, irregularity of outline – these were the characteristics of the picturesque, and they are characteristics we find in all Gainsborough's landscapes.

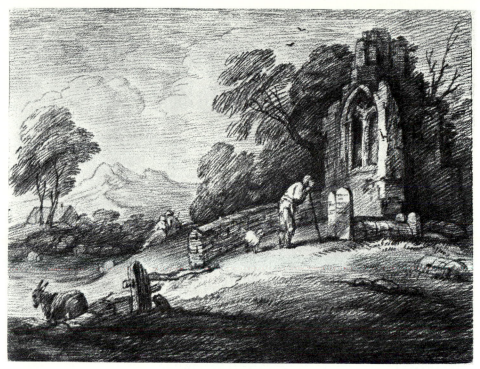

Thomas Gainsborough, Country Churchyard *(1//9–80)*.

And they are present too in that unfinished masterpiece of his last years, *Diana and Actaeon*. Here in Gainsborough's only classical subject, the goddess and her nymphs are gathered under the trees, against a waterfall, a silvery grey spiral of semi-transparent nudes; they are startled by Actaeon's appearance, yet he is hardly distinguished from the woody background, so light is the painter's brushwork throughout. *Diana and Actaeon* is exactly contemporary with Wright's *Indian Widow*, which indicates the unprecedented diversity of British painting in the later Augustan period.

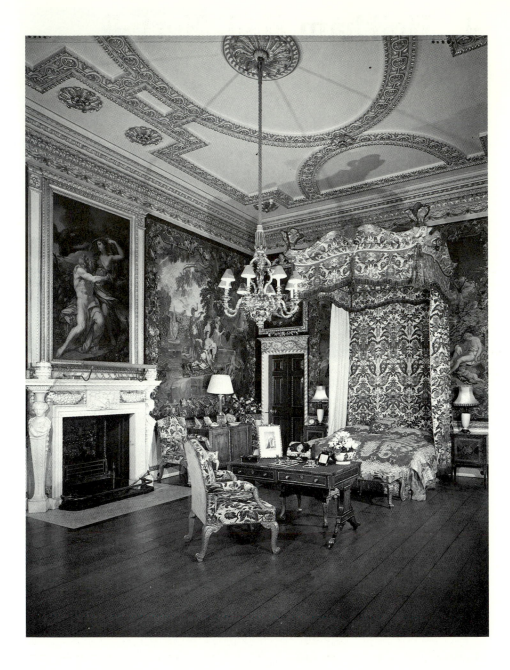

The Green State Bedroom, Holkham Hall.

4 Holkham Hall, Norfolk

CINZIA MARIA SICCA

Holkham Hall, one of the most resplendent and elegant country-houses built in England in the first half of the eighteenth century, is an exceptional document of eighteenth-century culture. Built to house an ever-growing collection of manuscripts, antique sculpture and contemporary paintings, it was a public statement about the wealth accumulated by a family of professional commoners for whom academic pursuits had remained of utmost importance. Its construction, spanning the years 1734–62, coincides with the transition from neo-Palladianism to neo-classicism, a more than merely chronological coincidence since stylistically the house contains strong neo-Palladian elements, and at the same time heralds the transformations that are generally associated with the neo-classical internal distribution of Robert Adam's houses. Holkham is also the last important house to have been conceived by an amateur architect supported by a team of professionals; indeed it is perhaps the most complete and coherent artistic statement ever formulated by the leading connoisseurs of the first half of the century. The house was in fact the result of the collaboration between its owner, Thomas Coke (1697–1759), who was largely responsible for the design, and his friends, the 3rd Earl of Burlington and William Kent, with the help of Matthew Brettingham in the role of clerk of the works, as well as craftsman. Thus Holkham provides a vivid picture of the way in which a variety of specialised skills were called upon and interwoven to create a complex piece of architecture which would be an expression of cultural values and social aspirations.

Orphaned at the age of ten, Thomas Coke succeeded to his estates in 1707. These lay in Norfolk, Suffolk, Buckinghamshire, Oxfordshire, Somerset and London, with annual rents of about £5800, supplemented each year by casual profits, mainly from fines paid for renewals of long leases and sales of wood, of up to £1000. Over the next ten years Coke's guardians improved the estate 'by management', which resulted in a 12 per cent increase in rents, and greater productivity on the farms through the introduction of crop rotations. These sound foundations enabled the estate to survive the great strains laid on it by the ward during his travels on the continent from 1712 to 1718, and even more so once he had come of age.

Thomas Coke's Grand Tour was one of the longest, lasting five years, and perhaps one of the most enlightened of the period. The young boy travelled under the careful supervision of Dr Thomas Hobart, a Doctor of Medicine of Cambridge University (1700) and fellow of Christ's College, and under his guidance Coke was taken through a full course of humanist studies. He learnt Greek, took lessons in mathematics at the Oratorian University of Angiers, learnt to play the flute, engaged an architectural master in Rome, became involved with the Florentine Accademia della Crusca's antiquarian forays into Etruscan art and language, and finally gained a reputation throughout Italy and France as a great buyer of coins, books and manuscripts. It was impossible to bridle his expenditure on paintings and works of art in general, and by the time of his return to England his acquisitions of pictures, drawings, prints and statues had totalled the impressive sum of £2917 19s 0d. His taste in painting was unusual and assured, for unlike the majority of his contemporaries he did not limit himself to buying sixteenth- and seventeenth-century old masters, but consistently bought and commissioned paintings of contemporary artists. It was in the course of one of his visits to the Roman artists' studios, during spring 1714, that Coke met William Kent, then studying under Giuseppe Bartolomeo Chiari, the leading Roman painter, and offered to take Kent on a tour of Emilia, Lombardy and Veneto. The journey established the basis of their future relations.

Like several contemporaries of his, Thomas Coke organised his return to England so that it would almost coincide with his coming of age and taking full possession of his estate. Less than a month later, he married Lady Margaret Tufton, third daughter and co-heiress of the 6th Earl of Thanet. The couple settled in London, in Thanet House, Great Russell Street, a house of modest proportions and with few public rooms. Even considering that paintings could be hung in the private quarters, soon there must have been no room left on the walls, nor was there room for proper storage of the books, manuscripts and sculptures acquired abroad. Yet the idea of enlarging the old Norfolk family seat, Wheatley Manor, at Holkham, or possibly even of building an entirely new one, had to be postponed for a while since in 1721 Coke suffered a heavy loss of £70,000 from speculation in South Sea Stocks.

His financial difficulties were, however, compensated by his political success: in 1722 he was returned MP for Norfolk, and he established himself as one of Robert Walpole's most loyal supporters, soon enjoying the prime minister's patronage. After receiving numerous honours he was, in 1733,

William Kent, drawing of the south front of Holkham Hall.

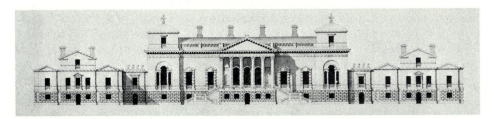

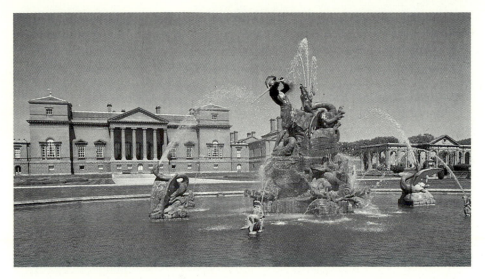

The south front, Holkham Hall, with the fountain representing Perseus and Andromeda.

appointed joint post-master general, a sinecure which provided him with a neat annual stipend of £1000 a year, plus the profits from the Dungeness Lighthouse which brought in a penny a ton from every vessel that passed it. In 1744 he was elevated to the title of Earl of Leicester, and in 1745 he became post-master general, a post that he held until his death in 1759.

His new status presupposed a suitable lifestyle, with a large country-house for entertaining and power-building. Wheatley Manor was small, old-fashioned and decidedly unusable for such purposes, so Coke set out in 1726 to formulate plans for a new mansion. The house was to be relatively simple, rectangular in shape, with a projecting Corinthian portico on the south front, and slightly projecting corner towers as in so many other contemporary neo-Palladian country-houses, such as Wanstead and nearby Houghton. There were to be a ground floor, a principal storey and an attic storey – this latter was eliminated in the final design. If the elevation was not particularly novel, the ground plan departed considerably from the standards of the time.

The plan hinges on a central axis running from north to south, and consisting of a square hall with a vaulted semi-circular (apsidal) end leading through a fan staircase up to the principal storey, and into the saloon which is screened by the portico on the south. The state rooms double back from the saloon, around interior courts never used by previous neo-Palladian architects. Indeed the ground plan, with the repeated use of the *enfilade* on three sides of the building and the internal courts, bears little relation to Palladio's architecture but betrays, instead, a strong French influence, specifically of François Mansart's plans for Parisian *hôtels*.

Building could not be started immediately; Coke's financial affairs had been improving but not considerably enough to embark on a long-term, onerous project. However, by 1729 the gross rental income exceeded £10,000 a year and this alone, without considering the income from his sinecure, placed

Coke among the 400 richest men in Britain, and made him secure enough to start building his new country seat.

As there was no way that he could afford building Holkham in stone, Coke decided to make virtue out of necessity and to build the structure of the house only with the materials available on the estate. A red seam of clay was exploited to make bricks for the garden walls. But a classical house like Holkham could certainly not be built in red brick and so, while alternative solutions were sought, work progressed on the grounds according to designs prepared by William Kent. In particular, an artificial basin was created below the present terrace, and a dam was created to form the lake.

Aerial view from the south of Holkham Hall, park and William Kent's obelisk.

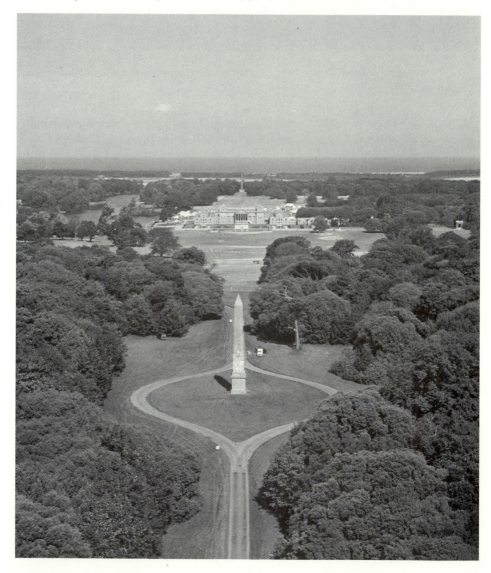

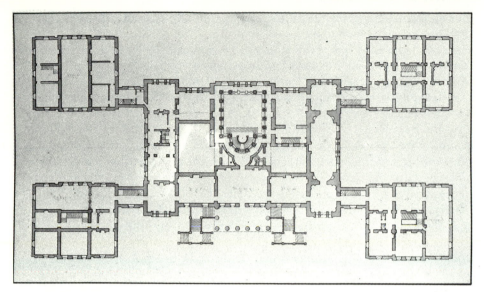

William Kent, plan of the principal floor, Holkham Hall.

The first masonry structures to be erected in the park were the Obelisk and the Temple, both designed by Kent. The Temple, which commanded a view of the ornamental basin and of the site chosen for the new hall, was made of white bricks, and was the testing ground for the materials with which to build the hall, since it had been discovered that bricks produced from another brick earth on the estate were durable and acquired a colour close to that of seasoned Bath stone. The workforce necessary to operate the brick kiln was provided by local people, all tenants of Coke who would pay their rent off by providing their labour. They also came with their tools, such as spades and ropes and pikes, so that there was no need for Coke to pay for these other expenses. The laying of the bricks required, however, a specialised skill and Thomas Griffin had to be called up from London with his team. Like the bricks, all the timber necessary for the foundations, flooring and roofing of the house came from the Coke estates.

Building operations for the new hall began in 1734 on what was referred to in the accounts as the New Wing or Family Wing. Coke's 1726 designs had been revised and submitted to the scrutiny of the Earl of Burlington and William Kent, who was responsible for the addition of the four corner pavilions. This idea was borrowed from John Webb's drawings for the expansion of the Queen's House at Greenwich. At Holkham the four pavilions were to house on the east side kitchen, laundry and chapel; and on the west the family and guests. The pavilions, characterised by a strong 'staccato' quality, connected to the main body of the house, containing the state rooms, by means of narrow corridors which encased the service staircases.

The plan of the main body of the house underwent few, though significant modifications. Whereas in the 1726 design the east half of the house consisted

of two identical apartments, in the executed building the northernmost of the two had been reduced to almost useless proportions. The south apartment, instead, had grown into a full state apartment made up of saloon, drawing room, state bedroom and closet, thus reintroducing the formality of late seventeenth- and early eighteenth-century planning while, at the same time, not denying the new tendencies towards privacy and comfort which were met by smaller and cosier rooms in the family wing. A further example of this division is provided by the dining arrangements; there was a winter dining room in the 'rustick' floor (the ground floor) of the family wing (in summer they dined outdoors), but state dinners took place in the dining room in the main body of the house. This is a room provided with a deep half-domed recess for the buffet (which thus pre-dates the one designed by Adam at Kedleston), with hidden entrances for the servants at the sides.

Though the formal approach was meant to be from the south, so that the house with its 320-feet frontage and hexastyle Corinthian portico would be in full view of the visitor driving down from the Triumphal Arch and the Obelisk hill, the actual entrance was from the north front through a small, unassuming door. The visitor was suddenly projected into an incredible space: the hall measured 46 by 70 feet and was 43 feet high. The rectangular space was ringed by fluted alabaster columns of the Ionic order, standing on a high alabaster plinth, and supporting a heavy entablature and deeply

The Marble Hall, Holkham Hall.

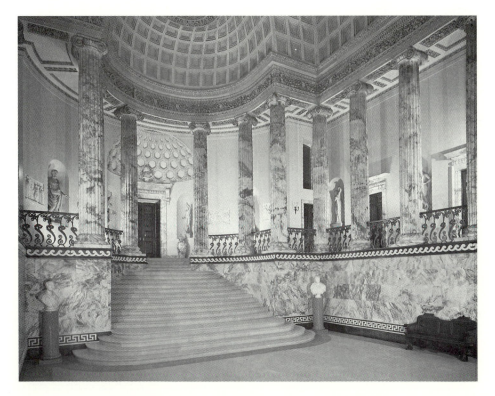

coffered cove. The Marble Hall is a space of outstanding classical feeling, which would have had a powerful impact on eighteenth-century visitors acquainted with the classical Roman temples from which so many details had been borrowed, such as the general proportions of the order derived from those of the temple of Fortuna Virilis, the ornaments of the cove based on those of the Pantheon of Agrippa, the hexagonal coffers of the great niche leading into the saloon modelled on those in the temple of Peace.

To add to the classical feeling of this room there were casts of classical sculptures decorating the niches along the colonnade. The Hall (completed in 1764) was obviously designed almost as a *coup de théâtre*, to frame the view of the owner of the house appearing at the top of the staircase to greet his guests. But there is also a strong mystical element, the suggestion of a route of initiation leading towards the inner space lying behind the door framed by the columns. It is possible that the plan of the Marble Hall contains a certain amount of free-masonic symbolism, which is also present in the bas-reliefs on the fireplaces in the saloon.

The Statue Gallery on the west side of the main block was referred to by Arthur Young as 'the rendez-vous room' or the social centre of the house. It linked the family and strangers' wing, not only to each other but also to the dining room at the north end and the drawing room on the south.

Comfort was one of the preoccupations of the builder, who installed a furnace beneath the floor of the hall. This was kept warm by means of brick flues that, in Brettingham junior's words, 'have their funnels for the conveyance of smoke carried up in the lateral walls'. There was also an engine (installed in 1741) conveying water to a lead cistern placed on the lower roof of the family wing for the bath and water closets, where the stools were made of marble.

In contrast to its plain formal exterior, the interior of Holkham Hall was lavish and splendid, with extensive use of mahogany, marble, and richly carved and gilt ceilings. As in other neo-Palladian houses there was a basic division between rooms painted white and heavily gilt which served as repositories for books and statuary – at Holkham even the window curtains were of white damask; rooms destined to house paintings, where the walls were hung with damask or cut velvet in strong colours, such as crimson, green and yellow; and rooms, such as the bedrooms, hung with tapestries. At Holkham the tapestries for the green state bedroom were specially made at Mortlake after designs by Francesco Zuccarelli. Furniture was relatively sparse, and tended to be concentrated in rooms such as the library and saloon. In the library, for instance, there was a large settee covered with black leather, six large armchairs, three easy chairs, nine rush-bottomed chairs, two mahogany tables with drawers, two mahogany reading desks and a mahogany chess table.

Paintings were by far the most important furnishings; by the time of Coke's death there were 233 paintings in the house, hung very densely, two or three deep, and generally following a thematic arrangement. The saloon, which has now been rehung as in the eighteenth century, contained only history paintings and was meant to illustrate virtue and the strength of love. All the canvases had been commissioned and acquired in Rome.

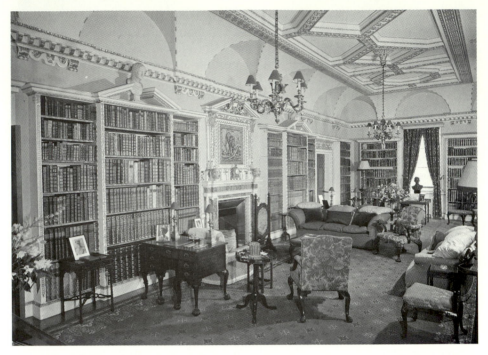

The Long Library, Holkham Hall.

The Saloon, Holkham Hall.

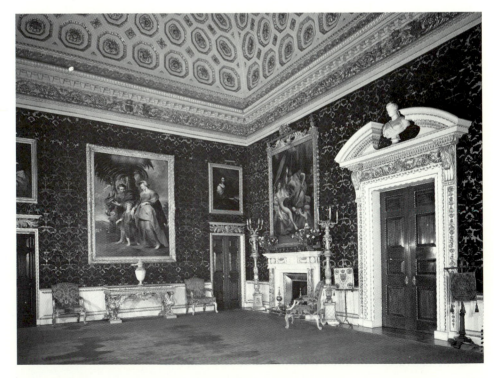

A similar arrangement by subject-matter governed the hanging of the dressing room to the state bedroom, known since 1756 as the landscape room. Twenty-two landscape paintings of the greatest seventeenth-century masters were gathered in this room; today only the Claudes and Dughets are kept here, but in Coke's time there were paintings by Domenichino, Salvator Rosa, Luca Giordano, Orizzonte, Locatelli and Vernet. The view from the Venetian window of the landscape room presented the onlooker with a modern, man-made version of the pastoral landscapes decorating the room. To the south-east he could see the pleasure ground with Kent's orangery and two grottoes; views towards the Obelisk and Temple opened in front of him to the south, while to the south-west he could see the mount with Kent's stone seat at the head of the basin. Very little remains of the original gardens, but the modern visitor to Holkham can still appreciate the vision of beauty that guided the builder and enjoy the house which, unlike so many others, has undergone almost no change since its completion.

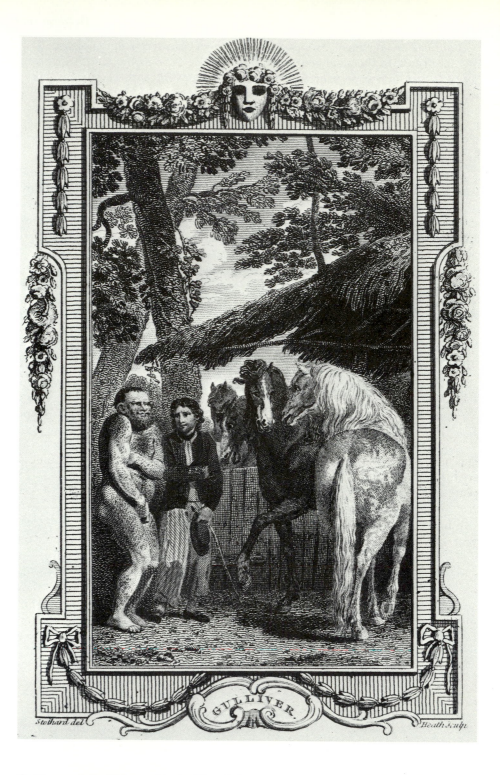

Gulliver and the Yahoo with the Houyhnhnms, *Thomas Stothard's illustration for* The Novelist's Magazine (*1782*).

5 Literature

PAT ROGERS

Introduction: Anglo-Augustan attitudes

There is no accounting for the vagaries of literary taste. In the high Victorian era a Scottish scholar wrote a history of English literature in two volumes, often reprinted. In it he allotted twelve pages to Milton, nine to Shakespeare, three to Byron – and eighteen to Erasmus Darwin, the author of a versification of Linnean botany, *The Loves of the Plants* (1789). Late eighteenth-century poetry is now better understood than it was a generation ago; but nobody will ever value Darwin in quite that way again.

To appreciate the greatest literature of the eighteenth century requires no special training or powers, though it does ask of us alertness, and a readiness to dissociate at times from modern sensibility in sympathy with an older pattern of emotional and psychological assumptions. Swift, Pope, Johnson and Gibbon create the readers they need through sheer power of expression and urgency of message. It is harder to come to terms with the second-order writers, like Darwin, and perhaps hardest of all to do justice at the end of the twentieth century to the near-great Hanoverian writers, figures such as Addison, James Thomson or Lord Chesterfield. These three figures were once extraordinarily influential, with editions pouring off the press year after year, for many decades after their deaths. They are now very difficult to retrieve, but the effort is worthwhile, for they are mostly in tune with the central energies of their age, whereas the Swifts and Richardsons stand often in an oppositional relation to the dominant ideas of their time.

We must first decide what these dominant ideas were. To speak very broadly, the characteristic slant of the age ran in the direction of clarity, order, compression, generality, smoothness of texture, refinement, restraint, civility, and above all what was called 'ease'. This last expression suggests a tempered yet relaxed approach. One of Alexander Pope's (1688–1744) most famous couplets, from his *Essay in Criticism* (1711) asserts, 'True ease in writing comes from art, not chance, / As those move easiest who have learned to dance'.

To display ease was to show a typical blend of mixed attributes –

confidence without arrogance, learning without pedantry, friendliness without
familiarity, and so on. Lord Chesterfield spent years trying, with little
ultimate success, to inculcate these qualities into his son and godson. Critics
and rhetoricians constantly adjured fledgling writers to exhibit such virtues,
and to abstain from the flashier kinds of writing. One can learn a great deal
about a given literary climate by inspecting the list of banned substances – in
Augustan aesthetics, these might include what was termed the 'pert', the '*à la
mode*', the 'trifling' or, of course, simply the dull – implying not merely
tedium but also a heavy, 'hebetating' or constipating quality. The satirists of
the Scriblerus Club composed in 1727 an anti-manual called *Peri Bathous: or
the Art of Sinking in Poetry*, which defines contemporary poetics by
negatives; it shows what Pope, Swift, Arbuthnot and their friends most
admired in literature by displaying the inverse.

Until recently, it would have been customary to subsume the literary
values we have just been considering under the convenient term
'Augustanism'. From the 1690s, people began speaking of a new Augustan
age in English literature, but in recent times the concept has come under
intense fire. It has been argued that people in the eighteenth century did not
admire the Emperor Augustus uncritically, and so it is absurd to attach his
name to the most deeply held positives of the later culture. More seriously, it
is asked whether expressions like order, moderation and restraint truly reflect
the practice of the best writers of the time. So there are two challenges to
face here. First, the issue as to whether 'Augustanism' is a helpful concept, in
describing the set of literary values traditionally associated with English
writers in the first three-quarters of the eighteenth century. Secondly, the
more radical question as to whether these stock associations are correct
anyway. Is Pope's *Dunciad* in fact moderate and balanced, or is it rather
shrill, despairing, extremist in form and style, bizarre, fantastic and
exorbitant in its effects?

This new way of looking at the writing of early Hanoverian Britain has led
to a shift in emphasis. We are now encouraged to look at what were formerly
considered un-Augustan activities within the culture. We are ushered in the
direction of outsiders in society, who might be variously the poor, the mad,
women, homosexuals, blacks or criminals. The implicit backing for this
strategy would lie in the belief that great writers like Jonathan Swift
(1667–1745) and Samuel Johnson (1709–84) are in effect outsiders in the
community, separated by the intensity of their moral or metaphysical vision.
On this reading *Gulliver's Travels* is not the wild misanthropic nightmare of
private paranoia, but the appropriate response of a free and healthy spirit
alienated by the disorders of the real England under the sway of Robert
Walpole. A new interest has grown up in cults such as free-masonry and
Rosicrucianism. Sexual underworlds have been explored and attention given
to people who were thought of as freaks in their lifetime, but who can be
viewed as victims of the 'Augustan' constraints. Within literature, emphasis is
laid on the dark and fantastic sides of human experience; the troubled
Johnson has been freed from the grip of (some would have it) the breezy and
superficial Boswell, whilst the obsessive and psychologically fraught fables of
Samuel Richardson (1689–1761) have gained at the expense of the apparently

cheerful and easy-going narratives of Henry Fielding (1707–54). Graveyard poetry by Thomas Gray and his contemporaries, once a minor by-road of poetic history, has been brought to the centre of attention; madness has become almost the normal state to be expected in a truly poetic sensibility of this period, with the mental collapse of several writers seen as an authentic aspect of their creativity.

There is some truth, as well as some exaggeration in this picture. But it is possible to go too far in this direction, and to align some mild melancholia of a country clergyman under George II too readily with the deep existential gulfs to be found in Dostoevski, Conrad or Kafka. Georgian England was not all sweetness and light, and neither was its literature; but it was not pervasively sourness and gloom, for that matter.

Over the particular issue of the concept of Augustanism, we need not agonise too much. The term was generally used, when it was current, to describe certain leading motifs and attributes of *some* English writing between roughly 1675 and 1775, with a main bearing on the restricted period 1700–50. It was always felt to be less appropriate to some of the new tendencies becoming apparent in the second half of the century: hence the invention of other terms such as 'pre-Romantic' (itself under assault nowadays) to refer to the more brooding and personal poetry of witers such as Gray and Collins. It never fitted very well the pragmatic, forward-looking vision of Defoe, even in the very heyday of 'pure' Augustanism; and though it suits Fielding, it scarcely illuminates the nature of Richardson's art. In some respects it makes good sense when applied to Johnson, whose roots lay in earlier intellectual history, and who was resistant to the European Enlightenment which – to put a complicated matter shortly – undermined the foundations of the Augustan creed.

The term is well enough, in short, if we use it with care; and do not attach excessive significance to its useful, periodising function. In fact, 'Augustan' literature is not all Augustan, any more than all literature of the Romantic era is romantic, or all modern writing modernist. But the word serves a purpose in pointing to a moment when certain kinds of literary ends and means were especially favoured. It rightly suggests that Swift, Pope and Johnson were deeply representative men of their time, and not just displaced persons whose great books might have appeared at any time in history.

Another term which has lost favour in recent years is the once popular label 'neo-classical', partly because it risks confusion with the rather different use of the phrase in the visual arts, where neo-classicism refers to a movement both better defined and considerably later in history. Moreover, the classicising urges of eighteenth-century England were always held in check by a combination of countervailing forces. British empiricism kept at bay any slavish adherence to Aristotelian orthodoxy among writers and critics. There are insanely pedantic followers of rules such as Thomas Rymer in matters concerning tragedy or John Dennis concerning epic; but the rules are essentially of their own devising. Then again, most 'classical' doctrine was mediated through French channels, and it was Boileau as much as Horace who provided an *ars poetica* for the age, Le Bossu and Rapin more than Aristotle who represented traditional orthodoxy in a handy form.

It is also worth remembering that the extent of classical learning among the reading public, and even among writers, can easily be exaggerated. The greatest student of the ancient world from this period was Edward Gibbon. As a boy he missed two crucial years of school through illness; it is still striking to find that he did not pick up any Greek at all from Westminster School or Oxford University. It was in Lausanne, aged eighteen, that he remedied the loss of years 'wasted in sickness or idleness', as he puts it in his memoirs, and seriously began the study of Greek. Then most women were excluded from classical learning, though a few brave bluestockings such as the scholar Elizabeth Carter and, less professionally, Hester Thrale braved the scorn of male bigots.

None of this affects the truth that Greek and, especially, Latin writers were the normal stock of schoolroom reading (nobody then studied vernacular literature in academic surroundings). It cannot be denied that there was genuine love and appreciation of a few favourite authors from the ancient world, most obviously Virgil, Horace, Ovid, Cicero, Terence, Martial, Homer and Pindar. Year after year translations and editions of these writers poured from the press: scarcely a decade went by without new versions of Aesop's fables, of the Greek tragedians, of Lucretius, of Juvenal or Persius. There were at least twenty significant renditions of Horace between 1680 and 1780. Much attention was given to historians of every order: Tacitus was perhaps the most admired figure, but an almost equal currency was enjoyed by Plutarch and Xenophon, whilst amongst Latin historians Sallust, Statius and Lucan followed in the wake of Suetonius and Livy. There were special favourites in other kinds such as the letters of Pliny the younger and the satiric fantasies of Lucian. All these were in some sense living classics.

In addition to the business of straight translation, there was a popular mode of critical re-creation in which the modern poet took the themes and structure of an ancient work, but substituted contemporary examples. This form, generally known as the imitation, was practised by many of the leading writers: today the best-known cases are provided by Pope's imitations of Horace, together with Johnson's updating of Juvenal in *London* and *The Vanity of Human Wishes*. Not very far from this are the opposing forms of satiric reworking known as burlesque and travesty. Some of the cruder travesties make an unappealing read today, but works such as Swift's *Description of a City Shower* prove that classical set-pieces could be amusingly brought into a modern perspective, whilst the Scriblerian group devised a type of urban pastoral which reflects urgent topical reality rather than simply lampooning an old-fashioned mode of writing. In all these forms, ancient language is pressed up against modern feeling, and the effect is to throw the latter into sharp relief. Much eighteenth-century literature utilises these effects, directly or indirectly: thus, *Tom Jones* plays off the nobility of an epic adventure against the banalities of everyday life in the street or the inn; Defoe's *Tour* of Great Britain replays Virgilian Georgics on English soil; Thomson's *Seasons* transfers Mediterranean idyll to a temperate climate and landscape with distant vistas of the city.

This blend of literary reminiscence with topical reality gives eighteenth-century writing some of its characteristic flavour. The age was one of political

consolidation after the turmoil of the previous century; there were extensive improvements in travel, dramatic developments in industry and agriculture, and a range of new cultural media – the newspaper, concert-halls and playhouses across the country, assembly rooms and bookshops on a scale never before approached. The emergent novel has a whole new area of social life to deal with, and the popular new magazines chronicle a mode of existence more urbanised, more humane, more diverse than anything known in the age of Chaucer, Shakespeare or even Milton. Whilst the penal code remained severe, and the poorest people lived in the same unmitigated squalor as their forebears, most of the population shared to some degree in the bustle and expansion of Hanoverian Britain.

Peace and prosperity were not in evidence at all times or in all places, but they are not just the mythical constructs of liberal historians. An abiding confidence and sense of possibility pervade much of the literature: in this sense Defoe's *Tour* is more generally representative of the 1720s than is Pope's *Dunciad*. Towards the end of the period, a work like Burke's *Reflections* on the French revolution manifests some of the anxieties which were emerging, but at the same juncture Boswell's *Life of Johnson* expresses the continuing vitality of Augustan positives. We should be alive to the dark forebodings, but we should not allow these to drown out the chorus of hope, energy and activity.

Social changes necessarily influence the inner life of literary genres. Perhaps the most notable aspect of eighteenth-century writing is the relative dominance of non-fictional prose: forms such as the periodical essay, history and travel books occupy a larger place than they do in the modern age. Moreover, patterns of narrative in fiction were heavily influenced by the practice of historians. *Tom Jones* incorporates moral essays at the head of each constituent book, not as a withdrawal from serious imaginative business but as a way of imposing order on the anarchic life of the surrounding fictional events.

The most interesting aspect, direct or oblique, was that exerted by the travel book. Major works from *Robinson Crusoe* and *Gulliver's Travels* onwards use or parody narratives of travel. Several of the greatest writers wrote a straight travel book: Defoe on Britain, Fielding on his voyage to Lisbon, Sterne on his sentimental journey to France and Italy, Smollett on his travels in quest of health, Johnson and Boswell on the Hebrides. Apart from this, many absorbing traveller's tales are to be found in letters and diaries, further examples of the eighteenth-century leaning towards non-fictional prose forms. Lady Mary Wortley Montagu writes of her journeys on the European continent; Thomas Gray describes his visits to picturesque localities, and Horace Walpole his rambles to historic houses. Hester Thrale reports on France and Italy; William Beckford gives us a luscious picture of his sojourn in Portugal.

When aspirant travel writers took up their pen, there were models on every side. Thus Samuel Johnson could base his *Journey to the Western Islands* partly on a plan laid out by one friend, Charles Burney, whose musical travels had just appeared, and partly on the style of another friend, Giuseppe Baretti, whose *Journey from London to Genoa* was equally fresh. This area of

activity is an essential context for the rise of the novel, and it marks a clear shift in taste – as time went on, it became harder for educated readers to maintain their former degree of insularity. The library of even a small country-house would be stacked high with narratives of travel at home and abroad.

Poetry from Pope to Burns

John Dryden died in 1700, but it was not until the second decade of the new century that his natural successors were able to take over fully: Swift, because he was slow to find his natural style as a poet, and Pope, because of his youth. In the interval the most impressive practitioner in a variety of verse forms was Matthew Prior (1664–1721). He was the author of charming miniatures such as 'To a Child of Quality of Five Years Old'; hard-headed lyrics like 'A Better Answer to Cloe Jealous'; one spirited ballad, 'Down Hall'; a risqué tale, 'Paulo Purganti and his Wife'; and a remarkable poem which earned the admiration of Pope and Swift, 'Jinny the Just'. This is a tribute to a women who had been both housekeeper and mistress to Prior, written in rippling triple rhymes which underline a kind of jocose tenderness, recalling Swift's attitude to Stella:

> Her blood so well mixed and flesh so well pasted,
> That though her youth faded her comeliness lasted,
> The blue was worn off but the plum was well tasted.

In addition, Prior wrote two major poems in very different moods. *Solomon on the Vanity of the World* (1718) is one of the most elevated Augustan exercises on a moral theme; indeed, its picture of the 'sad experience of decay' in old age outdoes anything in Pope's *Essay on Man* – or for that matter Edward Young's hugely successful *Night Thoughts* (1742–6) – in terms of human insight. Quite unlike this is *Alma: or The Progress of the Mind* (1718), a discursive, jaunty and amiable mock-treatise on the seat of the soul. The skittish octosyllabic couplets are less robust than in Butler's *Hudibras* (1663–78), the most important model for Prior's flippant treatment of scholastic ideas. His learned wit has a Sternian air at times as it unravels the twists and turns of our mental processes, as in the witty contrast between the young English boy learning to spell by gnawing his gingerbread from left to right, whilst the 'Hebrew's hopeful son' proceeds in the opposite way:

> Devour he learning ne'er so fast,
> Great A would be reserved for last.

Another talented writer, Anne Finch, Countess of Winchilsea (1661–1720) left a fairly small body of distinguished work, especially reflective and atmospheric studies such as *A Nocturnal Reverie*.

But splendid poets such as Prior and Lady Winchilsea soon had to concede primacy to the amazingly precocious talents of Alexander Pope (1688–1744). In 1709, barely twenty-one, he published his teenage *Pastorals*: polished, civilised and replete with that kind of consciously indulged nostalgia for an implausible Arcadia one finds in Debussy and Ravel:

See what Delights in Sylvan Scenes appear!
Descending Gods have found *Elysium* here.
In Woods bright *Venus* with *Adonis* stray'd,
And chast *Diana* haunts the Forest Shade.
Come lovely Nymph, and bless the silent Hours,
When Swains from Sheering seek their nightly Bow'rs;
When weary Reapers quit the sultry Field,
And crown'd with Corn, their Thanks to *Ceres* yield.

('Summer')

The *Pastorals* make up a Botticelli tetrad, each part differing in setting, mood and pace, but all together fusing into a haunting idyll of lost content. To ask of these poems what relevance they have to the lot of real-life peasants is to betray a literalism that proceeds from a failure in imaginative engagement. Judged as art, Pope's poetry will survive almost any serious test.

Like Virgil, Pope moved on from eclogue to georgic. His youthful *Windsor Forest* was revised to celebrate the end of the long drawn-out Marlborough wars in 1713. Pope manages to make his poem an illicit Tory, even Jacobite, party manifesto, yet it transcends its locality in time and space (the Thames Valley at the end of Queen Anne's reign) as it debouches into the wide ocean at its noble climax:

The Times shall come, when free as Sea or Wind
Unbounded *Thames* shall flow for all Mankind,
Whole Nations enter with each swelling Tyde,
And Seas but join the Regions they divide;
Earth's distant Ends our glory shall behold,
And the new World launch forth to seek the Old . . .
Oh stretch thy Reign, fair *Peace*! from Shore to Shore,
Till Conquest cease, and Slav'ry be no more:
Till the freed *Indians* in their native Groves
Reap their own Fruits, and woo their Sable Loves,
Peru once more a Race of Kings behold,
And other *Mexico*'s be roof'd with Gold.

It is true that Pope has off-loaded the colonial burden on to the Spanish, but then the first British empire had not taken shape when he wrote on the eve of the Peace of Utrecht. At its deepest level this is not a report on world affairs, but a vision of communality. Its most vivid inner life is that of myth and prophecy, and here the accumulated energies of the poem (the Ovidian tale of Lodona, the seerlike entrance of Father Thames, the allegory of hunting as warfare) come to the poet's aid. *Windsor Forest* is the culmination of the non-satiric early Pope, as *The Rape of the Lock* is of his early satiric side.

Even more characteristic in its youthful élan is *An Essay on Criticism* (1711), which is now a slightly under-rated poem. To observe that Pope was not just the Oscar Wilde of his time but also its Dorothy Parker is to understate the seriousness of the *Essay* as a contribution to critical debate. With its enormous intellectual bounce, it is a sparkling primer in Augustan theory, relentlessly pointed and bejewelled because the aesthetic it recommends dealt in just those qualities. The cut-glass epigrams are more than a desperate gesture against a surrounding culture of licensed inarticulacy

Alexander Pope's Thames-side villa at Twickenham.

(as any twentieth-century use of epigram must be), but a decorous endorsement of the ideas expressed:

> A perfect Judge will *read* each Work of Wit
> With the same Spirit that its Author *writ*,
> Survey the *Whole*, nor seek slight Faults to find,
> Where *Nature moves*, and *Rapture warms* the Mind;
> Nor lose, for that malignant dull Delight,
> The *gen'rous Pleasure* to be charm'd with Wit.
> But in such Lays as neither *ebb*, nor *flow*,
> *Correctly cold*, and *regularly low*,
> That shunning Faults, one quiet *Tenour* keep;
> We cannot *blame* indeed – but we may *sleep*.

The carefully inserted italics are worth preserving, though they may be a distraction at first – Pope's antitheses are so minutely calibrated (*read/writ*; *Nature/Rapture*; *ebb/flow*, normally a dead cliché; *Correctly cold/regularly low* – the first might be worrying but the second is a full-scale disaster). It is an art of delicate verbal adjustment, and the final Byronic bathos comes with an added thump because the contrast is so much more basic and unmissable. Throughout the poem Pope confronts the idea of the true nature of judgment raised in this excerpt; the sanity and moderation he looks for in the critic are exemplified in his own good-humoured, easy-going language.

It is an astonishing triumph of tone for a man of twenty-three, and illustrates Pope's control of every poetic resource which was needed for a poem in the high Augustan idiom. By 1717 he could issue a retrospective

exhibition of his youthful works, in a volume which also contains the tense
emotional melodrama of *Eloisa to Abelard* and the vehemently passionate
Elegy to the Memory of an Unfortunate Young Lady, personal in some oblique
way which readers can recognise but no scholar can define. At this stage, on
the brink of thirty, Pope was turning away from mainstream creative activity
and devoting himself to the translation of Homer and later to editing
Shakespeare. It was satire which first brought him back to active poetic
composition, with the earliest version of *The Dunciad* and the beginning of
the *Moral Essays*. But there was also the opportunity to give himself a
philosophical and theological base with the appearance of *An Essay on Man*
(1733–4), at one time his most influential work across the whole of Europe.
One can readily understand why the *Essay* no longer commands the same
degree of interest. Those spanking couplets of the earlier *Essay* have become
plodding rhythmically; the joyous epigrams have become leaden
commonplaces, and the daring wit mere routine paradox. In fact, the trouble
is that Augustan idiom is supremely good at rendering worldly, sociable and
mythical truths, but it cannot stretch to prolonged metaphysical speculation.
The fault is generally found with Pope's shallow philosophical message;
actually it lies in the potentialities of his medium, the poetic art of his day.

Indeed, the most successful 'philosophic' poem of this decade was arguably
the work not of Pope but of a Scottish writer half a generation younger,
James Thomson (1700–48). His discursive four-part poem *The Seasons* came
out in stages between 1726 and 1730, and thereafter underwent revision for
the rest of its author's life. It is a new kind of literary entity: part-epic, with
nature rather than a human character (the hero): part moral essay, part
Miltonic imitation, part descriptive and scientific tract. *The Seasons* contains
certain 'lyrical' elements, for instance in the pastoral story of Damon and
Musidora in *Summer*, but usually Thomson incorporates landscape scenery
within a wider survey of the human environment. The manner of progression
is based on association, an affair of mood and feeling more than of Pope's
analytic logic: as Margaret Doody has said, 'Thomson expresses a sense of
ecstasy in seeing':

> Some easy passage, raptured to translate,
> My sole delight; as through the falling glooms
> Pensive I stray, or with the rising dawn
> On fancy's eagle-wing excursive soar.
> Now, flaming up the heavens, the potent sun
> Melts into limpid air the high-raised clouds
> And morning fogs that hovered round the hills
> In particoloured bands; till wide unveiled
> The face of nature shines . . .

<div align="right">(Summer)</div>

At first reading Thomson's style can seem loose and blowsy, but closer
acquaintance shows that the Latinate syntax allows the poet to achieve a
stately rendition of great natural displays like a storm. Thomson writes as an
impresario for the large theatrical events within creation, whether
meteorological, geological or astronomical. All these are seen as expressions
of the hand of providence, mysterious but not ultimately indecipherable.

Thomson's other work of surviving interest is *The Castle of Indolence* (1748), a poem in Spenserian stanzas describing the contest of industry and idleness. The first canto evokes the world of sloth, delighting in languorous scenes of decadent inactivity: Thomson heaps up the torpor to a point just short of absurdity. In the second canto we are introduced to the contrary principle, embodied in a knight of industry who embodies Hanoverian business at its most socially conscious. Sloth has some of the qualities of the English malady, that is melancholia; industry is also the bracing medical regime advocated by eighteenth-century physicians. There is only one other Spenserian imitation from this period which preserves any degree of life today, though many more were essayed. This is *The School-Mistress* (1737: revised 1742 and 1747) by the Midlands *littérateur* and amateur landscape gardener, William Shenstone (1714–63). Spenserian writing is a way of highlighting the 'antique' for comic effect, but it also permits the poet to escape the highminded dignity associated with blank verse and the taut intellectual imperatives of the heroic couplet. But soon new Augustan lyric forms evolved which made Spenserian costume unnecessary.

This new movement was ready to take over on the death of Pope and Swift in the middle 1740s. Its major figures at the outset were Thomas Gray (1716–71) and William Collins (1721–59), each a generation younger than Pope. A third figure who took longer to achieve his own idiosyncratic voice, Christopher Smart (1722–71), preserves more interest for us today, by reason of the greater ambition of his language and the innovative design of his poems. All three were writers of considerable talent who found the existing vehicles to hand inadequate to their purposes. Collins finally drifted into a depressive inertia, Gray devoted himself to miscellaneous learning and confined his poetry to occasional gnomic lyrics, and Smart found himself in Bedlam. But it could be argued that Smart was liberated as a writer by his alienation, where the others were rendered mute. Whilst Collins never moved on from the plangencies of the odes he produced in 1747, especially the 'Ode to Evening', with its subtle atmospheric colouring, and Gray attained the summit of his powers in the Eton College ode of 1747 and the famous *Elegy* of 1751, Smart supplanted some conventional early verse with the complexly patterned and highly inspirational verse of *A Song to David* (1763).

An even more radically novel approach is shown in Smart's *Jubilate Agno* (written around 1760, first published 1939). This is composed in a kind of free verse, i.e. a series of antiphonal prayers set out in a catalogue of names, objects, images and arcane allusions. There is a kind of deranged confessional note at times:

> Let Noah rejoice with Hibris who is from a wild boar and a tame sow.
> For I bless God for the immortal soul of Mr. Pigg of Downham in Norfolk.
> Let Abdon rejoice with the Glede who is very voracious and may not himself be eaten.
> For I fast this day even the 31st of August N.S. to prepare for the Sabbath of the Lord.

I do not know what this means, and the effort of modern scholars to reduce the poem to a rational scheme seems to fly in the face of its poetic logic, which is one of constant tangential flights. But there is an extraordinarily

compelling effect as the poem gradually piles up its store of disparate detail. Smart can be viewed as a holy innocent, but the interest of *Jubilate Agno* lies in the tension between the apparently random associative flow of Smart's mind with its repeated framework of intercession and response, and the enumeration of qualities, as in the case of Jeoffry ('. . . for fifthly he washes himself. / For sixthly he rolls upon wash.') One comes to Smart absorbed by questions of private pathology, but one ends up instead taken by the novelty of his idiom.

The case is almost the opposite with Gray. The immortal *Elegy in a Country Churchyard* adopts a deeply conventional language, chaste in its diction, replete with echoes from the best classical sources, refined in touch to an almost excruciating degree. It is the very precision of the grammar which serves to make a central point, the helplessness of humanity in the face of larger powers. People are constantly at the mercy of agencies beyond their control; they are 'prey' to the abstract processes of time, 'repressed' by penury, while their lot 'confines' and 'circumscribes' their doings. The mute inglorious Milton is celebrated for his inability to be his potential; denied an elegy in his own person, he is the recipient of the poem's collective tribute, for which a kind of unknown soldier-poet stands in during the concluding epitaph. Gray's is an apparently impersonal art which allows readers to import their own memories and associations, so general are the locutions, especially the personified nouns and qualifying epithets:

> Far from the madding crowd's ignoble strife
> Their sober wishes never learned to stray;
> Along the cool sequestered vale of life
> They kept the noiseless tenor of their way.

'Cool sequestered vale' is a representative phrase: simple monosyllables set against the long Latinate word, diction set against homely adjective, alliteration spread over the phrase (the *l* sound dominates the entire line), and typically Gray plants the main energies in mid-line, leaving the verse to die away slowly towards its end. Gray carries on the high Augustan poetic in one important respect: his care in the placing of stress, the phonetic architecture of the lines, the positioning of key parts of speech. The art of poetry, for most of the eighteenth century, lay in distribution of materials as much as in the raw *materia poetica* themselves.

To move one more generation ahead is to reach two significant figures who emerged in the third quarter of the century. James Macpherson (1736–96) is vastly important in the history of taste with his 'translations' of the Gaelic poet Ossian, produced between 1760 and 1765; but these are prose-poems in a special lingua franca which did not enter the mainstream of poetic idiom. The same is true of the Rowley poems of the amazingly precocious Thomas Chatterton (1752–70): despite the linguistic ingenuities of his mock-medieval verse, it belongs in a study of Romantic myth or of antiquarian curiosities. Once the medieval crust has been peeled off, the poetic innards are not especially notable for brilliance of imagery or felicity of expression.

Apart from two considerable poems by Oliver Goldsmith, the main utterance from this period is to be found in William Cowper (1731–1800). He

was another constitutionally melancholic man, and poetry was indeed consciously used as a remedy for depression. The *Olney Hymns* (1779), on which he collaborated with John Newton, furnish a useful reminder that hymnology was a major area of poetic activity. Cowper's lasting contribution derives from two sources: the blank-verse moralistic poem *The Task* (1785) and a series of intense short poems, mostly written in later life. Both categories include some impressively direct and heart-felt writing; the quality of his verse rises in technical control when he approaches matters of close personal concern. *The Task* is midway between Thomson's *Seasons* and Wordsworth's *Prelude* in date and also in emotional distancing; Cowper stands closer to his material than does Thomson, but views the natural scene in a comparatively detached manner.

> I saw the woods and fields, at close of day,
> A variegated show, the meadows green,
> Though faded; and the lands, where lately waved
> The golden harvest, of a mellow brown,
> Upturned so lately by the forceful share.
> I saw far off the weedy fallows smile
> With verdure not unprofitable, grazed
> By flocks, fast feeding, and selecting each
> His fav'rite herb; while all the leafless groves,
> That skirt th'horizon, wore a sable hue,
> Scarce noticed in the kindred dusk of eve.

A more anguished note is heard in many of Cowper's shorter poems, notably the poignant lines 'On the Receipt of my Mother's Picture', the verses 'To Mary' with their evocative use of these two words as a refrain, and the harsh Calvinistic allegory of 'The Castaway'. Though Cowper could work freely in different veins (the jaunty energy of 'John Gilpin', for instance), it is the depth of feeling in his poems of loss, regret and isolation which travels across the centuries to us.

The one eighteenth-century poet who regularly speaks to us almost as a contemporary and, as it seems, by nature, is Robert Burns (1759–96). It may sound inappropriate to describe Burns as the greatest poet in the language from this age, since the 'language' in this case is not standard English. But even if Burns is radically Scottish, in idiom as well as in outlook, it remains true that the basis of this style is traditional English poetic enlivened by the sappy, demotic Scots idiom, full of homely proverbs and sharp conversational accents. Burns is an intensely sophisticated writer, well aware of his predecessors on both sides of the border: his fund of allusion is wide, but he raids Pope in a truly Popian way, and he manages to play new tricks with the forms of his Scottish forebears, Ramsay and Fergusson. He wrote some justly famous lyrics, including 'The Banks o' Doun', 'A Red, Red Rose' and 'Annie Laurie' (often with a vague traditional basis), which display the most exquisite blend of tender sentiment and robust realism. Uncomplicated in structure, yet wonderfully polished in verbal architecture, these poems assail us with their clamorous phonetic life:

> Till a' the seas gang dry, my dear,
> And the rocks melt wi' the sun:
> I will love thee still, my dear,
> While the sands o' life shall run.

Burns is equally adept in the vigorous social and political manner of 'For a' and a' that', the homely fabular style of 'To a Mouse', the sturdy patriotism of 'Scots what hae', the satire of hypocritically 'unca guid' church elders in 'Holy Willie's Prayer', and the hypercharged narrative energy of 'Tam o' Shanter'. In every form, as also in his vivid letters, Burns commands a racy, densely packed language which gives his work a lasting currency.

In one sense Burns represents a dialect of high Augustan idiom, but as often the mutant form proved stronger than the main stock. Augustan poetry developed along several fronts; a formidable body of women poets, for example, have emerged from long neglect in recent years – with the sadly short-lived Mary Leapor (1722–46) among the most impressive. The art of poetry remained to contemporaries the keystone of literary composition, even if today we tend to be drawn rather to the innovations of the novel; there is much challenging verse to enjoy from a period whose artistic scope compasses both a Pope and a Burns, and whose lesser poetry covers just as wide a range.

The satire of Swift and Pope

Characteristically, satire is a form of reaction. Other modes of literature draw on real life, but in satire the dependence on everyday events and personalities is more marked. Satirists work directly off external reality, and however subtle or oblique their criticism they rarely stray from the actual or the contemporary. In formal terms, too, satire is reactive, preferring devices like parody, paradox, allusion and transposition.

The eighteenth century conducts its mockery of the world through a variety of mock idioms. Parody is the central instrument for greater and lesser satirists alike. In the case of Jonathan Swift the most obvious example would be *Gulliver's Travels* (1726), which is formally cast as a series of four journeys conducted by a ship's surgeon, and related in the exact manner of popular travel narratives of the day. Equally, *A Modest Proposal* (1729) offers itself as the earnest reforming pamphlet of a public-spirited pamphleteer (there were many such solemn tracts published every year, offering vegetarian diet or the suppression of the coffee-houses as a certain cure for national ills). *The Battle of the Books* (1704) mimics the style of an excitable journalistic account, as well as the narrative line of an epic poem. Its longer companion-piece, *A Tale of a Tub*, extends *ad absurdum* the habits of pedantry, both self-indulgent redundancies of modern authorship and the swelling paraphernalia of fusty scholarship.

Another major work to take scholarly excesses to a ludicrous (and hence, in a satiric context, culpable) extreme is Pope's *Dunciad*, especially when the poem first published in 1728 was augmented by a series of preposterous

accretions between 1729 and 1744. Even the bare fact that the poem becomes much longer, including a complete new Book IV within the text as well as numerous appendices and notes 'outside' the text, can be seen as ramming home Pope's central point: more and more unwanted books are being produced, and more and more waste paper drifts through the streets of London. Again, John Gay's *The Beggar's Opera* (1728) relies principally on its parody of the motifs of the fashionable Italian opera.

The two major satiric works of Samuel Johnson, *London* (1738) and *The Vanity of Human Wishes* (1749), are formally announced as poems in imitation of Juvenal. Many other books which are not exclusively satiric contain similar features: Fielding's *Tom Jones* (1749) regularly brings epic conventions down to earth, whilst Sterne's *Tristram Shandy* (1759–67) flirts with a succession of styles and modes, from the writing of wills to the enunciation of an ecclesiastical imprecation, from sermons to love-letters. Today we usually separate these works from formal satire; but actually they belong as squarely in the domain of satire as in the house of fiction. Fielding had begun as the author of burlesque tragedy such as *Tom Thumb* (1730), and Sterne had made his debut with *A Political Romance* (1759), a squib dealing with church courts.

The eighteenth-century satirists developed a battery of new devices for setting one thing against another – ways of contrasting ideas, values, principles, attitudes, styles, identities. Most Augustan satire operates on a binary scale, contrasting giants and dwarfs, ancients and moderns, great men (politicians) and their little suffering subjects, heroes and nonentities. The 'mock' idioms referred to are the means of putting these contrasting entities into some kind of friction. Among the best-known techniques thus utilised are mock-heroic, burlesque and travesty, imitation and mock-panegyric (Swift is the great master of this last). But there are also the town eclogue, the Lilliputian ode, the 'transprosing' of earlier works, and much else. A contemporary critic of *The Rape of the Lock* referred to Pope's 'heroic doggerel', and the poet might have adopted this as one form of satiric exposure. It will be apparent that there is an element of paradox in most of these terms. When Gay subtitles *Trivia* (1716) 'the Art of Walking the Streets of London', he is trivialising the idea of an art. It is only one stage beyond this when Pope links the serious and important idea of a rape, with its cluster of associations from Lucretia onwards, to the frivolity of a young lady's hairdo. Little semantic surprises were always at work in satire.

A simple version of this technique of contrasts is the opposition of a noble, heroic and distant age, as realised in epic, with a debased, sordid and all-too-present contemporary world. The familiar term 'Augustan' suggests that the loyalties of the eighteenth century must always have been backward-looking, and it is certainly true that the main line of so-called Tory wits in the tradition of Dryden tend to identify with the glories of the past, now threatened by a rampant commercial civilisation. Thus, in *The Battle of the Books* we see modern warriors (with the satire decoded, writers) dwarfed by the armour of their ancient progenitors. But the contrast does not always work so simply, the apparent polar opposites in Swift especially tend to shift around in disturbing magnetic storms, and the target is not always easy to

locate with certainty. There are moments in *The Dunciad* and in Johnson's *London* where the energies of the text seem to pull in these contrary directions: urban life is squalid and harsh, but it is *real*, and the attempt to live in an idealised past seems foredoomed.

The country as a locus of calm meditation, the good life lived according to the dictates of Horace, has a strong appeal to the eighteenth century. But there is a robust counter-tradition in which rural life is satirised as dull, provincial and soul-destroying: Johnson and Lady Mary Wortley Montagu contribute to this vein, but the finest expression comes in Pope's *Epistle to Miss Blount, on her Leaving the Town* (written 1714). The heroine Zephalinda is banished from urban enticements, but also from any rational amusement – she goes from 'opera, park, assembly, play' to a regimen bounded by 'plain work and . . . purling brooks, / Old-fashioned halls, dull aunts, and croaking rooks'. This wonderful poem is a kind of anti-Horatian epistle, which reneges upon a former loyalty. The major satirists are regularly subverting our expectations, because they confront their own deepest allegiances in the midst of the work.

This is nowhere more clear than in what is perhaps the greatest of all satires in English – *Gulliver's Travels*. Here the fundamentally rational Swift subjects the power of reason to merciless criticism; the basically patriotic Swift grinds British pretensions into little pieces. The fiercely loyal churchman, albeit troubled believer, produces a tale whose ending many competent readers have seen as despairing, even nihilistic. The cheerful, sociable good fellow whose motto was *vive la bagatelle* portrays human relations as brutal and oppressive. The sound Church of England man, the devotee of good order and strict administration shows human institutions to be corrupt and manipulable. The middle-class inhabitant of a common-sense Lockian age, the Dean in a Church which prided itself on avoidance of the extremes of catholicism and dissent, writes a book in which moderation is merely the impotence of the uninvolved, and where the 'sane' observer turns out the maddest of all the book's lunatics by the end. There is a real sense in which the book can be said to mock the central values by which Swift himself aspired to live. A fierce current of passion wells up in *Gulliver*, and the decent, all-too-well adjusted hero breaks under the strain, an outcome perhaps necessary for his creator to survive without his own psychological collapse.

The desperation that underlies an apparently placid text is produced by the most exquisite technical ordonnance. It is vital to the effect that Gulliver should make four separate, out-and-back voyages. Each time he returns to England, and this is always a moment of maximum revelation, at the end of each part and the start of its successor. This is seen most strikingly at the conclusion of the second and fourth books. Gulliver returns from Brobdingnag with his sense of scale totally disorientated, so that he views ordinary-sized people as no more than tiny animals which he might crush as he passed them. This delusion is fostered by his stay by turns in Lilliput, among the dwarves, and then in Brobdingnag, among the giants; his mistake would not have occurred so readily if he had gone straight to the land of giants. Gulliver's inability to readjust to normal-size reality and his

reluctance to settle back into family life ominously foreshadow his alienation at the end of the fourth book; by that time he has projected all his acquired phobias on to normal humanity, and in a comic image of his condition prefers to sit in the stable among the beasts whom he has come, in his delusion, to regard as transcending the human condition. But Swift's point – that we cannot transcend the human – comes across through the sheer imaginative energy of satire, destructive quite as much as constructive, rather as a bitter and sadly disabused conclusion. The force of the feeling belongs to a Timon rather than to a Socrates or an Erasmus.

Something like this happens in *A Tale of a Tub*, notably in the famous 'Digression on Madness'. Again Swift is personating a madman, but this time the narrator is complete with his delusions from the start. Happiness, indeed, is defined as 'a perpetual possession of being well deceived', and among all the many eighteenth-century visits to Bedlam this is one of the most unsettling – the jumbled accretion of suspended prefaces and misplaced digressions which constitutes its elaborately unformed 'form' helps to generate a sense of bewilderment amid frenzied yet pointless activity. The narrator's absurd confidence in the clarity and conviction of his own rhetoric displays his modern hubris, when it is set alongside the crazed intricacies of his zigzag argument. Swift, like Johnson, feared the power of the unbridled imagination, but his own poetic fancy produces a succession of dazzling conceits, allowing the narrator to consider

whether a Tincture of Malice in our Natures, makes us fond of furnishing every bright idea with its Reverse; Or, whether Reason reflecting upon the Sum of Things, can, like the Sun, serve only to enlighten one half of the Globe, leaving the other half, by Necessity, under Shade and Darkness . . .

The *Tale* employs jumbled form and incoherent rhetoric to show the unreliability of undisciplined thought, but its wildness is what gives it life.

Swift's third great satire, *A Modest Proposal*, begins with studied calmness, offering apparently a sober response to the famine and beggary of Ireland. It is only gradually that the inhumanity of the projected solution, that of using unwanted babies as a food source, becomes clear, and the claim of 'modesty' is exposed. A few key phrases help to blow the author's cover: the casual reference to the 'delicious, nourishing and wholesome' quality of babies' meat, and the heartless choice of words ('twenty thousand [children] may be reserved for breed'). By the end a note of desperation has crept into the proposer's utterance, when he suggests that his new scheme at least has in it 'something *solid* and *real*, of no Expense, and little Trouble . . .' Again there is some autobiographic involvement, as the satirist looks back to his own broken illusions.

Fitfully, Swift's verse contains passages of the same coruscating force. Best known is the bleak psychological realism of *Verses on the Death of Dr. Swift* (1739), a mock elegy to the author himself. The jabbing octosyllabic lines compress within their short compass a cruel vision of the world's indifference:

Behold the fatal Day arrive!
How is the Dean? He's just alive.

Now the departing Prayer is read:
He hardly breathes. The Dean is dead.
Before the Passing-Bell begun,
The News thro' half the Town has run.
O, May we all for Death prepare!
What has he left? And who's his Heir?
I know no more than what the News is,
'Tis all bequeath'd to publick Uses.
To publick use! A perfect Whim!
What had the Publick done for him!

Effects of comparable force and conciseness are found in a survey of the
literary world *comme il va*, entitled *On Poetry: A Rhapsody* (1733) and in a
bitter lampoon on the ineffectual Irish parliament, *The Legion Club* (1736).
This 'cursed long libel' is cast in one of Swift's favourite forms, the mock-
panegyric: towards the end, the author calls for the assistance of Hogarth's
art

Draw them like, for I assure you,
You will need no *Car'catura . . .*

Caricature was a recent import into the language, and this exotic skill is one
which, Swift implies, only a few choice spirits have yet mastered. It is for
young Hogarth to carry on where the author and Pope have laid down the
burden they had long borne as conscience of the nation.

The directly opposite technique to mock-encomium is that of false blame,
that is a putative attack which turns out to be an endorsement. The supreme
example of this device in Swift occurs in a series of poems he wrote to his
friend Esther Johnson, known as 'Stella'. In the years before her death in
1728, Swift wrote for Stella a number of birthday poems, oddly charming
despite their grudging air of qualification and half-reproof. 'Resolv'd to
mortify your Pride, / I'll here expose your weaker Side': behind the banter
lie affection, respect and a sense of Stella's resplendent worth: 'You, every
Year the Debt enlarge, / I grow less equal to the Charge.' The simple
birthday poems show the feints and sleights of satire inverted to produce a
starkly beautiful mode of commendation.

The other major satirist of the period, Alexander Pope, presents some
instructive points of contrast and comparison with Swift. Swift was an
Anglo-Irish member of the established church, who was condemned to
physical exile. Pope, a Home Counties member of the proscribed Roman
Catholic faith, underwent something nearer internal exile, because of his
religion and his desperate invalid condition. Both men in the Scriblerus Club
helped to develop an allusive, learned and disrespectful vein of satire: there
are roots for *Gulliver*, for *The Dunciad* and for *The Beggar's Opera*, in the
doings of the club. But even Swift's best poems have the air of licensed
ventures into a province not wholly his own. Pope was a highly professional
poet in adopting a vocation and plotting a career on the model of Virgil. His
influence on English poets in every branch of the art was incalculable, but at
the heart of his achievement lies his work as a satirist.

Two great mock-heroic poems are augmented by a brilliant series of

Horatian imitations and four verse epistles on moral themes, along with many brilliant crackerjacks, such as his famous epigram on a dog which Pope presented to the Prince of Wales:

> I am his Highness' Dog at *Kew*:
> Pray tell me Sir, whose Dog are you?

In sheer imaginative conviction, that is density of specific detail allied to the most exquisite fashioning of the poetic texture, nothing can quite compare with *The Rape of the Lock* (first published in two cantos in 1712, revised version in five cantos in 1714). The plot is based on a real-life piece of gossip, concerning the premarital escapades of a young Catholic girl who had been the victim of a coltish young nobleman's pranks. The very first couplet alerts us to the standard mock-epic device of exalting trivial material into the matter of high art:

> What dire Offence from am'rous Causes springs,
> What mighty Contests rise from trivial Things.

The trouble is that, to a well-bred young lady on the brink of marriage, any cause for offence was far from trivial – and amorous affairs were something to be negotiated with the utmost caution, or else the consequences for her prospects in life were dire indeed. It is the miraculous achievement of *The Rape of the Lock* that almost every line in the poem is the merest persiflage; almost every line carries the deepest implications. Belinda, the heroine, is a silly chit, bemused by her shallow upbringing as well as by her innate vanity; but she is also a mythical archetype, a victim of the sexism of history, and a displaced Berenice.

At the end of the poem Belinda's stolen lock is wafted up to the heavens as a new star. The concluding lines claim that Belinda will be immortalised by this means:

> *This Lock*, the Muse shall consecrate to Fame,
> And mid'st the Stars inscribe *Belinda*'s Name!

The claim is both comically absurd and painfully accurate, just as the 'rape' is a nasty sexual event as well as a preposterously exaggerated non-event. But the emphasis can be put the other way: there is a serious issue about sexuality at the heart of the fable, and yet the poetry is always defusing the situation through its wit, its inappropriate range of fantasy and its readiness to see the funny side of every potentially tragic event.

The construction of the poem is extraordinarily complex. There is a minute epic drama, with the customary episodes (for example, a journey to the underworld in Canto IV), besides a large number of individual allusions to Homer, Virgil, Milton and others. It is a replay of earlier mock-heroic classics, notably Boileau's *Lutrin* and Garth's *Dispensary*. Sustained allusions are made to a variety of sources, including Mercutio's Queen Mab speech from *Romeo and Juliet*, snatches of Spenser, a number of periodical essays by Addison and Steele, and the comedies of Wycherley and Congreve – both, incidentally, friends of the poet.

The matter does not end, however, with precise literary resonances. As is

apt in a poem which has elementals as leading characters, in the shape of
sylphs and gnomes, much play is made with the old idea of the four elements
– Canto I is clearly dominated by air, Canto II takes place on water, and
Canto IV is set deep in the earth at the outset. The first four cantos conform
still more regularly to an allied scheme, that is the favourite Renaissance
model of the four times of day. The earliest stage ought to be dawn, but here
we have a comically delayed aubade: the alarm goes off at noon (when
'sleepless Lovers' are said to awake) but Belinda is still sunk in her
'Morning-Dream'. Stage two is traditionally high noon, associated with the
sun-god Apollo, and this is exactly rendered in the boat journey up the river.
The third stage is represented by evening, and the teatime games in Canto
III are framed by the setting sun. The fourth stage is that of midnight, and
appropriately Pope sets Canto IV in a dark grotto 'screen'd in Shades from
Day's detested Glare'. The final canto makes up a resumptive element, much
as James Thomson was to add a concluding hymn to his four poems on *The
Seasons*.

In comparison with the formal perfection of *The Rape of the Lock*, there is
something ill-proportioned about the shape of *The Dunciad*. Its extension
from its original three-book form (1728) was made by means of a totally new
series of episodes, which appeared as *The New Dunciad* in 1742. This became
Book IV in the final version of 1743, and many readers have felt that the new
material is not fully integrated. In the revised version Colley Cibber,
dramatist, theatrical manager, autobiographer and a Poet Laureate with more
skill in court patronage than in courtly verse, is aptly made leader of the
Dunces' party, and the plot requires him to work in league with a Queen
Dulness who has many obvious lineaments derived from the consort of
George II, Queen Caroline. *The Dunciad* had always been a largely political
work: within the first half-dozen lines, as far back as 1728, we had been
reminded, 'Still Dunce the second reigns like Dunce the first'. But as Pope's
opposition to the Walpole administration grew more bitter through the 1730s,
this strand became equivalently stronger in the poem. By 1743 it is as
important that the King Dunce has political connections as that he should be
an incompetent writer. For the scope of the satire is amplified in the new
fourth book, and what had originally been a plague of authors and a
publishing ecodisaster has now become a vision of ubiquitous moral, political
and social decay. The wonderful peroration to *The Dunciad* had perhaps been
too grand for the events described in 1728; but in the revised version
'universal Darkness' indeed threatens, as

> Art after art goes out, and all is night,
> See skulking Truth to her old cavern fled,
> Mountains of casuistry heaped o'er her head!
> Philosophy, that lean'd on Heaven before,
> Shrinks to her second cause, and is no more.
> Physic of metaphysic begs defence,
> And metaphysic calls for aid on sense!
> See mystery to mathematics fly!
> In vain! they gaze, turn giddy, rave, and die.
> Religion blushing veils her sacred fires,

And unawares morality expires.
Nor public flame, nor private, dares to shine,
Nor human spark is left, nor glimpse divine!
Lo! thy dread empire, Chaos! is restored;
Light dies before thy uncreating word;
Thy hand, great Anarch! lets the curtain fall,
And universal darkness buries all.

Even the control exercised by Pope's matchless virtuoso writing cannot altogether withstand the onset of intellectual anarchy.

One does not have to accept Pope's gloomy estimate of England under Walpole to enjoy the immense bravura of the writing; the remarkable skill in bringing together diverse targets, ranging from opera, butterfly-collecting and tulip mania to trends in philosophy and education; or the amazing surrealistic fantasies:

Round him much Embryo, much Abortion lay,
Much future Ode, and abdicated Play;
Nonsense precipitate, like running Lead,
That slip'd thro' Cracks and Zig-zags of the Head;
All that on Folly Frenzy could beget,
Fruits of dull Heat, and Sooterkins of Wit.

This is recognisably the historical Cibber, with his hopeless birthday odes seeping out every year. But he is also the descendant of Dryden's MacFlecknoe, and this is important because the plot of the poem hinges on succession (mimicking the succession both of monarchs and of laureates) and it is a conscious updating of *MacFlecknoe*. One of the key images running through *The Dunciad* is that of abortion; literally interpreted, this refers to the abortive literary ambitions of poetasters like Cibber, but the deeper currents of the notion run into hidden psychological caverns, where the forbidden and repressed side of Augustan rationality confronts the idea of parturition.

For the most part the *Imitations of Horace* lie closer to the familiar domain of social satire. The most vivid single items are perhaps the prologue to the series, as the *Epistle to Arbuthnot* (1735) became in due course, and the two dialogues which make up the *Epilogue to the Satires* (1738). These works contain an apologia for Pope's own life as a satirist and an examination of the public role of satire, quite apart from an aggressive reassertion of the opposition case against Walpole. A vivid passage at the end of the first dialogue of the *Epilogue* contrasts the fate of 'virtue' (that is, the opposition) with 'vice' (the Walpole government machine). Vice prospers under official patronage:

Let *Greatness* own her, and she's mean no more:
Her Birth, her Beauty, Crowds and Courts confess,
Chaste matrons praise her, and grave Bishops bless:
In golden Chains the willing world she draws,
And hers the Gospel is, and hers the Laws:
Mounts the Tribunal, lifts her scarlet head,
And sees pale virtue carted in her stead!

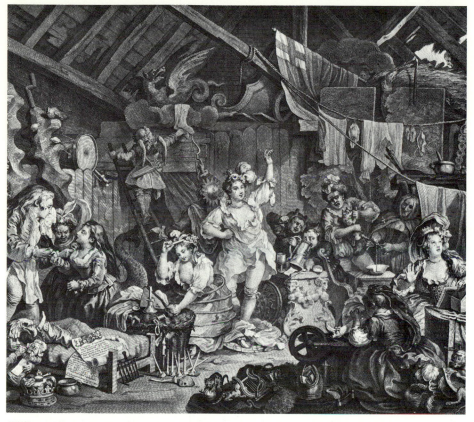

William Hogarth, Strolling Actresses Dressing in a Barn *(published 1738), a satirical view of life behind the scenes.*

The vision extends beyond the topical to a sense of the pervasive effects of corruption in any political system.

By comparison, the *Moral Essays* have a slightly more relaxed air: even the intensities of praise and blame for those with taste and without it, anatomised at length in the *Epistle to Burlington*, strike a more measured note than the fierce personal animus of the *Epistle to Arbuthnot* permits. Three of the four *Moral Essays* achieve outstanding articulacy on topics that are not particularly easy to convert to great poetry: the characters of women in *To a Lady* (1735); the use of riches in *To Bathurst* (1733); and taste, specifically in architecture and landscape gardening, in *To Burlington* (1731). These three poems are beautifully organised, as they move from character-sketch to anecdote, from convivial chat with a friend to intense meditations on the course of nature. At a key juncture in the epistle to Burlington, the poet moves from the wicked knockabout satire of vulgar Timon to a brief reflection on the transience of all human constructs:

> Another age shall see the golden Ear
> Imbrown the Slope, and nod on the Parterre,
> Deep Harvests bury all his pride has plann'd,
> And laughing Ceres re-assume the land.

Another age would have turned to epic, or lyric, or perhaps more recently the novel, to express its sense of mutability: in the Hanoverian era satire was the natural form to accommodate these ideas.

After Pope and Swift the course of satire follows a downward path. John Gay managed to attain some of their delicacy, but not their strength, in poems such as *Trivia* (1716); his *Beggar's Opera* (1728) is another variant of the anti-Walpole rhetoric, here playing with the conventions of Italian opera, to denigrate the misdeeds of people in high places. Samuel Johnson emerged as Pope's natural successor with his caustic updating of Juvenal's imperial Rome as Georgian London in 1738, but his only other major contribution to formal satire was in the still darker poem on *The Vanity of Human Wishes* (1749). By the middle of the century satire has weakened from a mode of writing into an attitude, to be found in Johnson's own *Idler* essays or the novels of Smollett, but no longer as committed as it had been in the days of *Gulliver*. Indeed, by the time we reach Cowper's *Table Talk* and *The Progress of Error*, published in 1782, what we have is rather a sort of good-natured grumbling on broad moral issues. A single exception might be made in respect of Charles Churchill (1732–64), whose meteoric career, wild private life and adherence to John Wilkes have distracted attention from his considerable skill as a writer of formal satire. Almost all his longer poems, notably *The Rosciad*, *The Prophecy*, *Gotham* and *The Times*, contain passages of great verve; but, as he put it in *The Candidate*,

> Enough of Satire – in less harden'd times
> Great was her force, and mighty were her rimes.

Satire survived as a minor feature of the literary landscape, as many could achieve a surface resemblance to Pope's ordered couplets, without being able to replicate the underlying threat. It was not until Burns that a major talent was devoted to satire, and it was later still, with Byron's *English Bards and Scotch Reviewers* in 1809, that a true successor to the great Augustans appeared.

The novel from Defoe to Fanny Burney

For a hundred and fifty years the novel has been the dominant literary genre; in the seventeenth century, it hardly existed as a distinct mode. It was during the period covered in this volume that a recognisable kind of modern prose fiction evolved. One consequence for readers is that we generally feel the lack of a clear central voice of authority, even in the face of such acknowledged masterpieces as *Clarissa*, *Tom Jones* and *Tristram Shandy*. The novel still inhabited a *demi-monde* up to the time of Fanny Burney, who was embarrassed about entering this unladylike purlieu in the republic of letters for that reason. For writers, the novel remained much more marginal and aberrant than we can easily conceive today. The pioneering novelists (most obviously Sterne) had read far fewer novels than the average educated person in the West nowadays. Even Fielding, who consciously set out to enhance the status of the form, drew more on ancient epic, stage comedy, romance and

the moral essay than he did on (as he thought) the halting practitioners who had preceded him – Defoe, Eliza Haywood, and so on.

This situation might suggest uncertainty but there are also opportunities for experiment, a clean slate, a site of untrammelled innovation. The three great novels mentioned in the last paragraph are all amazingly original, in form, style and outlook. The founding fathers and mothers of the novel took advantage of the freedom from constraint which demireps enjoy.

There were naturally some readers who were strongly drawn to the experience of reading fiction. Many of these were women, such as Lady Mary Wortley Montagu, desperately anxious in her Italian exile to receive parcels of the latest books from England. There were avid male readers too, though the balance of the sexes in the contemporary audience is impossible to fix with accuracy. Whether or not village church-bells rang out at the then idyllic retreat of Slough to greet Pamela's wedding, Richardson's novel unquestionably spawned innumerable sequels, parodies, translations and ripostes. Throughout the century the novel steadily grew in visibility.

But we must not exaggerate the swiftness or the completeness of this change. One striking instance may be cited; Hester Thrale (later Piozzi), the friend of Johnson and Fanny Burney, had a lifelong addiction to reading and wrote a number of interesting books. She owned thousands of books on all kinds of recondite subjects. But she possessed only a handful of novels, and once in a fit of depression she confided:

No books would take off my attention from present misery, but an old French translation of Quintus Curtius – and Josephus's History of the Siege of Jerusalem. Romances and novels did *nothing* for me: I tried them all in vain.

Such a preference for ancient history over modern fiction was far from eccentric in the period: the new form had to displace existing tastes in reading which were not supplanted without a long struggle.

Daniel Defoe (*c.* 1660–1731) is more of a primitive than a pioneer. In his masterpiece, *Robinson Crusoe* (1719), he found an ideal vehicle for his purposes: the story of an average, not very sensual man cast adrift from civilisation, finding the hand of providence in his deliverance and survival. Defoe's peculiar blend of secular and spiritual concerns informs the fable, as does his lifelong obsession with catastrophe and the wonders of nature. The storms that rage through Defoe's fiction may serve to allegorise tribulations in personal life (of which Defoe had his fair share), but they are also the way God punctuates his great message of salvation to those believers who have learnt to read creation.

It is well known that later thinkers such as Rousseau and Marx have found in *Crusoe* a ready-made exemplum for their particular views. It was the radical impurity of the novel which enabled Defoe to pack *Crusoe* with a rich cargo of ideology. Unpacked, this amounts to what is often termed the 'myth' of Crusoe, that is a series of overlapping themes grouped around the idea of an outcast, a prodigal son, a colonialist, an adventurer, a proto-imperialist, a closet capitalist, an avatar of bourgeois self-advancement in the 'middle station' of life, a pre-Victorian apostle of self-help, a Puritan convert, man in the state of nature – and much else. Some of these versions of Crusoe are

hard to reconcile with the details of the narrative (contemporaries would have thought of him more as a Christian missionary than as any sort of entrepreneur). But the diversity of the list shows the richness of the book's inner life.

In *Crusoe* Defoe evolved a prose that can make few claims for elegance, but which renders the hero's day-to-day, indeed minute-by-minute, experience with extraordinary precision. A good example is found in the journal Crusoe keeps during his early days on the island.

> . . . and the first thing I did, I filled a large square case bottle with water, and set it upon my table, in reach of my bed; and to take off the chill or aguish disposition of the water, I put about a quarter of a pint of rum into it, and mixed them together; then I got me a piece of the goat's flesh, and broiled it on the coals, but could eat very little; I walked about, but was very weak, and withal very sad and heavy-hearted in the sense of my miserable condition; at night I made my supper of three of the turtle's eggs, which I roasted in the ashes, and eat, as we call it, in the shell; and this was the first bit of meat I had ever asked God's blessing to, even as I could remember, in my whole life.

The passage starts as though it will be concerned with external things, and Defoe's famous particularity in measuring appears in such phrases as 'I put about a quarter of a pint into it'. But the sentence straggles into personal feeling, absorbed more by consciousness than by objective reality. We are close to the physical events, and so Defoe can refer to '*the* turtle's eggs' or '*the* ashes', as previously mentioned. But the narrator's own relationship to these events is what matters; in the final cadences there is a characteristic intervention ('even as I could remember') which delays the main clause.

Defoe's main contribution to the new form was this power of intense realisation of commonplace experience: the old epic or high tragedy could have survived without intimate personal detail, but the novel could not. This faculty is equally evident in *Moll Flanders* (1722), with its remarkable depiction of the heroine's muddled life, as she lurches from sexual escapade to crime, and veers between an almost terrifying honesty and a tortuous self-deception. The book also contains more vivid comedy than any other novel by Defoe, much of it concerned with the games lovers play as they manoeuvre for position and advantage. That theme is more insistently present in *Roxana* (1724), the story of a courtesan gradually trapped by circumstances and ending up (apparently) as the unwilling accomplice in her own child's murder. But the conclusion is huddled, and for most readers it will seem a disappointingly inconclusive book.

A more assured artistic success is *A Journal of the Plague Year* (1722), which graphically reconstructs the events of 1665 in and around London. It is the most sensuously alive of Defoe's narratives, full of the horrific stench and corruption of a city under siege. Once again Defoe's imagination was drawn to the idea of catastrophe: this time there was more than personal obsession involved, for he wrote in the wake of the South Sea Bubble in 1720, and the entire text can be read as a fictional replay of that national trauma. There are hints of *The War of the Worlds* here; but we should recall that the same metaphor of a spreading national disease occurs in *The Dunciad*, just six years later.

Defoe is unique in his time for the literary power and creative vitality of his works, although he is equalled in technique and constructive skill by several of the women writers – most notably by Eliza Haywood (1693–1756). Though her best-known work, *Betsy Thoughtless* (1751), appeared late in her life, she was active much earlier on, and earned along with Defoe a niche in *The Dunciad*. Symbolically enough, she is found there, 'Two babes of love close clinging to her waist'. Insofar as this extends beyond the usual calumny directed against women who ventured to come out as professional authors, it represents a suggestion that the new novels were bastard children of literature, an attitude which the Scriblerian aristocracy of letters could maintain without difficulty. Later women writers had to struggle against the same prejudice, and whilst Henry Fielding safely emerged as a respectable classic, his sister Sarah Fielding (1710–68) has scarcely escaped from the kitchen in the house of fiction. The novels of Charlotte Lennox (*c.* 1730–1804) excited the admiration of Johnson and others, most notably her sparkling satiric romance, *The Female Quixote* (1752).

By the time that Lennox and Sarah Fielding were publishing, the role of women in works of fiction had been transformed by the practice of Samuel Richardson (1689–1761) who was a friend and supporter of both these ladies. Richardson had initially found a way in the first part of *Pamela: or Virtue Rewarded* (1740) to make the sexual experience of a teenage maidservant into something morally challenging. The novel is cast in epistolary form, and the isolated condition of the heroine is made more actual by this device. The advantage of using letters is that Pamela can be shown as addressing real people (her family) rather than performing to the imaginary audience of implied readers. In his sub-title Richardson is remembering a familiar proverb. 'Virtue is her own reward'; he intends the book to bear this out, for the point is not that Pamela conveniently earns an earthly reward for a show of 'vartue', as Fielding suggested in his cruel parody, *Shamela* (1741): rather, the novel illustrates the way in which natural, unaffected goodness will bring self-content and the possibilities of a full life. Not all maids will marry their masters, and not all maids would wish to marry Mr. B; but dutiful daughters will at least turn out contented wives. All Richardson's morality is conventional; the detailed dramatisation lifts his work above dull homiletics.

This is most evidently the case in his masterpiece, *Clarissa* (1747–8). This time the story is more complex, involving a wider family background, a hero with more personal and social identity, and a more elaborate structure involving different tones of correspondence. Nevertheless, the central drama is that of the heroine – her persecution, her seduction, her ultimate rape, and her saintly death. Notoriously *Clarissa* is a slow-wheeling, massively dense book; and it needs to be, to express the gradual curve of Clarissa's earthly and spiritual condition (down and then upwards). Her rape, rather than her death, is the low point; but even this is not the sensational climax it might be in the fevered romances of the day. The long attrition between Clarissa and her oppressors, notably Lovelace, involves more than sexual dominance, though indeed this form of power relation is seen as crucial to the possibilities of independent life for women. Richardson has, too, the courage to make his hero genuinely attractive as well as genuinely evil. If *Tristram*

Joseph Highmore, Pamela shows Mr. Williams the hiding place for her letters.

Shandy is a book where all climax is averted, then *Clarissa* is one where logic inexorably works itself out despite the efforts of characters and narrator to forestall the tragedy.

Richardson tried to repeat some of these effects in a male context with *Sir Charles Grandison* (1753–4), but few readers have found comparable merits in the later novel. Richardson has turned to comic, social and discursive means, where those of *Clarissa* had been tragic, private and dramatic. The unsuitable woman in the hero's life is made melodramatically neurotic and Italian; she and the 'good' woman, Harriet Byron, have some of the depth of portrayal found in the earlier book; but nothing can save the irredeemably virtuous Sir Charles, while praises of this 'best of men' run through the book.

In his lifetime Richardson was placed in rivalry with Henry Fielding, and posterity has found ever more refined ways of pursuing the comparison. In each case an innovative first novel is followed by a masterpiece, and then comes a slightly disappointing out-of-character item to conclude the sequence. Fielding's opening salvo came with *Joseph Andrews* (1742), which soon abandons its notional purpose of burlesquing *Pamela*, and takes the English novel out to joyous open roads of rumbustious comedy. The glory of the piece by general consent lies in Parson Adams, a wonderfully fresh

creation despite his lineage in earlier comedy. Adams is at once innocent and commonsensical, ineffectual and highly competent (as with his fists), irascible yet immensely good-hearted. An equally important component in the design is the character of the narrator, cheerfully importunate, allusive, capable of arrogance but not of mean spirit. With the addition of this genial master of ceremonies to its stock of devices the novel took a long step forward. Not even Cervantes, Fielding's great master, had employed so free a narrative voice. It is the opposite extreme from Richardson's highly dramatised epistolary manner; thus, within a generation, English fiction had already acquired a sophisticated set of formal arrangements.

Tom Jones (1749) supplies the prime evidence; it is an outstandingly resourceful work, cast in an elaborate scheme (eighteen books, halfway between Homer and Virgil). The opening six books concern Tom's childhood and adolescence in the deep country; the individual books cover periods ranging from five years right down to three days. Then the pace quickens as Tom goes out on the road. At the very midpoint of the novel, the complicated farce at the inn of Upton takes place. These two central books take up twenty-four hours exactly: the pattern of expansion then reverses the earlier movement. With Book XIII we reach the last segment of the novel, based on London, and the time-span covered in these six books increases once more, though in a matter of days rather than weeks or months.

Each block of the narrative has a corresponding tone and texture: in the first and last sections, we have a relatively stable *dramatis personae*, characters who remain visible for long periods as the relatively static hero and heroine waltz around one another. By contrast, during the middle section, whilst Tom and Sophia are on the road, each in turn pursuing the other, we encounter a changing cast of characters, many of them outsiders and vagrants (punch and judy men, soldiers, a highwayman, and so on). Typically we are in a world of chance meetings, stray contacts between socially uprooted individuals (as Tom has himself become after his dismissal from his boyhood home at Paradise Hall). By contrast Somerset is a stable, traditional society where everyone knows his or her place, dominated by landed gentry such as Allworthy and Squire Western. London is more claustrophobic and its dominant image is the prison where Tom finds himself. In short, the formal layout mirrors a complex scheme in the narrative, echoing Tom's social condition as he moves from one sphere of life to another.

This patterning, emphasised by the critical essays set conspicuously at the head of each book of *Tom Jones*, enhances rather than weakens the vigour of the narrative. The same could be said of the full-scale mock-heroic passages which interlard the story. Fielding largely abandoned these methods in his last novel, *Amelia* (1751) and the outcome is a less engaging, less exuberant and ultimately less successful work. Sentiment has to do more of its own work, without the help of literary pointing or authorial intervention. Despite this, there are some fine genre pictures in *Amelia*, as the story descends into levels of urban squalor little traced in literature since the time of Defoe.

Fielding had another rival among contemporary novelists, according to some views then current. This was Tobias Smollett (1721–71), a Scottish doctor with naval experience who developed the main Cervantic line with

books such as *Roderick Random* (1748), an angry and scornful picture of mid-century manners; and *Peregrine Pickle* (1751), nearer to traditional picaresque, with some topical coverage of London scandals thrown in. In *Sir Launcelot Greaves* (1762) Smollett makes an attempt at the full-blown Quixotic enterprise. Some good moments ensue when the absurd idealist Greaves confronts the wicked machinations of his adversaries, but the characters – villainous or otherwise – are too eccentric to provide a convincing picture of the social order. A more effective narration appears with the epistolary manner of *Humphry Clinker* (1771), where a group of characters move around Britain supplying different accounts of the passing scene to their chosen correspondents. *Humphry Clinker* provides a broad survey of contemporary life in vivid brush-strokes, and shows how far the novel had advanced as a medium of social comment.

Smollett's comparatively thin achievement as an artist cannot stand alongside the amazingly individualist reworking of the novel which came from the hand of Laurence Sterne (1713–68). Quite simply, *Tristram Shandy*, which appeared in instalments between 1759 and 1767, is a prolonged experiment. Fielding had evolved the novel of the open road, with long vistas, broad narrative effects, and unimpeded progress along a well-charted itinerary. By contrast *Tristram Shandy* turns the world of fiction into something resembling the chaos of modern urban traffic: it is replete with stops and starts, sudden U-turns, unexpected diversions and the threat of collisions. The mood is comparably taut, one of jangled nerves and panicky shifts of gear. Yet this is a great comic work, where the fraught uncertainties of the narration are constantly lightened by the high-spirited and elastic quality of the narrator.

Much of the joke is implicit in the anti-climax of the first scene. Traditionally comedy presents young lovers thwarted by their elders and finally achieving their goal – officially marriage, in reality consummation in bed – at the dénouement. This is all inverted in *Tristram Shandy* – the main couple of the book are already in bed together, already middle-aged and married, and have lost all their oestrus and desire. Not surprisingly after this, the nominal hero, Tristram, has great difficulty getting born. He never approaches sexual fulfilment; the book ends with another image of impotence. In fact, the entire novel turns around sterility, failure, anxiety.

We expect the 'life and opinions' of Tristram to form a progress towards maturity and achievement. Instead we get the fall of the house of Shandy: nobody moves on, Uncle Toby lives out his past, Walter substitutes one fantasy after another for reality, death is pervasive (Tristram has numerous intimations of his own approaching demise), there is a total inability to communicate – Walter and Toby do not listen to one another as they harangue the void, poor Mrs Shandy is seldom allowed a mumbled sentence. Yet the final effect is far from dispirited, such are the élan and bounce of Sterne's story-telling, above all in the energetic staccato rhythms of his prose:

As Obadiah's was a mixed case; – mark, Sirs, – I say a mixed case, for it was obstetrical, *scrip*-tical, squirtical, Papistical, – and as far as the coach horse was concerned in it, – caballistical – and only partly musical . . .

What the narrative method does on a large scale, the prose does in little. *Tristram Shandy* abandons preordained sequence, and lives by spurts and sallies. Nobody could quite follow Sterne's act, and the novel went back to its destined path for the next century and a half.

Max Byrd has aptly said of *Shandy* that, as 'the first great work of the new imagination, [it] celebrates just those private claims and moments that the Augustans repress'. The observation applies equally to *A Sentimental Journey* (1768), a fictionalised version of Sterne's travels in France and Italy in search of health (actually the *Journey* gets no further than the south of France). Here the distance between narrator and reader is still more elided, with Parson Yorick communing with all willing to share his generous impulses. The book ends with a famous *double entendre*: 'So that when I stretch't out my hand, I caught hold of the Fille de Chambre's END OF VOL. II'. This is an emblem of non-consummation as it is of non-completion; one cannot be sure whether Sterne is mimicking prudery or drawing attention to the unattainable. Either way, his art of zigzag and blind alleys shows the novel, within little more than a generation from *Crusoe*, turning away from adventure towards the life within. It is a commonplace that Sterne anticipates the latter history of the novel; but then it was always his business as a writer to get ahead of himself.

The last considerable practitioner active in our period was Fanny Burney (1752–1840). Although she outlived Jane Austen comfortably, her most creative time as a writer occurred well within what is generally called the Johnson era. She made an instant hit with her youthful novel *Evelina* (1778), the story of a young lady's entrance into the world. This can be seen as a feminine equivalent to the picaresque, with elaborate social rituals surrounding the heroine, whereas the footloose *picaro* is allowed to rattle unhampered around the world. *Evelina* is constructed in a neat arch of three segments, and its epistolary style suggests intimacy and heartfelt feeling rather than the dry factuality of the male rogue's tale. Despite a conventional resolution (poor Evelina has to wait on the discovery of a father and the attainment of a husband to become herself), the book survives through its sharp social observation and relaxed comedy. However, its less famous successor, *Cecilia* (1782), is a deeper book, with a more mature heroine and a more searching emotional range. Interestingly, too, the hero, Mortimer, is allowed against expectation to be irresolute, self-doubting and dependent upon the stronger Cecilia. Along with some melodrama, there are some poignant scenes in the book, especially those involving the lovers (once approaching a kind of Schubertian lyrical outburst in a garden) and those concerned with Cecilia's philanthropic friendships. Men do not emerge very well, with Cecilia's three guardians either manipulative or vulgarly repressive. However, Burney was too conservative in background to reach through to open feminist statement; the ending is less radical than the earlier implications had promised. Still, *Cecilia* is the last great Augustan novel, that is to say the culmination of the early history of the form. After 1800 things would be different, and even the apparently unradical Jane Austen would have to outgrow her apprenticeship in the old ways of writing.

The climate of Johnson

'The age of Johnson', long beloved of textbook compilers and other drudges in literary history, is no misnomer. Samuel Johnson (1709–84) truly dominates the world of letters for a third of a century. This was partly by sheer force of personality, the side which is most familiar to us from Boswell, but which emerges with equal clarity from other sources – from Mrs Thrale, from Fanny Burney, from Sir John Hawkins and many others. It is also to do with his place in Hanoverian culture, for Johnson seems to proceed in a stately unmoving measure, like a Ptolemaic earth around which lesser bodies rotate. These 'lesser' figures include many of the most important writers and artists of the day, ranging from the painter Reynolds to the actor Garrick, from the historian Gibbon to the musician Burney, and from the politician and man of letters Burke to the dramatist Sheridan. Even though the famous literary Club was all male, Johnson had a number of important contacts with women – most notably with Mrs Thrale and Fanny Burney, but also with the novelist Charlotte Lennox and the bluestocking Elizabeth Montagu. He touches contemporary life at innumerable significant points, politics and business as well as the arts. Johnson's intellectual contribution was immense in its diversity: crucially, the great *Dictionary*, but also considerable creative works (in poetry, the novel and the essay), one masterpiece of criticism, an outstanding psycho-biography, and one of the most profound travel books which has ever been composed.

Johnson sums up the era, but he was not altogether representative of it. His massive idiosyncrasies of character, as well as the sturdy independence of his mind, made him appear a wild monster to some of his contemporaries. But behind the surface freakishness, which caused a landlord in Derbyshire to describe him to Boswell as 'Oddity . . . the greatest writer in England', lies a huge sanity; just as behind his psychic disturbances, about which so much fuss has been made, lies a deep normality and common humanity. It is an adventitious fact that he found in Boswell an almost perfect biographer, who was able to render a whole complex of social life whilst narrating the subject's life-story. Thanks to Boswell, we know Johnson chiefly as he appeared within the community – in the tavern, the coffee-house and the pleasure garden, rather than the study. This is a good thing, for Johnson's private struggles have a chiefly biographic interest, whereas his public life moves beyond pathology into the deepest well-springs of national life.

In one way he was very typical of the leading figures in the Hanoverian arts. Like many other writers, actors, painters and composers, he was a provincial of relatively humble background, who struggled to success from unpropitious circumstances. It is indeed the exception to find a luminary of the London artistic world in this epoch whose origins lay in the capital. London was a magnet for Johnson, just as for so many others, and he is distinguished by the fierce loyalty which he developed for the city.

This migration from the provinces to the city (echoing a transition made by thousands of men and women) had obvious implications for the artistic career of individuals in the Johnson circle. It helps to account for the intense professionalism of Reynolds and Burney – their single-minded drive for

Thomas Rowlandson, Coffee House *(c. 1780)*.

success, their astounding diligence in their quest for honours and recognition. But it also affected the nature of the art produced. Smollett's sense of displacement from Scotland allows him to render the adventures of the orphaned and exiled with special clarity. His first and probably best book, *Roderick Random*, presents in his own words a modest merit struggling with every difficulty to which a friendless orphan is exposed. In the end, as is the way of things, the hero turns out not to be a true orphan at all – but Smollett is confronting an existential state as much as a literal condition of birth. In similar fashion Goldsmith's *The Deserted Village* takes on added poignancy – it is already an exceedingly poignant work – from the fact that its author never returned to his roots in County Longford in the Irish midlands.

As regards Johnson, it is striking that his first important work, *London* (1738), plays around a complex network of competing feelings. The poem follows its model in Juvenal by portraying an act of renunciation: 'injured Thales', reminiscent of Johnson's friend Richard Savage, 'bids the town farewell', resolved to breathe the purer Welsh air 'from vice and London far'. But even within the poem there are contradictions and ambiguities: London is corrupt and sordid, but also vigorously alive. And going outside the text we inevitably confront the point that Johnson, far from renouncing London, proceeded to settle there for the rest of his long life. Though intensely loyal to his boyhood home of Lichfield, it was many years before he made regular visits, and a profound compulsion prevented a journey back to see his dying mother.

Carlyle apostrophised Johnson in the guise of the hero as man of letters, and as one who dignified the trade of professional writing by his stern resolution to live by the power of his pen, rather than by flattering wealthy patrons. Johnson's readiness to accept a pension from the crown in 1762 does not conflict with this assertion. He paid the King in print none of those obsequious courtesies which litter the panegyrical dedications of the reign; even when he supported the King and his ministers, as at the time of the War of the American Revolution, he kept aloof from sycophancy. And £300 per annum did not make very rich one who had known real poverty. One story tells of a beggar who stopped Johnson and said he wanted money. 'So I do too', replied Johnson simply. It was not a callous dismissal; the relative indigence in which Johnson passed most of his life is a standing rebuke to the rest of us.

However, Carlyle perceived another dimension to Johnson's greatness. He wrote, 'Figure him there, with his scrofulous diseases, with his great greedy heart, and unspeakable chaos of thoughts; stalking mournful as a stranger in this Earth . . .' There is indeed a quality of farouche loneliness in the man. His disdain for conventional good breeding, his reluctance to join the fashionable herd in modish sentiments, his capacity for outrageous and spontaneous gestures, his huge sense of fun and lack of pomposity in dealing with children or afflicted people – these are the natural adjuncts of a writer who could see Shakespeare in a wholly individual way, who battled first-hand with *Paradise Lost* in his life of Milton, who would not bow down before Rousseau in the contemporary cult of feeling, who could describe the influential Hume and his followers in language of homely scorn – 'Truth, Sir, is a cow which will yield such people no more milk, and so they are gone to milk the bull.' His own scepticism in matters outside religion was highly developed: everything had to be tested and examined. Even the *Dictionary* contains numerous entries which cite previous definitions but express lack of credence in these former explanations.

In all this, we see a man with a kind of savage and primitive purity, an instinctual independence, a pre-civilised directness of vision. One of the things that draws us to Johnson is his attachment to waifs and scoundrels, witnessed by the strange menagerie of people who came to inhabit his far from luxurious home in Bolt Court, where he lived from 1776. Another attractive trait is his readiness to accept the friendship of Boswell, and indeed to reciprocate it, when most of polite London thought the younger man a dissolute upstart. Warmth and humanity shine out in Johnson's life, as in the generosity of spirit which allowed him to apologise freely after a heated argument; and they also appear in the pages of the *Rambler* and the life of Savage. Johnson does not attempt to conceal the many faults in Savage's character; but there is a strong sense of 'there but for the grace of God', and a firm recognition that it ill becomes the privileged to disparage such an unfortunate (albeit self-destructive) human being. 'Those are no proper judges of his conduct who have slumbered away their time on the down of plenty.'

Johnson contributed to most of the significant forms of literature, to poetry and, unsuccessfully, to tragic drama; to the moral essay, to travel literature,

and to satire. His miscellaneous writings for the trade, including prefaces, dedications and short essays on current affairs, exhibit his enviable capacity to turn his hand to anything, but they do not constitute what we should easily recognise as art. A more durable quality is found in his prayers, meditations and sermons; for anyone as intensely religious as was Johnson, such writings represent a major expense of spirit.

The work which it is now hardest to appraise at its full value is the *Dictionary* (1755). It was in the lengthy compilation of this work – virtually unaided, apart from amanuenses who stood in for the modern photocopier – that Johnson truly found himself as a writer, harnessing his immense powers to a major task which required the fullest stretch of his mind. The superbly trenchant definitions, together with the mass of supporting quotations, offer a critical account of English as a means of thought and communication. Joined to these was the eloquent Preface, pervaded by the traditional notion that 'the chief glory of every people arises from its authors', and full of Johnson's clear-headed and sceptical realism: 'It remains that we retard what we cannot repel, that we palliate what we cannot cure.' The discussion in the Preface of the causes and effects of linguistic change still bears insistently on our current worries about words in the 1990s.

Johnson is probably most celebrated today for his literary criticism, and this is for good reason. He brought to the critical task a cluster of qualities which are hard to command even as single attributes. He was learned in many fields, with a specially formidable equipment in the area of Renaissance humanism derived from his prodigious reading as a boy and a young man. He had an outstandingly good memory, a cognitive faculty now much under-rated. This helped him to detect allusions and reminiscences in poetry, above all, and contributed to his extremely acute sense of verbal propriety. Many of his discussions in the field of practical poetics remain as thought-provoking as anything ever produced: one can still learn much from his passage on 'representative metre' (that is, sound imitating sense), which suddenly emerges during his analysis of the *Essay on Criticism* in his life of Pope.

Again, Johnson was preternaturally hard-headed and logically rigorous: he did not allow authors to get away with short-cut arguments, fallacies or unsupported generalities. He was sympathetic where he admired strongly, but

The definition for 'lexicographer' in Dr Johnson's Dictionary *(1755).*

LEXICO'GRAPHER. *n. f.* [λεξικὸν and γράφω; *lexicographe,* French.] A writer of dictionaries; a harmlefs drudge, that bufies himfelf in tracing the original, and detailing the fignification of words.

Commentators and *lexicographers* acquainted with the Syriac language, have given thefe hints in their writings on fcripture. *Watts's Improvement of the Mind.*

quite unashamed of expressing dislike or disdain where this seems called for. His Preface to the edition of Shakespeare (1765) exhibits most of these qualities, and so do the lesser-known notes to this edition, which embody a particularly clear-headed response to the Shakespearian text. He can enlist a dogged fidelity to the exact words on the page which is at least as precisely observant as the best passages of Richards or Leavis, Empson or Wilson Knight. This was not because he was trained as an analytic critic (other than having studied classical poetry in great detail in his youth); it was an innate talent for reading, and an assiduously prepared receptivity to all forms of literature.

Another great work deriving from Johnson's later years is his *Journey to the Western Islands of Scotland* (1775). This makes an admirable foil to Boswell's more anecdotal account of the same trip: Johnson provides a survey of manners and customs, where Boswell concentrates on incident and dialogue. The key passage of the *Journey* occurs at its centre, when the travellers are rusticated for a time on the Isle of Skye. Johnson proceeds to analyse various features of Highland life, ranging from the economic organisation to language, myth, popular superstition and much else. It is an exemplary piece of cultural commentary, which today would require the combined services of a sociologist, an economist, an anthropologist, a cultural historian and a folklorist. The encounter of a learned metropolitan mind with the raw reality of distant Highland areas provides a classic eighteenth-century clash of the civilised and the 'primitive'; no book better reflects the psychomachia of an age which was proud of its high Mediterranean heritage, yet beginning to yearn for Nordic austerities.

One short poem written near the end of his life shows that Johnson's creative powers had not waned. This was the elegy he composed for his friend Robert Levett, an obscure medical practitioner who spent the last twenty years of his life in Johnson's household. Levett is characterised by oxymoron as 'obscurely wise, and coarsely kind'. His ministrations to the poor displayed 'The power of art without the show'. Levett was 'Of every friendless name the friend'. In nine lapidary quatrains, Johnson manages to express grief for his friend without violating the norms which the restraint of Augustan poetics placed on him. It is precisely the achievement of a poem like this one to say intense and personal things in a dignified, impersonal and even oblique way:

> In misery's darkest caverns known,
> His useful care was ever nigh,
> Where hopeless anguish poured his groan,
> And lonely want retired to die.
>
> No summons mocked by chill delay,
> No petty gain disdained by pride,
> The modest wants of every day
> The toil of every day supplied.

Here the method is one of generalising for added weight and plangency; to say that lonely people crept away to die would draw attention to their individual deaths in squalid circumstances, whereas the style works to

establish a general human condition by means of a personified abstraction ('want') which transcends the separate instances.

The *Lives of the Poets* (1779–81) appeared originally as prefaces to a collection of the major English poets, as then defined. They embody some of Johnson's most mature and fully pondered views, based on a lifetime's firsthand acquaintance with the literary life. Their interest lies poised somewhere between the areas we should now clearly discriminate as the critical and the biographic. Sometimes personal factors can be felt to obtrude a little too much, as in the case of a great poet, Milton, whose private and political selves tend to distract Johnson at times. However, where Johnson found a truly congenial subject, as with Dryden and Pope, he writes with sustained intellectual energy and sensitive awareness of poetic effects. Another major life in this series is that of Cowley; the poet is no longer a living classic, but the discussion is, thanks mainly to Johnson's trenchant and not easily answerable comments on the excesses of the metaphysical style. In an age which knew no Pelican guides, no World's Classics or Everyman Library, it was Johnson who did as much as anyone to establish a living tradition in poetry. One cannot pick up the *Lives* even for a brief moment without coming on some touch of inspired understanding, either of men and women or of books. Here one finds a master-class in reading early modern poems, a course in Augustan poetics and a documentary history of the eighteenth-century mind.

In no other era would one expect to find an actor at the very centre of the literary world. But David Garrick (1717–79) emphatically belongs in the mainstream of this narrative, as he touches significant developments in literature at many points. He was a lifelong friend of Johnson, starting as one of the very few pupils Johnson attracted to his school outside Lichfield. When the two men went to London, it was the younger who first achieved fame, when his performance as Richard III in 1741 heralded the arrival of a magnetic stage presence. By 1747 Garrick had become manager of Drury Lane theatre, an event marked by Johnson's fine prologue reviewing the history of English drama from Shakespeare onwards.

For the next three decades Garrick dominated the theatre; though there were able actors and actresses in profusion, it was he who gave the stage a central role in English culture such as it has never quite enjoyed since. He did much to bring discipline to theatrical companies, experimenting with 'authentic' scenery and costumes, and instituting regular rehearsals. He helped to regularise the technique of acting, developed a whole grammar of gesture, and brought the eloquence of dramatic representation within the purview of rhetoric. He acted as a director in the modern sense, but also as chief executive of the company, advancing its use of publicity (one reason for the numerous images of Garrick made by the greatest painters – Reynolds, Gainsborough, Hogarth, Zoffany and others). He extended the repertoire, writing new plays of his own as well as bringing on stage many of the best new works of the era; he worked as play doctor, revamping older pieces; he kept Restoration comedies alive and maintained, for almost the first time, a stock of classic plays for intermittent revival.

Above all Garrick took a key role in the burgeoning enthusiasm for

Sir Joshua Reynolds, Garrick Between Tragedy and Comedy *(1761)*.

Shakespeare. At first this meant playing the central roles in the more popular items – some plays we value today were rarely seen on the eighteenth-century stage, whilst others were invariably seen in truncated or adulterated versions – most notoriously, Nahum Tate's anodyne *King Lear* and Colley Cibber's extensively improved *Richard III*. Garrick himself had to face criticism for his *Hamlet* (1772), which indeed was not without the Prince but did dispense with many features commonly thought worth keeping, including the macabre comedy of the final act. Voltaire, at least, would have approved. But such seeming aberrations ought not to distract us from the major service which Garrick performed in fostering an awareness of Shakespeare.

 All this came to a head in the great Shakespeare Jubilee of 1769, masterminded and overseen by Garrick. It was perhaps the most representative artistic event of the whole eighteenth century, combining high art with low junketings; it had specially commissioned music by Thomas Arne, backdrops by Joshua Reynolds, and a new ode by Garrick himself. It was crudely commercial on one level, and naively nationalistic on another. Yet it marks a hugely important epoch in cultural history, with the birth of bardolatry, and it sums up a whole process of growing taste for earlier literature. When Goethe and Herder celebrated Shakespeare in 1771, they were replaying the Stratford ode in a different key. It is no exaggeration to

say that whole course of European romanticism might have been diverted but for the events of 1769. They had one master publicist as their organiser, and another – James Boswell – as their press officer. The event marks a high point in Garrick's unique dominance of the English performing arts. It can only be matched by the mania surrounding his retirement in 1776, again an episode of European magnitude.

After his death in 1779, the leading representative of the theatre in the Literary Club was Richard Brinsley Sheridan (1751–1816). In fact Sheridan's three major plays all date from Johnson's lifetime: his witty updating of Restoration comedy, *The Rivals* (1775); his brilliant study of hypocrisy and malicious gossip, *The School for Scandal* (1777); and his exuberant satire on playhouse politics, *The Critic* (1779). Among these *The School for Scandal* is his masterpiece, a work with the vigour in characterisation and skill in dramatic management of Ben Jonson; its dialogue is as pointed and eloquent as that of Oscar Wilde, but the civility is less self-conscious and strained.

Eloquence was indeed almost a fatal Cleopatra for Sheridan; it brought him immense reputation as an orator when he entered the House of Commons in 1780, after which the stage took second place to public affairs in his life. His six-hour speech during the trial of Warren Hastings in 1787 was once a classic item of English eloquence; such elaborate rhetoric now strikes us as chilly and we regret Sheridan's gradual relinquishment of his career as a dramatist. It is true that he managed Drury Lane quite successfully after Garrick's retirement, but the new house erected in 1794 was not to everyone's taste. It burnt down in 1809, leaving Sheridan's financial affairs – already severely damaged by gambling – in a disastrous state. Sheridan was a figure of the Johnsonian meridian who was unable to perform with the same self-assurance in the twilight of eighteenth-century values.

Eloquence is also a touchstone in the case of Edmund Burke (1729–97), Johnson's only rival as a conversationalist in the Club. His major contribution to literature, narrowly defined, came in his early aesthetic treatise on *The Sublime and the Beautiful* (1757). This was both influential and innovative, stressing the psychological factors in artistic response and drawing attention from the creator of an artwork (where it had generally lain previously) towards the reader or beholder. Burke gives a new valuation to emotions such as awe and terror, allowing more importance to 'negative' qualities such as darkness, silence, solitude, roughness and sheer scale. It is not directly a refutation of the Augustan positives of harmony, proportion and smoothness, but in setting out an equal pairing of the beautiful and the sublime Burke in effect helped to downgrade the former in favour of the latter.

Burke's power as a writer is more directly seen in works such as *Reflections on the Revolution in France* (1790), which moves beyond prophecy of the horrors to come in Paris into a metaphysical discussion of political order, as well as *A Letter to a Noble Lord* (1796), an *apologia pro vita sua* unmatched in argumentative cogency. To men and women of Johnson's day, the arts of rhetoric thus engaged were barely distinct from the expressive devices employed in poetry or music; but the gap has been widening ever since, and we no longer have a critical vocabulary to describe the aims and methods of eloquence.

A masquerade scene in the Pantheon, 1773.

The year of the festivities surrounding Garrick's retirement from the stage was notable in several ways, quite apart from events on the other side of the Atlantic. Joshua Reynolds delivered his seventh discourse to the Royal Academy; Pierre Letourneur began to issue the first reliable French translations of Shakespeare's plays – a pioneering effort inspired by Garrick's jubilee. But the most remarkable literary events in Britain came in the publication of Adam Smith's *Wealth of Nations*; the first part of Charles Burney's *History of Music*; and the opening instalment of Gibbon's *Decline and Fall of the Roman Empire*. The works by Reynolds, Smith and Burney are part of a wide-scale enterprise to chart modern learning and taste. Collectively these books show the immense intellectual capacity of the Literary Club at this juncture, especially when we consider that Sheridan's greatest plays emerged a year earlier and a year later, respectively, that Burke had just a few months earlier delivered his great speech on conciliation with the American colonies, and that Goldsmith's last success, *She Stoops to Conquer*, was only three years old. Thomas Warton's innovative history of English poetry had first seen the light a bare two years earlier.

It was a moment of astonishing creativity, the high-water mark of English eighteenth-century literary culture, and the Club's own contribution was immense. But it is the great history of Edward Gibbon (1737–94) which casts the largest shadow; even though modern research has overtaken the detailed findings of the *Decline and Fall* and supplanted many of its sources, virtually no professional historian will deny its pre-eminence as a narrative and as a conceptual analysis of the course of empire. Its huge scale, temporally and

geographically, is matched by a firm intellectual control, with Rome the pivot of everything. Gibbon gave several accounts of how he came to envisage the great work whilst musing in the ruins of Rome. In fact, the genesis of the work goes back many years; Gibbon's early reading in antiquarian volumes, his passion for historical geography, his belated Grand Tour to Italy in 1764–5, his intense literary urges from boyhood onwards – and of course his keen interest in the life around him, for the *Decline and Fall* is among other things a survey of the human comedy.

Gibbon managed to unite the different powers of the 'erudites' and the philosophical historians as no one else could. The former were the learned antiquarian scholars who had emerged in the seventeenth and early eighteenth centuries; a representative work here is Montfaucon's *Antiquité Expliquée* (1719). The second group was essentially the historical vanguard of the Enlightenment, with Montesquieu and Voltaire at its head, and with the Scottish historians Hume and Robertson following a comparable path. Put crudely, the contrast is between heavy factual documentation with little analysis as against clear ideological surveys rather short on close empirical evidence. It was Gibbon's distinction to yoke the detailed research of Montfaucon with the intellectual clarity of Montesquieu and the epigrammatic brio of Voltaire, uniting large-scale architectural skill with small-scale felicity in expression. There is a wholeness and unity about his work; as one critic has observed, his world is much the same from the Rome of the Antonines to the banks of the Ganges and the wilds of Tartary. Like Johnson and Reynolds, he saw human nature as essentially identical across time and place. This might make for an apparently static conception of the fortunes of mankind, and thus one which modern readers, accustomed to some dynamic notion of progress, would find unacceptable. Yet his insights into personality are by no means outmoded, while his sense of the way society operates upon its individual members often provides a deeply convincing picture of communities in action. It is a reminder, if we need one, that Freud did not invent psychology, nor Marx social science.

For many readers, the language of the work is one of its most compelling features: Gibbon combines a gift for picturesque scene-painting with an equal talent for wicked Tacitean asides. He is most famous for dismissive ironies, and they are certainly present, but not all his wit is destructive. Antithesis is a stock recourse, as for all the Augustans, but antithesis where the point extends beyond verbal play. 'His death was more useful to mankind than his life', he writes of a monk: the neatness is secondary to the intellectual assertion which is made. Of St Augustine he observes, 'his learning is too often borrowed; his arguments are too often his own'.

At the time it was Gibbon's notorious scepticism which caused the greatest offence, a reaction the author certainly anticipated and probably welcomed. Most people today are likely to be less sensitive on this score. Nevertheless, there is still strong meat in Gibbon's pages, and one should not turn to his book in search of a roseate view of humankind. Though his method was influenced by the Enlightenment, with its broadly optimistic view of progress in morality and politics, his own worldview was tinged with the pagan outlook represented in much of his education – the stoic disdain for easy

palliatives, a Virgilian sense of the fragility of human contrivances. He looks
back as well as forward. In this respect he is closely comparable to Johnson.
The fact that the two men did not get on well together in the Club may have
more to do with their likenesses than their differences. Often their ideas
chime exactly; when Gibbon writes to his friend Lord Sheffield, 'I am
convinced that if celibacy is exposed to fewer miseries, marriage alone can
promise real happiness since domestic enjoyments are the source of every
other good', he is all but paraphrasing Johnson.

Yet Gibbon never married, and this was true of so many of these celibate
Augustans. There is also a whole gallery of eminent spinster writers
throughout the century. Gibbon describes his youthful courtship of a Swiss
girl (later to become the mother of Mme de Staël) in his absorbing
autobiography, but it is not the most convincing passage in the book. The
famous recapitulation of events for once sacrifices good sense to a smart
cadence: 'I sighed as a lover, I obeyed as a son; my wound was insensibly
healed by a faithful report of the tranquillity and cheerfulness of the lady
herself.' There must have been many women reading these words who have
thought Suzanne Curchod did well to escape the man who could write them.

Gibbon's autobiography, sometimes known as *Memoirs of my Life* (first
published posthumously in 1796, but now available in more satisfactory
versions), merits attention as a significant study of the growth of its author's
mind. Together with his letters and journals, it gives access to the
Hanoverian mentality in its more intellectually austere guise. Like the *Decline
and Fall*, it shows the serene face of an inwardly anxious enquiry.

The career of Oliver Goldsmith (1728/30–74) is exemplary in several ways.
In an age which prized versatility, and a particular ambience where general
'literature' was valued above specialised so-called creative writing, he stands
as the most comprehensive man of letters in the Club. He enjoyed very high
esteem for many generations after his death, and no less a figure than Goethe
spoke warmly of the lasting influence which *The Vicar of Wakefield* had
exerted on him. But he has never regained his former position in the
twentieth century, and the recent revolution in taste has not yet worked in his
favour. The miscellaneity of his output which once granted him a central role
in literary discussion has become a drawback to modern readers.

It is hard to think of a contemporary writer who has achieved genuine
distinction in the novel, in poetry, in drama and in discursive forms of non-
fiction. This Goldsmith assuredly did attain, and it is a pity that most of his
engaging work in the essay form, notably in his *Citizen of the World* papers
(1762), is couched in an idiom that is baffling to many people today. These
essays are written in the person of an Oriental traveller, whose innocent eye
takes in the social doings of Hanoverian London. They contain abundant
humour and a good deal of wit, and behind the easy-going charm there is
much shrewd observation of fads and fashions. *An Inquiry into the Present
State of Polite Learning* (1759) remains one of the keenest surveys of the
conditions of authorship at this period, and also analyses the whole Augustan
notion. Most of his prolific hackwork in the field of history has sunk without
trace, but his biography of Beau Nash has survived more freshly, along with
a curious and fascinating *History of the Earth and Animated Nature* (1774),

eight volumes packed with quirky detail and personal reflections on the whole span of creation.

Goldsmith's only extended work of fiction, *The Vicar of Wakefield* (1766), centres round a benevolent but innocent clergyman whose family becomes embroiled in a series of complicated misfortunes. Though virtue is frequently in distress, the full force of sentimentalism is kept at bay by Goldsmith's sharp humour and a degree of moral realism. Goldsmith has a strong sense of actuality which gives the novel greater conviction and urgency than anything else written in this decade. Finally, like everything which Goldsmith produced, it is written in a clear, resourceful and sometimes evocative prose.

It is easier to respond spontaneously to Goldsmith's poetry and drama. His finest poems are *The Traveller* (1764), a pan-European 'prospect of society', and *The Deserted Village*, which adopts the manner and form of Pope to explore a new feeling of loss and regret about the countryside in an age of improvement and enclosure. Much ink has been spilt seeking out an actual location for this poem, but it is only incidentally a private work, and scarcely autobiographical at all: where Gray's *Elegy* starts from a highly individual landscape and moves on to increasingly personal feeling, *The Deserted Village* maintains a dignified distance up to the end. The sense of an acute threat to the traditional rural order is stiffened by the hard-edged clarity of the couplet form, whilst the precision of observation prevents the scene from swimming before the poet's eyes. A shorter poem written at the end of Goldsmith's life, *Retaliation*, shows a more acerbic side to his nature: the banter of fellow Club members such as Garrick, Burke and Reynolds is easy-going in tone but often deadly in deeper implication. As so often, we see that the Hanoverians could express through *vers de société* ideas of some profundity, just as Mozart could touch on grave issues in a casually commissioned serenade.

This comment could also be applied to *She Stoops to Conquer* (1773), which remains one of the most enjoyable stage comedies of the age, more or less director-proof and full of good acting parts. There is for once a reasonably positive and fulfilling role for the young heroine, in the shape of Kate Hardcastle, whilst her cranky parents and ebullient step-brother Tony Lumpkin offer abundant opportunities for resourceful performers. It would be a poor heart which did not rejoice at the rich foolery engendered by the mistakes of a night, and whilst the love plot is slighter emotionally than that of Beaumarchais's almost contemporaneous *Barbier de Séville*, the comic energy is quite as vigorous. The good sense of an age is perhaps best seen in its licensed departures from rigidly reasonable standards, and the bright comedy of *She Stoops to Conquer* represents an enduring wholesomeness of mind.

So, for that matter, does the conversation, indeed the whole attitude to life, of Samuel Johnson, as focused in James Boswell's great biography (1791). This work has an unquenchable life of its own; it survives as a kind of reference-book to the age, it is a source of endless anecdotes (apposite or inapposite), it gives most readers their clearest sense of an eighteenth-century writer in his diurnal existence. For a long time it was regarded as the supreme achievement of British biography, and Boswell somehow clung on to fame even when Johnson's own works were not widely read. Now that we

have a clearer sense of Johnson – one, that is, built up from a wider range of literary and biographic evidence – we might feel there would be less need for Boswell. In fact, the better we understand Johnson, the more valuable Boswell's contribution proves to be; and the more sophisticated our sense of the nature of biography, the more remarkable does Boswell's achievement seem. Few narratives in a post-Joycean world tell a lifestory more compellingly; few case-studies in a post-Freudian world explore a personality more provocatively.

Boswell (1740–95) attempted many other things in his own life, but nothing else remotely approaches the study of Johnson in depth or sense of purpose. We should make an exception in the case of the *Tour of the Hebrides* (1785), but this is in effect a trial shot for the *Life* and is therefore to be judged in the same terms. At first sight the account by Boswell looks chattily insubstantial by the side of Johnson's measured periods; but Boswell knew perfectly well what he was doing, and that in essence meant supplementing the magisterial *Journey to the Western Islands* with a more intimate picture of the heroic figure at the heart of the enterprise. Boswell stalks his prey around the Highlands, waiting for Johnson to display himself in characteristic attitudes. When the time comes for the narrator to be silent, Boswell shows sufficient tact (a quality with which he is not often credited). At Iona, he simply quotes the words of his 'great and pious friend . . . who has described the impressions [the island] should make on the mind with such strength of thought and energy of language'. Boswell added in a footnote, 'Had our tour produced nothing else but this sublime passage, the world must have acknowledged that it was not made in vain'. Amid Boswell's egocentricity was a generous urge which always permits Johnson, as the central figure in the story, enough space to work with.

If we think of Boswell as egocentric these days, that is largely the fault of his private journal. An amazing series of finds in the past sixty years have revolutionised our sense of his being. Historians and psychologists, as well as literary students, have worked over the diaries as they have emerged into print, and contemplated a naked identity exposed as few have ever been exposed. It is the earliest coherent segment of the diary, published as the *London Journal*, which has left the deepest impression; it suggests a Boswell forever young, footloose, sexually rampant and voracious for experience. In fact Boswell grew older, like everybody else. Whilst his addiction to women grew no less, and his addiction to drink increased, his character tended to darken in the face of reversals and disappointments. Yet there is for instance a significant account of a visit to the home of his patron Lord Lonsdale, in the winter of 1787–8. By this time Boswell was on the slide, his political ambitions thwarted, his wife dying and his great hopes beginning to fade. But his account of the three weeks spent in Cumberland embody an extraordinary comic vision of his humiliations, and are written with unparalleled zest.

The other outstanding diaries from this era were written by members of the extended Johnson circle, excluded from the Club by their sex. Fanny Burney's journals are at their freshest in the early years, when she burst upon the literary world with her novel *Evelina*, but her journal was kept up for another half century with sustained vigour and acuity. The picture she gives

of her marriage with the émigré General d'Arblay, and then of her puzzling and unsatisfactory son Alexander, provides insight both into family life around the end of the century and into Fanny Burney's own complex character. For some time Fanny was a close friend of Mrs Hester Thrale (1741–1821), but the latter's second marriage to an Italian musician meant that she was no longer *persona grata* with most of polite society, a group to which Fanny unquestionably belonged. Hester Thrale kept a fascinating logbook of her life, now published as *Thraliana*, and wrote thousands of letters, exhibiting wit, warm feelings of a positive and negative kind, and a fund of good sense. Her *Anecdotes* of Johnson were long overshadowed by Boswell, but are now valued for their shrewd appraisal of a man she knew more intimately than did any other human being in the latter years of Johnson's life. Among her later books *Observations and Reflections* (1789), based on travels through France, Italy and Germany during self-imposed exile, makes for equally lively reading; she is never dull, often challenging, and the possessor of a flexible, responsive prose style.

Like the rest of the Johnson circle, Mrs Thrale found her mind deeply permeated by the example of the great man at its centre; but his was an enabling presence, and the constellation of talent around him is almost as remarkable as his own achievement. The whole map of literature was to change radically, within twenty years of Johnson's death; but the last notes of high eighteenth-century literature were bravely sounded by the friends who survived him.

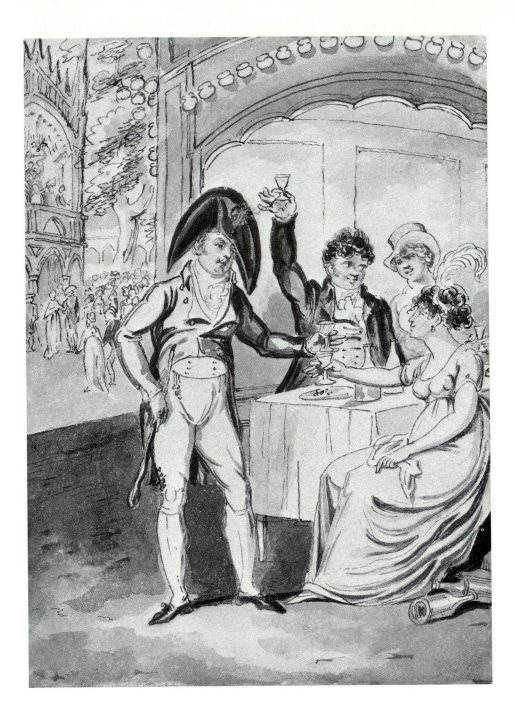

Isaac Cruikshank, Incident on a party to Vauxhall: the Supper Box at Vauxhall *(after 1794).*

6 Vauxhall Gardens

T.J. EDELSTEIN

The allure of London's Vauxhall Gardens was legendary throughout the eighteenth century. Such was its fame that Oliver Goldsmith appears there, after his death, in Thomas Rowlandson's 1784 watercolour. Primarily the pleasure gardens of a burgeoning middle class, Vauxhall nevertheless attracted the entire range of English society. The panoply of guests in the foreground of Rowlandson's drawing features the *haut monde*: the Prince Regent admiring his mistress 'Perdita' Robinson, Captain Topham, the Duchess of Devonshire, Lady Duncannon, Mrs Thrale, Dr Johnson, Boswell and Goldsmith. They are all serenaded from the 'Gothick' orchestra by Mrs Billington, the daughter of a German oboist settled in London, and a singer of international reputation. It was at Vauxhall that Georgian London had gathered for more than fifty years – its politicians, householders, aristocrats, literati, musicians, labourers, artists, merchants, prostitutes and thieves. To most of these gay revellers Vauxhall was simply a place of fun and amusement. They could stroll through a garden filled with the latest styles in architecture, listen to the most recent music, hear the newest gossip or view the most novel in a series of monumental paintings that featured games, pastimes and current events. But to a part of the audience at the Gardens, the paintings expressed not frivolity but particular moral and political precepts.

Situated south of the Thames in the parish of Lambeth, Vauxhall began as Spring Gardens, opening to the public shortly after the Restoration. Pepys mentions it frequently in his diary and he notes the music and pleasant company, particularly that of young ladies. These latter personages caused some discomfiture to Sir Roger de Coverley and Mr Spectator, who described the place as 'a kind of *Mahometan* paradise', and related:

As we were going out of the Garden, my old Friend thinking himself obliged, as a Member of the Quorum, to animadvert upon the Morals of the Place, told the Mistress of the House, who sat at the Bar, That he should be a better Customer to her Garden, if there were more Nightingales, and fewer Strumpets.

(Joseph Addison, *The Spectator* No. 383, 1712)

Louis François Roubiliac,
George Frederick Handel
(1738), depicted as Apollo
playing on a lyre.

Jonathan Tyers was certainly aware of this most important literary reference to the property of which he obtained the lease in 1728; one of the paintings hanging in the back of a supper box at Vauxhall Gardens was 'Two *Mahometans* gazing in wonder and astonishment at the many beauties of the place'. On 7 June 1732 Tyers opened Vauxhall to the public with a *Ridotto al fresco* (an outdoor entertainment with music) attended by over four hundred people, among them the ground landlord, Frederick, Prince of Wales. Tyers indeed constructed the illusion of paradise. Those who came to Vauxhall encountered diverse pleasures for their senses. The Gothic and chinoiserie

architecture, brightly painted, embodied the latest in rococo design. Sparkling lamps illuminated the buildings, walks and rural downs. Statues and ornaments dotted the landscape. Music could be listened to formally or heard wafting across the night air. Paintings of various subjects were more plentiful than at any other public location in the country.

The first work of art of distinction to grace the gardens was the statue of the composer Handel, represented as Apollo playing a lyre, which originally occupied a niche surmounted by representations of 'Harmonie and Genii'. The composition was the first major commission of the sculptor Roubiliac. Unveiled in May of 1738, the statue quickly became one of the chief attractions of the Gardens, discussed in newspapers and illustrated the following month in George Bickham's *The Musical Entertainer*.

Musical performance was one of the earliest and most important of the entertainments at Vauxhall. Although Handel does not appear to have had an official relationship with Vauxhall, his music was heard frequently at the Gardens. The most successful performance was when Tyers persuaded him to allow a rehearsal of the *Music for the Royal Fireworks* to take place at Vauxhall in 1749. The *General Advertiser* noted:

Yesterday there was the brightest and most numerous Assembly ever known at Spring Gardens, Vauxhall . . . an audience above 12,000 persons (tickets 2s. 6d.). So great a resort occasioned such a stoppage on London Bridge [the only bridge across the Thames at that time], that no carriage could pass for three hours.

In architectural design as well, Tyers sought to attract the multitudes by emphasising the more exotic styles of the moment. In the buildings and pavilions constructed over a period of twenty years, visitors to Vauxhall encountered the 'Turkish Tent', 'Gothic Pavillions' and 'Chinese Pavillions', all part of the most ambitious scheme of rococo architecture in England, albeit one of the most flimsy because the pavilions were little more than stage sets. These works constructed for Tyers embodied such architectural theories as Batty Langley's *Ancient Architecture restored and Improved by a Great Variety of Grand and Usefull Designs, entirely new in the Gothick Mode for the Ornamentation of Buildings and Gardens* of 1741–2, or the series of publications in the early 1750s by William Halfpenny (Michael Hoare), *New Designs for Chinese Temples, Rural Architecture in the Chinese Taste* and *Chinese and Gothic Architecture Properly Ornamented*.

By the early 1740s a series of paintings decorated the supper boxes surrounding the centre of the garden called the Grove, which was formed by rows of trees with the Orchestra in the centre. These paintings were the supposed suggestion of Tyers's neighbour in Lambeth, William Hogarth, 'a *Gentleman*, whose *Paintings* exhibit the most useful Lessons of *Morality*, blended with the happiest Strokes of *Humour*' as noted by their contemporary, John Lockman. Measuring about fifty-five by ninety inches, the paintings, largely the work of Francis Hayman, primarily depicted games and pastimes but also illustrated literary, historical and genre subjects. As with music and architecture, Tyers emphasised the topical. Recently produced plays, new works of popular literature and current historical events were all depicted at the Gardens.

John S. Muller, A General Prospect of Vauxhall Gardens.

It is clear from the few records that exist that the arrangement of pictures was not static but *A Description of Vauxhall Gardens* records their arrangement and subjects in 1762. For example, the pavilions on one side of the quadrangle were decorated with the pictures: *The taking of Porto bello in 1740 by the late admirable* [sic] *Vernon, Mademoiselle Catherina, the famous dwarf, Ladies angling, Bird-nesting, The play a bob-chery* [sic], *Falstaff's cowardice detected, The bad family, The good family* and *The taking of the St. Joseph,* the first and last being part of a series of naval subjects by Peter Monamy.

The numerous collections of songs sung at Vauxhall were of a similar diversity. For example, *The First Part of the Vaux-Hall Concert. Containing all the New Songs Sung this Season at Vauxhall,* (?1760) contains 'I'll Assure You', 'The Maid's Confession', 'Pretty Molly', 'The Yorkshireman's Resolution to fight the French', 'The New Robin Hood' and 'John Barly-corn'. The liveliness of these themes stimulated the festive atmosphere, like others of the paintings which depicted *A shepherd playing on his pipe and decoying a shepherdess into a wood, Music and singing, Players on bagpipes and hautboys* and *The kiss stolen.* Such subjects reflected the behaviour of the visitors to Vauxhall – strolling, singing, eating, talking, drinking or engaging in amorous intrigues.

In 'Weekly essays' in the *Scots Magazine* in the summer of 1739, S. Toupee describes 'An Evening at Vaux-Hall'. Several important facts are elucidated in these essays; that the gardens had become the favourite haunt, not only of the aristocracy and those in the news – the 'toute nouveaúée' [sic] depicted in

G. Bickham, The Invitation to Mira.

Bickham's engraving *Spring Gardens, Vaux-Hall* in 1741 – but of all classes, and that the paintings were an important facet of the Gardens:

The annual improvements in *Vauxhall* gardens, and the great resort of personages of the first rank, have for the last five years, drawn a multitude of people together every fine evening during the entertainment of those honored walks; The price of admittance, without a ticket is one shilling for each person; from which last article alone it is computed, that . . . not less than *one thousand* shillings are received each evening of performance during the season.

. . . a number of young fellows are hurrying into boats; who, though they set out by themselves, seldom return without female companions. . . .

Sir John from Fenchurch-Street, with his Lady and whole family of children, is attended by a footman. . . .

At the next stairs, Mr. William, an apprentice in Cheapside, by the contrivance of her confidant, who accompanies them, is taking water with Miss Stuckey, his master's daughter.

An honest mechanick and his spouse come next. He assures her his Royal Highness himself favours *Vaux-Hall* with his presence almost every week.

. . . After the piece of musick is finish'd, a silence ensues, of a length sufficient to allow the company time to take a circuit of the gardens before another begins; which is the same before each piece; and those intervals are chiefly employed in visiting the walks, remarking the company, and viewing the paintings These paintings forming something like three parts of a square, the Prince's pavillion . . . and the house belonging to the manager, form the fourth. . . .

The walks leading close by the front of the arbours, (each of which is large enough to entertain ten or twelve persons to supper) the paintings at the back of every arbour afford a very entertaining view; . . . the eye is relieved by the most agreeable surprise of some of the most favorite fancies of our poets in the most remarkable scenes of our comedies, some of the celebrated dancers, &c. in their most remarkable attitudes, several of the childish diversions, and other whims that are well enough liked by most people at a time they are *disposed to smile*, and everything of a light kind, and tending to *unbend the thoughts*, has an effect *desired* before it is *felt*!

That Vauxhall was a place of gaiety and frivolity is undeniable. Throughout the eighteenth century, numerous writers detailed the entertainments and social engagements there, either in their own person or those of fictional creations. Oliver Goldsmith in *The Citizen of the World*, James Boswell in his *London Journal*, Horace Walpole in his letters, Lydia Melford in Smollett's *The Expedition of Humphry Clinker* and Fanny Burney in *Evelina* describe Vauxhall as the hub of London's social universe.

Yet the themes of the gardens and paintings at Vauxhall contained other levels of meaning. They were possibly private ones for Tyers and his circle, although as the writer in the *Scots Magazine* suggests, the scenes at Vauxhall 'tending to *unbend the thoughts*, ha[ve] an effect *desired* before it is *felt*'. A second level of meaning reverses the levity and spontaneity which the Vauxhall images convey and makes them instead exemplars of the vanity of such pursuits. Certain aspects of the imagery at Vauxhall might also have been understood to allude to particular contemporary political issues.

Jonathan Tyers, who constructed his country retreat Denbies around the themes of death and *memento mori*, was praised by many for reforming the morals of Vauxhall and for providing a setting for innocent entertainment. In

truth it is doubtful that the nightingales now outnumbered the strumpets, but John Lockman praised Tyers 'for his having suppress'd a much-frequented rural Brothel, . . . [and] for his having chang'd the leud Scene above-mentioned, to another of the most rational, elegant, and innocent Kind'. A verse 'Epitaph on Mr. Jonathan Tyers' in the *Whitehall Evening Post* of 18 July 1767 expresses the same thoughts, one of its couplets noting of him:

> Who drew by moral craft th'attentive throng,
> And bade his minstrels play to virtue's song.

While the gardens at Vauxhall were not organised around a specific poetic theme, as at Stourhead, Stowe or Tyers's own Denbies, they nevertheless used the vocabulary of associationism. Contemporary writers on the gardens even discussed how to move through them in order to appreciate these conceits fully. John Lockman advised his readers:

Advancing beyond this *Side* of the *Quadrangle*, we walk between two Rows of *Pavillions* and *Alcoves*; the Former being adorn'd with *Pictures*, From this end of the *Alley* in question, (looking up the Garden) we perceive two *Vistos*, parallel with the grand one at our entrance, and running the whole Length of the *Gardens*. The first *Visto* is formed of very tall Trees, arch'd over, and terminated by a Gothic *Obelisk*. – To change our Situation for a Moment: A Spectator, who, in the Night, should stand at that *Obelisk*, and look down the *Garden*, would perceive at the Extremity of this View, a glimmering Light, (that in the opposite *Alcove*) which might image to him an *Anchoret's* Cave; for instance, that of the imaginary *Robinson Crusoe*.
 (*A Sketch of the Spring-Gardens, Vaux-hall. In a letter to a Noble Lord*, 1752?)

John S. Muller, Vauxhall Gardens showing the Grand Walk.

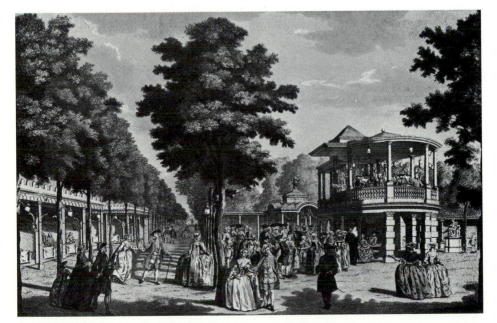

The author of the *Description of Vauxhall* in 1762 repeated many of Lockman's observations but also added his own perceptions about the associative elements in the garden.

Almost half of the paintings at Vauxhall depict games and pastimes, not simply those of the seasons when the gardens were open but ones which suggest the passage of time throughout the year – the play of skittles, leapfrog, an archer, blindman's buff, sliding on the ice, building houses with cards, battledore and shuttlecock and fortune-telling. Occasionally the inherent risk becomes apparent as when the boy bird-nesting falls from the tree or one of the sliders cracks his head on the ice. In the depiction of the seesaw, for example, the woman riding sidesaddle is saved from falling off by her companion, and the young man at the top thrusts out his hands to save himself. When the painting was engraved in 1743 by L. Truchy and published as one of a series of Vauxhall subjects by John Bowles, moralising verses, probably by Lockman, accompanied each scene. The verses beneath *The Exercise of SeeSaw* differentiate between the potential fall of the woman as a physical accident and as a moral disaster:

> When at the top of her adventrous Flight.
> The frolick Damsel tumbles from her Height:
> Tho her warm Blush bespeaks a present Pain
> It soon goes off she falls to rise again:
> But when the Nymph with Prudence unprepar'd
> By pleasure swayed – forsakes her Honours Guard;
> That slip once made, no Wisdom can restore.
> She falls indeed! – and falls to rise no more

The strumpets perambulating through Tyers's pleasure garden should certainly have taken heed of that advice. This poem, like others under the Vauxhall engravings, makes a distinction between the game and its emblematic reading: it embodies the general meaning of the Vauxhall Gardens' paintings. The first way to experience them is obviously and directly, as delightful representations of innocent games. On another level they warn of the vanities of such pursuits.

Significantly the scene of the seesaw does not take place in a natural landscape. The seesaw is precariously constructed of random, jagged pieces of wood. Spindly trees with blasted trunks grow on a diagonal to it, and on an axis parallel to that of its fulcrum, a ruined tower rises in the background. Reinforcing the motif of ruins one found throughout the actual gardens at Vauxhall, a fragment of a column lies in the foreground and two broken columns are under a scaffolding to the right. Clearly, Hayman has incorporated a common seventeenth-century iconographic device to express the passage of time and the fragility of life. He weds this emblematic vocabulary to a contemporary genre scene to imply the reverse of its playful subject. This subsuming of an emblematic tradition into a contemporary idiom occurs throughout the Vauxhall paintings.

Hayman's iconographic technique in *The Exercise of SeeSaw* has important precedents in seventeenth-century imagery, most prominently in the emblem books of the Dutch writer Jacob Cats whose emblems, contrived as

Francis Hayman, The Exercise of See Saw *(c. 1740–3)*.

naturalistic scenes, were well known in eighteenth-century Britain. His images include those of fishing, sliding on the ice, and battledore and shuttlecock. Most seventeenth-century English emblem compilers were more overtly religious than Cats. In 1635 Francis Quarles published *Emblemes* with engravings by William Marshall, a work which went through numerous editions until 1736. Several of the emblems depict a soul's quest for grace by using contemporary genre scenes of games. And, although none is a direct visual precedent for Hayman, they nevertheless demonstrate how such an emblematic tradition survived until the eighteenth century when its specifically religious doctrine became part of a vernacular visual vocabulary.

Even closer to a Vauxhall subject is an emblem in George Wither's *A Collection of Emblemes, Ancient and Moderne*, first published in 1635 and published in various forms until 1732. Wither's emblem of a man moving on a slippery path with its engraving by Crispin van de Passe form a close parallel to Hayman's *Sliding on the Ice* and the verse accompanying the engraving. Of course, this gradual transformation of an emblematic tradition happens in literary as well as visual works. The same image of sliding on the ice, with a similar moral, occurs in John Gay's *Trivia: or the Art of walking the streets of London* (1716). His *The Shepherd's Week* contains verses that could have inspired the seesaw and *Ladies angling*. Another poem that uses the subject of games is William Somerville's, *Hobbinol, or the Rural Games* (London, 1740). Somerville, in the circle of Frederick, Prince of Wales, dedicated his poem to Hogarth and called it 'a Satire against the Luxury, the Pride, the Wantoness, and quarrelsome Temper of the middling sort of people'. Unfortunately it contains no images of direct relevance to Vauxhall.

Remi Parr after Francis Hayman, Games at Vauxhall: Sliding on the Ice*; etching and engraving.*

Emblem books were also incorporated into children's literature. Three of the songs in Thomas Foxton's *Moral Songs composed for the Use of Children* (1728) relate to subjects at Vauxhall – 'The Angler's Reflection', 'On the Flying of a Paper Kite' and 'Upon Boys sliding'. In 'The Angler's Reflection' the playful little fishes lured by the art of man are compared to the 'heedless Mortals' ensnared by pleasure, vanity and deceit. Similarly the boys sliding on the ice, who ultimately meet disaster, are likened to the inevitable result of a life of futile pleasures, and the vicissitude of a paper kite elicits the moral that fame and fortune may fall to earth as easily. Clearly if children were meant to draw such cautionary maxims from their play it seems likely that the implication of the unremitting frivolity of the Vauxhall scenes could have had a similar effect on Tyers's audience.

The use of games as emblems continued throughout the eighteenth century. John Newbery's *A Little Pretty Pocket-Book* (1744) contains crude woodcuts of a great many of the Vauxhall subjects. Flying the kite, dancing round the maypole, thread the needle, fishing, blindman's buff, shuttlecock, cricket, leapfrog and bird-nesting are all represented in his *Alphabet Plays*. It is tempting to speculate that Newbery used not only such precedents as Foxton's *Moral Songs* but was also inspired by the Vauxhall paintings. Like the verses beneath the Vauxhall engravings, Newbery's pages contain both a

description of the game and a 'rule of life', or moral to be drawn from it.

This emblematic reading of the Vauxhall paintings is confirmed by a broadside, 'Frank Hayman A True Story' (1798) written by John Taylor, a pupil of Hayman's. Directed towards a popular audience, it demonstrated how the meanings of Vauxhall had been codified by the end of the eighteenth century:

> The shuttlecock that like ambition flies,
> Driv'n by contending factions to and fro;
> The blinded boy who wanders by surmise,
> True emblem of our darkling state below.
> And other pastimes of our early days,
> Recal in various scenes life's jocund May
> Where e'en the proud philosopher might gaze,
> And envy ignorance its thoughtless play.

The conclusion is unavoidable that at least to a part of the audience of Vauxhall the paintings of games and pastimes displayed there represented the vanity of earthly pursuits. More speculatively, it is possible that some of the Vauxhall paintings contained not only these generalised moral apothegms but also political allusions. The use of games was not uncommon in political prints to present the vagaries of political alliance. An article in 1738 in the *Craftsman*, the principal newspaper of the Opposition, comments about

A Manuscript . . . upon the *Plays* and *Pastimes of Children*; [that] would shew that they were so many *political Satires*, to ridicule such *Follies* and *Corruptions*, as it was not safe to do in any other Manner.

It was exactly at this time that the subjects of the Vauxhall paintings, with their emphasis on games, were determined.

Nothing specific is known of the politics of Jonathan Tyers but his relationship with Frederick, Prince of Wales, is documented by a conversation piece by Hayman of the Tyers family posed around a fireplace prominently decorated with an almost life-sized medallion of Frederick. Of course, Frederick was the ground landlord of Vauxhall but he was also the symbolic head of the Opposition. As such, he became the embodiment of the Opposition's ideal of a Patriot King, an idea articulated in a large body of contemporary literature, most notably in Bolingbroke's *The Idea of a Patriot King*. The perception of this humanist Patriot King as one who would restore the political and social balance to true principles and liberty through his own moral example was an idea sympathetic to the central themes at Vauxhall.

As a result of these theories the conception of nationalism and patriotism became synonymous with the Opposition. 'Rule Britannia', for example, was written for Frederick in 1740 as part of a musical drama, *The Masque of Alfred* by James Thomson and David Mallet; the music was by Thomas Arne. Similar sentiments appeared at Vauxhall in the verses beneath the engraving of cricket, a game sometimes sponsored by Frederick.

In 1750 the same theme of a Patriot King appeared in a poem entitled 'Vaux-Hall' written by a 'Young Gentleman'. The writer directly links the aspirations of the Opposition with Vauxhall:

Let greater Poets whose harmonious Lyres,
Apollo strengthens with his choicest Fires.
Let them in loftier Strains sublimely sing,
The immortal Glories of BRITANNIA's King.
Or hail in FREDERICK our rising Joy,
And make his Merits all our Soul's Employ.

. . .

But, oh, on Earth, what praise shalt thou receive,
As long as Vaux-hall blooms, or Mankind live;
For still the vast Design in spite of Blame,
Shall load with Honour thy distinguish'd Name,
And give a glorious and immortal Fame.

More overt political imagery was also present at the Gardens. A painted copy of Hogarth's *Henry VIII and Anne Boleyn* originally hung in the room which became the Prince's Pavilion. Conceived as an anti-Walpole satire, the figures conspiring in the background were at one time associated with Frederick and his mistress Miss Vane. The image was removed from Vauxhall in 1745, it is tempting to speculate, because of political reasons. The four Shakespearean subjects which eventually filled the Prince's Pavilion contained no precise political references although two of the plays, *King Lear* and *Hamlet*, treat questions of royal succession and *Henry V before the Battle of Agincourt* depicts the ultimate Patriot King.

N. Parr, The King and the Miller of Mansfield *(1743).*

Another fictional royal subject originally hung in the Gardens, Robert Dodsley's *The King and the Miller of Mansfield*, was first produced in 1737 at the Drury Lane Theatre, where Hayman designed scenery. Considered a product of the Opposition, the play describes a King wandering among his people as a common man who discovers corruption in his own court. This painting was executed before 1743 when it was issued in the original series of engravings, but was the only work illustrated in that series that was removed before the 1762 *Description*, possibly after Frederick's death in 1751.

That death is alluded to by John Lockman when he concludes his *Sketch of the Spring-Gardens, Vaux-Hall*. He notes that:

> To crown the Reputation of this much-frequented *Recess*, the late PRINCE, and the PRINCESS OF WALES, the great Patrons of all things excellent, gave the highest sanction to them . . . To sketch a *Garden* is very easy; but to portray MINDS where dwelt Grace, Benevolence; every Virtue that can adorn the Soul, and make a People happy. . . .

Gradually the character of Vauxhall changed, and it became less a place for the interaction of society than an amusement park. The Gardens were finally dismantled in 1859; but as early as 1836 the illusion of Vauxhall had disappeared; Charles Dickens visited it by day, and the observations of Boz can serve as the signal of the end of Vauxhall:

> We paid our shilling at the gate, and then we saw for the first time, that the entrance, if there had been any magic about it at all, was now decidedly disenchanted, being, in fact, nothing more nor less than a combination of very roughly-painted boards and sawdust. We glanced at the orchestra and supper-room as we hurried past . . . we just recognised them, and that was all.
> We walked about, and met with a disappointment at every turn; our favourite views were mere patches of paint; the fountain that had sparkled so showily by lamp-light, presented very much the appearance of a water-pipe that had burst; all the ornaments were dingy, and all the walks gloomy. There was a spectral attempt at rope-dancing in the little open theatre; the sun shone upon the spangled dresses of the performers, and their evolutions were about as inspiriting and appropriate as a country-dance in a family vault.

But in its day Vauxhall remained, above all the most popular pleasure garden of the eighteenth century, the mecca of wits, bawds, writers, beauties, gossips, and those just desiring a pleasant evening. Its decorations and music made the avant-garde accessible to a wide spectrum of the population and, to a smaller audience, the English themes of Vauxhall – its games, plays, battles, and gardens – functioned as more complex images of the importance of virtue to a nation.

Christ Church, Spitalfields, London (1714–29). Nicholas Hawksmoor.

7 Architecture

SALLY JEFFERY

Introduction

The period of British architecture covered by this volume (1700–85) begins
with the later works of Sir Christopher Wren and the flowering of the style
known as the English baroque in the hands of Nicholas Hawksmoor, Sir John
Vanbrugh and Thomas Archer. From *c*. 1715, in a campaign partly inspired
by political ideas, the works of Palladio and Inigo Jones were championed as
examples of a refined and desirable taste in architecture, and Palladianism
and its principal exponents Colen Campbell and Lord Burlington gained
many supporters in the years following. However, at the same time other
interests which had their origins in the views of men like Wren, Hawksmoor
and Vanbrugh, continued to develop. There was an increasing appreciation of
all kinds of ancient work, whether classical or not, together with changing
attitudes to the countryside and nature. In the work of William Kent,
William Chambers and Robert Adam a variety of sources and styles was
explored and used with an ever-increasing delight in picturesque and
romantic settings; and at the end of the period studied here, the concepts of
variety, informality, primitivism and asymmetry were beginning to be
accepted. They joined the classical ideas of formality and symmetry to
present both architect and patron with considerable freedom of choice.

'After the manner of the Ancients' was a phrase which reverberated
through the minds of those designing and commissioning buildings in the
eighteenth century, and one which was powerfully evocative for them.
Knowledge of what the ancient Roman world was like was sparse enough,
but with the help of descriptions and illustrations of surviving Roman
buildings, their own imaginings and especially the references in classical
literature with which every educated person was familiar, a picture could be
built up and used as the basis for original architectural designs.

It was principally by means of publications that ideas were communicated.
They had been a key source of information from the seventeenth century
onwards, but during the eighteenth century they increased in number and
accuracy of illustration, and brought a progressively more detailed and wider

acquaintance with contemporary design in Britain and Europe, and with the buildings of ancient Rome, ancient Greece and other more remote parts such as India and China.

At the beginning of the eighteenth century, most architects used foreign publications, above all from Italy, as their standard works of reference. A representative collection might have included the only surviving Roman treatise on architecture by Vitruvius, and the writings of fifteenth- and sixteenth-century architects and theorists such as Alberti, Serlio, Palladio, Scamozzi and Vignola in either Latin or Italian, or translations of them from Flanders or France. These books discussed and sometimes illustrated the use of antique building forms (such as temples) and the ways they could be applied to contemporary architectural designs. In a number of cases the authors showed their own designs as examples. Above all, they discussed and illustrated the architectural orders – columns, capitals, and entablatures – whose proportions govern classical buildings. This was essential knowledge for all those seeking to design buildings, and relatively few architects in the seventeenth century had thoroughly mastered it. Some French texts such as Perrault's commentary on Vitruvius of 1683 and Desgodetz's *Edifices antiques de Rome* of the same year were commonly used as well. English writings on architectural theory by Wren and others generally remained in manuscript form and were thus unavailable to a wide readership.

The first of the major publications of the new century was *Vitruvius Britannicus* in three volumes (1715–25), by Colen Campbell, which sought to present a view of significant British architecture of the previous generation, as well as some of the author's own designs. (Further volumes by other authors came later.) After this, a series of books promoted by Lord Burlington appeared, charting the move of taste away from the style of Wren and his contemporaries Hawksmoor, Talman, Vanbrugh and Archer, towards the more controlled and severe forms seen in the work of Andrea Palladio in sixteenth-century Italy and Inigo Jones in seventeenth-century England. There had been a new translation of Palladio by Dubois and Leoni in 1716. Later there were William Kent's *Designs of Inigo Jones* (1727), Lord Burlington's *Fabbriche Antiche* (1730) publishing Palladio's drawings of Roman baths, Isaac Ware's *Designs of Inigo Jones* (*c*.1733) and his influential translation of Palladio of 1738 with much clearer and more accurate illustrations than those in the Dubois/Leoni version, and John Vardy's *Designs of Inigo Jones and William Kent* (1744). By this time, the neo-Palladians were beginning to chart their own progress as well as recording seminal designs by their two exemplars. James Gibbs stood outside the neo-Palladian circle, but his *A Book of Architecture* (1728) and *Rules for Drawing the Several Parts of Architecture* (1732) were much consulted and therefore very influential. Isaac Ware's *A Complete Body of Architecture* of 1756 was also much used as a guide to design and building practice. In 1759, William Chambers's *Treatise on Civil Architecture* appeared, which remained the major text for many years. Edmund Burke's *Inquiry into the Origin of Ideas on the Sublime and Beautiful* of 1757 codified some of the already existing ideas on aesthetics, to which many of the buildings later in the century alluded. There was a rising interest in ruins *as* ruins, with all the associations

(a)

(b)

(c)

(d)

LIX

Illustrations from The Rules for Drawing the Several Parts of Architecture *by James Gibbs (1732) (a) a Doric Venetian window, (b) a Corinthian capital, (c) an Ionic dentel cornice and scroll support, (d) various fret patterns.*

that their classical or medieval form and ruinous state implied. There were books on the ruins of Palmyra and Baalbec (both by Robert Wood) and Diocletian's Palace at Split (Robert Adam) at about this time.

Following upon this increased awareness of all things ancient came the fashion for a richer and more exotic selection of styles from which to create a design. Books appeared on Gothic (by Batty Langley in 1742), on Chinese (Chambers in 1757), and on the Adam brothers' eclectic taste (*The Works in*

Architecture of Robert and James Adam of 1773, 1779 and 1822). James
'Athenian' Stuart and Nicholas Revett began publishing *The Antiquities of
Athens* in 1762. This heralded the popularity of Greek classical forms as
distinct from Roman.

Travel brought architects a personal experience of the ancient world,
highly coloured by the passage of time and the elements and by their own
expectations. Thomas Archer is known to have been in Italy in 1691, and
both James Gibbs and William Kent spent considerable periods in Rome.
Gibbs undertook a period of training in the architectural office of Carlo
Fontana in Rome, which, when he returned home, gave him a considerable
advantage over others who had not travelled. As the century progressed,
foreign travel increased and study of the ancient buildings at source became
accepted as a necessary part of the training for architecture.

Patrons too went to Italy on the Grand Tour. Young men seeking future
careers in architectural design, painting and sculpture could make useful
contacts abroad. William Kent met two important patrons during his time in
Rome – Lord Burlington, who was to give Kent his protection in all sorts of
design projects, and Thomas Coke, later Earl of Leicester, with whom
Burlington and Kent later collaborated on the design of Holkham Hall (see
chapter on Holkham by Cinzia Sicca). Holkham is an interesting example of
the way patrons themselves could be influential in the design process.

Gentlemen on the Grand Tour were often avid collectors, and the objects
they collected influenced the way they perceived architectural design,
particularly of their own houses. The houses of Lord Burlington and Lord
Leicester were designed to set off their possessions. Thus, at Chiswick and at
Holkham there were sculpture galleries, and rooms where the walls were
hung with textiles to set off paintings. The paintings themselves played an
important part in the formation of the taste for the picturesque. Serene
scenes of the Roman Campagna, with rustic Italian farmhouses and the sunlit
ruins of country-castles by Claude Lorraine, and the wilder mountain scenery
of Salvator Rosa, often embellished by rocks and ruins, helped the
Englishman at home to visualise his proposed house in its setting of an
idealised landscape.

Houses dominated as a building type in this period, and therefore private
patronage overshadowed that of the Crown and the Church. The aristocracy
and landed gentry built very imposing houses at the beginning of the century,
marking a recently achieved increase in political power. However, merchants
and self-made men increasingly acquired wealth and influence and built
themselves houses to rival those of the aristocracy. Patrons of all kinds began
to prefer smaller houses, not wishing to live a life of courtly formality to rival
the King and Queen. The importance of the court as a model declined and
men and women lived less grandly but more comfortably in their town
houses or small suburban 'villas', which were planned to have communal
areas such as dining rooms and saloons instead of sets of private rooms (see
Mark Girouard's *Life in the English Country House*).

The commissioning of churches during the eighteenth century followed a
pattern which reflected both political and religious events. Wren's greatest
bequest to the nation was the new St Paul's Cathedral and the supervision of

the rebuilding of fifty or so parish churches in the City of London after the Great Fire of 1666. The taste for church building was inherited by the next generation of architects and churchmen. However, they were not only involved in completing the tasks begun by Wren. Church building in Queen Anne's reign was seen as a positive statement about the re-assertion of the power of the Church of England, as well as of the Protestant succession, and an ambitious series of new churches was begun. Once George I was on the throne and a Tory majority in the House of Commons had given way to Whig, church building receded in importance. Relatively few ecclesiastical buildings went up thereafter until the end of the century.

The number of important public buildings of this period was quite small. A favourite project of the time was the rebuilding of the Houses of Parliament. Wren's office had envisaged this when the Palace of Whitehall burned down in 1698, William Benson and Colen Campbell were apparently plotting for it when they declared the House of Lords an insecure structure in 1719, and Lord Burlington and William Kent hoped for it when they prepared designs for it in the 1730s. The project had to wait more than a century before another fire at Westminster made it again the centre of interest. Some designs for public buildings by Kent were executed – the Royal Mews, the Horse Guards, the Treasury. The greatest public building of the second half of the century in London was Somerset House by William Chambers. Dublin was more successful than London in acquiring a magnificent new Parliament House built (1728–39) to the designs of Sir Edward Lovet Pearce in a strong and monumental classical style which retained elements of the old baroque taste. A fine series of public buildings by Thomas Cooley and James Gandon (both followers of Chambers but capable of more powerful designs) were the Royal Exchange, the Custom House, and The Four Courts. The Four Courts (of 1776–96) has something of the severity of French neo-classical architecture of the pre-Revolutionary period. In Scotland there was little notable public building until the advent of the work of the Adam brothers in the form of a Register House and a University building in Edinburgh.

Three houses widely separate in date and of moderate size will serve as introductory examples of the changing approach to design in the eighteenth century. Thomas Archer (*c.* 1668–1743) designed Roehampton House (south-west London) in 1710 for Thomas Carey. All architects at this time recognised the classical tradition. The most prominent Roman building type was the temple, with a columned portico below a triangular pediment, and most large houses made some allusion to this in the form of classical columns or pilasters supporting an entablature and a pediment. Archer's powerful design, as seen in a contemporary engraving, quoted the temple form in its four heavily blocked vertical strips (suggesting columns) and its giant pediment open at the centre, with the gap bridged by a balustrade with urns. The house was apparently built without the pediment, but retained its strongly accented centre bay and a small open pediment over the door. It consists of a semi-basement plus two nearly equal main storeys and an attic. Archer evidently enjoyed manipulating architectural features in a bold and imaginative way. His fantastic treatment recalls the work of Michelangelo in

Roehampton House, Roehampton, Surrey, proposed entrance front (1710). Thomas Archer.

the sixteenth century and Bernini and Borromini in the seventeenth century. He could have seen their work when in Italy, but no doubt also consulted it later in the form of publications such as de' Rossi's *Studio d'Architettura Civile* of 1702.

Wrotham Park, Middlesex, of 1754, for Admiral John Byng by Isaac Ware (d. 1766), employs many similar architectural features but produces a very different result. The key to the difference is in the controlled nature of the design, as opposed to the free-wheeling classicism of Archer some forty years earlier. Certain conventions and rules have been applied here which did not constrain Archer. The temple porticos each side are more temple-like, with columns in the round and complete but unadorned pediments. The first floor has larger windows than both ground and attic floors and the roof is visible. There are no fantastic details: rather the overall effect is severe, indicating that the designer was a serious student of the work of Palladio, rather than of the freer delights of Michelangelo and his Roman successors.

The third example is Downton Castle in Herefordshire of 1774, designed for himself, though with a little professional assistance in the early stages, by Richard Payne Knight (1750–1824). It is idiosyncratic and revolutionary, and heralds the new taste for freedom from rules of taste and style which was to

Wrotham Park, Middlesex (1754). Isaac Ware.

be carried through into the nineteenth century. Knight has discarded classicism on the exterior and with it symmetry. The house is like a medieval fortified building which might have grown haphazardly and in stages. Inside, however, Knight used a classical style. The house was therefore in what he described as a 'mixed style', with Greek and Gothic 'employed with the happiest effect in the same building'. The Roman 'manner of the ancients' was no longer the only option, and Knight's eclecticism was indicative of the path to be followed in the early part of the nineteenth century.

Architectural training

There was no architectural profession in the modern sense at the beginning of the eighteenth century and no formal provision for training. Those who designed buildings fell into two categories. First, there were gentlemen, like Wren, who received instruction in mathematics, geometry and drawing as part of their education. Most such owned a set of drawing instruments, and would have known the rudiments of architecture. Second, there were those who came to design through building. Masons, bricklayers and carpenters had traditionally been charged with setting out designs and with overseeing building works. They were the key craftsmen employed on a house. If it were built of timber, as many were until the seventeenth century, the carpenter framed the wood, and therefore took a leading part in the construction and design process. If it was of stone, then the mason would be the major contractor and so on. These traditional roles had existed and developed for centuries, and continued to develop in the seventeenth century, so that such men increasingly were to be found as Clerks of Works overseeing teams of builders. They were often referred to as 'surveyors'.

Practical expertise was acquired first of all through an apprenticeship which usually lasted seven years. Apprentices could learn such skills as surveying the ground and trying it for foundations, setting out the site, setting up plans and elevations, producing drawings and specifications for the work to be done by the different craftsmen, preparing the terms of contracts,

settling disputes with the craftsmen, measuring up the work for payment when it was done, as well as dealing with both patron and workforce. Once apprenticeship was successfully completed, the craftsman could look for work independently of his master, as a journeyman, and then as a master himself, and call himself a surveyor. Richard Neve, in 1726, addressing 'Every Man that is disposed to Build', recommended employing such a person:

. . . let me perswade all Builders, to make choice of such Surveyors, and Workmen, as understand what they are going about, before they begin the Work, viz. Such as be Masters of what they pretend to, as a Surveyor that understands how to give the Draught, or Model of a Design . . .

In the City of London, a man had to be a freeman of the City in order to work. Completing an apprenticeship and thereby gaining membership of a livery company (or trade guild) made him eligible for this. Freedom could also be obtained, 'by patrimony', from father to son, and the widow of a freeman achieved freedom 'by courtesy', so that she could continue her husband's business. Similar systems, inherited from the medieval trade organisations, operated in other cities. In the eighteenth century the strict control of trades which had operated earlier was weakening. Tradesmen moved about to work – perhaps now in the City of London, now in Westminster, now on a country-house. However, from Wren to Adam, leading architects (and important building organisations like the Office of Works and the Fifty New Churches Commissioners) tended to gather around them men they trusted, and to keep their team together from building to building. Many of the families intermarried, forming a tight-knit community.

Men trained through apprenticeship were to be found assisting those who had no practical background themselves. Henry Herbert, later Earl of Pembroke, the gentleman-designer, collaborated with Roger Morris, a professional builder, at Marble Hill. Morris apparently began his career as a bricklayer and later assisted Colen Campbell. He went on to design and build villas and houses independently, becoming highly valued in his own right. If the experience of those trained by apprenticeship proved insufficient there were many books which offered assistance and advice on classical forms and their use. For example, William Robinson, a London carpenter, published *Proportional Architecture* in 1733, which announced in its introduction:

Finding ourselves as well as most of our fellow Workmen perplex'd in practising according to the Rules laid down in Books of ARCHITECTURE, we industriously employ'd our time and thoughts, some Years since, to bring them into a more regular and useful method.
In order therefore to remove those impediments which have obstructed the study of that Noble Art, we have here attempted to render the understanding of the Five Orders more intelligible, and the use of some other Rules more practicable . . .

Many of these men developed large and profitable businesses, which were in every way like the practices of the gentlemen-architects they were gradually superseding. Robert Taylor, for example, trained as a mason and stonecarver, but soon abandoned the practical side of building to concentrate on supervising and designing. His success was achieved apparently by very hard work. Horace Walpole commented:

Marble Hill House, Twickenham, Middlesex (1724–9). Henry Herbert and Roger Morris.

The atrium, Marble Hill House.

What the king of Prussia did for Science, Taylor did for trade; he never slept after four in the morning. When he had any journey, he did it in the night, and thus never but in a carriage, slept at all. When other people were at diversions he was in bed.

As a result, Taylor's fortune when he died amounted to £180,000, whereas, again according to Walpole, Kent was worth £10,000, Gibbs £25,000 and Wren £50,000. Both Morris and Taylor travelled abroad to extend their knowledge of European architecture.

From the days of Wren, the Office of Works had nurtured all the skills required of an architectural designer. Its principal posts were filled by gentlemen who had mastered the arts of design and it had a fine pool of practical expertise in its master craftsmen, nearly all of whom had independent practices of their own and were in a position to offer good professional training to their apprentices. Apprenticeship to a distinguished master was sometimes the route taken by the sons of gentlemen if they wished to practise the business of designing and building. By the mid-eighteenth century, George Dance the Elder had trained his son George in all the arts of the architect which he himself learned as a mason, a practising builder, and as Clerk of the City's Works in London; and in addition he sent him on the Grand Tour like the gentlemen-amateurs of Lord Burlington's time. George Dance the Younger, in turn, took the young John Soane into his office in 1768 to train him specifically to practise architecture, rather than as an apprentice to a particular trade. Others, notably Sir Robert Taylor and James Paine, began to take young men into their offices as articled clerks at about this time. In addition, there were lectures at the newly formed Royal Academy, and the possibility of scholarships for foreign travel.

From the background of the trade guilds another society grew up, which had considerable influence in the building world of the eighteenth century. It came to be called the fraternity of Free and Accepted Masons, and had its origin in the old lodges of stonemasons which met in and around London. At the end of the seventeenth century, when Wren apparently became a member, it was changing in character from a confraternity of stonemasons into a kind of friendly society with a much wider membership and with rituals based on the traditions of the 'craft'. In 1717, certain old lodges held a meeting to organise the Grand Lodge for the Cities of London and Westminster. The new organisation expanded fast to include many who had never held a chisel or a gavel and who came from all backgrounds. By the end of the period covered by this volume, it was an organisation with a sizeable membership, including many architects and builders, among whom were Hawksmoor, James, Gibbs, Thornhill, Langley, the elder Wood, the elder Dance, and Soane. In addition, very many influential and titled people who had no connexion at all with the building profession were members. The first noble Grand Master, the Duke of Montagu, was installed in 1721 at a ceremony attended by Lord Herbert. Both Lord Burlington and William Kent were apparently freemasons. Royalty became members too. It was therefore a very significant force in that it influenced both the practical matter of building and the pattern of patronage.

John Vanbrugh and Nicholas Hawksmoor

At the beginning of the eighteenth century Sir Christopher Wren (1632–1723) was still at the height of his powers, beginning to build at Greenwich, and deciding upon the shape of the dome and west towers at St Paul's Cathedral. Into his busy office at Scotland Yard in about 1679 had come a young recruit named Nicholas Hawksmoor (*c.* 1661–1736), from the county of Nottingham, already interested in architecture and draughtsmanship, and possessed of a lively intelligence which had been sharpened, probably, at his local school. He came to Wren as a clerk, to help with the administration of the numerous projects then current at the Office of Works, of which Wren was Surveyor General. By the time he began to work separately from Wren, Hawksmoor was probably one of the best qualified men in the business of architectural design and building.

At the beginning of the century John Vanbrugh (1664–1726) was just starting out as an architect, after having been a soldier and a playwright. He was therefore full of ideas but unversed in architectural arts, and Hawksmoor was the ideal assistant. They worked together on two great houses – Castle Howard (1701–12) and Blenheim Palace (1705–25). The Earl of Carlisle, Charles Howard, had already received designs from William Talman for a large new house on his estate in Yorkshire, but finding him difficult and expensive, approached his friend Vanbrugh instead. Vanbrugh took on Hawksmoor shortly afterwards to help him. It was the beginning of a brilliant and astonishing architectural partnership. Swift wrote in 1706: 'Van's Genius without Thought or Lecture / Is hugely turned to Architecture', reflecting the contemporary impression that Vanbrugh's amazing and monumental designs seemed to spring fully formed from nowhere. The truth is probably that Vanbrugh had the imagination to conceive the ideas and the gift of communicating them to Hawksmoor. Hawksmoor, in turn, had a powerful architectural vision which was able to take the raw material thus offered and transform it into the design conceived by Vanbrugh, adapting it to practicalities as he went, so that the house as built was truly a product of both their minds. As evidence for this it is known that the initial approach was made to Vanbrugh, many of the drawings were by Hawksmoor, but both were capable of designing independently of the other. Hawksmoor himself, however, recognised his supporting role when he wrote in connexion with Blenheim that he was 'like a loving Nurse that almost thinks the Child her own'. The exact nature of the complementary roles played by the two remains nevertheless a matter for discussion and has been explored most recently by Charles Saumarez Smith.

Castle Howard follows in the footsteps of Wren's unexecuted designs for Hampton Court, Whitehall and Greenwich. The giant pilasters and dramatically curving arms flanking the entrance courtyard, together with the prominent use of the Doric order, give it a severe, military appearance. On the garden front, a long range of rooms is spread out to each side of the main two-storey block, which has a giant Corinthian order. In the new monumental fashion of the turn of the century, the building is topped by a strong horizontal line in cornice and balustrade. Most surprisingly, a dome

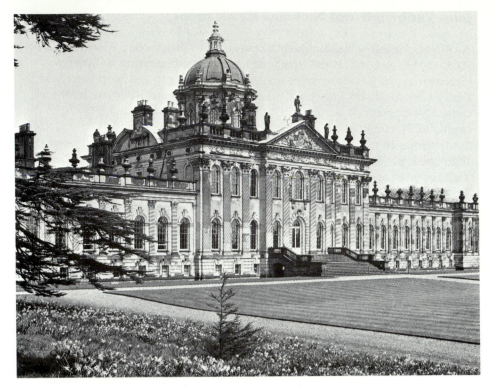

Castle Howard, North Yorkshire (1701–12). John Vanbrugh and Nicholas Hawksmoor.

on an octagonal drum rises behind this – the first large domestic dome in Britain. What greater statement of power and wealth could there be?

The landscape was shaped to serve the same purpose, as described in the next chapter by Michael Symes. For this, interestingly, both Vanbrugh and Hawksmoor designed buildings independently, permitting an assessment of their individual attitudes. The Temple of the Four Winds of 1726–8 is by Vanbrugh. The idea springs from Palladio's Villa Rotonda, and it seems that in this later addition to the estate Vanbrugh was responding to a new and rising fashion. Hawksmoor, on the other hand, continued to produce colossal images which dominated their surroundings even after the new fashion was generally accepted. In his Mausoleum of 1729–42, designed after Vanbrugh's death, he stuck to his personal vision of the antique, inspired here by the Roman tomb of Cecilia Metella. He suffered the indignity of having his design submitted to the criticism of Lord Burlington, who thought his columns were placed too close together for true elegance. Hawksmoor defended his design because he felt it was appropriately sombre for its purpose and was also practical to build.

In 1718–19 Vanbrugh built a miniature castle for himself at Greenwich, with turret, battlements and round-headed windows, and a whole series of out-buildings and a defensive-looking gateway and walls. He was susceptible to old buildings with historic associations. This applied not only to the ruins

of antique civilisations, which were generally acknowledged to be the source of good design, but also to medieval structures of various kinds. For example, in 1709, defending his wish to retain the ruins of the old royal property at Woodstock, near Blenheim, he presented what he called his 'Historical Argument':

There is perhaps no one thing, which the most Polite part of Mankind have more universally agreed in; than the Value they had ever set upon the Remains of distant Times . . .

The ruins would make 'One of the Most Agreable Objects that the best of Landskip Painters can invent'. On another occasion, in discussing a design for the remodelling of Kimbolton Castle, Huntingdonshire, he suggested:

Something of the Castle Air, tho' at the Same time . . . regular . . . to have built a Front with Pillasters, and what the Orders require could never have been born with the rest of the Castle . . .

He was appreciating old buildings for their historic associations, and suggesting building in a version of the castellated round-arched mode to blend with the existing structure, although he still felt the need to conform to current practice and make his additions 'regular' or symmetrical. His own small castle at Greenwich was undoubtedly built with these points in mind. In this respect, Vanbrugh proved to be remarkably prophetic of later eighteenth-century taste.

Hawksmoor's personal contribution to early eighteenth-century architecture lies less in country-houses (although he did design a most accomplished one at Easton Neston, Northamptonshire) than in his work for the Universities of Oxford and Cambridge and in the field of ecclesiastical building. His inventive brain prompted him to try out ideas even when there was only a slim chance of them being used. The Universities were expanding during the late seventeenth and early eighteenth centuries, presenting exciting possibilities for new building and even city replanning. Hawksmoor had closer contacts with Oxford than Cambridge, but for both he made plans of the city centre based on regular squares and straight streets, punctuated by devices such as obelisks, campaniles and dramatic classical temples designed to form focal points and to close vistas. In addition, he expended much effort on designing new buildings. Much of this was fantasy, but nevertheless his impact at Oxford is important in the Clarendon Building for the University Press, in the Radcliffe Camera (whose design owes more to Hawksmoor than to Gibbs, who actually produced the final drawings), and in the Colleges of All Souls and Queen's.

For the Queen's College there were a number of impressive schemes, the most spectacular having an oval many-columned chapel in the centre of the courtyard, and for All Souls there were various projects for the total rebuilding of the College. The most significant thing about all these, apart from their brilliant inventiveness and variety, was the fascination they revealed for all things ancient in building. Whenever possible, Hawksmoor used the classical language of the columns and capitals of the architectural orders – Doric, Ionic, Corinthian and Composite. However, if this proved

The Queen's College, Oxford; the Screen (1733–6). Nicholas Hawksmoor.

unpopular, as it did with the authorities at All Souls (who preferred a more traditional style to accord with the Gothic of the college chapel), then Hawksmoor could almost equally happily explore the possibilities of a medieval style. At All Souls, the college buildings eventually erected to his designs were based on what previously existed there, and also, for the centrepiece, on his close acquaintance with Beverley Minster. Thus ancient structures from different ages and civilisations could form the basis for his work. It is interesting to compare his screen walls at All Souls (1728–35) and Queen's (1733–6) for an insight into the way he could use either classical or Gothic.

The names of Wren, Hawksmoor, Vanbrugh, Archer and Gibbs are all associated with a major church-building campaign of this period. In the opening years of the century, the influence of the noblemen and churchmen who had invited William to take the throne still reverberated architecturally. Queen Anne's succession in 1702 gave increased heart to the Stuart cause and at the same time encouraged the Church of England to make moves to recover some of the power lost during the Commonwealth and at the Glorious Revolution. With a landslide Tory victory at the election of 1710, a plan to build fifty new churches in London and Westminster and their outskirts was formulated – a plan which would make a political and religious statement in architectural language. In 1711, an Act passed through parliament for church building to be undertaken using public money in

parishes where there were large populations (often dissenting from the established church) and few churches. Only twelve churches were eventually built, but they are among the most interesting buildings of their time because they speak so eloquently of the aims of those who commissioned them and because information survives about the aims of the architects who designed them.

A commission was formed to carry into effect the provisions of the Act. It consisted largely of Tory clergymen, nobility and gentry, and City dignitaries, but also included Sir Christopher Wren and his son Christopher, Thomas Archer and John Vanbrugh. To give the commissioners professional support, there were two surveyors. Nicholas Hawksmoor served from 1711 to 1733 in this capacity, with, successively, William Dickinson, James Gibbs and John James.

Both Wren and Vanbrugh made recommendations to the commissioners on the design of the proposed churches. Sir Christopher Wren suggested a simple 'auditory' type of church, like St James Piccadilly, which could be relatively cheaply constructed of brick with stone dressings, and which would comfortably accommodate about 2000 people all of whom could see and hear the common act of worship at the communion table, pulpit and clerk's desk, either from the body of the church or from the galleries on each side. He envisaged modest structures which would be 'beautiful and convenient, and as such, the cheapest of any Form I could invent'. In this he seriously misjudged the spirit of the Act and its first commissioners. They wanted something much more assertive, of which John Vanbrugh had the measure rather better than Wren. The Act required each church to have a prominent tower and to be built of stone. To these requirements, the commissioners added a porch, a font large enough for dipping, and arrangements inside which would make the altar, at the east end readily visible to the congregation. Vanbrugh recommended towers which would be 'high and bold', porches which would be 'solemnly Magnificent' and the whole 'form'd for the utmost duration' of stone. They should have the appearance of strength and 'the Reverend look of a Temple it self; which shou'd ever have the most Solemn and Awfull Appearance both without and within that is possible'. In short, they were to 'become ornaments to the Town, and a Credit to the Nation', and also, though this remained unsaid, ornaments to the Church of England.

Christ Church, Spitalfields, begun in 1714 to the designs of Nicholas Hawksmoor, is one of the most impressive of these churches, conforming in every respect to the recommendations of Vanbrugh. It reflects, in addition, the varied interests of its architect. The porch is like a gigantic Venetian window – the classical writ large – above which is an equally large tower surmounted by a spire – a traditional British medieval form. Inside, there is a suitably 'solemn and awfull' atmosphere achieved by the monumental scale of the columns and the light filtering down from the clerestory and side windows. The mix of classical and medieval references is characteristic of Hawksmoor.

Archer's St Paul Deptford, of 1713–30, and the minister's house beside it reflected his wide first-hand knowledge of French, Italian and probably

Austrian work of the time. The porch, however, seems more like a homage to the larger St Paul's – the cathedral – and the spire perhaps also pays tribute to the work of Wren in the City church of St Mary le Bow. All of those designing the new churches must have been very aware of Wren's tremendous achievement, and of the fact that he was a Commissioner, although not a very active one.

James Gibbs (1682–1754), the architect of St Martin-in-the-Fields, was a protégé of Wren, a colleague of Hawksmoor as surveyor to the Commissioners for a time, and a well-qualified designer, who spent some years in Rome studying architecture. In 1715, with the change of government and the consequent change of commissioners, he lost his surveyorship. He was a Roman Catholic and, as a Scot, a supporter of the Stuart cause. In 1721, building started on the church which was to be his masterpiece. It was commissioned from him independently by the influential vestry-men of the large parish of St Martin and was therefore not one of the 1711 Act churches, but it makes an interesting comparison with them. The early designs show that Gibbs was eager to experiment with Italianate forms – one was for a church with a circular nave. The design became progressively more like a classical temple to a degree unique among churches of the time – a rectangle with a shallow-pitched roof forming a triangular pediment at the front and back. The front was given a chaste, six-columned portico, with a plain, unbroken pediment. The traditional British tower and steeple presented obvious problems here. Gibbs chose to set them, somewhat incongruously, as if protruding from the roof.

This church-building campaign drew to a close in about 1730, having run out of both money and enthusiasm. Few churches were constructed thereafter until the end of the century, when the problem of providing places in church for the expanding population was again addressed, resulting in the 'Million Pound Act' of 1818.

Palladianism

The year 1714 marked the end of the reign of Queen Anne and of the Stuarts as monarchs of Britain. It did not mean a sudden break in architectural ideas, however, although this impression is often given. The careers of Vanbrugh, Hawksmoor, Gibbs and Wren continued, with gradual changes in response to gradual shifts in taste and patronage. Country-house building also continued, and so did the spread of European (especially Italian and French) ideas, although tempered by British traditions.

There was, however, a change in politics, with the Whigs forming a government in 1715, and retaining a majority for many years. They worked for a strong parliament, a limited monarchy, the Protestant succession and maintenance of the balance of power. With them came changing attitudes to religion. Queen Anne was a devout member of the Church of England, but she was also a Stuart. Although Roman Catholicism was feared and controls were operated, there was a certain tolerance. George I came from very different roots, and attitudes towards Catholics hardened, especially after the

St Martin-in-the-Fields, London (1721–6). James Gibbs.

Jacobite rising of 1715. With this came a reinforced hostility to Catholic countries, and a wish to forge a newly powerful and independent British nation. Many of these ideas had been in circulation earlier and now re-emerged. In architectural terms, there was a hostility to stylistic forms associated with Roman Catholic countries, and with the Counter Reformation. It was felt that the extravagant and exaggerated architecture to be found there was inappropriate to a Protestant nation which cherished its independence. Together with this, an increased admiration developed for Inigo Jones – the seventeenth-century court architect who had achieved an almost legendary reputation since his death in 1652. What was now seen to be his chief virtue as a designer was the carefully controlled nature of his works, the use of proportional systems and the severity of his classical façades. Set beside the tremendous experimentation with classical form which went on in the period associated with the English baroque (approximately 1670–1720), even Jones's most decorated buildings seemed quite plain. Above all, in addition to being a uniquely gifted architect, Jones was British.

A sequence of writings, as well as one or two buildings, helped to form the ideas of an influential minority while the majority was still greatly admiring the works of Archer, Vanbrugh and Hawksmoor. In 1710, William Benson, a wealthy Whig MP apparently in touch with fashionable architectural ideas, built Wilbury House for himself on his Wiltshire estate. It was in marked contrast to contemporary architecture in that it was closely based on Amesbury, a nearby house thought to be by Inigo Jones, and was therefore one of the pioneers of the Jones revival, or English Palladianism. One who voiced the new opinion was John James (*c.* 1672–1746). In a letter of 1711 seeking employment as a surveyor to the church-building Commission (a post which he only succeeded in getting in 1716) he wrote that he would like to have the opportunity of showing, in his work, 'that the Beautys of Architecture may consist with ye greatest plainness of the Structure'. This ideal of beautiful plainness had 'scarce ever been hit by the Tramontani (those north of the Alps) unless by our famous Mr Inigo Jones'.

These two instances merely hint at what was being discussed. Anthony Ashley Cooper, 3rd Earl of Shaftesbury, wrote a letter from Naples to Lord Somers in 1712, setting out in detail what he referred to as his 'Project'. He was an ailing man, living in Italy for his health's sake, and he wrote, he said, in 'a kind of spirit of Prophecy', seeing in newly 'united Britain the principal Seat of the Arts'. He linked this pre-eminence closely to the idea of liberty. In discussing the arts, he made some caustic remarks about Wren:

thro' several Reigns we have patiently seen the noblest public Buildings perish (if I may say so) under the Hand of one single Court-Architect; who, if he had been able to profit by Experience, wou'd long since, at our expense, have prov'd the greatest Master in the world.

As a result of what he called a 'Zeal' for 'Ecclesiastical Structures' there would be 'many Spires arising in our great City' which would attract criticism 'as retaining much of what Artists call the Gothick kind'. Shaftesbury was here using 'Gothick' as a term of abuse for what he felt would be the tasteless architecture of the 1711 Act churches. It was for the public, he felt, to demand something different:

When the *free* spirit of a Nation turns it-self this way, Judgments are form'd; Criticks arise; the public Eye and Ear Improve; a right Taste prevails, and in a manner forces its way.

Britain was, then, ready to take a step forward to achieve this aim. Shaftesbury proposed academies of the arts of painting, sculpture and architecture as part of the programme. His 'Project' was only published in 1732 (in the fifth edition of *Characteristicks*) but the importance of the letter was recognised as soon as it arrived in England, and its contents were circulated, and the idea of forming a new national taste taken up.

This was a most unusual campaign, stemming from political change which would bring a new independence, and proclaiming as a corollary of this a new liberty of thought concerning the arts in Britain. Two architects stand out as of primary importance in their response to these ideas – Colen Campbell and Richard Boyle, 3rd Earl of Burlington.

Colen Campbell and Lord Burlington

Colen Campbell (1676–1729) was born in Scotland, and trained and practised as a lawyer there before turning to architecture. Any specific schooling he received in this art seems to have come from James Smith, then recognised as the leading Scottish architect and Surveyor of the Royal Works in Scotland until that office was abolished. His drawings, which later belonged to Campbell, reveal a strong interest in the work of Palladio and when Campbell moved to London and encountered the emerging movement for reform in architecture based on the work of Palladio and Jones, it may have struck a familiar chord from his past. However, the designs he submitted to the 1711 Act Commissioners in 1712, when he had apparently recently arrived in London, were noteworthy for neither their originality nor their Palladian flavour. It would seem, therefore, that when he planned the influential *Vitruvius Britannicus*, which came out in three volumes in 1715, 1717 and 1725, he was responding principally to ideas circulating in London at the time. The books were a handsomely produced visual record of the state of British architecture of the time, but with more than a hint of the way the art was to travel in the form of Campbell's own designs. There is very little text. The body of the books consists of fine, clear engravings. The written message is confined to the Introduction, and to the brief notes relating to each building illustrated.

Campbell began by drawing attention to the British esteem for 'Things that are Foreign', and commenting on the reliance placed on Italian architects, especially 'the great Palladio', who had 'exceeded all that were gone before him, and surpassed his Contemporaries', and whose work would 'rival most of the Ancients'. Since his day, the 'exquisite Taste for Building is lost'. 'The Italians can no more now relish the Antique Simplicity, but are entirely employed in capricious ornaments . . .'. Campbell gives the merest nod to Wren, Vanbrugh, Archer, Hawksmoor and a few others and recommends as an exemplar for the British 'the Famous Inigo Jones' whose works had regularity, beauty and majesty.

The annotations to the engravings of his own designs make it clear that Campbell sought to follow this path in his own work. He particularly wished 'to introduce the Temple Beauties in a private Building', and in his comments on his first design for Wanstead in Essex he said the front was 'adorned with a just Hexastyle, the first yet practised in this manner in the Kingdom'. This 'just hexastyle' – a six-columned temple front – and indeed the full form of a temple were also proposed by Campbell for a 'Church in the Vitruvian style'. The 'Temple Beauties' in a church were of course celebrated in the eventual form of Gibbs's St Martin-in-the-Fields. The publication of *Vitruvius Britannicus I* in 1715 gave voice and focus to a discussion which had clearly been taking place in architectural circles for several years, and it contained designs to illustrate the new ideas. As yet, however, very little had been built, although Campbell's reputation had begun to procure him commissions. The books gave his work additional publicity, and more commissions followed.

Richard Boyle, 3rd Earl of Burlington (1694–1753), was 21 when the first volume of *Vitruvius Britannicus* was published, and he was one of the subscribers. He had already undertaken a more than usually intensive study of the arts, especially architecture. His first visit to Italy in 1714–15 had taken the form of the Grand Tour which was becoming the norm for young nobles and gentlemen. He returned to Italy in 1719, specifically to study the work of Palladio, using Palladio's own published treatise as a guide, and he purchased original drawings by Palladio and brought them back to form part of his collection.

On returning from his second Italian visit, Burlington began to design in earnest, always referring to Jones and Palladio. His buildings were stylistically in startling contrast to those designed by the established architects of the previous generation. The difference lay in their plainness, their simple lines and their carefully proportioned elements. Campbell and Burlington were evidently in close contact. Between them, they produced some of the most influential designs in this period of British architecture.

Campbell made a number of designs for a large country-house for the banker Sir Richard Child at Wanstead in Essex (built from 1713 onwards). Three of the designs were published, with suitable comments, to promote the new ideas they represented. Wanstead's importance lies not only in the fact that it was built with a classical six-columned temple front, but also in the fact that the temple form stretched through the house from front to back. It was as though Campbell had embedded an entire Roman temple in the centre of the house. There were references to Palladio and Jones in the scale and proportions of the windows, in the emphasis on the first floor, which dominated both ground and attic storeys in size and ornament, and in the relative plainness and restraint exercised throughout. A comparison between Wanstead and Castle Howard reveals that Campbell owed a considerable debt to Vanbrugh, although he had 'corrected' Vanbrugh's design to make it Palladian, perhaps as an example.

Campbell designed Mereworth in Kent for the Hon. Colonel John Fane, later 7th Earl of Westmorland, in *c.* 1722, for use as an occasional residence. It was derived from Palladio's famous Villa Rotonda near Vicenza, which had

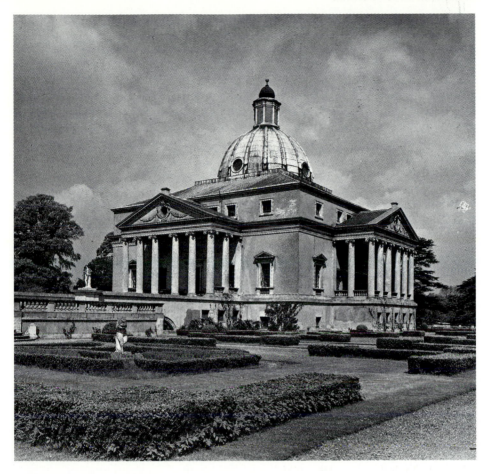

Mereworth, Kent (c. 1722). Colen Campbell.

a central dome and a hexastyle portico on each of its four sides, but in this early work Campbell was still close to contemporary English work. What resulted was an anglicised version of the Italian building, with heavier porticos, decorated pediments, and above all a very prominent melon-shaped leaded dome and heavy lantern, related to Wren as well as to Palladio.

Lord Burlington's work was very different. He designed and built a villa for himself from about 1727 beside his country-house at Chiswick, apparently intending it as a pendant to his existing home, but not a replacement of it. The germ of the idea must have been in his mind since his return from Italy but the design apparently dates from *c.* 1726. Conversations with Campbell, and his own explorations of the writings and drawings of Palladio and other sixteenth-century Italians produced the final idea, which also drew on ancient Roman buildings.

Chiswick's smaller size, very sharply defined detailing and clear lines give it the quality of a well-cut jewel. In every sense it is less heavy than Mereworth. It has elegant staircases at front and back, fluted Composite

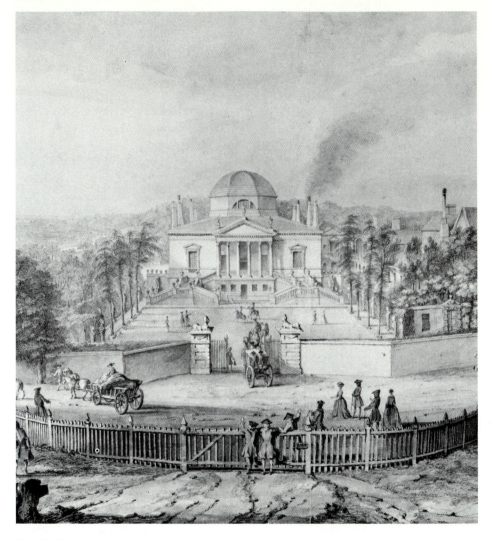

Detail of a view of Jacques Rigaud of the south front of Chiswick House, Chiswick, Middlesex (c. 1727–9). Lord Burlington.

columns rather than plain Ionic, and an octagonal drum and shallow stepped dome. For some of the detailing Burlington looked to drawings by Palladio and Scamozzi which he owned. This is true of the Venetian windows set into arched recesses which were to become such a feature of the architecture of the next generation, and the semi-circular windows in the drum supporting the dome, derived from measured drawings by Palladio of the Baths of Diocletian in Rome.

The publication of *Vitruvius Britannicus* aroused considerable interest in Palladian architecture, and the built designs (Wanstead, for example) attracted attention as the latest and most fashionable thing in Whig circles. Robert Walpole, who headed the Whig government from 1721, commissioned (apparently that same year) a great country-house from Campbell for his

estate at Houghton in Norfolk. Campbell had dedicated a design to Walpole in the second volume of *Vitruvius Britannicus*, and was therefore already seeking his patronage in 1719. In the third volume of 1725, he showed his design for Houghton, which clearly owed a great deal to the south front of Wilton House, Wiltshire, published in volume II and thought to be entirely the work of Jones. There is room for speculation as to the extent of Campbell's work at Houghton. As built, it had modifications in the form of the domes over the pavilions, as well as discrepancies of dimensions. Gibbs – hated by Campbell and excluded entirely from *Vitruvius Britannicus* – designed the domes and perhaps more. However, Houghton as illustrated in *Vitruvius Britannicus* was a most significant design incorporating the familiar and recognisable Wilton pavilions into a modern house.

Apart from Chiswick, Burlington designed a relatively small number of country-houses, town-houses and public buildings, all of which contributed to his reputation as a great patron of the arts and chief exponent of the new Palladian taste. One of the most important, because it was in the public eye, was the Assembly Rooms in York (1730–2). The foundation stone called Lord Burlington 'the Maecenas of our age'. Francis Drake, in his history of York, *Eboracum* (1736), wrote:

Your Lordship's great great knowledge in this art soars up to the *Augustan* age and style; and that Pretorian palace, once in old EBORACUM . . . must, if now standing, have given place to your *Egyptian* hall in our present York.

Assembly Rooms, York (1730–2). Lord Burlington.

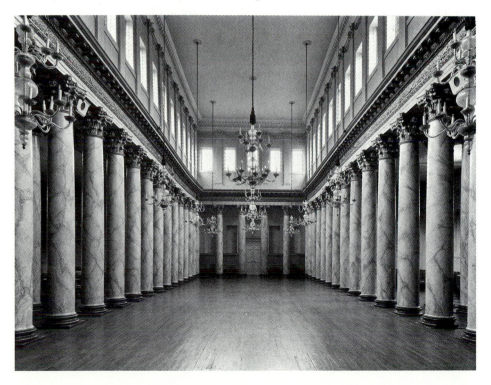

The building consisted of a large dancing room, a common assembly room and a grand tea room. As indicated by Drake, Burlington was quoting antique sources once again – appropriate for a city of Roman origin. Vitruvius had described an Egyptian Hall, which Palladio had discussed and illustrated. Inigo Jones drew on this source for the Banqueting House, Whitehall (though in modified form) and Burlington's Assembly Rooms, in setting the approving seal on the concept, led to a series of 'Egyptian Halls', the best known of which is probably that at the Mansion House, London, by George Dance, of 1739–52. The principal features of Burlington's hall, apart from its careful proportions (112 × 40 × 40 feet), were the use of a giant colonnade all round which produced a main central space and side and end aisles. The columns supported a clerestory above. The effect was suitably Roman and grand, although there was criticism of the closely-set columns. The sequence of room shapes around the main hall – circle, cube, triple cube – were based, like those at Chiswick, on sequences found by Palladio in Roman bath buildings.

The varied and influential design talents of William Kent (?1684–1748) should be considered in relation to the interiors of Chiswick and Houghton. Kent's background was not privileged in the way Burlington's was. He came from the East Riding of Yorkshire where he was said by Vertue to have been apprenticed to a coach painter. He seems to have managed, nevertheless, to attract patrons who were prepared to send him to Italy in 1709 for further training. In Rome, he studied painting, recorded, copied, saw as much as he could, and acted as a dealer. He acquired a knowledge of Italian interiors, architecture and gardens which was to be of great service to him once back in Britain.

As an Englishman in Rome with a knowledge of the arts, Kent met a number of people on the Grand Tour. Of these, the most important were Lord Burlington himself, probably in 1714 and certainly in 1719, and Thomas Coke, later Earl of Leicester, who was to be his patron at Holkham Hall. On Burlington's return to England in 1719, Kent travelled with him from Paris, and thereafter remained in constant touch with the Earl. Burlington seems to have recognised in Kent a talent for design. He expected this to manifest itself in painting, but in the event it was in other fields – architecture, landscapes, interiors, furniture design and book illustration – that Kent excelled. (The partnership of Kent and the Earls of Burlington and Leicester is explored by Cinzia Maria Sicca in her chapter on Holkham Hall, and Kent's contribution to garden design is discussed by Michael Symes with reference to the landscapes of Rousham and Stowe.)

Because Kent was very closely involved with Lord Burlington and his family at Chiswick, it is difficult to discover the exact part he played in its design. Burlington must have discussed the design of the villa itself and its interior decoration with his friend. Beyond this the extent of the collaboration is uncertain, because Burlington had his own definite ideas and made his own designs. The traditional view that Kent was responsible for the design of the interiors at Chiswick cannot be upheld, but he does seem to have painted the ceilings (which have the characteristics of his work elsewhere), and he also produced some designs for furniture for Lady Burlington.

At Houghton, on the other hand, the interiors were largely the responsibility of Kent, who was working there by 1725. They were of the utmost grandeur, and used the richest of materials – mahogany doors with gilt carving, carefully selected and varied marble for the chimneypieces and overmantels, the richest tapestries, hangings and upholstery, including crimson cut velvet for the Saloon and plain green velvet for the state bedroom. The first floor here was the 'floor of taste, expense, state and parade' as Lord Hervey commented. The family lived in 'the rustic', or ground floor, which was dedicated to hunters, hospitality, noise, dirt and business, according to the same source. Kent's work drew much from Jones for chimneypiece designs, but much also from his Italian experience for the furniture, which was vigorous and bold, used marble and gilt wood extensively, and was exuberantly and imaginatively decorated with swags of fruit, flowers, eagles, classical heads, palms, husks and acanthus leaves. Furniture was considered as an integral part of the architectural scheme for the interiors. The famous green velvet state bed, embellished with yards of gold lace, had a strongly architectural design, as well as one of Kent's favourite motifs – a scallop shell – incorporated in giant form on the bed head. Interiors and furniture of this period have little of the architectural restraint of the exteriors. It is as though the designers were following the words of Inigo Jones in 1614 which tell of a wise man who outwardly carries a gravity, but inwardly 'hath his Immaginacy set free'.

Kent was actively involved in official architectural works because of his posts at the Office of Works. Wren was displaced as Surveyor of the King's Works in 1718, after which the Surveyorship was occupied by men of no great architectural expertise. The business of designing was carried on by more junior officers, whose posts often had little to do with their real functions. Kent, promoted by Burlington whenever possible, was first Master Carpenter, and then Deputy Surveyor and Master Mason.

The new English villa

The ideas promoted by Lord Burlington were limited and limiting, and there was never total conformity to them. Palladianism had particular associations with the Whigs, but the Whigs were scarcely a coherent group in any case, being, as Swift observed, 'patched up of heterogeneous inconsistent parts'. Other architects who had no particular loyalty to that party, nor to Palladio and Jones, continued to be in demand. Gibbs – a Scot, a Roman Catholic and a Tory – worked mainly for Tory patrons in a style which had strong links with that of Wren and his associates. The political demarcation was not absolute, of course. Jane Clark has suggested recently that Lord Burlington himself was secretly associated with the Stuart cause. Vanbrugh, a Whig by politics, never abandoned his early monumental manner, although he did respond to the new fashion. The ideas of William Kent, while echoing Burlington's when in the classical mode, were very free and far-ranging when applied elsewhere. His interest in antiquarian matters led him to explore the medieval style of building – something which may have been encountered by

Vanbrugh's earlier essays in that direction. Finally, one of Burlington's greatest contributions – the development of the English villa – was taken up by his contemporaries and the next generation of architects, and transformed into something different and exciting.

The new English villa was to evolve from the country-houses designed by Palladio or the ancient Roman houses described by Vitruvius, but initial interest in the form in the eighteenth century was aroused because of its links with Jones, Palladio and the antique. The first change was one of terminology. Palladio designed houses for villas – in other words the villa to him was a farming estate and not the house which served it. In Britain, the word villa came to be used as the name for a type of house inspired by examples in Palladio's work. Wrotham Park and Chiswick both illustrate its characteristic form, with its tripartite division of the main façade. Palladio wrote in his treatise that he usually included a temple portico on a private house. Apart from the fact that this gave it grandeur and magnificence, he believed that the ancients had used the form on their houses and that it was from these that temples derived. The English villa therefore often had a temple portico framing the central part of the façade. Within the central section there were three openings, framed by a single opening in each side section. Most villas had three floors, ground, first and attic, of which the first – the *piano nobile* of the Italians – was the most important. Villas were occasional homes, not too far from the city for accessibility and often without any agricultural land, although they usually had grounds for a garden.

Architects of Lord Burlington's time wishing to recreate the houses of the ancients began by consulting Palladio, and supplemented the rather sketchy information in his treatise with that to be gleaned from Vitruvius and Pliny the Younger. Vitruvius described the various features of the houses of the Greeks and the Romans, and Palladio provided illustrations based on this description. He particularly concentrated on the atrium, or large entrance hall, of which there were a number of variants. Pliny the Younger described in detail his country retreats, celebrating the delights of the countryside and the loose margin between house and nature, with terraces giving easy access to the garden, and certain parts of the house being open to the sky. Robert Castell, in his *The Villas of the Ancients Illustrated* (1728) attempted to translate Pliny's descriptions into plans. English villas in the country, set in pleasant grounds, were thus sanctified by antique tradition, and the new Palladians explored the possibilities. The lack of clear evidence on which to base a reconstruction simply added to the fascination.

Burlington was not the first to explore the possibilities. Inigo Jones and his follower John Webb had produced designs inspired by the same sources in the seventeenth century and James Gibbs designed Sudbrook House, Petersham in 1715, at a time when Burlington's project was still gestating. Sudbrook was relatively small, built as 'a pleasant retraite from bussiness' not far from London, and drew on the open loggia idea of Jones's Queen's House, Greenwich. Smaller houses began to be seen as very practical. Large and impressive country seats were expensive to build and run, and not always comfortable. The villa, small by definition, could be much more convenient. So Henrietta Howard, Countess of Suffolk and mistress to George II, built a

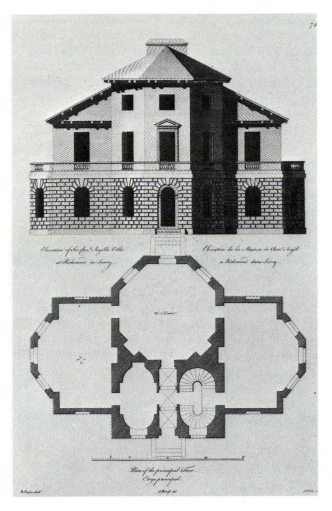

Asgill House, Richmond, Surrey (1761–4); plan and elevation. Robert Taylor.

villa at Marble Hill (1724–9) which could be reached after an easy ride from London or, even more conveniently, by water. Designed by Henry Herbert, later Earl of Pembroke, assisted by Roger Morris, it contained living rooms, mostly on the ground floor, and some state rooms above, with access through a four-columned hall emulating the tetrastyle atrium described by Vitruvius and illustrated by Palladio.

Because of their practical advantages, increasing numbers of villas began to be built around the mid-century. Sir Robert Taylor (1714–88), trained as a City of London mason and sculptor, built up a considerable practice by designing town- and country-houses, mostly for City men. His villas considerably expanded the Palladian vocabulary. Like his contemporaries, he must have taken a keen interest in the excavations at Herculaneum proceeding during the 1760s. A good surviving example of a villa by Taylor is Asgill House, Richmond of 1761–4. Although retaining the accepted tripartite form Taylor made the ground and first floors of equal height, while still emphasising the first floor windows by their decoration. Thus, the Palladian formula of the *piano nobile* is abandoned inside, and all the main

rooms are given equal height – necessary in such a small building. The interior planning is ingenious. Taylor was particularly inventive in designing staircases which would take up as little space as possible while remaining decorative and grand. The temple front, too, has been modified and takes on a much more rustic air, with boldly projecting eaves. Through it, the attic rises, crowned with a rustic roof of its own. As with all of Taylor's villas, the building is carefully set in its landscape. The whole composition is tremendously attractive. Subtle references to Covent Garden church give it the sanction of 'the famous Inigo Jones' and it exudes the air of a modest Italian country retreat as seen in Claude's paintings, enhanced by the suggestion of the Tuscan order – essentially rustic in mood.

William Kent also experimented with such ideas. He used them both in architectural and garden design, and interpreted them in both classical and Gothic styles. An interest in the past of all ages meant that medieval work was beginning to be considered by antiquarians. Vanbrugh's reaction in wishing to conserve the ruins of Woodstock Manor was an early manifestation of this. His 'castle' at Greenwich showed him trying to create an atmosphere of medieval antiquity for himself. Kent seized on the 'castle air' and worked at its forms. Like Vanbrugh, he apparently responded to the romantic associations of medieval-style buildings. He also seems to have welcomed a style with which everybody was less familiar, and which was therefore less likely to have limitations applied to it. No 'noble rules' here, but freedom to adopt very attractive motifs such as ogees and quatrefoils, and mix them, if he wished, with scallop shells and Vitruvian scroll or fret patterns.

Kent produced a number of his own Gothic designs, some of which were built. He also had the opportunity to enlarge and embellish a Tudor Gothic gatehouse, built originally in 1447–86 for William Waynflete, Bishop of Winchester, as part of a larger house at Esher in Surrey. The brick gatehouse, or tower, was unlike a villa in form, but it had all the attributes of a small country-house, including the rustic air later cultivated by Taylor. Kent added a pair of wings to the gatehouse, three storeys high and with canted bays to the east and Gothic windows all round. He gave the original structure quatrefoil windows and double-curved ogee arches at the door, and wonderful mock fan vaulting with heraldic devices inside. It was, and the gatehouse still is, immensely pretty and light-hearted, in contrast to the self-conscious seriousness of Palladianism.

Kent not only broke new ground with his choice of Gothic forms at an early date. He was also extremely innovative in his vision of landscape and in the varied buildings which contributed so strongly to the impression it created. Kent made a number of designs for garden buildings in the grounds at Esher, only some of which were built, in a variety of different styles. His drawing, and Rocque's engraved plan of Esher of 1737 show a grotto, a hermitage, a fishing temple, a belvedere, a thatched house, a Chinese temple, an Oriental tent, a Palladian bridge, and a Chinese bridge. Among the most interesting of the unbuilt designs is a sheet with three versions of a Chinese temple – a very early use of this exotic style. The thatched house, which was built, is an early example of the use of vernacular buildings in garden settings

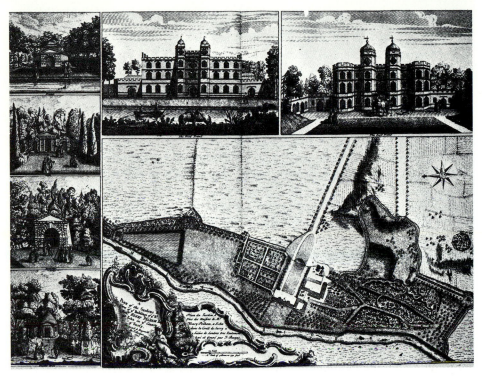

John Rocque's plan of Esher, Surrey, with the embellished gatehouse and, top to bottom, Temple, Grotto, Hermitage, Thatched House. William Kent (from 1729).

to evoke a rustic atmosphere. The whole house and its estate was thus formed into a picture landscape by Kent, who responded to the natural geographical features with varied planting and buildings, and echoed the natural winding course of the River Mole in the serpentine form of paths. The repercussions of such treatment were felt during the rest of the eighteenth century, and continued to reverberate into the nineteenth, and even today.

Kent's Gothic was decorative and imaginative but he was not a serious student of the style. However, his ideas had appeal for serious antiquarians as well. From early in the eighteenth century there was a value set on ancient work of all kinds, whether classical or medieval, although knowledge of the former far exceeded the latter. John Talman – son of the architect William – travelled a great deal, and carefully examined Gothic architecture in Italy, as well as classical work. He collected architectural drawings and antiquities and was partly responsible for the founding of the Society of Antiquaries in 1717. This Society was a positive factor in the increasingly serious consideration of Gothic. Medieval studies had far to go, however, and the stylistic differences of the period were often misunderstood and misinterpreted. Most people at the time used 'Gothick' as a term of abuse, as Shaftesbury did – meaning barbarous, uncivilised and uncontrolled. Both Wren and Hawksmoor took medieval work more seriously. Wren associated 'the Gothick Manner' with

Arabic influence. Hawksmoor tried to analyse the medieval style of building, defining 'this Term Gothick' as:

The Manner of Building, so different from the Greek & Latin Style, which came in at the fall of the Roman Empire, and among the first Christians.

Gradually, the historic associations of the style roused interest, and it came in time to represent the virtues of primitive societies. The Temple of Liberty at Stowe (1741–7), by James Gibbs is an illustration of this, using Gothic forms to represent the freedom of the ancient British civilisation. Perhaps the most seductive idea of all was the way the medieval style was associated with ruined buildings set deep in the countryside and hung about with trailing branches and plants – the perfect evocation of country life as described by Pliny, but with a British flavour. In certain cases, genuine ruins were used to give a flavour of romance to a newly created view. Fountains Abbey was used in this way at Studley Royal gardens. Finally, admiration increased for painters such as Claude, who had sought to express in oils the ineffable ideal of the ancient world, and had incorporated into his work ruins of both medieval castles and classical temples. For the new Briton, trying to create his own picturesque scene, it was a natural progression to incorporate ruins of medieval Britain, or to invent new ones which recalled old styles.

By the time Horace Walpole (1717–96) – fourth son of Robert Walpole of Houghton – began to consider a house for himself, Gothic had become very popular. Pope had admired its strength and solidity, Gibbs and Kent had used it, and a number of builders had seen its potential and published pattern books showing how to work with its motifs. William Halfpenny, a Richmond carpenter, produced many such. Batty Langley, of Twickenham, who ran a school of architecture and drawing and produced numerous publications, wrote *Gothic Architecture Improved* (1747), which sought to systematise the new style to fit the idea of the classical orders. However, Walpole's innovation was to use Gothic for a modern house, rather than for additions to a medieval one or for a garden building which had been seen as its appropriate context previously.

Walpole was wealthy and literate, and a leader of taste. He was certainly aware of Kent's activities in the Gothic style, and had read Halfpenny and Langley. His comment in 1748 on Waynflete's Tower (Esher Place) was: 'Esher I have seen again twice and prefer it to all villas . . . Kent is Kentissime there.' He therefore dubbed Esher a villa, accepting the fact that it was neither true to the accepted form nor a classical building. He acquired the lease of a small recently-built riverside house at Twickenham in 1747 and began to plan its transformation. He became the owner of Strawberry Hill in 1749, and continued to live there and add to it until his death in 1796. Walpole's mind was behind its creation, but he was much helped by friends and professionals who constituted what he referred to as his Committee of Taste. All were devoted to the study of Gothic – 'fellow Goths'. Strawberry Hill therefore emerged as a statement of this new taste, and gave its name to a style of decoration: Strawberry Hill Gothic.

The house purchased by Walpole was three bays wide, and symmetrical. He extended it behind and to the east side in a series of building campaigns,

An ogee-arched doorcase with two quatrefoils from Gothic Architecture Improved by Rules and Proportions *by Batty Langley (1747)*.

and it finished up full of what he called 'charming irregularities'. In fact, it was specifically built so that its various parts – cloister, gallery, tower – appeared to have accumulated over the years. 'I am going to build a little Gothic castle at Strawberry Hill', Walpole had written. For the interiors, inspiration was drawn from the engravings and descriptions of the early topographers. Drydale's engraving of the choir screen of old St Paul's, for example, was the basis for the bookcases in the library, and the fan-vaulted gallery was based on the aisles of Henry VII's Chapel in Westminster Abbey. The detail was accurately copied, but not the material. The bookcases were of timber and the vaults of papier mâché, while the originals of both were of stone. This gave Strawberry a delicate, fragile, slightly unreal appearance, closely related to the two-dimensional illustrations which inspired its detail, and enhanced by the use of the most decorative of curved forms available in the Gothic repertoire – the ogee (a double or s-curve). Inside, it was filled with appropriate furniture, and had an atmosphere of gloom which Walpole cultivated. His collections were large and varied, and parts of the house were designed specifically as a backdrop to the collection.

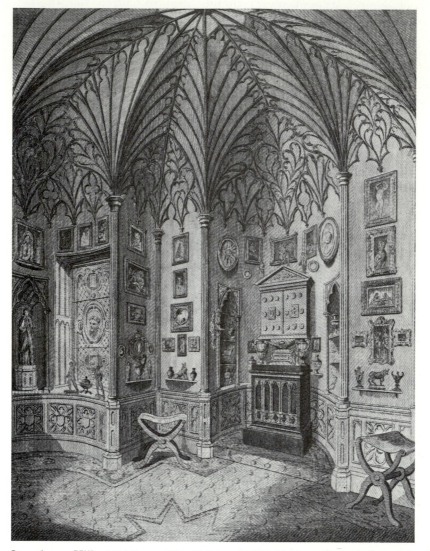

Strawberry Hill, Middlesex. The Cabinet (1761–3), from Description of the Villa of Mr. H. Walpole *(1784)*.

The continuing use of curved Gothic forms and the introduction of deliberate asymmetry seen at Strawberry Hill were further evidence of the increasing freedom of taste and the development of eclecticism, and they were perhaps also the architectural expression of the decorative style known as rococo. The double curve, or serpentine line, was one of the principal characteristics of this style which had its roots in France at the turn of the century. Elaborate curves, shell and palm-leaf motifs, figures of birds and monkeys, and asymmetry were all increasingly cultivated to lighten contemporary interiors, and these features began to influence design in Britain in the 1730s. The impact of rococo was mainly felt in the design of attractive artefacts and ornaments, often made by immigrant Huguenot artists

and craftsmen. Numerous publications supplied detailed patterns for others to follow. Objects in silver and gold, porcelain and glass, textiles and furniture all began to exhibit rococo features. Wonderful rococo effects were soon to be seen in interiors, in the plasterwork of ceilings and walls and in the carved details of overmantels and doorcases. William Hogarth, in 1753, championed the serpentine 'Line of Beauty and Grace' in his *Analysis of Beauty*. Kent's Gothic and Chinese at Esher, and Walpole's Gothic asymmetry at Strawberry Hill may be seen as part of the new taste. They should be viewed against a background of preference for the classical, but they were prophetic of the changing times which would, very soon, give greater freedom of choice in architecture, as in other realms.

Speculative building and town planning

With the rise of the contracting builder in the eighteenth century, and the increasing population of the major centres, the number of houses built as speculative ventures steadily increased. The rich and influential still had their town-houses designed and built individually, but large numbers of people leased more modest houses in town, built for a landowner by speculative builders. The earliest instance of this in London was the Covent Garden square of the 1630s. By the eighteenth century, many more areas were being laid out in streets and squares. John Wood, who moved to Bath and built there so successfully, began his activities in London on the estate of Edward Harley, Earl of Oxford, which included Harley Street, Cavendish Square, Oxford Street and the rest.

In London and elsewhere, town-houses had traditionally been timber-framed and their pattern along a street had been haphazard, depending on the ownership of the various plots of land. Things changed dramatically after the fire of London in 1666. Ensuing legislation in London ruled on the overall height of houses and controlled the number of storeys according to the size and importance of the street. Because of the risk of fire, timber was confined to interior construction with the exception of some details like window frames and sashes, and brick was the favoured material for exterior walls. These regulations were reviewed from time to time. The most significant later legislation in London was the Building Act of 1774, drafted by Sir Robert Taylor and George Dance the Younger, which sought further to reduce fire risk, to codify previous legislation and to set down more detailed structural requirements for each category or 'rate' of building. Thus, a certain uniformity was established in London streets.

Other towns and cities followed with legislation of their own, especially if they experienced destruction by fire themselves. Brick was the natural choice of material in London, where clay for brickmaking was plentiful. Elsewhere, other materials were easier to obtain, and so regional variations followed a natural pattern.

The significance of Covent Garden was the fact that controls were exercised over the design in order to ensure a totally uniform appearance of the houses. Various less elegant experiments followed. One of the most

interesting was the development of Grosvenor Square, laid out on an open field site belonging to Sir Richard Grosvenor and planned by a carpenter–surveyor, Thomas Barlow. The usual procedure was to issue building leases of about 60 or 99 years on which only a peppercorn would be due as rent for the first few months before ground rent became payable. The builder would construct the house as quickly and cheaply as possible, exercising the art of 'building slightly' as Isaac Ware called it, and would then sell with most of the lease still to run. The estate retained the freehold, and received income from rent. Builders, depending on their resources, took one or several leases. At Grosvenor Square, uniformity was attempted by proposals to lease several sites on a single side to one builder. Colen Campbell made a grand design in 1725 for 'Seven New intended Houses on the East Side of Grosvenor Square'. It presented itself like the main façade of a monumental town-house, with a rusticated ground floor, on which stood a row of giant attached Corinthian columns. Monotony was avoided by the use of seven large evenly-spaced entrance arches which gave access to the houses. Above these were Venetian windows, giving further emphasis. Unfortunately this design was not built. On the north side of the square, another even grander unified design in brick and stone was proposed, this time with a pedimented and columned centrepiece flanked by 'wings' as at Wanstead. Edward Shepherd, the builder responsible, acquired three leases and built his own symmetrical composition, which was later given a slightly lop-sided air by the refacing of the adjoining corner house. Londoners were nevertheless able to grasp the potential of the idea.

These two examples illustrate the way the design of the London terraced house evolved. Campbell's included a giant order of columns. Shepherd's had columns attached to the centre only. The remainder was left plain, but suggested by its proportions the ghostly presence of a controlling order. Most terraced houses of the Georgian period did not achieve the grandeur of an expressed architectural order, but they owed much of their appeal to the unifying effect of the proportions of their implied columns or pilasters.

It was the London initiative of Grosvenor Square which was taken up by John Wood the Elder and his son in Bath (see the chapter on Bath by Bryan Little). The Woods adopted London ideas, but interpreted them in stone, not brick, and set them into an innovative sequence of streets. Wood was a very eccentric amateur antiquarian with an active imagination. His work at Bath was intended to recall not only the imperial splendours of the Roman era, but also, apparently, the ancient druidical temples connected with the religion of the primitive British inhabitants of pre-Roman Bath. Curved lines were celebrated here in the form of a 'circus' and crescent. Such variety in planning was quickly taken up by others, so that by the end of the century these forms proliferated in all the most fashionable cities and watering places such as London, Edinburgh and Brighton.

Many of the architects already mentioned were involved in designing and building such houses in small numbers. The Adam brothers, whose work is discussed in the next section, were involved in large-scale speculative building in both London and Edinburgh. Their enterprise at the Adelphi (1768–72), where they built a whole network of streets running back from a

main range on the embankment of the Thames, was almost a financial
disaster, only averted by a lottery at the last moment. The brick houses had a
modest air of plainness, relieved from time to time by characteristically
elegant iron balconies and pilaster strips decorated with a Greek honeysuckle
device. The general standards of the London Building Acts and of planning
conventions were upheld in the building of Edinburgh New Town, which
was laid out on a long narrow site in 1766 to a regular grid plan with a
square at each end. Provision was made for various sorts of houses, graded
according to the number of storeys and determined by the importance of the
street. The results were remarkably uniform and imposing. In 1791 Robert
Adam produced an elegantly simple design for terraces of houses in Charlotte
Square which were built, but his church designed to close the vista was only
executed in modified form.

William Chambers and Robert Adam

Foreign travel continued and increased after 1750, bringing acquaintance
with the antique world as well as the study of other civilisations, such as
those of China and India. In addition, the concept of going back to first
principles and primitive forms led, in architecture, to an even greater interest
in the medieval than Walpole and his Committee of Taste had shown. They
had focused on a particular style – Gothic. Now, there was serious
investigation of the vernacular forms of medieval work. Such varied interests
naturally led to discussion and dispute. By the end of the century fashionable
disagreement about the relative merits of Chinese and 'Hindoo', Greek and
Roman was everywhere, and acceptance of a single style was never to return.
 The careers of William Chambers (1723–96) and Robert Adam (1728–92)
encapsulate the essence of the 1760s and 1770s. They stood for different
attitudes to style, and disliked each other heartily as a result. In fact there are
numerous parallels in their careers. Both were of Scottish families and had
large practices which ranged over a wide area, including Scotland and
Ireland. For both of them, travel played a key part in their training, as did a
systematic preparation for the practice of architecture, and both recognised
this before embarking on their respective Grand Tours. Adam and Chambers
had the guidance of the Frenchman Charles-Louis Clérisseau as a drawing
master when in Rome, and both therefore had access to French attitudes to
the antique. Adam was more receptive to a wider range of detail than
Chambers and his design and decoration developed with greater freedom,
using numerous and varied forms. There was disagreement between them on
this very point – how much new and seductive detail should be allowed into
the established classical vocabulary which depended largely on Italian and
particularly antique Roman sources. Adam and his brothers claimed to have
brought about 'a kind of revolution' in architecture and interior design,
which Chambers disapprovingly referred to as their 'affectations'.
 The work of William Chambers leaves the impression of being much less
adventurous than that of Robert Adam, but in his day he was much admired
and he is remembered especially for his brilliant *Treatise on Civil Architecture*

of 1759 which brought a wide knowledge of French and Italian designs to this country. Before turning to architectural training, he sailed as a merchant with the Swedish East India Company, travelling to India and China where he saw as many buildings as he could. Later, he studied architecture with Blondel at the Ecole des Arts in Paris, thus acquiring access to the French academic system for a kind of architectural training which was as yet unavailable in Britain. Finally, he went to Italy, where he spent five years. On his return to Britain in 1755, he published *Designs of Chinese Buildings* (1757) and managed to attract the attention of royal patrons. An official post followed, and he rose to become head of the Office of Works organisation. His career was dominated by official building commissions, although there were also a number of private houses, especially in his early work. His other great achievement lay in his work to found the Royal Academy of Arts in 1768 with Sir Joshua Reynolds, thus fulfilling Shaftesbury's prophecy.

Chambers and Adam may be observed at similar starting-points in two designs for ruined buildings. Chambers designed a mausoleum on the death of Frederick, Prince of Wales, in 1751. He was in Rome, and not surprisingly took as his model two of the most famous antique buildings there – the circular tomb of Cecilia Metella, and the also circular-domed Pantheon. Adam's ruin painting (made after his return to England) illustrates his characteristically free treatment of sources. Its central domed hall, constructed out of brick, may be based on the baths buildings at Hadrian's Villa, Tivoli, or possibly the Temple of Minerva Medica in Rome. To this, Adam has added rooms on either side decorated with a variety of motifs – bucrania (ox skulls), Greek honeysuckle, urns, an antique altar and statues. These designs, neither of which was built, illustrate the powerful effect on architects of seeing the ancient ruins for themselves. The mouldering remains of ancient Rome, partly buried and romantically decorated with trees and plants, produced quite a different picture from the meticulously recorded details of Desgodetz or Palladio. They could be used by the designers to create in Britain echoes of the ancient buildings as they actually appeared in the eighteenth century, not as they used to be, and in settings which would evoke emotional responses.

Both Adam and Chambers were familiar with the pervasive interest in creating picturesque scenes with which Vanbrugh had experimented early in the century. For him, the inspiration had come from 'Landskip painters', and he had tried to recreate their works with real landscape and old, or seemingly old, buildings. This appreciation of the natural features of the countryside was very strongly present in William Kent, who sought to embellish the landscapes with which he was involved with a great variety of buildings which would create an illusion, or evoke surprise and delight. He was therefore concerned, as Vanbrugh had been, with emotional effects. Burke in his *Philosophical Enquiry into the Origin of our Ideas of the Sublime and the Beautiful* of 1757 tried to organise a system of aesthetic responses. He identified beauty with smallness, smoothness, gradual variation and delicacy of form. The sublime was characterised by terror, obscurity and infinity. As the century progressed, Burke's ideas on sublimity and beauty were absorbed and challenged by those designing both buildings and landscapes, so that the

idea of the picturesque (always an imprecise term, defying definition and used variously) began to encompass elements of surprise and delight, but also sometimes roughness, sudden variation and irregularity which could provoke the less obviously pleasant but very intense sensations of shock and even terror.

In this, the work of the engraver and architect Giovanni Battista Piranesi (1720–78) played an important part. He published numerous prints, of which some came straight out of his fertile imagination (like his series of ruined and awful prison interiors). Others were based on a detailed knowledge of the ruined monuments of ancient Rome, embellished by his baroque imaginings, and creatively composed into extraordinarily powerful picturesque images which could be either monstrously mysterious and imbued with terrible associations or more light-heartedly monumental. Both Adam and Chambers were aware of his work and their drawing master in Rome, Clérisseau, was himself influenced by Piranesi, and passed on to them a taste for picturesque ruin compositions and a most accomplished watercolour technique.

Chambers was very responsive to the setting of buildings in a landscape, each one created by the designer to evoke a particular emotion in the spectator. The ruined mausoleum was intended as a single building, possibly for the garden at Kew, on which he worked for the Dowager Princess of Wales from 1757. Not all the buildings there were designed by Chambers, but the overall planning of the garden with a peripheral walk was his. Here were an Alhambra, a mosque, a Gothic cathedral, a number of classical temples, a classical orangery, a ruined arch, a Chinese pagoda and a 'House

A view of the Wilderness, Kew Gardens, with the Pagoda (1761–2). William Chambers.

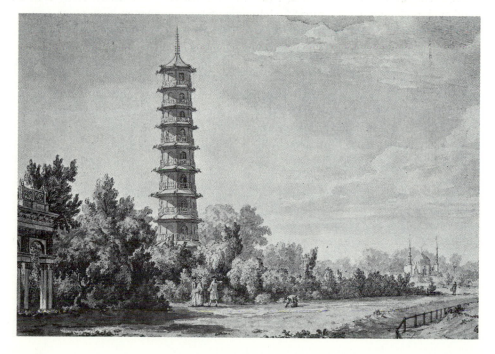

of Confucius', all on a relatively small scale, and each arranged to be seen framed by its own part of the landscape, with the whole presenting an immensely varied set of experiences. This diversity was described by Chambers in his *Dissertation on Oriental Gardening* in 1772, where he identified three types of garden scenes – 'enchanted', 'horrid' and 'pleasing' – whose effect was enhanced by the contrast of one with the next. Chambers was calling not only on the classical repertoire, but on a number of other exotic sources. Chinoiserie motifs had been used in Britain for a number of years, particularly in interior design. Chinese wallpapers began to be available in the 1730s, featuring, as well as delicately detailed buildings and figures in Chinese dress, much ornamental use of elegant birds with long legs and curving necks, fragile trellis forms, naturalistic flowers and leaves and winding stalks and tendrils. Chambers's knowledge of original Oriental work gave him the authority to present Chinese designs when the fashion for Chinoiserie in all forms was at its height. However, at Kew, as at Strawberry Hill, there was no effort to present buildings in authentic materials, neither were they archaeologically correct. The pagoda is a standard brick octagon. It is the added details that give it a Chinese flavour, which was much stronger when it still had its glazed tiles and its 80 coloured roof dragons in iron.

This extraordinary commission was not at all characteristic of Chambers's work. He preferred to design in the classical Roman style, and complained

Parksted, Roehampton, Surrey (1760–8), now Manresa House. William Chambers.

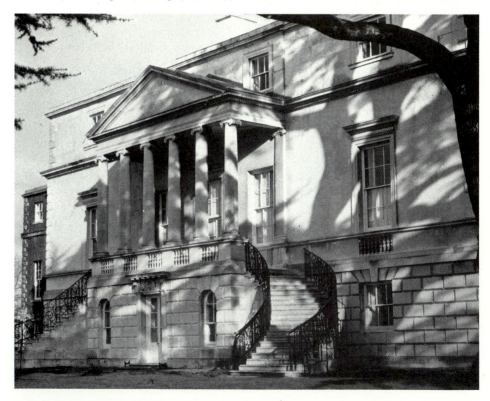

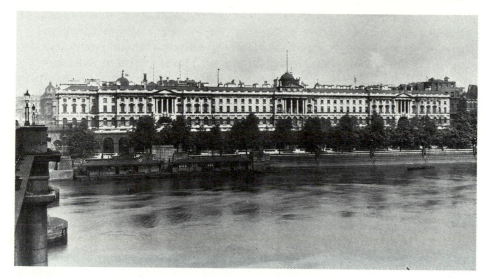

Somerset House, London (from 1776). William Chambers. East wing completed by Sir Robert Smirke, 1835; west wing by Sir James Pennethorne, 1856.

bitterly when building 'a cursed Gothic house' at Milton Abbas, Dorset – a style imposed on him there by the previous designer, Vardy, and by the patron. He inherited a respect for the villa form, with its pattern of 1:3:1 in the openings and produced a number of variations on this theme early in his career. At Parksted (now Manresa House), Roehampton, designed in 1760–1 for Lord Bessborough, Chambers followed the pre-ordained lines quite closely. He showed ingenuity, as Taylor did, in the planning of his staircases. Interiors were ornamented with traditional Roman motifs – heavy cornices, acanthus leaf in symmetrical patterns, and fret.

Chambers's training in France profoundly coloured his view of classical architecture. French architectural attitudes were traditionally based on concepts of reason and logic in handling classical forms, with a rejection of the extremes of the baroque style, and of the rococo as far as exteriors were concerned. Although rococo decoration was first established in France at the beginning of the eighteenth century, it was never accepted in a wholehearted or extravagant manner, as it was in Bavaria, and never for exteriors. Chambers would have been encouraged, in Paris, to look to Rome, and when he eventually went to Rome himself, he absorbed the ideas of Piranesi and Clérisseau. What resulted may be called an imaginative archaeological approach, which also sought inspiration in the work of Michelangelo, Palladio and Ammanati.

Chambers's most important work is undoubtedly Somerset House (1776–96), where he designed a large group of public buildings and offices to replace the old palace. The Strand façade was monumental, and suitably so since it housed the Royal Academy of Arts itself. For the great courtyard, Chambers produced what Sir John Summerson has called 'a docile English "square"', based on the ordinary terraced houses of London. As such, it was

no doubt practical, but it lacked scale as did the river front. The whole composition is an interesting work of its time because it shows Chambers drawing on a range of classical sources, both ancient and contemporary. He makes reference to the façade of old Somerset House by Inigo Jones in his new frontispiece, quotes French sources such as Antoine and Le Vau, evokes Michelangelo and Palladio in the detail, and refers directly to Roman sixteenth-century palace design in the entrance arcade, which closely recalls the Palazzo Farnese entrance. In this eclecticism, Chambers is a predecessor of the architects of the early nineteenth century, such as Barry and Cockerell, and to all those who later wove a rich fabric from the threads of past styles.

Robert Adam came from a family which had been concerned with building for generations. His father, William, was the leading Scottish architect of his day, and his brothers, John and James, were both architects in their own right as well as being involved in the family business in Scotland and in England. Robert was abroad for more than three years – 1754–8. He travelled to Rome via Paris, Genoa and Florence, in great and expensive style. His was a deliberate campaign to attract distinguished patrons and treat with them as an equal, although he was not born a gentleman. He went to Rome with the Earl of Hope, and thereby gained entry to polite society and made many useful contacts. Piranesi was one of those he met there, who greatly influenced his approach. He adopted the idea of using a variety of antique Roman buildings to create a pleasing composition. He studied his source material in great detail and produced measured drawings and surveys wherever he went. One of his major projects was a survey of Diocletian's

Kedleston, Derbyshire, south front (1760–70). Robert Adam.

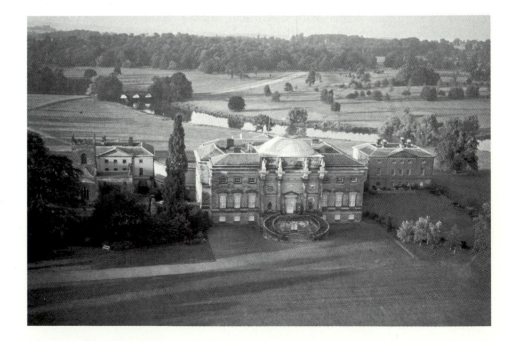

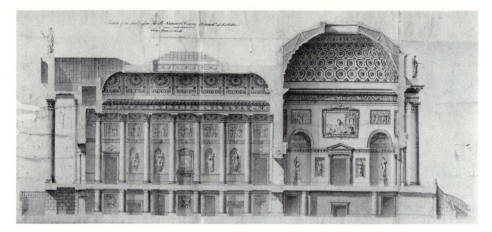

Robert Adam, cross-section design of the Marble Hall and Saloon of Kedleston (1760).

palace at Spalato (Split) in Dalmatia. What he saw there stimulated and interested him. The planning of the palace inspired similar arrangements at Syon and Kedleston. The details were accurately recorded and later used, but with what he called 'legitimate enhancement'. Thus a Diocletian capital recorded at Split was tightened up and used on a house at Bowood (Wiltshire), in the wing referred to as 'the Diocletian Wing'.

At Kedleston, in Derbyshire, Nathaniel Curzon had already embarked on an extensive rebuilding campaign to replace his existing brick house when he saw Adam's sketches. The design of the new house was placed in Adam's hands in 1760. It was decided to retain the Palladian design for the north front already begun by Matthew Brettingham and James Paine. This was completed with only minor modifications. For the south front, however, a very different style was adopted, illustrating Adam's interest in

the rise and fall, the advance and recess with other diversity of form, in the different parts of a building, so as to add greatly to the picturesque of the composition.

He drew on two famous Roman monuments – the Arch of Constantine and the Pantheon – to compose his façade, incorporating the idea (already explored by Paine) of a domed saloon behind it.

At Kedleston, as elsewhere, Adam (in collaboration with his patron) was in control not only of the architectural design but also of the interior decoration and much of the furniture and fittings and the architectural features in the garden and park. The interior designs show his concern for a coherent decorative scheme, his varied sources, his sensitivity to colour, and his attention to detail. As well as room plans and elevations, there are designs for painted panels, chimneypieces, light fittings and full-scale working drawings of architectural details. He used a carefully chosen team of workers to ensure that the craftsmanship was up to his high standards.

Much of Adam's work was concerned with the decoration or enlargement of existing buildings. Later in his career, however, and especially in Scotland, he designed public buildings and country-houses which provide a useful

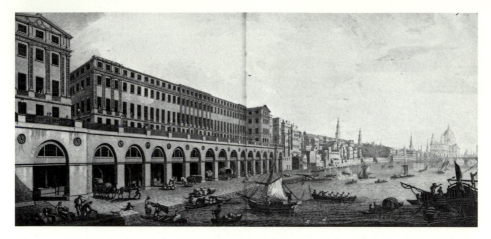

The Adelphi, London (from 1768), demolished in 1937. Robert and James Adam.

summary of his eclectic and picturesque qualities. The Register Office in Edinburgh recalls the Palladian fashion of an earlier generation, lightened and embellished with panels and roundels of ornament, and dominated by a large Pantheon-style dome. The University Building recalls the movement and Roman grandeur seen at Kedleston.

Adam's early preoccupation with picturesque buildings blossomed in his late works in Scotland into a full development of the 'castle' style spoken of by Vanbrugh at the beginning of the century. Adam, incidentally, had a great admiration for the work of Vanbrugh, and in addition would have been aware of the experimentation with castles and mock-ruins, and medieval buildings generally, by William Kent, Horace Walpole and others both in England and Scotland. In fact, Adam himself worked at Strawberry Hill from 1766, designing the ceiling and chimneypiece for the Round Drawing Room. Culzean Castle, Ayrshire, of 1777–90, is one of the most spectacular of Adam's castellated houses. It is symmetrical, and apart from its battlemented parapets and cross-shaped windows in the turrets, the architectural detail is all thoroughly Georgian. Palladian arched recesses hold rectangular sashed windows, and a beautiful circular saloon creates a bay window overlooking the sea. It is interesting to compare this with Downton Castle, discussed at the beginning of this chapter. Richard Payne Knight was perhaps slightly more adventurous in his mixing of styles than Adam, but both were exploring in the same eclectic manner.

The years around the mid-century were formative ones. In France Laugier was considering the material for his *Essai sur l'Architecture*, published in 1752, and Rousseau published *Julie, ou La Nouvelle Héloïse* in 1761. Ideas of returning to primitive values and first principles were therefore 'in the air'. Rousseau's work aroused considerable interest in the emotional impact of a primitive existence in a wild and lonely natural setting, evoking as it did the romantic and sentimental image of nature untouched by civilisation, and man and woman in a state of primitive virtue. Laugier's treatise, very different in both subject and scholarly approach, nevertheless explored a somewhat

similar theme in seeking the origins of the Greek temple in the form of the
primitive hut, with living tree trunks for columns and a pitched roof forming
the triangular shape of the pediment with its gable. Kent had already shown
a considerable interest in small vernacular buildings to enhance his garden
designs, and there had been numerous thatched cottages, hermits' cells and
root-houses to adorn subsequent landscapes. Laugier's theories, which were
taken up and illustrated by Chambers in his *Treatise*, gave an antique
authority to the concept of the primitive hut. Cottage architecture began to
be used for estate houses and small rustic villas, and became famous in the
hands of John Nash at the beginning of the nineteenth century.

The interest in archaeological exploration led travellers to explore more
remote sites and evidence of other civilisations than the Roman. Adam
travelled to Dalmatia, but James 'Athenian' Stuart and Nicholas Revett,
sponsored by the Dilettante Society, travelled to Athens itself with the
purpose of recording what they saw in the form of measured drawings. This
marked a rising new interest in Greek architecture as distinct from Roman.
There were earlier travellers to Greece, but they were relatively few, and the
drawings and engravings they brought back did not give an accurate picture
of the distinctive forms of the Greek orders. From the mid-century onwards,
more interest was taken in the Greek temples of Italy – in Sicily and
particularly at Paestum. Paestum was put on the itinerary of the Grand
Tourists, and its impact was felt in architectural design in both France and
Britain. Artists recorded the massive, cigar-shaped Doric columns resting
without a base on the temple platforms, and the equally massive cushion
capitals supporting the entablature. To a generation which, following
Laugier, was concerned with the primitive values of the ancients, and going
back to first principles such as load-bearing columns, the impact must have
been enormous. In addition, the temples at Paestum, set on a wild and sun-
bleached plain beside the sea, created a romantic view in the picturesque
mode. The popularity of the Greek style grew quickly.

Towards the end of the eighteenth century, architects were faced as never
before with stylistic choices. Roman, Greek, High Renaissance, medieval,
Chinese – all these were available and attractive in certain contexts, and
experiments were beginning to mix them together. The concept of accurate
reproduction of the various details was also becoming more important. For
Roman work, detail had been studied by the sixteenth-century theorists, and
Palladio's work particularly was known in Britain. But for the rest,
knowledge was quite scanty, and needed to be built up. Stuart and Revett
began to publish ancient Greek architecture in 1762. Walpole and his friends
began the same process for Gothic detail, which was used, nevertheless, as
ornament. It remained for the next generation to codify medieval work and
use it in a convincingly archaeological way.

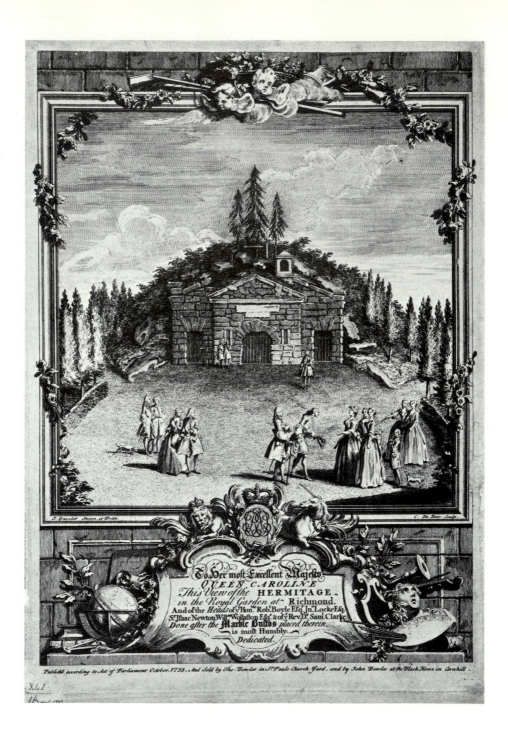

To Her most Excellent Majesty
QUEEN CAROLINE
This View of the HERMITAGE
in the Royal Garden at Richmond.
And of the Heads of y Honᵇˡᵉ Robᵗ Boyle Esqᵗ. Jnᵒ Locke Esqᵗ.
Sᵗ Isaac Newton Willᵐ Wollaston Esqᵗ. & of y Revᵈ Dᵗ Samˡ Clarke.
Done after the Marble Bustos placed therein.
is most Humbly.
Dedicated.

View of the Hermitage in the Royal Garden at Richmond (1735).

8 'The English Taste in Gardening'

MICHAEL SYMES

Introduction

The English garden travelled a long way in its career from 1700 to 1785. Its journey, from rigid formality of design at the turn of the century to the abstract and seemingly naturalistic parks of Brown and the dramatic 'Picturesque' gardens at the end of the period, is as serpentine as some of its paths and lakes, covering several movements and detours such as rococo and the ornamented farm. It is not a single definable form, therefore, and the five examples discussed below have been chosen to illustrate its diversity and extraordinary range. The garden expresses many of the concerns, philosophical, political and otherwise, which characterise and shape other art forms of the time, and is in particular bound up with liberty, construed in both artistic and political terms. Horace Walpole said in 1773, 'The English Taste in Gardening is . . . the growth of the English Constitution'.

It was also Walpole who, in his *Essay on Modern Gardening* (written in 1770), spoke glowingly of the new garden:

How rich, how gay, how picturesque the face of the country! The demolition of walls laying open each improvement, every journey is made through a succession of pictures; and even where taste is wanting in the spot improved, the general view is embellished by variety Enough has been done to establish such a school of landscape, as cannot be found on the rest of the globe.

In the same year, Thomas Whately in his *Observations on Modern Gardening* could claim with satisfaction that

Gardening, in the perfection to which it has been lately brought in England, is entitled to a place of considerable rank among the liberal arts . . . it is an exertion of fancy, a subject for taste; and being released now from the restraints of regularity, and enlarged beyond the purposes of domestic convenience, the most beautiful, the most simple, the most noble scenes of nature are all within its province.

One must beware, however, of seeing the garden movement as a continuous process leading up to the grand climax of Capability Brown, the so-called Whig view of garden history.

There are many factors that influenced the English garden. Often claimed to be the one original British contribution to the fine arts, paradoxically it took much from the European continent, particularly Italy. The possible sources and influences include: theatre scenery; architecture at home and abroad; Renaissance gardens and contemporary landscape in Italy; classical buildings and imagined classical landscape; the paintings especially of Claude and Poussin which evoked that landscape; the urge to throw off the shackles of a formal garden tradition shaped largely by Dutch, French and Italian ideas and to establish a native style; a political ideology of freedom which drew strength from real and supposed Saxon and medieval ideals and forms; military architecture and formations; urban planning (streets = garden avenues); the literary tradition of retreat and contemplation; a pursuit of nature, following the long dominance of art in gardens.

The results were varied and sometimes complex. A designer such as Vanbrugh composed in a showy, theatrical manner, for the basic elements of a garden scene, foreground, middle ground and distance, are like the perspective of a theatre set – also, of course, like a painting. Much of the eighteenth-century garden was based on illusion – foreshortened distances, sham bridges, the creation of a 'Golden Age' of pastoral by means of classical buildings and Italianate pines and cypresses. Even Brown's parks gave the illusion of being natural, for trees would not grow naturally in tidy clumps at the top of a hill. Illusion was accompanied by allusion: the terrace walk at Farnborough Hall, Oxfordshire, has bastions appropriately looking out over the site of a Civil War battlefield, while the poet Shenstone's literary garden at the Leasowes, West Midlands, was filled with benches and urns whose inscriptions encouraged the visitor to think or feel accordingly. Buildings would often create mood or suggest some significance by virtue of their form (see Stowe, below).

The purpose-built ruined priory at the Leasowes, Shropshire. Engraving c. 1770.

As with all art forms, garden design could be taken to extremes, and Pope warned against the vast expenditure on 'Timon's Villa' (possibly Canons) where sense had not modified ostentation. His answer (in *An Epistle to Lord Burlington*, 1731) was:

> In all, let *Nature* never be forgot.
> Consult the *Genius* of the *Place* in all.

The latter was its particular character and quality, which would involve bringing out the best or reshaping where nature was deficient, with the guiding design principles of surprise, variety and concealment of the bounds.

The plea to turn to nature was born in the writings of philosophers such as Shaftesbury, whose *Moralists* (1709) equates nature with good, and prefers overgrown, rocky wildness to the 'formal Mockery of Princely Gardens'. The empiricist movement, as exemplified by Locke, sought validation through experience, and the nature it comprehended was not regulated and formal but irregular and unpredictable. This view of nature took time to evolve in gardens, however, and straight lines and other signs of artifice lingered on.

The face of the countryside was altered radically by enclosure. This brought in much of what was common land into the possession of the local landowner, and also determined the ownership of fields by boundaries of hedgerows. Not only was much more land available for landscaping as well as farming, therefore, but the appearance of the countryside generally, as could be seen from within a garden looking out, was tamer and more controlled than before. The 'ha ha', or sunk fence invisible from a short distance, also had considerable influence in bringing the countryside into the visual plan of the garden.

One idea has prominence from Pope to Uvedale Price and Richard Payne Knight at the end of the century, and that is using painting as a basis of garden design, both in its principles (perspective, grouping, light and shade) and in copying actual paintings. In Pope's words: 'All gardening is landscape painting. Just like a landscape hung up'. The content of what was deemed picturesque changed, however, from the smoothly beautiful to the rugged and broken, as seen in Claude and Salvator Rosa, respectively.

Castle Howard

In the bleak, hilly country north-east of York stands one of the wonders of the eighteenth century: Castle Howard. House and gardens commemorate that remarkable all-rounder Sir John Vanbrugh (1664–1726). In turn soldier, playwright and architect (self-taught), Vanbrugh brought both his military and theatrical knowledge to bear on his architectural work at Blenheim and Castle Howard. At Blenheim there was a huge fortified garden by Vanbrugh and Henry Wise which was actually called a military garden – a walled area with eight bastions each 150 ft across at the corners of the rubblestone walls. The trees in the grounds were planted according to the disposition of the troops at the battle of Blenheim. At Castle Howard there were equally striking fortifications in the shape of a long crenellated curtain wall stretching

across the entrance drive, punctuated by a pyramid arch, towers and bastions. A second, shorter wall of similar style was constructed further out by Hawksmoor *c.* 1730. They are patently mock fortifications since they could have served no practical purpose in the period in which they were built and they only go part way round the park. They display Vanbrugh's theatrical flamboyance, though with both the blessing and the influence of his patron, the Earl of Carlisle, who must be credited with at least sharing the vision and the overall design. Carlisle continued to develop the grounds until twelve years after Vanbrugh's death.

Castle Howard is an 'heroic' garden rather than a 'beautiful' one. The scale is vast, with great panoramas sweeping over the countryside, and the imagery is heroic – Hercules, Meleager and an Apollo Belvedere feature among the statues. It has been compared to epic poetry in its ambition and grandeur, and contemporary writers would often discuss it with reference to Roman authors.

Vanbrugh was responsible for a number of buildings in the grounds such as the walled kitchen garden, a parterre with small obelisks, the Obelisk commemorating the Duke of Marlborough (another interesting link with Blenheim), the bastion wall and above all the Temple of the Four Winds, which, out of sight of the house, recalls the dome of the latter in its own

New River Bridge with the Mausoleum by Nicholas Hawksmoor beyond, at Castle Howard, Yorkshire.

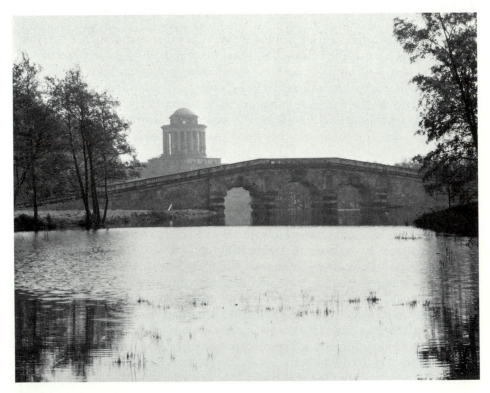

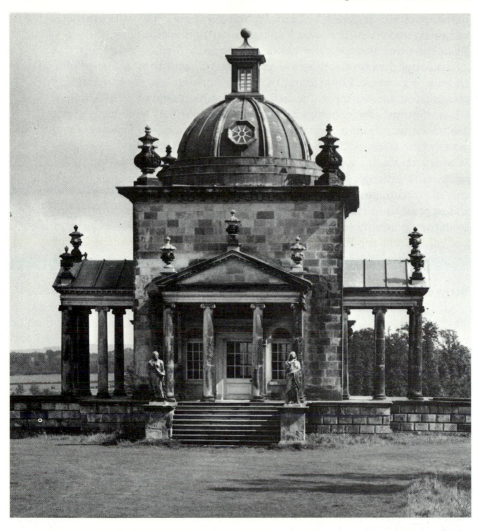

The Temple of the Four Winds, Castle Howard. John Vanbrugh.

dome. The house thus projects its form and inspiration into the landscape. The Temple is positioned on a knoll with a superb view – in one direction to Hawksmoor's Mausoleum (from 1729), which so bewitched Walpole that he said he was tempted to be buried alive in it. One of Vanbrugh's contributions to the landscape garden was his sense of positioning a building with regard to its setting in the view, both to be seen and to see from, and to shaping the building accordingly (the Temple has four porticoes, for instance).

There are numerous signs of a new approach to landscaping in the works at Castle Howard. The terrace walk, curving round from the house to the Temple of the Winds, is an early departure from the expected straight line, although this may partly be explained by its following the course of the village street that formerly stood there. Wray Wood, with its maze of twisting

paths, possibly designed by Stephen Switzer (pre-1718), was distinctly irregular; and then there was Vanbrugh with his feel for the 'Genius of the Place' in siting buildings for maximum impact.

Vanbrugh has probably not received the full recognition due to him as a creator of gardens. Considering that he lived in an era when regularity still prevailed in garden forms, he had an astonishing degree of foresight. At Claremont in Surrey, he described the site in 1708 as 'singularly romantik', a use of the word and a concept that would not come into general use until many years later; at Blenheim he considered that the ruins of the old Woodstock Manor would form a scene worthy of the best of landscape painters. Vanbrugh foreshadowed two important developments here – the cult of ruins in gardens (usually purpose-built) which was to be so widespread from the mid-century onwards, and the Picturesque approach to landscape planning, which predates both the pictorial scene-making of Kent and others and the Picturesque movement proper late on in the century.

Stowe

The gardens at Stowe, near Buckingham, altered substantially during the first three-quarters of the century. They are a rich field of study: more visited and more described than any other gardens of the time, they enjoyed the active participation of most of the famous names of architecture and garden design, Vanbrugh, Gibbs, Bridgeman, Kent, Leoni, Capability Brown, as well as the leading sculptors Rysbrack and Scheemakers and the great master of leadwork, Carpenter. They are complex both in visual arrangement and in their iconography, which is heavily political but which also celebrates Love, Valour and Friendship.

Sir Richard Temple, Viscount Cobham (1675–1749) inherited Stowe in 1697. The early history of his creation of the gardens is a chapter of formality, when Bridgeman laid out a large, regular area sloping south from the house with straight walks, canals and many an intersecting axis, the whole bounded by a 'ha ha', the device that Bridgeman popularised but did not, as Walpole thought, invent. At the same time Vanbrugh was commissioned to design a number of garden buildings, including the Rotunda, the lakeside pavilions and a pyramid (now gone). It is George Clarke's contention that Bridgeman's layout, though grand in scale, was unexciting and that Vanbrugh's skilful placing of buildings created fresh and stimulating vistas, the scene constantly changing as one viewed the buildings from different, sometimes unexpected, angles.

During the 1730s there was a totally new approach. It is difficult today to say whether the concept was Cobham's or William Kent's, or both, with advice from others such as Pope, but the regularity was gradually softened, and a set area, the Elysian Fields, was developed as a scene with a character and purpose of its own. A grotto was built, from which flowed the River Styx, and further down this stream passed through the Elysian Fields. On one side was the Temple of Ancient Virtue, designed by Kent after the Temple of Vesta at Tivoli, a model for countless circular garden temples with

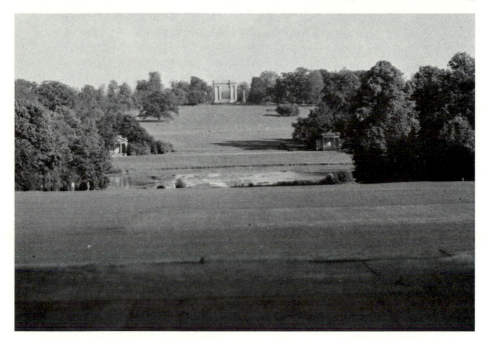

The gardens at Stowe, near Buckingham.

colonnades. Opposite was the Temple of British Worthies, a curving gallery containing busts of distinguished figures from the distant to the recent past – Alfred, Shakespeare, Bacon, Inigo Jones, Raleigh, Locke, Milton, Newton and others, sixteen in all. Kent also designed the Temple of Venus, the Hermitage and a quaint Pebble Alcove where the family motto 'Templa quam dilecta' was picked out in coloured pebbles. Lord Cobham took the motto literally in filling the grounds with temples.

As the century wore on, so the grounds became more naturalistic in appearance. Lancelot 'Capability' Brown (1716–83) learned his craft at Stowe in the 1740s, first in the kitchen gardens, and he may possibly have had a hand in the Grecian Valley, a dog-leg that was heavily grassed in the valley itself and wavily wooded on top of the slopes. Even while he was still in Cobham's employ he was loaned out to neighbouring estate owners to design for them, so he may well have had some practice at Stowe. Bridgeman's Octagon lake became natural, and the parterre became a great lawn stretching down from the house to the lake.

Stowe was remarkable for its number and variety of buildings and for its coverage of many aspects of the landscape garden: its influence at home and abroad is understandable. Apart from architectural interest, and the complexity of the axial plan, much of which remains, there is a programme which runs through many of the artefacts. Much of the sculpture, and several of the buildings, testify to the political ideology of Cobham and his friends, who formed a Whig Opposition group from 1733 in disagreement with the Whig government of Sir Robert Walpole. The Temple of Ancient Virtue was

contrasted with the ruinous Temple of Modern Virtue nearby, a collapsed fragment with a headless statue identifiable with Walpole ('A very elegant piece of Satyr', as William Gilpin called it in 1748). The Gothic Temple, originally known as the Temple of Liberty, had a (genuine) Gothic anti-Rome motto, reflecting on Walpole's administration, which was often compared at the time to Rome in its decadent years. The Temple of Friendship housed busts of Cobham's political friends.

The iconography was tendentious, therefore. In addition to the political message, there is a theme of erotic love running through the Temple of Venus (with its lubricious murals), the Cave of Dido and a number of buildings with statues of Venus, including the Rotunda. Friendship is celebrated in the Temple of that name, while the Temple of Concord and Victory celebrates the successful conclusion of the Seven Years' War, and other exploits are commemorated by the column to Cobham's relative Thomas Grenville who died at sea, and the tribute to Captain Cook. The Temple of Ancient Virtue and the British Worthies praise the courage, vision and independence of thought of various figures of history.

Rousham

The garden of Rousham, Oxfordshire, stands as the finest memorial to William Kent's (1684–1748) work as a landscape designer. As was often the case he transformed an earlier, basically formal layout, in this case by Bridgeman. At Rousham we see the essence of Kent's craft: a circuit which has to be followed in the correct sequence, an unfolding of surprises, and the creation of a number of set scenes each with its own character. The overall effect is classical – as Horace Walpole said, a retreat 'fit for a Roman emperor – with the heart of the garden the Vale of Venus, opening up unexpectedly as the visitor emerges from a woodland walk. Venus herself presides, with attendant *amorini* (now absent) riding swans, while Pan and a faun stand at each edge where the wood skirts the vale. All look outwards, as in a theatre set, to be viewed from below, the theme being natural, erotic love in a rural setting. The triangle of figures is mirrored in the amphitheatre, where Ceres, Bacchus and Mercury form another tableau representing nature's bounty of food and wine. Other set-piece scenes include the Pyramid with a lawn below it; the Praeneste terrace based on a Roman original (the town that is now Palestrina); the Temple of Echo with its backcloth of trees and the figure of Apollo nearby; and the Palladian gateway, with its figures of Flora and Plenty, foreshadowing the motif of the amphitheatre.

In contradistinction to the classicism within the garden, the country outside the boundary (marked by the River Cherwell) was given a different flavour. Although not part of General Dormer's estate, it contains two features with which Kent intended to create a medieval, Gothic feeling, that is, native rather than Roman. One is his Gothicising of the mill by the river, which became accordingly the Temple of the Mill, and the other is the 'eye-catcher', an arched façade placed on rising ground in a field opposite. The countryside is thus brought into the garden as a whole, the river serving the

Venus' Vale at Rousham, Oxfordshire. William Kent.

same purpose that a 'ha ha' might elsewhere.

Kent's approach to garden design was that of an artist, planning for visual impact, and the major inspiration of his work was Italy, where he had spent ten formative years. Many of his effects are therefore Italianate, with evergreens such as cypresses helping to create scenes that might have been found in Italy; but he was adventurous and experimented with other styles such as Gothic. He made use of serpentine lines – at Rousham there is a serpentine rill leading to the cold bath – and introduced 'clumps' ahead of Capability Brown. He liked to make use of slopes and to contrast lawn and grove. He did not abandon formality altogether, but his approach was much more naturalistic than that of his predecessors.

Stourhead

Stourhead, Stourton, Wiltshire, is, more than most gardens, a personal vision of its creator, Henry Hoare (1705–85), of the banking family. He belongs to that gifted group of gentleman owners of the mid-century like Charles Hamilton of Painshill, amateurs who realised their own private paradises over a number of years. Stourhead is well known as one of the most visited gardens in Britain, with overwhelmingly visual appeal, a series of pictures which continually change as the visitor walks round the lake. Walpole in his journal of visits to country seats exclaimed, 'the whole comprises one of the most picturesque scenes in the world'. Hoare's original conception in the 1740s seems to have been to create a neo-classical scene owing much to ancient Rome via the paintings of Claude, so that temples such as the Pantheon (modelled on that at Rome) form ever-shifting focal points in the

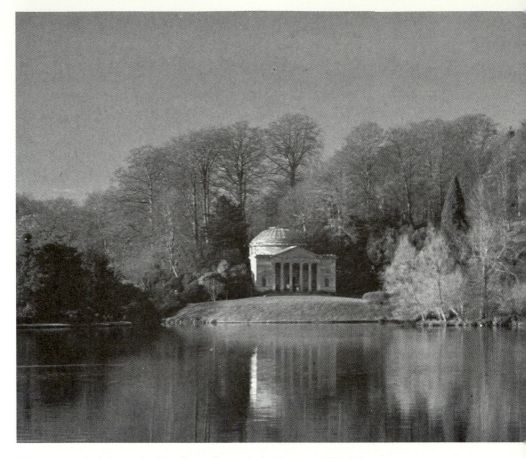

View across the lake to the Pantheon, Stourhead, Stourton, Wiltshire.

view. Later, however, there were overlays of other styles to accord with
garden fashion: a Chinese Umbrello, a Turkish Tent and a rough Hermitage
are all children of post-1750 taste. The Gothic Cottage near the Pantheon is
probably late eighteenth century, at the time of the 'village picturesque'.

 Painting is not the only key to the development of Stourhead's design. The
circuit can be read variously: the first building to be encountered, the Temple
of Flora, proclaims the Virgilian warning *Procul, o procul este profani!*
(Begone, you who are uninitiated). This suggests not only that one has to be
initiated into the interpretation of the garden but that Virgil holds the
possible solution. Kenneth Woodbridge argues plausibly that the circuit
parallels Aeneas's journey in Book VI of the *Aeneid*, the grotto representing
the underworld. Hoare quoted the relevant passage in a letter to his daughter
– *Facilis descensus Averno* (Easy is the descent to hell, but to find your
way back to the upper air, that is the hard task), and the grotto accordingly
has a gradual slope down to its entrance and steep steps up out at the other
end. Within the grotto a River God points the way just as the god of the
River Tiber, in an engraving by Salvator Rosa, pointed the way to Aeneas to
found Rome. But, looking out across the lake from the grotto, the visitor is

drawn to the Bristol Cross and the church, from pagan to Christian, for what
Hoare was attempting to found at Stourhead (justifying the change from
Stour*ton*) was a well-head of culture and civilisation based on ancient *native*
tradition (the largest building, two miles out, is Alfred's Tower).

The circuit can be taken more generally to be an allegory of life,
proceeding from youth/spring (Flora) to tribulation (grotto), to maturity
(Pantheon) and finally to the wisdom of old age (the Temple of Apollo,
reached by a steep zig-zag path). There may be sub-themes running through
the circuit, such as the Choice of Hercules (who was the central figure inside
the Pantheon): Hercules was associated with gardens, and the choice was
between the easy path of pleasure and the difficult path of virtue, symbolised
by the dividing of the path down to the lakeside and up to the Temple of
Apollo.

Bowood

Capability Brown's commissions numbered over 200, and his concept of the
parkscape garden was not only influential as a style but shaped taste for that

kind of scenery. A mature work that survives in good condition is Bowood, near Calne, Wiltshire, created for the 1st and later the 2nd Earl of Shelburne over a number of years from 1761.

An enormous lawn sweeps majestically down from the house to the lake 200 yards away. The Victorian terracing close to the house at Bowood obscures the fact that the lawn would have come right up to the house. The lawn and the winding lake (formed by damming) in the middle ground are characteristic of Brown's aesthetic, which was simple and which at best could be peacefully majestic and at worst formulaic and dull. He planted trees singly or in clumps for effect, and there would often be a perimeter band of wood (the 'belt') delineating the boundaries of the estate. At Bowood extensive beech woods serve this purpose. Clumps of trees would frequently crown an otherwise bare hill. Brown may have aimed to create a naturalistic scene, but it was a highly stylised and controlled nature. His abstract approach is far removed from the pictorial and associative gardens of his immediate predecessors.

A further aspect of Bowood demonstrates another trend of the second half of the century, and that is the so-called 'rococo valley'. Designed by Charles Hamilton in 1781, in his retirement from Painshill, and executed in 1785 by local grotto-builder Josiah Lane, it consists of a centrepiece waterfall flanked by grotto passages that continue each side of the stream. Behind the waterfall

Waterfall at Bowood, near Calne, Wiltshire.

itself is a honeycomb of passages: the visitor can peer out through a curtain of water. Further up the valley, a little way beyond the fall, is a Hermit's Cell, roughly fashioned from rock, with ammonites in the ceiling.

This illustrates one feature of the rococo movement, namely its relation, etymologically and actually, to rockwork. Grottoes are not in themselves necessarily rococo, but the valley at Bowood, small in scale but containing an elaborate configuration of constructions in rock, is a rococo complex by virtue of its compactness, intricacy and creation of fantasy.

It has been claimed that the waterfall was modelled on a view of the falls at Tivoli by Gaspard Dughet (brother-in-law of Poussin). Hamilton knew Rome well, having stayed in Italy for prolonged periods, and must have seen Tivoli for himself, but he was also a collector of paintings, and his creation of Painshill shows painterly awareness and skill. At Bowood he created a scene with a flavour of Italy but embellished it with contemporary native grotto work, thus making something highly individual. The naturalistic style of grotto dates it to the latter half of the century and to the growing taste for the Picturesque, where irregularity and apparent wildness would be conspicuous. Josiah Lane was also responsible for the grotto works at the slightly later Picturesque garden of Fonthill.

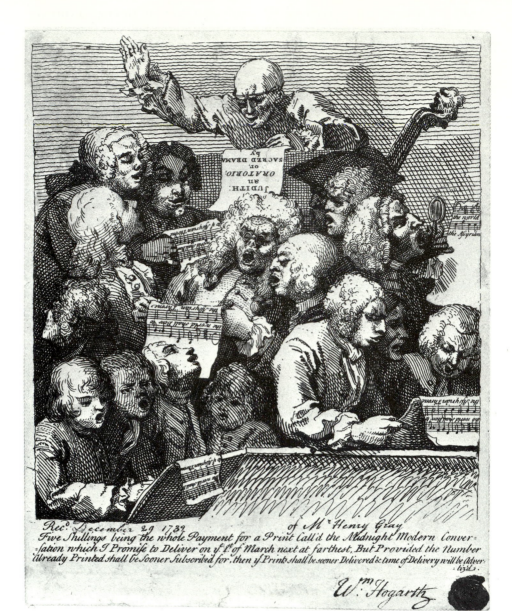

William Hogarth, The Chorus *depicting Willem Defesch's oratorio*, Judith.

9 Music

NICHOLAS ANDERSON

Introduction

History has repeatedly shown that Britain because of her geographical location, has been able to observe and to learn from events occurring beyond her shores. In the visual arts of the Renaissance and baroque periods the most significant stimuli came from abroad, especially from Italy. In music too, Italy and, to a more limited extent, France played decisive roles in the formation of styles during both the Restoration and the eighteenth century. During the first half of the eighteenth century culture in Britain enjoyed a period of comparative stability. Political power remained with the aristocracy and wealthy landowners, but cultured society was no longer confined exclusively to those of privileged birth but existed, to a growing extent, among bankers, merchants and a new breed of politicians who were able to buy themselves into Parliament. Clubs and coffee-houses rather than the Court became centres for elegant and informed conversation amongst those fortunate enough to belong to a class which entitled them to a good education: 'We are refined', wrote Lord Chesterfield, 'and plain manners, plain dress, and plain diction, would as little do in life, as acorns, herbage, and the water of the neighbouring well, would do at table'. The early decades of the century were sympathetic to the arts even if the audience was small, and they witnessed the appearance of the journalist as opposed to the diarist.

English music in the first half of the eighteenth century was dominated by the outstanding genius of Handel (1685–1759). Handel was a German by birth but, after travel in Italy, he visited England in 1710, returned there in 1712 and became a naturalised Englishman in 1727. In London he found a society sympathetic to music's cause but without a figurehead. His great English predecessor, Purcell, had died fifteen years earlier in 1695 and a new generation of indigenous composers had yet to emerge. As in the previous century, conditions were ideal for foreign musicians to visit or take up residence in England: 'He who in the present time wants to make a profit out of music takes himself to England', wrote the Hamburg critic, Johann Mattheson, in 1713. Among the most prominent foreigners in London apart

from Handel, and enjoying admittedly variable degrees of profit and success, were Giovanni Bononcini, for a time Handel's greatest operatic rival, Ariosti, Barsanti, Geminiani, Pepusch, Porpora, Giardini, Galuppi, C.F. Abel and J.C. Bach.

Handel's influence both upon musical life and upon his younger contemporaries in Britain can hardly be overstated. Much had been learned of Italian and French musical styles from the genius of Purcell who blended them with that of his native country. It was an age of travel, furthermore, when educated and wealthy citizens embarked on grand tours, usually to Italy, France, Germany and the Netherlands. They returned full of enthusiasm for the academies, *camerate*, theatres and opera houses which they found in Italy, eager to establish similar activities at home. By the time that Handel arrived in London Italian opera had been playing with variable success for about five years. It was, however, in 1711, with Handel's first opera for the London stage, *Rinaldo*, that it became firmly established; and during the subsequent two decades it was Handel's genius which made London an operatic centre of international renown. He himself contributed no fewer than thirty operas between 1711 and 1741.

In Handel's time, Italian baroque opera had become largely a vehicle for beautiful melody and ravishing singing. The action was described in the recitatives, while the long *da capo* arias (ABA in form) conveyed not so much the psychological feelings of individuals as generalised moods and emotions; and thus they could be sung without offending realism by castrati taking masculine roles (such as Julius Caesar), singing with fantastic virtuosity in the high voice which Italian baroque serious opera preferred for emotional utterances. After the great aria the singer left the stage to lengthy applause. Moreover, there were very few vocal duets, trios or larger ensembles other than the *coro* which usually brought the opera to a happy conclusion.

Handel's own operas, however, whilst staying within these conventions, do not readily lend themselves to generalisation. His *da capo* arias display exceptional variety in length, texture, rhythm, key and 'affect' and, as Winton Dean has remarked, he 'carried the accompanied recitative to an elaboration and an intensity of emotion it had never attained before and was not to reach again until Mozart or even later'. In recent years audiences and some modern producers have shown an eagerness to accept earlier operatic conventions. As a result we have been able to rediscover in Handel's operas his genius as a vocal melodist, and also to appreciate the dramatic life he infused into the stiff conventions of *opera seria* (or serious as distinct from comic opera).

Opera in a foreign tongue was not, however, to everybody's taste as that witty educationalist, Addison, made plain in his *Spectator*, whose first issue appeared less than a week after the first performance of *Rinaldo*. In the issue of 6 March 1711 he derided the extravagances and the absurdities of Italian opera which he considered lacked common sense rather than good taste:

To consider the poets after the conjurors, I shall give you a taste of the Italian '. . . *Eccoti, benigno lettore, un parto di poche sere, che se ben nato di notte, non è però aborto di tenebre, mà si forà conoscere figliolo d'Apollo con qualche raggio di Parnasso'*. 'Behold, gentle reader, the birth of a few evenings, which, though it be the offspring of the night, is not the abortive of darkness, but will make itself known to be the son of

Apollo, with a certain ray of Parnassus'. He afterwards proceeds to call Mynheer Handel the Orpheus of our age, and to acquaint us, in the same sublimity of style, that he composed this opera [*Rinaldo*] in a fortnight. Such are the wits to whose tastes we so ambitiously conform ourselves. The truth of it is, the finest writers among the modern Italians express themselves in such a florid form of words, and such tedious circumlocutions, as are used by none but pedants in our own country.

When the fortunes of opera declined during the 1730s Handel broke new ground with the English ode and, above all, with the English oratorio which he developed along different lines from the Italian oratorio of the time. In these works Handel continued to exercise his talents as a dramatic composer, producing a series of masterpieces throughout the 1740s. Directly as a result of his oratorio performances Handel developed, one might almost say invented, a new orchestral form, that of the organ concerto. He himself played these between the acts of his odes and oratorios. With opera and oratorio Handel made his most brilliant and substantial contribution to musical life; but he worked in practically every other musical sphere as well, writing concertos, suites, sonatas, anthems and miscellaneous pieces for the Anglican church, as well as music for special occasions. His music was published, performed in theatres, concert rooms and private houses; and in fashionable circles, as often as not, the composer and his music must have afforded a lively topic of conversation. Several instances of Handel's wit have been recorded, among which the following anecdote, related by Charles Burney, is a charming instance:

One night, while Handel was in Dublin, Dubourg [Matthew Dubourg, English violinist and musical director], having a solo part in a song, and a close to make, '*ad libitum*', he wandered about in different keys a great while, and seemed indeed a little bewildered, and uncertain of his original . . . but, at length, coming to the shake [trill], which was to terminate this long close, Handel, to the great delight of the audience, and augmentation of applause, cried out loud enough to be heard in the most remote parts of the theatre: 'You are welcome home, Mr. Dubourg!'.

From the beginning of the eighteenth century the focus of musical life in London turned away from the court towards theatres, concert-rooms, private houses and pleasure gardens. Theatres were built in profusion, sometimes opening and closing within a short space of time. The most important theatre for Italian opera was the Queen's or, after 1714, the King's Theatre in the Haymarket, built in 1705 by the playwright and architect, Sir John Vanbrugh. Handel conducted the première of his *Rinaldo* there as well as all subsequent premières of his operas until 1734. Theatres at Lincoln's Inn Fields, Drury Lane and, from 1732, Covent Garden also played an active role in the promotion of musical entertainment. Lincoln's Inn Fields Theatre served as a home for many different shades and varieties of playhouse entertainment such as pantomime, masque and ballad opera; it was here, in 1728, that one of the greatest theatre triumphs of the century, *The Beggar's Opera*, was first staged. Flushed with its success the manager, John Rich, built a larger theatre at Covent Garden to which the company moved when it opened in 1732. Lincoln's Inn Theatre, meanwhile, was taken over by Handel's rivals, The 'Opera of the Nobility', under the patronage of the

Prince of Wales. The Drury Lane Theatre mainly presented straight plays but during the 1720s also staged masques. Other theatres of the time included the Little Theatre in the Haymarket, a theatre at Goodman's Fields, and the Pantheon which opened in 1772 for concerts and masquerades.

The eighteenth century in Britain witnessed a growth in almost all aspects of music making. Societies were founded, festivals inaugurated and concert-rooms opened in London and in many of the larger towns and cities. Amateur and professional musicians were not only active in the promotion of the music of their own day, but also began to take an interest in their musical heritage. In 1710 an 'Academy of Ancient Music' was founded and, in 1726, an 'Academy of Vocal Music' which met fortnightly in 'an attempt to restore ancient church music'. Later on, in the 1760s and 1770s William Boyce (1710–79) published an important anthology of English church music both from the seventeenth century and the Elizabethan period. The 'Three Choirs Festival' was inaugurated in about 1715 in aid of charity, but was only one among many innovations established for charitable purposes. Another was the 'Foundling Hospital' founded by Thomas Coram in 1739. From 1749 Handel gave an annual performance of his music in its chapel in support of the foundation and, in 1750, presented it with an organ.

In short, a flourishing musical life was fostered. As well as the great figure of Handel and several lesser European ones, Britain could boast of plentiful indigenous talent in composers like Boyce, Arne, Avison, Maurice Greene and John Stanley. Notable, too, was the emergence of the music historians Sir John Hawkins and Dr Charles Burney, the author of *A General History of Music* in four volumes. Music printing thrived, too, and was dominated in the first half of the century by John Walsh, father and son. Walsh became Handel's regular publisher from about 1734 but music of all kinds was increasingly in demand from clubs, societies and private subscribers. Printing standards varied and so, too, did ethical ones; piracy was a busy trade since copyright regulations were largely ineffectual. Song-sheets were printed profusely during this period, among the finest of them coming from the presses of the distinctive and gifted map-maker, George Bickham. His collection of songs, *The Musical Entertainer*, issued between 1737 and 1739, contains particularly fine examples of his detailed illustrative work.

Operas, serious and comic

During the first half of the eighteenth century taste was largely for Italian music and from the last years of the previous century Italian singers had been giving concerts in London. Tourists and men of letters, such as Joseph Addison, for example, travelled through Europe, visiting the great cities and, where possible attending theatres, concerts and opera productions. In Venice, remarks Addison, Italian operas were a 'great Entertainment The Poetry of them is generally as exquisitely ill, as the Musick is good'. But who can endure, he asked, 'to hear one of the rough old Romans squeaking thro' the Mouth of an Eunuch?'

By this time there was a growing interest in Italian opera which justified an

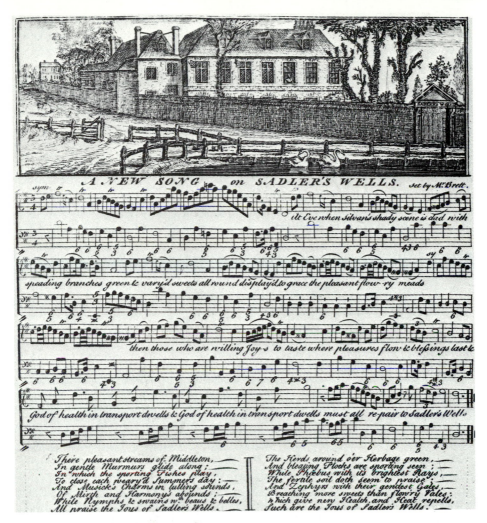

A New Song on Sadler's Wells *(1746); engraving by George Bickham.*

attempt at establishing it in London. Two theatres embarked on a lively competitive course of presenting operas to the public. The Drury Lane Theatre was first off the mark, in 1705, with *Arsinoe, Queen of Cyprus*. The music was compiled by Thomas Clayton, one-time violinist in the court orchestra of William and Mary; he had recently returned from a visit to Italy armed with librettos and songs which he put to use in *Arsinoe* and *Rosamond*. Spoken drama, not in itself part of the opera, was included in the performances of *Arsinoe*, since this was the well-established custom of the previous century. Clayton, having described the work as 'An opera, after the Italian manner; All sung', outlines his intentions in the Preface:

The Design of this Entertainment being to introduce the Italian Manner of Musick on the English Stage, which has not before been attempted; I was oblig'd to have an Italian Opera translated: In which the Words, however mean in several Places, suited much better with that manner of Musick, than others more Poetical would do.

Clayton's *Arsinoe*, with its libretto in English, was the first all-sung opera in London. Later, in the same year, the Queen's Theatre in the Haymarket, newly opened by the architect and dramatist Sir John Vanbrugh, and the dramatist William Congreve, responded with *The Loves of Ergasto* by a German composer, Jakob Greber. Unlike *Arsinoe* this was reputedly sung in Italian and employed an Italian cast, described by one witness as 'the worst that e're came from thence'. The Queen's Theatre, having suffered an inauspicious beginning, must have been heartened by Drury Lane's production of *Rosamond*.

Notwithstanding the literary distinction of its librettist, Addison, the music, composed or perhaps partly compiled by Clayton, was of lamentable quality and the production, in 1707, was one of the great operatic failures of the century. Addison must have been galled by the disaster since he had been perceptive in seeing that more was required than imitation to make a successful opera. In a later edition of *Rosamond* Thomas Tickell rallied round Addison in his Prologue to the opera:

> The Opera first Italian Masters taught,
> Enrich'd with Songs but innocent of Thought,
> Britannia's learned Theatre disdains,
> Melodious Trifles and enervate Strains:
> And blushes on her injur'd Stage to see,
> Nonsense well tun'd, and sweet Stupidity.

The next and last all-sung opera at Drury Lane, in 1707, was *Thomyris, Queen of Scythia*, a pasticcio with music arranged mainly from Giovanni Bononcini and Alessandro Scarlatti and with recitatives by Pepusch. The performances were notable for the first appearance on the London stage of an Italian 'castrato' singer. He was Valentino who, whilst the remainder of the cast sang in English, sang his arias in Italian. Soprano and alto castrati had appeared in operas from the beginning of the seventeenth century but reached the height of their popularity during the mid- to late-baroque period. They were mostly Italian but several acquired international reputations and considerable wealth, above all, perhaps, in England during the period of Handel's operas. The best of them had voices of considerable strength and sexless purity and, for these qualities, they were much in demand as great vocal instrumentalists.

In the two seasons which followed, the Queen's Theatre experimented with bilingual operas in Italian and English. The most successful of these was *Pyrrhus and Demetrius* which ran to twenty-three performances in the 1708 season. The music was largely taken from Alessandro Scarlatti's successful opera, *Pirro e Demetrio*, with the libretto translated by Owen Swiney, a colourful Irishman who occupied an influential position as opera impresario and manager of both the Drury Lane Theatre and the Queen's Theatre in succession. The experiment of bilingual opera, however, was short-lived for, as Addison later contemptuously remarked:

the Audience got tired of understanding half the Opera; and therefore to ease themselves intirely of the Fatigue of Thinking, have so ordered it at present, that the whole Opera is performed in an unknown Tongue.

Indeed, the following two operas at the Queen's Theatre showed a pronounced bias towards performance in Italian. The anonymous *Almahide*, staged in January 1710, had minor characters only singing in English, whilst *Idaspe* was sung entirely in Italian with music by Francesco Mancini.

With the success of *Idaspe* the future of Italian opera in London was for the time being assured. The public had been delighted both by the excellence of the singing, above all that of the 'castrato' Niccoló Grimaldi, known as Niccolini, and by his fight with a lion on stage. Addison's only complaint was that the lion could not be persuaded to perform his part in an encore. This was the point which domestic opera had reached when, on 24 February 1711, Handel's *Rinaldo* was staged at the Queen's Theatre, which now focused all its attention on Italian opera.

Before his arrival in London, Handel had spent four years in Italy. Throughout the seventeenth and eighteenth centuries Italian culture was considered essential to an artist's education. Italy was the home, not only of the principal baroque vocal forms – opera, oratorio and cantata – but also of the principal instrumental ones – concerto and sonata. Italy played a vital role in the formation of Handel's mature style and while there he met many of the leading Italian composers of the day, including Corelli, Caldara, Vivaldi and, above all, Alessandro Scarlatti.

The most important lesson he learnt there, chiefly from the operas and cantatas of Alessandro Scarlatti, was the command of a rich, free and varied melodic style, long-breathed but rhythmically flexible, which distinguished all his later music. With it he won an absolute mastery of the technique of writing for the voice. The warm climate of Italian lyricism melted the stiffness and angularity of his German heritage, and at the same time refreshed his counterpoint; . . .

(Winton Dean: 'Handel' in *The New Grove*, 1982)

When Handel left Italy in February 1710, he seemed to have determined on regular employment as a court Kapellmeister in his native Germany. In June of that year he accepted such a post at the Hanover court but at once obtained leave of absence for a year in order to visit London. By the time of his arrival there in the autumn of 1710 Handel found himself in a city where, as already outlined, Italian opera had just begun to flourish. The Queen's Theatre in the Haymarket had a regular opera company and a permanent orchestra, enthusiastically supported by the aristocracy. All it needed, in fact, was a composer of Handel's talent. Handel was by no means unknown before his arrival in London and, according to his later biographer, John Mainwaring, reports of his 'uncommon abilities' had reached England in advance of the composer himself. Almost at once, the new theatre manager at the Queen's Theatre commissioned an opera from him, *Rinaldo*, which opened on 24 February 1711.

Rinaldo was the first Italian opera written specifically for the London stage. The libretto was based on a famous episode in Tasso's epic poem, *La Gerusalemme Liberata* ('Jerusalem Delivered'). The story, much favoured in baroque opera, is set during the first Crusade. It was the first of five 'magic' operas, in which the supernatural element plays an essential part, all of which contain memorable scenes and a wealth of fine music.

Rinaldo was not, however, without its critics and among the most vociferous of them were those entertaining satirists of *The Spectator*, Addison and Steele. Their criticism was not unprejudiced since Addison's own opera, *Rosamond*, had been a resounding failure and Steele had a vested interest in spoken drama; but their remarks add colour to the picture of Italian opera in London at the time. Addison clearly found the extravagances in *Rinaldo* outweighed any sterling merit: 'Common Sense . . . requires, that there should be nothing in the Scenes and Machines which may appear Childish and Absurd.' Steele certainly found the production 'Absurd':

As to the Mechanism and Scenary . . . at the 'Hay-Market' the Undertakers forgetting to change their Side Scenes, we were presented with a Prospect of the Ocean in the midst of a delightful Grove; and th'[o] the Gentlemen on the Stage had very much contributed to the Beauty of the Grove, by walking up and down between the Trees, I must own I was not a little astonished to see a well-dressed young Fellow, in a full-bottom'd Wigg, appear in the midst of the Sea, and without any visible Concern taking Snuff.

Notwithstanding a minority of adverse criticisms *Rinaldo* was a resounding success. The lavish production, with the castrato, Niccolini, in the title role, was a triumph for Handel and the opera was performed fifteen times between February and June of 1711. Handel, just twenty-six years old and already admired in Italy, was now fêted in London, a city which he must have felt to be sympathetic to his cause. *Rinaldo*'s success was due to its realistic scenic effects – invariably an attraction to audiences at this time – and, above all, to its beautiful music.

In *Rinaldo* Handel was already putting into practice his almost inveterate custom of borrowing music both from his own earlier works and from the works of other musicians. Several numbers are drawn from his Italian secular cantatas as well as others from his earlier operas *Almira* and *Agrippina*. Among the 'borrowings' is Rinaldo's affecting aria 'Cara sposa' (Act I, scene 7) which, according to Sir John Hawkins, Handel 'would frequently say was one of the best he ever made'. No other opera of Handel's was performed during his lifetime as often as *Rinaldo*. Serious opera in English, meanwhile, was in its death throes and it faded until the production of Arne's *Artaxerxes* in 1762.

Handel's first visit to England lasted about eight months, at the end of which he returned to Hanover and to his duties as court Kapellmeister. That he intended to return to London at the first possible opportunity, however, is strongly implied by the fact that, almost at once, he began to learn English. In the autumn of 1712 he obtained permission from the Elector to make a second journey but, as Mainwaring put it, 'on condition that he engaged to return within a reasonable time'. Since by then Queen Anne's health was weak, and taking into account the fact that the Elector was next in line to the English throne, we may wonder just how seriously Handel took his conditions of leave. Late in 1712 he was back in London once more, but this time he settled there and eventually became a naturalised Englishman. Between the production of *Rinaldo* in 1711 and the early 1740s he produced some thirty Italian operas for the London stage with varying degrees of

success. All was far from well at the Queen's Theatre, where Owen Swiney, who had succeeded Aaron Hill as manager, 'Brakes & runs away & leaves the Singers unpaid, the Scenes & Habits also unpaid for. The Singers were in Some confusion but at last concluded to go on with the operas on their own accounts, & divide the Gain amongst them'. Swiney's position was taken by John James Heidegger, who was to work closely with Handel in the production of the majority of his operas.

An event of great significance for Handel took place in the winter of 1718–19, with a move to establish Italian opera in London on a more secure financial basis than hitherto. Leading members of the nobility, under the patronage of George I, who had succeeded Queen Anne in 1714, proposed a 'Royal Academy of Music'. Under such a scheme Handel could look forward to a salary, sound theatre management, an established orchestra and first-rate singers. Handel himself was authorised to go in search of the finest singers in Europe, which he engaged upon during a European visit in the summer of 1719. Shortly after his return the directors of the Academy appointed him 'Master of the Orchestra with a Sallary'. Handel was thus effectively in charge of the training of singers and players, though not responsible for providing all the works in a season. His first Academy opera, *Radamisto*, was rapturously received. In the second season and in others subsequently, operas by Giovanni Bononcini, staged by the Academy, offered serious rivalry to those of Handel for a while.

The Royal Academy survived until 1728, by which time the pitch of dissension among its directors and fierce squabbling among certain of the musicians – notably between the resident soprano, Francesca Cuzzoni, and the soprano Faustina Bordoni, who had been invited to join the company in 1725 – hastened its close. Mainwaring gives us an engagingly colourful account of the height to which tempers could rise in reporting an exchange between Handel and Cuzzoni during rehearsals of his opera *Ottone* (1723):

Having one day some words with Cuzzoni on her refusing to sing 'Falsa imagine' in OTTONE; Oh! madame (said he) je sçais bien que Vous êtes une véritable Diablesse: mais je Vous ferai sçavoir, moi, que je suis Beelzebub le Chéf des Diables. With this he took her up by the waist, and, if she made any more words, swore that he would fling her out of the window.

Handel's greatest heroic operas belong to the period of the Royal Academy, reaching a peak in *Giulio Cesare in Egitto* (February 1724), *Tamerlano* (October 1724) and *Rodelinda* (February 1725). By this time Handel had a wealth of fine singing talent at his disposal which he placed at the service of some of his most profound dramatic utterances. Cuzzoni (Cleopatra) and Senesino (Caesar) were outstandingly successful in their roles, and Handel's rich and evocative orchestral and melodic gifts did not fail to win over the audience. Among a profusion of memorable arias in *Giulio Cesare*, Caesar's 'Va tacito e nascosto', with its evocative orchestration, in which he likens Ptolemy's suspected treachery to a hunter stalking his prey with measured tread, and Cleopatra's two great laments, 'Se pietà' and 'Piangerò', stand out on account of their beautiful melodies and the deep compassion with which Handel draws their characters.

A ticket for The Beggar's Opera, *the first musical work played at Covent Garden (1733).*

In the same year as the Royal Academy closed its doors, musical theatre challenged Italian serious opera with *The Beggar's Opera*, produced at the Lincoln's Inn Fields Theatre on 29 January 1728. The work was a blend of English comedy with opera, in which John Gay (1685–1732) inserted a great many popular tunes from England, Scotland, Ireland and France into spoken dialogue. Gay's characters included gaolers, prostitutes and a varied assortment of thieves and ne'er-do-wells. Few aspects of respectable life escaped Gay's sharp satire – government, politics, law, class, even Italian opera were scrutinised and ridiculed. The music, too, had political overtones; the overture, by Pepusch, a proved master of pasticcio, who also arranged the songs, contains, for instance a melody known as 'Walpole', or, 'The Happy Clown' (Robert Walpole was the prime minister at the time). *The Beggar's Opera* ran for sixty-two nights, proving to be an immensely popular novelty. The success of *The Beggar's Opera* led to other similar ballad-operas, amongst which *The Devil to Pay* (1731) by Charles Coffey was, perhaps, the most notable, having an influence on German *singspiel*. These were spoken dramas with songs and sometimes more elaborate musical content which, from the 1750s, offered a popular and vernacular alternative to operas which were sung throughout. Handel's music, though usually in versions far

removed from the composer's intentions, made frequent appearances in ballad operas of the 1730s, which, unlike Italian opera, were staged all over Britain and enjoyed by a wide social range.

Neither the success of *The Beggar's Opera* nor the collapse of the Royal Academy deflected Handel from the continuance of his operatic career. In 1729 he rented the King's Theatre (the name changed according to the sex of the reigning monarch) from the directors of the Royal Academy and in partnership with Heidegger began a second opera Academy on the basis of an annual subscription. A new season opened in December 1729 but was indifferently received. The following three seasons were more successful, by and large, and included several new operas by Handel. *Poro* (1731) met with considerable success though *Ezio* (1732) was one of Handel's worst failures and had only five performances. These are two of three operas which Handel set to texts by the famous poet and librettist, Pietro Metastasio (1698–1782). *Sosarme* (1732) fared better but it was probably *Orlando* (1733), one of Handel's finest operas, which made the greatest impact upon his audiences at this time. Further trouble was in store for Handel's second Academy, however, in the form of a rival establishment calling itself the 'Opera of the Nobility', which was 'got up against the dominion of Mr Handel'. Almost all Handel's best singers deserted him for the opposition, including Senesino, whose role in the whole affair may have been less than honourable.

The Nobility opened in December 1733 with Nicola Porpora's *Arianna in Nasso*, whose cast consisted largely of singers from Handel's former company. In the following year the Nobility gained further ground by acquiring the services of Farinelli, perhaps the greatest of all castrati. Handel, meanwhile, entered into an agreement with John Rich whose new theatre at Covent Garden had been opened in December 1732. Rich offered Handel two days a week to stage his operas. During his three seasons there he wrote six new operas, employed some English singers as well as Italian, and also made use of a ballet troupe led by the celebrated French danseuse, Marie Sallé. Among Handel's greatest achievements of this period were the operas *Ariodante* (1735) and *Alcina* (1735), his last great operatic triumph.

During the mid-1730s both opera companies were in decline. Handel wrote three new operas for Covent Garden, none of which attracted the public, whilst the Nobility Opera began adding comic 'intermezzi' between the acts of *opera seria* in an attempt to draw an audience. In 1737 both companies folded and, though Handel was by now active in the spheres of oratorio and English ode, his health broke down and he left for Aix-la-Chapelle in search of a cure. He was not yet quite through with opera, however, and after making a remarkable convalescence, he was engaged for two more seasons by Heidegger, still at the King's Theatre in the Haymarket. *Faramondo* (1738) was a success: *Serse* (1738) was not. In the summer of 1740 Handel visited the Continent once more, returning to London in the early autumn when he completed his last two operas, *Imeneo* (1740) and *Deidamia* (1741). Both failed, but Winton Dean believes that 'the indifference of the public rather than the quality of the artists or the music seems to have been responsible . . .'. Public taste at the time perhaps inclined more favourably towards English burlesque opera, a notable example of which was *The Dragon of*

Wantley, a satire on Italian opera by John Frederick Lampe.

Although Handel now withdrew from Italian opera, the public maintained an interest in the form. During the next twenty years or so the King's Theatre, under various managers, presented some seventy different Italian operas, though many of them were pasticcios. One of the most effective managers was the Earl of Middlesex, who engaged the Venetian composer, Baldassare Galuppi (1706–85), for two seasons between 1741 and 1743, and the Austro–German Gluck (1714–87) for the season 1745–6. Burney, an ardent Handelian, thought little enough of Galuppi's music, in which the composer 'copied the hasty, light and flimsy style which reigned in Italy at this time, and which Handel's solidity and science had taught the English to despise'. Nevertheless, Galuppi's operas, especially *Enrico*, were sufficiently popular for the management to mount twelve of them between 1741 and 1761. In 1746 Gluck's *La caduta de giganti* was, according to Burney, 'performed before the Duke of Cumberland in compliment to whom the whole was written and composed'. This Duke was shortly to be complimented in music once more when, after the Battle of Culloden (16 April 1746), Handel celebrated the victory with his oratorio *Judas Maccabaeus*. Gluck contributed one further opera that season, *Artamene*, after which he returned to Vienna.

During the late 1740s an attempt was made to establish Italian comic opera in London but it was largely unsuccessful; and when the manager of the King's Theatre, Dr Croza, following the notorious example of Owen Swiney in 1713, absconded with the takings, 'the event', as Burney drily observed, 'put an end to operas of all kinds, for some time'. By 1754, however, serious Italian opera was being performed once again and in that year Handel's *Admeto*, first staged in 1727 with great success, was revived but received, according to Burney, 'with great indifference'. Meanwhile, at the King's Theatre new leading sopranos were engaged and a new leader of the band, Felice de Giardini, 'introduced new discipline and a new style of playing, much superior in itself, and more congenial with the poetry and music of Italy, than the languid manner of his predecessor, Festing', as Burney recounted. Giardini, evidently both talented violinist and competent composer, spent some forty years in London playing an active part in the musical life of the city and, for his pains, earning himself approbation from an unexpected source. In an exchange between Oliver Goldsmith and Dr Johnson, Johnson learned that Giardini earned about £700 a year: 'That is, indeed, but little for a man to get, who does best that which so many endeavour to do', Johnson replied.

In the autumn of 1760, under the management of the soprano, Colomba Mattei, the King's Theatre made another gesture towards Italian comic opera. This time the climate was more favourable and audiences were enchanted by *Il mondo della luna* and *Il filosofo di campagna* by Galuppi, who had already composed several serious operas to texts by the great librettist, Pietro Metastasio. Although serious operas were staged regularly throughout this and the following decade, the prevailing fashion during the 1760s favoured pasticcio. This form of entertainment involved contributions from various composers and was by no means a novelty. In 1721, for example,

Handel, Bononcini and Mattei contributed one act each to *Muzio Scevola*; but at that time such pasticcios were exceptions to the rule. By the middle decades of the century, however, operatic medleys of various kinds were among the most popular forms of staged entertainment. The public appetite for arias from Italian opera at the time can be assessed by the large quantity of them published between the 1740s and the 1770s and designed for domestic consumption.

The most gifted composer living and working in London during the 1760s was Johann Christian Bach (1735–82). He was the youngest son of J.S. Bach's second marriage and by the time of his arrival in London had already composed three serious Italian operas for Turin and Naples. Known as the London Bach, J.C. Bach's musical style was classical rather than baroque in the manner of his great father, and he was an important influence on the young Mozart whom he befriended. During his last two years in Italy Bach had been a somewhat dilatory organist at Milan Cathedral and it was during this period, between 1760 and 1762, that his career turned away from the church towards the stage. Bach arrived in London probably in the summer of 1762, having been commissioned to write two operas for the King's Theatre. By the end of that year he had been appointed music director of the theatre for the forthcoming season. Bach made London his home and, in the twenty years until his death in 1782, he made a distinguished and enduring contribution to its musical life.

Bach's first serious Italian opera for London was *Orione*, which opened at the King's Theatre in February 1763 and which alone of his operas, surprisingly, was revived in his own lifetime. It was enthusiastically received:

Every judge of Music perceived the emanations of genius throughout the whole performance; but were chiefly struck with the richness of harmony, the ingenious texture of the parts, and, above all, with the new and happy use of wind-instruments: this being the first time that 'clarinets' had admission in our opera orchestra.

<div align="right">(Burney: *A General History of Music*, vol. II).</div>

The role of the orchestra had increasing significance in the operas of the 1750s and 1760s, not only in the introduction and accompaniment of arias but also in recitative as well. Bach followed *Orione* with *Zanaida* in May of the same year but, in spite of public acclaim for these two operas, he was not re-engaged by the King's Theatre for the next season. A strong pro-Italian faction and petty jealousies seem to have been the reason.

In his year off from the King's Theatre Bach turned his attention to his young royal patron, Queen Charlotte, to whom he had been appointed Music Master. In 1763 he dedicated to her his Six Concertos for keyboard and strings. At about this time Bach developed, or perhaps resumed, his friendship with a fellow German compatriot living in London, Carl Friedrich Abel. (Their fruitful partnership in the establishment of public concerts is discussed in a later section.) By the following season, however, Bach was back at the Haymarket but, in Burney's words, 'Every one seemed to come out of the theatre disappointed' with his *Adriano in Siria*. The only all-Italian opera, by Thomas Arne (1710–78), *L'Olimpiade*, with a libretto by Metastasio, fared no better and was dropped after two performances. There

is not much to be related about Bach's last two operas or his ballad-opera, *The Maid of the Mill*. By the 1770s, Bach's opera presence in London, and that of other composers too, must have taken second place to that of an extremely prolific and successful Italian, Antonio Sacchini. As many as seventeen of his operas were given in London between 1773 and 1781, most of these at the King's Theatre. Burney, who was often capable of perceptive musical judgement, seems, however, to have overrated Sacchini's dramatic talent when showering praise upon him: 'His operas of the *Cid* and *Tamerlano* were equal, if not superior, to any musical dramas I have heard in any part of Europe.'

English serious opera in the vernacular, as we have seen, had soon yielded to Italian opera, though *The Beggar's Opera* was an indication that there was an enthusiastic audience for the vernacular. It was not until the 1760s, however, that English opera showed signs of becoming more popular and the greatest success was Arne's *Artaxerxes*, which was first performed at the Theatre Royal, Covent Garden in 1762 and remained in the repertoire for four consecutive seasons. Arne used a translation of Metastasio's *Artaserse*, which had already been set by other composers including Hasse and J.C. Bach. The cast was made up both of English singers and Italian castrati and Arne attempted to compose music in styles which would come most naturally to each. Burney was not without criticism but conceded that

Arne had the merit of first adapting many of the best passages of Italy, which all Europe admired, to our own language, and of incorporating them with his own property, and with what was still in favour of former English composers.

Artaxerxes gave rise to several imitations such as *The Royal Shepherd*, with music by George Rush, *Almena*, by Michael Arne and Jonathan Battishill, and *Pharnaces*, by William Bates, all English vernacular serious operas, and all staged at Drury Lane during the mid-1760s. Others followed, but with dwindling success, since the taste was now predominantly for ballad-operas and pasticcios (these forms of entertainment are discussed in the section 'Music in the playhouses').

Handel and the English oratorio

Whereas oratorio, whose foundations lay in Italy, was firmly established in a great many Italian cities by the 1660s, English oratorio was unknown before the arrival of Handel. English oratorio was Handel's creation and in its synthesis of English, French, Italian and German elements often appears strikingly different from its European counterparts. Handel's English oratorios usually consist of a drama in three acts based on or, at least, related to a sacred subject; in some, however, such as *Israel in Egypt* and *Messiah*, Handel used non-dramatic librettos. The music employed the styles of Italian opera and English sacred choral music but was performed as a concert, usually in a theatre but also in a concert hall and even, occasionally, in the music rooms of taverns where a concert tradition had grown up in London during the previous century. Between the acts the orchestra often performed

concertos and this gave rise to another of Handel's innovations, the organ concerto, in which he himself played the solos.

In the extensive and dramatic use of the chorus and by the division of his oratorios into acts – two features which distinguish Handelian English oratorio from its Italian counterpart – Handel reveals himself, as ever, a man of the theatre. He was not, however, lightly to be deflected from opera, a dramatic form of which he had become a renowned and consummate master and it was only during the 1730s, when the fortunes of Italian opera were on the wane, that he began to explore new outlets for his dramatic talent. Indeed, it could almost be said that he came to write English oratorios by accident. He took his first step in 1732 when the first London performances of an English oratorio took place. The work was his oratorio *Esther*, which he had written in 1718 for his patron James Brydges, Earl of Carnarvon and later Duke of Chandos. The three performances under the direction of Bernard Gates, Master of the Children of the Chapel Royal, took place in February 1732 at the Crown and Anchor Tavern in the Strand. According to a manuscript copy of the score:

the Children of the Chapel-Royal, together with a Number of Voices from the Choirs of St. James's, and Westminster, join'd in Chorus's, after the Manner of the Ancients, being placed between the Stage and the Orchestra; and the Instrumental Parts (two or three particular Instruments, necessary on the Occasion, Excepted) were perform'd by the Members of the Philarmonick Society, consisting only of Gentlemen.

The enterprise was a great success such that Handel's pupil, Princess Anne, asked him to stage the oratorio at the King's Theatre in the Haymarket.

However, whilst arrangements were taking place for this to happen, a pirated performance of *Esther* was advertised at the Great Room, York Buildings, for the following April. Handel responded by enlarging the score and announcing that he had done so. But there were further problems to overcome since the Bishop of London, who was also ex officio Dean of the Chapel Royal, forbade members of the Chapel from donning costumes and enacting a sacred subject in the theatre. Handel was obliged to comply with the Dean's instructions, adding the following sentences to his announcement: 'N.B. There will be no Action on the Stage, but the House will be fitted up in a decent Manner for the Audience. The Musick to be disposed after the Manner of the Coronation Service'. The performances of *Esther* took place in the King's Theatre in May 1732 and were enthusiastically received.

Handel's rivals were quick to recognise an opportunity for profit when they saw it. Hardly had the performances of *Esther* finished, before an opera company which functioned at the New Theatre, also in the Haymarket, staged Handel's English masque, *Acis and Galatea*, which he had composed in 1718, also for James Brydges at his seat at Cannons, near Edgware. Once again Handel responded to the piracy by expanding his score with music from other sources. The first of four performances took place at the King's Theatre in June 1732, sung in a mixture of English and Italian which must have pleased the English and Italian singers who took part in the performances. Although it was popular and several times revived in this form, Handel eventually returned to the delightful and musically satisfying

English version of 1718. As Winton Dean observed, 'Of such dubious and fortuitous parentage was the English oratorio born'.

The variety in Handel's oratorios is astonishing, yet, of course, there are ingredients common to them all and many of the essential ones such as recitative, aria and overture are the same as those in Italian eighteenth-century opera; but whereas in Handel's operas the chorus played a very small part, it assumed an increasingly large and dramatic one in the English oratorios which he produced between the late 1730s and the early 1750s. His subjects were drawn largely from the Old Testament though there were notable exceptions; one of them was *Semele*, referred to by Charles Jennens as 'No Oratorio, but a baudy Opera An English Opera, but called by "fools" an Oratorio, and performed as such at Covent Garden'. Jennens, of course, was right; *Semele*, though produced 'after the Manner of an *Oratorio*', is essentially an English opera with a libretto by William Congreve, stylistically close to its Italian counterparts. Jennens was an important figure in musical life at this time and his assiduously collected assembly of Handel's music gives posterity much to be thankful for. He provided Handel with texts for three great oratorios, *Saul*, *Messiah* and *Belshazzar*, as well as adapting Milton and adding his own flat, but serviceable *Il Moderato* for Handel's English ode, *L'Allegro, il Penseroso ed il Moderato*.

Handel followed up the success of *Esther* with further seasons of oratorio which usually occurred during Lent. Performances were held in theatres where, during the 1730s, Handel, ever reluctant to abandon opera, divided his time between opera, oratorio and English odes. One first performance, that of *Athalia*, in 1733, took place not in London but in the Sheldonian Theatre at Oxford where Handel had been invited by the University Vice-Chancellor to provide music to complement the occasion of a degree-giving ceremony. In January 1739 Handel gave the first performance of his oratorio *Saul* at the King's Theatre. The fortunes of Italian opera were now dwindling fast, but in *Saul* Handel created a work hardly less dramatic than his operas. It was his most lavishly scored oratorio yet, among the orchestral requirements being three trombones – far from customary in of an orchestra during this period – a carillon, which one onlooker thought 'had been some squerrls in a cage', and a pair of extra large kettledrums which Handel had to borrow from the Tower of London. These formidable drums, said to have been used at the Battle of Malplaquet in 1709, sounded an octave lower than standard kettledrums of the time and are heard in the famous 'Dead March' in Act III, as well as in a chorus in Act I. Handel must have liked the sound they made since he used them again in subsequent oratorios.

Saul was greeted enthusiastically, though his next oratorio, *Israel in Egypt*, which draws its libretto exclusively from the Bible, was considered by some to be unsuitable in a theatre, whilst others regretted the lack of much in the way of solo relief from a vastly imposing choral spectrum. Handel's Janus-like stance towards opera and oratorio was finally focused in the direction of oratorio both by an invitation to Dublin which he took up in 1741, and by an idea of Charles Jennens. Jennens, writing to his friend Edward Holdsworth on 10 July 1741 tells him that he hopes to persuade Handel 'to set another Scripture Collection' which he had made for him, 'for his own Benefit in

Passion Week. I hope he will lay out his whole Genius & Skill upon it', Jennens continued, 'that the Composition may excell all his former Compositions, as the Subject excells every other Subject.' The subject was that of Handel's most celebrated oratorio, *Messiah*.

Jennens compiled his text for *Messiah* from the Bible and stated his intentions in the word-book for the first performance:

Great is the Mystery of Godliness – God was manifested in the Flesh, justified by the Spirit, seen of Angels, preached among the Gentiles, believed on in the world, and received up in Glory: in whom are hid all the treasures of wisdom and knowledge.

The text, though essentially non-dramatic, nevertheless gave Handel scope to write music that is sometimes colourfully theatrical and at others deeply contemplative. *Messiah*, as Winton Dean has remarked, 'is a compound of three distinct styles, those of the English anthem, the German Passion and the dramatic oratorio'. Jennens justly saw the work as 'a fine entertainment', for although the subject is sacred there is nothing distinctly so in the style of Handel's music. '*Messiah*', observes Dean, 'sums up to perfection and with the greatest eloquence the religious faith, ethical, congregational, and utterly unmystical, of the average Englishman'.

In the winter months of 1741–2 Handel had already given a successful season of oratorios and odes in Dublin. Now, at the end of March, 'For the Relief of Prisoners in the several Gaols, and for the Support of Mercer's Hospital . . . and of the Charitable Infirmary', *Messiah*, which Handel had written in little over three weeks in the late summer of 1741, was first performed at Neal's Music Hall in Dublin on 13 April 1742. It was rapturously received and fully realised the high hopes which Jennens had placed on it.

Words are wanting to express the exquisite Delight it afforded to the admiring crowded Audience. The Sublime, the Grand, and the Tender, adapted to the most elevated, majestick and moving Words, conspired to transport and charm the ravished Heart and Ear.

(*Faulkner's Dublin Journal*)

Messiah was given its first London performance the following year. Its reception could hardly have been more different from that which Handel had witnessed in Dublin. Even before the performance Handel had got wind of protest by the Methodists, who viewed its being sung in a theatre as blasphemous. He attempted to mollify them and others who objected on similar grounds by advertising the work, not as *Messiah*, but as 'A new Sacred Oratorio', but even so, it failed and only began to impress British audiences in the following decade.

Handel followed *Messiah* with a steady succession of oratorio masterpieces during the next ten years, outstanding among them being *Samson* (1743), *Semele* (1744), *Hercules* (1745), *Belshazzar* (1745), *Solomon* (1749), *Theodora* (1750) and *Jephtha* (1752). Neither *Semele* nor *Hercules* is, in fact, an oratorio. *Semele*, in Handel's own words, was 'after the Manner of an Oratorio' and is a classical drama rather than a biblical one. *Hercules*, based on a stage play, is not biblical either and was termed by Handel a 'musical

drama'. Handel's dramatic sense in each of these works, as we should expect from a masterly opera composer, is vivid, powerful, resourceful and original. His handling of the choruses is infinitely varied and the pictures which they paint in the listener's mind are often profound in depth and minute in detail. Such is the five-part, so-called 'Nightingale Chorus' at the end of the first Act of *Solomon* in which Handel paints a vignette of nature which is full of enchantment. Of a very different kind, is the thrilling picture 'of clanking arms and neighing steeds' in a colossal eight-part chorus from Act III of *Solomon*. In Edward Dent's words, 'The handling of the chorus was the great lesson which he learned in England, and this dramatic use of the chorus came not from the English church but from the English theatre'.

The success which Handel enjoyed with the greater number of his oratorios encouraged native composers to try their hand at emulating the Handelian form. Maurice Greene (1696–1755) was one of the first off the mark with *The Song of Deborah and Barak* (1732). The work, though short compared with Handel's oratorios, contains much fine music and is not lacking in drama. Greene followed this with a handful of similar works, among which was *Jephtha* (1737). Other oratorios included Boyce's *Solomon*, and two by Arne (1710–78); the earlier of them, *The Death of Abel*, received its first London performance at Drury Lane. This marked the beginning of a period when Drury Lane mounted its own oratorio seasons in rivalry with Covent Garden, where Handel's oratorios were still being performed on a regular basis.

Arne's other oratorio was *Judith* which is interesting musically, because it contains several fine choruses and an early example by an English composer of a notated crescendo in the score of its overture; and historically, because for a revival in 1773, boys and countertenors, hitherto a standard ingredient in English choirs of the period, were replaced by women's voices. One other oratorio of the period is noteworthy, the *Gioas, rè di Giuda* by J.C. Bach. In 1770 Bach presented a commercially unsuccessful series of oratorios at the King's Theatre in the Haymarket. Unlike his competitors at Covent Garden and Drury Lane, Bach performed works in Italian, including his own *Gioas*, set to a libretto by Metastasio. Although he revived it early in the following year it seems not to have taken with the public, and in the ensuing Lent the oratorio season was discontinued.

As in opera, so too in oratorio did pasticcio find favour with audiences in the years following Handel's death in 1759. In 1767 Samuel Arnold cobbled together music by Corelli, Purcell, Benedetto Marcello and Handel for *The Cure of Saul*. Other pastiches drew exclusively from Handel's music, one of them, *Redemption*, assembled by Arnold in 1786, enjoying a degree of success.

Music in the playhouses

The dominant musical personality of Handel who, for a while, made London the leading opera centre of Europe, makes it all too easy to overlook activities which were taking place in the theatres and playhouses other than those

where Handel himself worked. During the first half of the eighteenth century at least six London theatres were open at one time or another, without taking into account the many fringe theatres that functioned off and on. Each of the main theatres employed singers whom they taught to act and actors whom they taught to sing. Theatre orchestras were busy, too, since even in the performance of spoken comedies and tragedies there might be accompanied songs or dancing. During the intervals music almost invariably was played and the repertory included overtures from Handel's operas, dances and 'concerti grossi' by Italian composers such as Corelli and Geminiani.

Although Italian opera was the chief form of entertainment staged by the King's Theatre in the Haymarket, other theatres offered a wider variety of drama, spoken, sung or incorporating both speech and music. Among such entertainments were masques, pantomimes, ballad-operas, pastorals and dialogue opera. In 1715 Colley Cibber, then manager of the Drury Lane Theatre, appointed Pepusch as musical director. Johann Christoph Pepusch (1667–1752) was a German composer who had lived in England since the turn of the century. Cibber decided to combat the Italian operas with English masques. This form of entertainment had developed during the reign of the early Stuarts in the previous century. After the Restoration, masques were generally all-sung and during the eighteenth century usually fulfilled the role of an 'afterpiece' following a spoken drama. Pepusch's first masque for the theatre was *Venus and Adonis* (1715), for which Cibber himself provided the libretto and which he described as 'an Attempt to give the Town a little good Musick in a Language they understand It is hoped that this under-taking, if encourag'd, may in time reconcile Musick to the 'English' Tongue. *Venus and Adonis* was a success but Pepusch's following three masques for Drury Lane were much less so. Cibber made one or two further attempts thereafter to re-establish the form but seems to have abandoned it by the end of 1717.

Successes with masque in the period between 1715 and 1735 were fewer than failures and so, during the 1720s, we find both Drury Lane and Lincoln's Inn Fields involved in another form of 'afterpiece' entertainment, English pantomime. Eighteenth-century pantomime contained airs, recitatives, ensembles and choruses interspersed with short instrumental pieces which accompanied the 'mime' element in the show. There was no spoken dialogue at this period of pantomime history when mythological stories were among the most popular, especially if they included scenes in the classical Underworld. Columbine, Pantaloon, Harlequin and other characters from the Italian 'Commedia dell'arte' were popular and considerable scope was given to composers to interpret dramatic situations musically.

During the period 1723 to 1728 Drury Lane and Lincoln's Inn Fields produced between them nearly six hundred pantomime performances of well over a dozen works. The most important figure was that of John Rich himself, who, as well as managing the Lincoln's Inn Fields Theatre and its successor at Covent Garden, played the role of Harlequin from 1717 until 1741. Rich's pantomimes were mainly devised by Lewis Theobald, chiefly remembered nowadays, if at all, as a victim of Pope, mercilessly pilloried in *The Dunciad* in its first version. In the rewritten version, as Dr Johnson

remarked, Theobald was 'degraded from his painful pre-eminence' and replaced by Colley Cibber. The music was supplied in all but one instance by Galliard. Rich, whom Roger Fiske describes as 'by far the greatest Harlequin of the century', scored his greatest successes with *The Necromancer or Harlequin Dr Faustus* (1723) and *Apollo and Daphne or The Burgomaster trick'd* (1726).

The Beggar's Opera, as we have seen, was unquestionably one of the most successful theatrical ventures of the eighteenth century and there were few other ballad-operas which enjoyed anything like its popularity. The librettist of *The Beggar's Opera*, Gay, eventually wrote a sequel to it, *Polly*, but it was banned by the Lord Chamberlain and not staged until 1777. The most successful ballad-opera after *The Beggar's Opera* was *The Devil to Pay*, which was staged at Drury Lane in 1731.

Much of the most interesting theatre music in London between the 1730s and early 1760s was composed by Arne, Greene and Boyce. The favoured forms at this time were the masque and the pastoral, between which there was little distinction other than that the masque often presented classical deities whereas in the pastoral the characters were mainly shepherds and shepherdesses. Among Greene's most successful pastorals was *Florimel, or Love's Revenue* which dates from 1734. Its revival in London during the 1970s revealed Greene as an effective composer for the stage with an ability to express a text in dramatically appropriate music.

Arne preferred masque to pastoral, and foremost among these was *Comus*, first staged at Drury Lane in March 1738. The librettist, John Dalton, adapted Milton's masque *Comus* – which had first been performed at Ludlow Castle in 1634 with songs by Henry Lawes – into a three-act entertainment with music and spoken dialogue. The lyrical appeal of Arne's songs, in which Burney found 'a light, airy, original and pleasing melody, wholly different from that of Purcell or Handel', both compensated for some routine orchestral numbers and kept the work, in one form or another, in the London stage repertory for the remainder of the century. It was not until *Thomas and Sally*, eleven years later, that Arne produced a work of comparable popularity. This, an all-sung afterpiece, is in effect a miniature opera with an engaging libretto by Isaac Bickerstaffe. Sally is pursued by the local squire who 'must not be denied'. She is saved in the nick of time by the return of her sailor lover who, with some well chosen words from his nautical vocabulary, sends the squire packing. *Thomas and Sally* was first staged at Covent Garden on 28 November 1760 and proved immensely successful.

By comparison with the considerable quantity of Arne's theatre music, that of Boyce seems small. His greatest success was *The Chaplet*, a pastoral performed at Drury Lane in 1749. In the course of the following eight seasons it had over one hundred performances, achieving wide popularity in playhouses both in and well beyond London. Boyce's earlier stage works include a masque, *Peleus and Thetis* (1736) and the *Secular Masque* (*c.* 1745). Neither these, however, nor his last major work for the theatre, *The Shepherd's Lottery*, another pastoral, given at Drury Lane in 1751, enjoyed the success of *The Chaplet*.

In the early 1760s Arne was involved in another kind of entertainment

which had a counterpart in the Italian pasticcio operas being staged at the King's Theatre. This was English pastiche opera, the first of which, *Love in a Village*, was performed at Covent Garden on 8 December 1762. The librettist was Isaac Bickerstaffe whose text Arne set both with his own music and with that of other composers including Handel and Abel, who wrote its overture. English pastiche opera was a more sophisticated entertainment than ballad-opera, for though it borrowed traditional tunes the orchestration was more elaborate and the idiom closer to that of serious opera. *Love in a Village*, consisting of music and dialogue, set a fashion for pastiche opera in the London playhouses during the following twenty years or so. Among many similar works which followed were *Love in the City* and *Lionel and Clarissa*, in which the composer and compiler of the music was Charles Dibdin (1745–1815). He, with the two Thomas Linleys and William Shield, was to provide much of the best English playhouse music during the last quarter of the eighteenth century.

Orchestral and instrumental music

The chief forms of instrumental chamber music during the first half of the eighteenth century were the solo keyboard suite, the sonata for one melody instrument and basso continuo, and the trio-sonata for two melody instruments and continuo. The most widely cultivated orchestral forms were those of the suite, concerto grosso and, from the mid-century, the solo concerto. To these we must also add the overtures and many instrumental or orchestral movements contained within opera and oratorio, especially those of Handel. As in these dramatic forms so, too, in the production of non-vocal music Handel was the dominant figure in Britain during this period.

It is not possible to date Handel's solo keyboard music with certainty and some of it was doubtless written before he came to England. Similar problems of dating occur with Handel's solo and trio-sonatas of which four sets were published during his lifetime. The keyboard music was intended for domestic use and collections of it were published in 1720, 1733 and 1735. Although comparatively small in quantity it is elegant, often inventive and, in the hands of stylistically informed players, full of vitality and charm.

Apart from the substantial corpus of non-vocal music within the operas and oratorios, Handel's orchestral compositions fall into three distinct categories: occasional music, concerti grossi and solo concertos. Even so, much of the music contained in his concertos was used, in one form or another, in his stage works or as interval music. The earlier of Handel's two magnificent occasional pieces was the *Water Music* which, however, was probably written for more than one outdoor occasion. The popular story about how Handel wrote and performed his *Water Music* in order to appease his former employer, the Elector of Hanover, when he arrived in London in 1714 as George I is, perhaps, only partly true. We have neither Handel's autograph nor his conducting score to assist us in performance details, but it is certain that some of the music was heard on 17 July 1717 when a royal barge party sailed up-river on the Thames from Whitehall to Chelsea. An

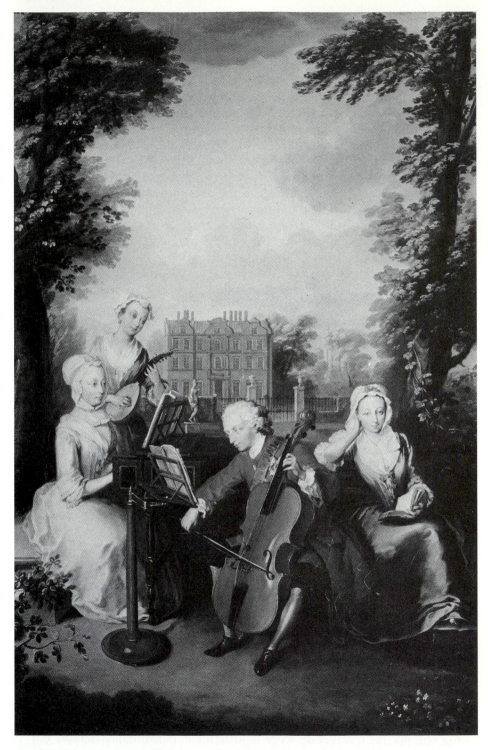

Philippe Mercier, View of Kew, *with Frederick, Prince of Wales playing the cello, accompanied by his sisters, Anne, Amelia and Caroline (1733).*

account of the colourful occasion appeared in the *Daily Courant* two days later:

On Wednesday Evening, at about 8 the King took Water at Whitehall in an open Barge . . . And went up the River towards Chelsea. Many other Barges with Persons of Quality attended, and so great a Number of Boats, that the whole River in a manner was cover'd; a City Company's Barge was employ'd for the Musick, wherein were 50 Instruments of all sorts, who play'd all the Way from Lambeth (while the Barges drove with the Tide without Rowing, as far as Chelsea) the finest Symphonies, compos'd express for this Occasion, by Mr Handel; which his Majesty liked so well, that he caus'd it to be plaid over three times in going and returning. At Eleven his Majesty went a-shore at Chelsea, where a Supper was prepar'd, and then there was another very fine Consort of Musick, which lasted till 2: after which, his Majesty came again into his Barge, and return'd the same Way, the Musick continuing to play till he landed.

The orchestra, too, was described on this occasion by the 'Prussian Resident' minister in London, Friedrich Bonet. He noted that the musicians 'played all kind of instruments, to wit trumpets, horns, oboes, bassoons, flutes, recorders violins and basses . . .'. River parties such as that described here were popular in London during the eighteenth century, as the many reports and contemporary copper-plate engravings testify.

Our knowledge of the performance of Handel's *Music for the Royal Fireworks* in 1749 is much greater, since the event is well documented. The occasion which prompted such a lavishly scored work was the signing of the Treaty of Aix-la-Chapelle, concluding the War of the Austrian Succession, on 7 October 1748. To mark the event elaborate plans were laid for a magnificent display of fireworks in the following year. Handel was to compose music for the occasion as well as a Peace Anthem for the Chapel Royal in St James's Palace. The King, George II, was at first against having any music at all, but then requested 'warlike instruments' to accompany the fireworks; however, an account by the Duke of Montagu, Master General of the Ordnance, suggests that Handel, with characteristic stubbornness, met the monarch only half way:

Now Hendel proposes to lessen the nomber of trumpets, etc and to have violeens. I dont at all doubt but when the King hears it he will be very much displeased. . . . I am shure it behoves Hendel to have as many trumpets, and other martial instruments, as possible, tho he dont retrench the violins . . . though I beleeve he will never be persuaded to do it.

An apparently successful public rehearsal in Vauxhall's Spring Gardens took place on 21 April with an audience of over 12,000 and a three-hour traffic jam of carriages.

The firework display proper was seen a week later, in Green Park. Horace Walpole provided a dry account of the visual events though not, alas, of the musical ones:

The rockets and whatever was thrown up into the air succeeded mighty well, but the wheels and all that was to compose the principal part, were pitiful and ill-conducted with no changes of coloured fires and shapes: the illumination was mean, and lighted so slowly that scarce anybody had patience to wait the finishing; and then what

contributed to the awkwardness of the whole, was the right pavilion catching fire, and being burned down in the middle of the show.

Handel's instrumentation for the Royal Fireworks music is impressive – 9 trumpets, 9 horns, 3 pairs of kettledrums, 24 oboes, 12 bassoons and a double bassoon – and, before he had completed the score, he had further decided upon strings as well, making this sumptuous overture and its five shorter movements among his most resplendent orchestral creations.

Compared with his contemporaries, Bach and Vivaldi, Handel wrote few solo concertos, preferring the concerto grosso in which a group of solo instruments, rather than just one or perhaps two, provides the contrasting element with a full orchestral body of sound.

Handel's first set of concertos (Opus 3) is scored for a variety of different woodwind combinations with strings and, in the last of the set, he introduced an obligato part for a chamber organ. Much of the music had been composed many years earlier for anthems, stage works and as smaller instrumental pieces; but they lose nothing in their concerto context and the finest music in the set is both colourful and beguiling. In 1738 followed Opus 4, six concertos of a kind which were, to a great extent, Handel's own invention. These were written for solo organ with an orchestra of strings and woodwind and were mostly intended for performances in theatres between the acts of his oratorios and odes. Handel played them himself and, from the first, they seem to have made wide appeal, for a second set appeared in 1740 and, in 1761, two years after his death, a third (Opus 7). Charles Burney has left a vivid and touching account of Handel's organ playing at oratorios during the last years of his life when he was blind:

To see him . . . led to the organ . . . and then conducted towards the audience to make his accustomed obeisance, was a sight so truly afflicting and deplorable to persons of sensibility, as greatly diminished their pleasure, in hearing him perform . . . for, after his blindness, he played several of his 'old' organ concertos, which must have been previously impressed on his memory by practice. At last, however, he rather chose to trust to his inventive powers, than those of reminiscence: for, giving the band only the skeleton, or ritornels of each movement, he played all the solo parts extempore, while the other instruments left him, 'ad libitum' . . .

In 1739 Handel set to work on what was to be his finest orchestral collection, his 'Twelve Grand Concertos', composed in a remarkable burst of energy during the autumn, and published in 1740 as the Composer's Opus 6. The 'Grand Concertos' are scored for string orchestra though optional oboe parts, not included in the printed set, exist for four of them. Handel drew upon a wide range of musical idioms in these concerti grossi, achieving a level of inspiration comparable with that of J.S. Bach's six Brandenburg Concertos.

In the eighteenth century a native tradition came into flower with a group of composers all of whom were a generation younger than Handel. The most gifted of them were Arne, Boyce, Avison and Stanley. Boyce and Arne, as we have already seen, were important composers for the voice but they also wrote a significant body of instrumental and orchestral pieces, some of which were by-products of larger vocal and choral works. Boyce's most celebrated

orchestral collections are the *Eight Symphonys*, published in 1760, and *Twelve Overtures* which appeared ten years later. Most of the music in these delightful pieces had originally served as overtures to odes or other theatre works. Boyce is not especially forward-looking in his musical style, but in his symphonies he reveals, with his melodic gift and his rhythmic vitality, an ability to assimilate many of the best features not only of English music but also of that from abroad, and from Italy in particular. Boyce's most notable contribution to chamber music was a set of twelve trio-sonatas, published in 1747. In Burney's words they were

longer and more generally purchased, performed and admired, than any productions of the kind in this kingdom, except those of Corelli. They were not only in constant use, as chamber Music, in private concerts, for which they were originally designed, but in our theatres, as act-tunes, and our gardens, as favourite pieces, during many years.

Arne, like Boyce, plundered his stage-music for the *Eight overtures in 8 parts* which were published in 1751. Further overtures followed in 1767 and, in about 1787, nine years after his death, *Six Favourite concertos* for keyboard were printed. Taken as a whole, the concertos reflect a versatility in Arne's style ranging from a Handelian grandeur to a reflective, even melancholy manner. John Stanley (1712–86), though less prolific in his instrumental compositions than Boyce and Arne, produced concertos of fine quality. According to Burney, Stanley lost his sight at the age of two 'by falling on a marble hearth with a china bason [*sic*] in his hand'. Stanley's first set of six concerti grossi for strings (Opus 2) was published in 1742, and shortly afterwards, reflecting the popularity of Handel's invention, they were arranged as concertos for organ and strings. These works owe something to Handel whereas the six concertos of Stanley's later set, published in 1775, lean by-and-large towards the early classical idiom of the time. Stanley's instrumental compositions include three sets of organ voluntaries which have remained popular to the present day.

The remaining English composer of significance at this time was Charles Avison (1709–70), who was foremost a composer of concertos, of which some fifty or so were published during his lifetime. Avison took as his model the style of his teacher Geminiani who lived in England for many years. Among his concertos are twelve arrangements of harpsichord sonatas by his great contemporary, Domenico Scarlatti. Avison's gifts lay in other directions, too, for not only did he write *An Essay on Musical Expression*, thought by Burney to be the first of its kind on musical criticism in England, but also played an active part in the promotion of public concerts.

Among the foreign musicians resident in England during the eighteenth century Johann Christian Bach and Geminiani made the most significant contributions to the orchestral and instrumental repertoire. Francesco Geminiani (1687–1762) was a great teacher, theorist and violin virtuoso. He came to London in 1714 and, apart from three extended visits to Ireland, remained in England until a final visit to Dublin in 1761 where he died in the following year. Geminiani was not a prolific composer but both his sonatas and concertos, modelled to a great extent on those of his own teacher,

Corelli, reveal meticulous craftsmanship and frequently require advanced technique in performance. Like Corelli and Handel he favoured the concerto grosso rather than the solo concerto. Almost two generations younger than Geminiani, J.C. Bach wrote in the elegant and charming 'galant' style of the mid-eighteenth century. He was a notably fine melodist who composed in almost all the instrumental forms of the time. Among his greatest achievements was a set of six symphonies, Opus 18, published about 1781, several fine keyboard concertos, six quintets, Opus 11, for flute, oboe, violin, viola and continuo, and *Six Favourite Overtures*, short symphonies in fact.

Concert life

Public concerts began in London during the last three decades of the seventeenth century and by the beginning of the eighteenth were a firmly if selectively established feature of musical life. The first three-quarters of the century witnessed a remarkable vogue for the Grand Tour and British visitors returned from countries such as Italy and France well acquainted with continental developments in the arts and sciences fired with enthusiasm for the foreign 'Academies' where learned gatherings took place and where music was frequently performed, wealthy English patrons of the arts set up an Academy of their own in 1726, at the 'Crown and Anchor' in the Strand, in London. Its aims were 'the study and practice of vocal and instrumental harmony'. It met fortnightly until 1731, during which period a substantial library was assembled and leading instrumentalists and singers were engaged. By 1729 its members included Greene, Pepusch, Samuel Wesley, Giovanni Bononcini, Croft, Geminiani, Festing and the artist, Hogarth; but an accusation of plagiarism, levelled at Bononcini in 1731, caused such a scandal that he and his supporters were forced to resign their membership.

The 'Academy of Ancient Music', as it now became known, flourished under the directorship of Pepusch until his death in 1752 and continued to meet at the 'Crown and Anchor' up to 1784 when it moved to the Freemason's Hall. The 'Crown and Anchor' was only one such London tavern where musical performances took place and the 'Swan Tavern' in Exchange Alley, Cornhill, the 'Angel and Crown' at Whitechapel, the 'Devil Tavern' in Temple Bar, and the 'Castle Tavern' in Paternoster Row are just some others where musical activities flourished at various times during the century. Coffee-houses, too, sometimes played host to musicians, both in London and in other cities, in much the same way as in Leipzig, where J.S. Bach held his student concerts with the 'Collegium Musicum'. Theatres, as we have already seen, gave frequent concerts, sometimes interspersed with the acts of a play.

This was also a period when, increasingly, music enthusiasts both bourgeois and aristocratic held concerts in their own houses. One such was William Caslon, type-founder and amateur musician. First, he held concerts in his house off Old Street in London. Then, after moving to Chiswell Street, he installed an organ in his music room and began a series of monthly concerts which, according to the music-historian, Sir John Hawkins:

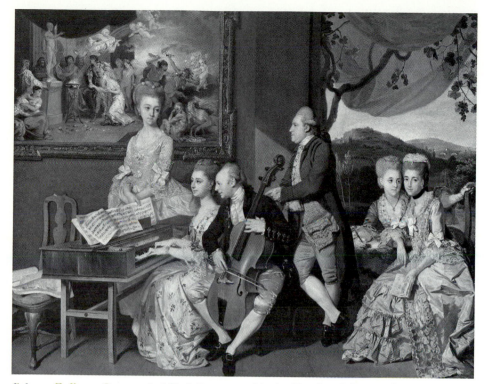

Johann Zoffany, George, 3rd Earl Cowper, with the Family of Charles Gore *(c. 1775)*.

for the convenience of his friends, and that they might walk home in safety when the performance was over, were on that Thursday in the month which was nearest the full moon, from which circumstance his guests were wont humorously to call themselves Lunatics The performance consisted mostly of Corelli's music, intermixed with the overtures of the old English and Italian operas . . . and the more modern ones of Mr. Handel. In the intervals of the performance the guests refreshed themselves at a sideboard, which was amply furnished; and, when it was over, sitting down to a bottle of wine, and a decanter of excellent ale, of Mr. Caslon's own brewing, they concluded the evening's entertainment with a song or two of Purcell's sung to the harpsichord, or a few catches, and about twelve retired.

The principal concert venue for London audiences during the first half of the century was Hickford's Room in James Street, off the Haymarket. Concerts had been given there since the last years of the previous century, but in 1714 the premises were redesigned and then attracted many of the most celebrated English and Continental musicians including Veracini, Geminiani and Hasse. Regular subscription concerts began around 1729 and in the following year Geminiani announced the first of an annual series of twenty concerts which almost spanned the decade. In 1739 Hickford's Room transferred to Brewer Street in Soho, where public concerts took place over the next forty years or so.

In 1751 the Italian violinist and composer, Felice de Giardini, who had arrived in England the previous year, began a series of subscription concerts

in partnership with the oboist, Thomas Vincent; these were held in a music room at 21 Dean Street. The most ambitious subscription concerts during the third quarter of the century were those organised jointly by J.C. Bach and Abel. Both men were highly successful in London musical life and both were painted by Thomas Gainsborough. Their first concerts, in 1765, were held at Carlisle House in Soho Square; here, the notorious Mrs Cornelys, one-time singer and mistress to Casanova – who remarked of her musical success that 'her good fortune had not depended entirely on her talent' – had started a Wednesday evening concert series in the previous year. Bach and Abel put on ten concerts in 1765 and increased the number to fifteen in the following year, alternately directing each one. The season lasted from January to May. In 1767 the author of *Tristram Shandy*, Laurence Sterne, by now himself a celebrity and an able amateur musician, attended one of their musical evenings. Writing a few days after the concert he remarked that 'the concert at Soho top full – & was (This is for the Ladies) the best assembly, and the best Concert I ever had the honour to be at'. Well before they made their final move in 1775 to the newly built Hanover Square Rooms the Bach–Abel concerts had become both celebrated and fashionable, including in the repertoire not only music by the two directors themselves but also that of many of the leading European composers of the day.

Outside London, public concert life was also active. Pepusch and Handel were among those who had given subscription concerts in Oxford in 1713 and 1733, respectively and in 1748 the newly built Music Room in Holywell

Thomas Gainsborough, Study of a Music Party *(1760s)*.

was ready for use. Other towns and cities which promoted musical entertainment included Worcester, Hereford and Gloucester, where the 'Three Choirs Festival' was held in turn from about 1715, Bath, Bristol, Birmingham and Manchester. In Newcastle upon Tyne Charles Avison organised subscription concerts from 1736; they were held at the 'Assembly Rooms in the Great Market and at Mr. Parker's Long Room in the Bigg Market' and continued to thrive until Avison's death in 1770. In Edinburgh weekly concerts were held in St Mary's Chapel in the Niddry Wynd from 1728, where in 1762 a concert room was built, St Cecilia's Hall. Aberdeen, too, had its subscription concerts, but the most celebrated music room outside London, owing to its association with Handel, probably was Neal's Music Hall in Fishamble Street, Dublin. It was built in 1741 and in the following year witnessed the first performance of *Messiah*. Arne, too, was associated with Neal's Music Hall and organised a series of concerts there in 1743.

As public concerts grew increasingly popular so too were music societies cultivated. In 1741 a 'Madrigal Society' was founded by a lawyer, John Immyns. The members, in Hawkins's words, 'were mostly mechanics; some, weavers from Spitalfields, others of various trades and occupations . . . their performance consisted of Italian and English madrigals in three, four and five parts;' Immyns, according to Hawkins, was an enthusiast for music of bygone days looking 'upon Mr. Handel and Bononcini as the great corrupters of the science'. A somewhat similar society, 'The Noblemen and Gentlemen's Catch Club', was founded in 1761. It consisted of professional and amateur musicians among whom were celebrities like J.C. Bach, Arne and Abel. Catches, which were rounds for three or four voices, became enormously popular at this time, as did glees or simple part-songs for male voices. Amongst many other societies were the 'Anacreontic Society' founded in 1766, whose members were wealthy amateurs, and the 'Concert of Ancient Music' founded in 1776. One of the chief aims of the 'Concert of Ancient Music' was the performance of music by earlier composers, governed by the rule that no work less than twenty years old should be played at its concerts. Handel's music was its chief source of supply and George III its most illustrious regular subscriber.

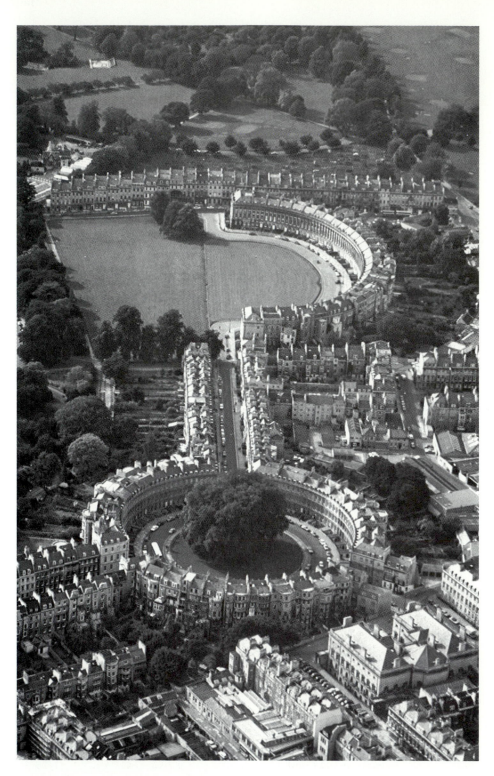

Royal Crescent and the Circus, Bath. John Wood, the Elder and Younger.

10 Augustan Bath

BRYAN LITTLE

Bath, with its medicinal waters and mild climate, with its river and beautiful hilly situation, and with its handsome terraces and parades and assembly rooms, was the most fashionable and architecturally the most ambitious of all Georgian spas in the eighteenth century. Tunbridge Wells, where Beau Nash presided as Master of Ceremonies during the summer, was an important rival. The Bristol Hotwells in the spectacular scenery of the Avon gorge was another summer spa, from which milliners, stationers and other shopkeepers migrated to Bath in the autumn. Cheltenham was a rising spa, with its popularity much increased by George III's visit in 1788, though its chief expansion came after the Napoleonic War. However, it was at Bath that the developers aimed to create 'Mayfair' conditions in a West Country setting. Here, Beau Nash became Master of Ceremonies in 1705 and distinguished himself, in the two sets of Assembly Rooms which in his time stood near the middle of the city, in the decorous regulation of social gatherings. He was also prominent, before the restrictions brought in by a Gaming Act of 1745, in the organisation of gambling. As the records in the Bath and Bristol papers reveal, almost everyone who mattered in Georgian England sooner or later, for medical or social reasons, came to Bath.

The social situation in such a spa gave ample work for tailors, milliners and dressmakers. Many of these, like personal servants or chairmen, lived in squalid and congested conditions in the lower part of the city. Cabinet makers, making furniture of standard types and modelling their work on pattern books and directories, were also numerous. However, coal-fired artefacts, such as glass and porcelain, came from Bristol and also, in the case of porcelain, from other centres of production.

Bristol ranked as the port of Bath, with secondary building materials and some consumer goods sent up the navigable Avon. In the absence of railways or of canal links with the Thames, many luxury goods came from London in the cumbersome 'fly' waggons which could take five days for the journey.

Despite its main Georgian expansion in the eighteenth century, Bath was not wholly a Georgian town. It had seen a long history as a Roman spa whose remains were, in the eighteenth century, starting to come to light, as a Saxon monastic centre, as a medieval cathedral city, and as a scene of the

cloth trade. Its most important building, dominating the centre, was the late
Gothic Abbey, started in 1499 to replace a late Norman cathedral.

Bath's eighteenth-century additions, so large as to transform the city and
make it untypical of towns like York, Worcester or even the much larger
neighbouring Bristol, were gradually cast round a basically medieval core. By
the time of the first census of 1801 the population had risen, at least tenfold,
to 32,000. Augustan Bath, nationally popular and akin to the smart areas of
London, became an architectural and cultural synthesis of the age whose
buildings ranged from English baroque to the Adamesque display of neo-
classicism.

Bath's architectural expansion started soon after 1700. Queen Anne's visits
in 1702 and 1703 increased the spa's popularity. But new building work was
still modest. Transport problems, not solved for over twenty years,
unfortunately impeded the layout and building of a baroque Bath. But some
interesting building, which blended triangular gables and baroque features,
did occur. So in Green Street and Broad Street gables go with windows
whose edges bulge out in a curvature known as bolection (moulded windows)
and with broken pediments above some windows. Shell-hooded doorways,
from soon after 1700, occur in Green Street, and in Trim Street where the
house once occupied by General Wolfe has a basically pre-Palladian façade.
Similar features could be found in the charming little Cold Bath, south of the
river, which was pulled down some years ago.

Weymouth House, and another near it in James Street South, had fine
vernacular baroque façades, with fluted pilasters, richly wrought console
brackets supporting horizontal door hoods, and windows subdivided by thick
glazing bars. The designer of these houses, as also of the Blue Coat School
built in 1711, was William Killigrew. Some houses in Abbey Churchyard,
across from the Pump Room, including the one associated with Field
Marshal Wade, have such features as giant pilasters or the use, on the main
façade, of all three main orders of classical architecture. Thomas Greenway
was another mason-cum-architect who now did significant work, notably in a
group of houses near the site of the West Gate, and in the attractive
Widcombe Manor whose giant Ionic pilasters and other features recall Wren
in his phase of French Renaissance inspiration.

Another architect who worked in Bath in the 1720s and 1730s, and who
overlapped with the elder John Wood (*c.* 1705–54) and was his rival, was
John Strahan who died in the 1740s. He laid out and designed the small
enclosure of Beaufort Square, Avon and Milk Streets running down towards
the river, and the irregular enclosure of Kingsmead Square where the
southern range has a few baroque fireplaces and an array of pre-Palladian
doorways and window edgings. More dramatic, in the same square, is
Rosewell House, dated 1735, with some window edgings which strongly recall
baroque decoration in South Germany and Austria. It was not surprising that
the elder Wood, the committed Palladian who now came into his own as the
chief architect in Bath under George II, mentions these playful embellish-
ments as 'ornaments without taste'.

John Wood made plans for the really ambitious extension, in three
directions, of the city of his birth and upbringing. His areas of growth were
spectacular, and were to extend Bath's urban expanse over tracts of ground

The Palladian Bridge, Prior Park. John Wood the Elder.

north, west and east of the ancient city, so far empty of buildings. Only when he knew that the navigation of the Avon, allowed by an Act of 1712, was actually to be made possible could he be sure of ample waterborne supplies from Bristol of such materials as soft-wood timber, slates, bar iron for railings, paving stones, and window glass. This was about 1725 and it was then that Wood, already familiar with Palladian squares in London, made plans for the Palladian, and hence Roman classical, expansion of Bath.

Wood's main Palladian activities were in the Parades, in Queen Square and the comparatively simple Gay Street, and in the notion, but not the completion, of the Circus. His ideas for development across the river were never carried out. In a simple Palladian idiom he also rebuilt the courtyard of St John's Hospital and a house for the Duke of Chandos. His most impressive private house, on the hillside overlooking Bath, was Ralph Allen's mansion of Prior Park, with its great Corinthian portico, a Venetian window at each end, and Ionic columns to support a pediment at the back. Down in the city the Mineral Water Hospital, started in 1738, was a somewhat severe, mansion-like block by Wood, with an Ionic giant order below its pediment.

The Parades are somewhat plainly Palladian, but were to have had dignified Corinthian embellishments. More accomplished is Queen Square, the 'forum' in a sequence which was also planned, like Wood's other urban groupings, to include a circus. Its pedimented northern side, with decorative urns more baroque than Roman, is a splendid Corinthian composition, successfully unifying a row of separate houses into a palace-like group. As the site of the square slopes the four sides fail to match each other. The level southern side is plain, but includes the charming diversion of two baroque doorways. The western side was not a continuous row, but had three good Palladian villas. At one corner of the square St Mary's Chapel had a cupola and a Roman Doric portico.

Queen Square, north side. John Wood the Elder.

At the top of Gay Street the Circus was planned before the elder Wood's death in 1754, and was finished by his son. Its main feature is the use, one above the other, of the Roman Doric, Ionic and Corinthian orders. Other domestic work by the elder Wood, in adjacent streets in Walcot New Town, was restrained in character, more so than the basically similar, but more lavishly pedimented town houses by Thomas Warr Attwood and other local builder-designers.

The younger John Wood, who lived until 1782, must have had a Palladian training from his father, but worked in a somewhat severe neo-classicism of the type which was akin to the simple classical idiom of such architects as Robert Adam (1728–92) and Henry Holland (1746–1806) and, in the decorative arts, to the Greco-Roman artefacts revealed by the excavations at Pompeii. This is very apparent in the Royal Crescent of 1767–75, dignified in its great sweep and its Ionic three-quarter columns, but bald and unexciting in its plain rectangular ground-floor doorways. The same severity appeared, though modified, in the outside detail and the interiors of his Upper Assembly Rooms which were quickly built in 1769–71. An elegant contemporary building by Robert Adam, opened in 1774, was the Pulteney Bridge, with a row of buildings on each side of the roadway to Bathwick where the residential estate was started fourteen years later but unfinished.

Interior decoration in Palladian houses did not necessarily correspond to their architectural style. The plasterwork, as one sees in the splendid panels in a house in Queen Square, and in some other houses, is in an ornate baroque taste. In two houses in the Circus and the Royal Crescent stucco ceilings, perhaps by plasterworkers from Bristol, are in the rococo style common in that city.

Sculpture, apart from Beau Nash's statue, which was probably by

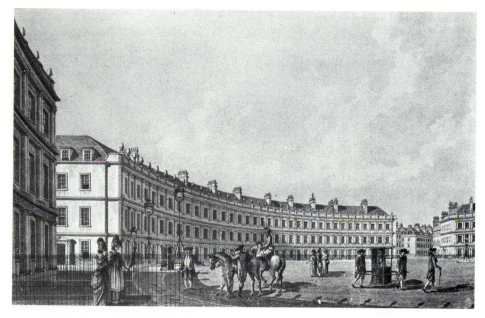

Aquatint by Thomas Malton the Younger, of the Circus, north segment. John Wood, the Elder and Younger.

Pulteney Bridge (1774). Robert Adam.

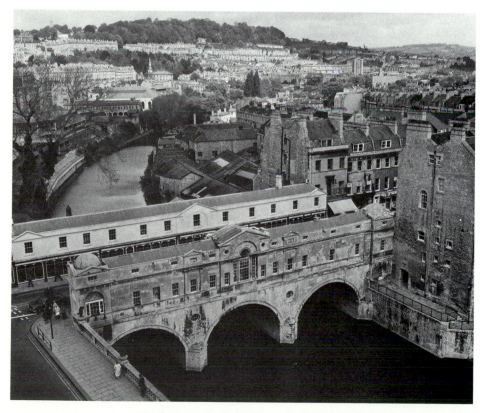

Monument by Jacob Bosanquet in Bath Abbey, by William Collins.

Giuseppe Plura, a sculptor from Turin who came to Bath in the 1740s and worked in a rococo idiom, lay largely in church monuments. These were notably in the Abbey, where several, of modest size but considerable quality, are in versions of baroque. Some others are by Plura, and Thomas King, in his neo-classical or early Grecian idioms, built up a large business, with many of his monuments in churches far from Bath. A few mural monuments are in the rococo manner, the best, by William Collins, being that in the Abbey to Jacob Bosanquet, of Huguenot origin and an important magnate in the East India Company. Other late Georgian monuments are in the rebuilt church of Walcot whose parish included much of fashionable Bath.

Neo-classicism predominated in Bath's architecture until the last decade of the eighteenth century, its main exponent being the talented Thomas Baldwin who became City Architect. His best works include the new Guildhall started in 1776, whose exterior includes a finely balanced, pedimented central composition of Ionic half-columns. Its banqueting hall is a superb, opulent room with a coved ceiling and a rich array of decorative motifs. Baldwin designed the rich Corinthian frontage, with its curved central feature, of Somersetshire buildings in Milsom Street. His later work included the laying out of the colonnaded Bath Street, with its unduly slender columns, which connects the Pump Room with his elegantly designed Cross Bath; the rebuilding of the Pump Room with an imposing Corinthian order; and, across the Pulteney Bridge, the octagonal Laura Place and the wide, partly pilastered Pulteney Street, the main thoroughfare of the Pulteney estate whose full development was frustrated by the Napoleonic War.

Banqueting Hall, The Guildhall (begun 1776). Thomas Baldwin.

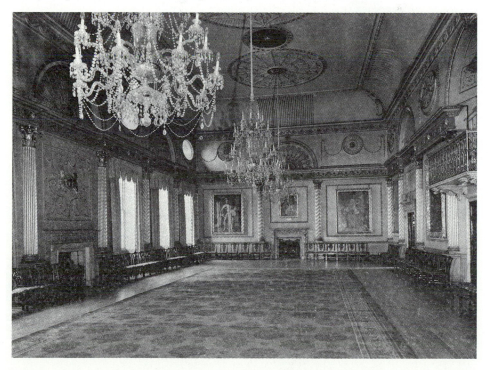

Among other formal compositions is the simple, secluded rectangle of Catherine Place, which was started about 1782. A little later John Palmer made plans for the charming rectangular 'Forum' of St James's Square, whose north and south terraces answer each other better than the elder Wood's equivalent terraces in Queen Square, with Corinthian pilasters and pediments in the middle, and delightful bow-fronted pavilions. Lansdown Crescent, also by Palmer, repeats some of the motifs of St James's Square. These included the use, in the middle of the crescent, of a pedimented centrepiece, not Corinthian but Ionic, of bow-fronted end pavilions as on the north and south sides of St James's Square, and of simple, unpedimented entrance doorways. It is in some ways a more satisfactory composition than the Royal Crescent lower down. The uncompleted hillside Camden Crescent, by Eveleigh, is a throwback to the Palladianism of Queen Square, whereas the same architect's Somerset Place had good Adamesque detail in a segmental and broken pediment more in the restrained baroque idiom of 'William and Mary'.

Eighteenth-century nonconformist chapels were of no note, and the Catholic chapel (now the People's Mission) built after the Gordon riot in 1780, has a plain interior, behind a neo-classical frontage, somewhat oddly set slantwise to the building's alignment.

Anglican worship occurred in a variety of buildings. The Abbey got much Georgian refurnishing, which included a fine marble altarpiece by Samuel

Somersetshire Buildings, Milsom Street. Thomas Baldwin.

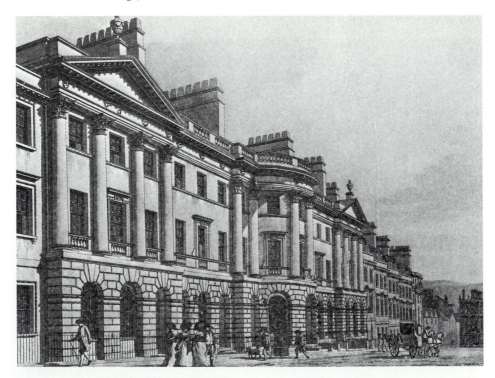

Lansdown Crescent. John Palmer.

Tufnell of Westminster, and figured the Adoration of the Magi. Two ancient churches were rebuilt. St Michael's, of 1734, ingeniously fitted into a triangular site, was by a local builder-designer named John Harvey and was a curious blend of late baroque curvature and spindly Palladianism; while the new St James's combined the classicism of the 1760s with Gothic detail also found in Bristol. Walcot church was rebuilt, above an older crypt, between 1777 and 1790. Its boxlike exterior has plain Ionic pilasters, there are fine Ionic columns inside, and its slender spire does deference to Wren.

Bath also had several of the 'proprietary' chapels which were allowed, and common, in Georgian resorts. These were privately owned chapels built for the holding of Church of England services, but belonging to the subscribers who also appointed the clergy. A few were classical, one was oval, and the Margaret Chapel off Brock Street combined Palladian and Gothic. The Countess of Huntingdon's chapel of 1765, first reckoned as a Church of England building, was Gothic, with ogee-headed windows of a more fanciful type to light the minister's house on the London road. Bathwick Villa, across the river, was a building with similar motifs. Below Lansdown Crescent, Palmer's Lansdown or All Saints' Chapel was octagonal and agreeably Gothic. Another important chapel was the Octagon Chapel off Milsom Street, in an Adamesque style by Thomas Lightoler, with a gallery, circular roof windows, and top lighting from a small dome. It was opened in 1767,

and a fine organ was soon installed. The music in this chapel was of high quality, and William Herschel combined his duties as the chapel's organist with the Directorship of music at the Assembly Rooms.

Bath, like other spa towns visited by people from fashionable London, was a place where there was a strong demand for a flourishing theatre. Sarah Siddons and other famous players of the Georgian period acted there. There were, however, problems connected with the actual buildings. Continued Puritanical objections to the theatre caused the closure of the first building, whose site became that of the Mineral Water Hospital. A somewhat makeshift playhouse was later fitted out in the basement of one of Bath's suites of Assembly Rooms. A more permanent building, unimpressive outside but eventually with a dignified, well-equipped auditorium, was built about 1749 and lasted for over fifty years. This was the theatre which was, for some years, managed jointly with the Theatre Royal in Bristol, the cream of whose patrons came from fashionable visitors to the Hotwells. Performances were on alternate evenings, with specially fast coaches built to provide a shuttle service for players and costumes.

Many important eighteenth-century writers spent time in Bath. Alexander Pope was often there, as a guest of Ralph Allen, at Prior Park. Henry Fielding was at first at Twerton, now inside the city but then a village down river. He later moved to Widcombe, conveniently close to Prior Park, and his patron Ralph Allen who became Squire Allworthy in his novel *Tom Jones*. Another novelist who knew Bath well was Tobias Smollett, in whose *Humphry Clinker* the main characters are made to migrate, as many others did in the autumn, from the Bristol Hotwells to Bath. Smollett makes his crusty character Matthew Bramble utter a shrewd sentence of architectural criticism. He noticed the staring whiteness (soon to be mellowed) of lately completed terraces and crescents, and made a neat reference to the Circus as 'Vespasian's amphitheatre [the Coliseum] turned inside out'. Daniel Defoe makes it clear, in his *Tour through England and Wales*, that he had visited Bath where he found the bathing 'more a sport and a diversion than a physical prescription for health', with 'all sorts of gallantry and levity' preoccupying the city. Though the Bath scenes in *Moll Flanders* are supposed to occur in Charles II's time the city Moll knew 'where men find a mistress sometimes but very rarely look for a wife' was of Defoe or of Beau Nash.

Fanny Burney, who for some years was Lady in Waiting to Queen Charlotte, was, like anyone in her social position, often in Bath. Like Sir Walter Elliot in *Persuasion*, she conveniently found that in Bath one could keep up appearances at less cost than in the fashionable circles of London. The spa which features in her youthful novel *Evelina* is, however, the Bristol Hotwells. But her husband, the French émigré General D'Arblay, died in Bath and they are both buried in Walcot church.

Oliver Goldsmith, Edward Gibbon and Dr Johnson all visited Bath, but their links with the city were not permanent or specially important. More dramatic, in two senses of the word, were Bath's associations with Sheridan. It was from Bath, in 1772, that he eloped with and married the beautiful singer Elizabeth Linley, a member of one of Bath's leading musical families.

His *The Rivals*, of 1775, was not written in Bath but is memorably set there. The scene is down near the Parades, rather than uphill in what was

then the smarter district of the Circus and the Royal Crescent.

If the Augustan age may be said to end when Dr Johnson died in 1784, Jane Austen, who was then a girl of nine, can be said to lie outside it. But her links with Bath, the scene of important chapters in *Northanger Abbey* and *Persuasion*, are indelibly part of Georgian Bath's story, both from the time of her early visits and from the last four years of her father's life from 1801 to 1805. Jane Austen did not like Bath; like Lady Nelson she found its summer climate close and oppressive, and was ill at ease with the social pretensions and artificialities of a spa which, when she knew it, was less fashionable than it had been. She was glad to escape to the better air and scenery of Clifton.

Georgian Bath, with aristocratic visitors who had ample leisure and much money, was an obvious rendezvous for portrait painters. Of these the most important were William Hoare, his brother Prince Hoare who was better known as a sculptor, Thomas Gainsborough, and Thomas Barker. Romney also visited Bath, but the city was not important as a scene of his work.

William Hoare, like Gainsborough, was born in Suffolk. He started his training in England, but continued it in Rome. After returning to England he moved to Bath about 1738, being attracted by the prospect of good business as a portrait painter in the spa city. He worked both in pastels and oils, and soon had lasting success. For a time he worked in London, but soon returned to assured popularity and reliable commissions in Bath. His career in Bath continued after that of Gainsborough, and he lived there until his death in 1792.

Thomas Gainsborough (1727–88) started as an artist in Ipswich, but was eventually lured to Bath by the prospect of many commissions when the spa was at the height of its fame. He was a talented landscape painter as well as an excellent portraitist, and some of his landscapes, including at least one which features Somerset coalminers, show scenery round Bath which Gainsborough must have found more hilly and varied than that of Suffolk. He lived and worked prolifically, for over twenty years, at various addresses, ending in a house in the lately completed, fashionable, and expensive Circus. Gainsborough left for London in 1774, but his Bath period was among the most important phases of his career.

More completely Bathonian, born there in 1769 and living in the city for most of his life, was Thomas Barker, known as Barker of Bath, a prolific landscape artist who lived until the reign of Queen Victoria. His early work was Georgian, and he built a gallery, with Greek Doric details, onto his house, known as Doric House, on a steep Lansdown slope.

Music came as an accompaniment to literary and artistic work. Thomas Chilcott, long the organist at the Abbey, was also of some note as a composer. Public recitals, with emphasis on work by Italian composers, but also including compositions by Handel, who visited Bath more than once, and by Haydn, were given in the Assembly Rooms, at first in those near the city centre, but eventually in the Upper Rooms. The Theatre Royal in Orchard Street was also used for concerts, some of them of great length. A programme of 1748 gives an idea of what could feature at a 'Musical Entertainment'. The date was 4 November, and the concert, starting at 6.30 p.m., was in Wiltshire's Rooms, where the first Bath performance of *Messiah* was given a few years later. Miss Gambarini, presumably of Italian

origin, presented the programme. She was billed to sing several Italian songs, and two English numbers from Handel's *Judas Maccabaeus*. She was to play, on the harpsichord, 'several new pieces by the best [unspecified] masters'. Finally she was to sing, from her own music, *Albion's Power by Sea*, in honour of Hawke's victory over the French in October of the previous year.

Another concert bill outlines the programme, in the Orchard Street Theatre, at 6.30 p.m. on 5 March 1780. The director was to be William Herschel. Not only was Herschel a leading figure in the city's musical life, but was also a pioneering astronomer, who discovered the planet Uranus in 1781. He had been a bandsman in Hanover, came to Britain in 1757, and established himself in Bath.

The programme in the theatre was to include Handel's *Alexander's Feast* and the *Coronation Anthem* with Mrs Weischell from London as soloist. An entr'acte consisted of a violin concerto. The price for boxes was five shillings, with three shillings for the pit and first gallery and two shillings for the upper gallery. On 12 December Mme Mara's concert started with an overture by Bach (probably J.C. Bach), songs by Mme Mara herself, a concerto by a dancing master named Pieltain, and, after the interval, a Haydn symphony and a fortepiano concerto by Koželuh. Twelve days later a *Sacred Oratorio of the Redemption*, compiled by Dr Arnold from the best works by Handel, was put on as a benefit for Rauzzini, now the chief personality in the musical life of Georgian Bath.

Venanzio Rauzzini was born in Rome in 1748. He started a musical career early, and eventually became a principal singer in the opera at Vienna. He was later employed for several seasons by the Elector of Bavaria. In 1770 he was there noticed by Dr Burney who mentioned him 'with approbation' and urged him to come to Britain. In 1774 he was a principal singer in the English opera, with a reputation on the piano and as a composer. Fanny Burney (Dr Burney's daughter) saw him in London in 1775 and remarked that 'every eye brightened at his entrance; he looked like an angel'. He soon came to Bath, becoming prominent as a performer, composer and teacher, with Mme Mara among his pupils. Many eminent performers took part in his concerts, notably in the Upper Rooms. He lived in Gay Street, but it was in his 'country-house' in Perrymead that he entertained Haydn, who visited Bath in 1794. Haydn described him as constitutionally generous and hospitable. He died in 1810 and was buried in Bath Abbey where a monument was put up by his eminent pupil, the singer John Braham, and by Anna Selina (Nancy) Storace, of the Anglo-Italian musical family.

Though the central area of Bath was medieval in origin the expanded city was, until the outbreak in 1793 of the French Revolutionary (later Napoleonic) War, a creation of the eighteenth century; many buildings in the historic centre were rebuilt, or newly built, in this period. As a result central Bath, on each side of the Avon, is now mainly Georgian in character. Its eighteenth-century social and cultural life reflected, in the architecturally ambitious setting of a spa in the West of England, the artistic and cultural activity also seen in fashionable London and in the great country-houses.

Part III
Appendix: Further Reading and Artists' Biographies

Contents

Introduction

This Appendix provides an introduction to the bibliography of the arts covered in this volume. More comprehensive further reading lists and artists' biographies can be found in the hardback edition of this volume which was published as *The Cambridge Guide to the Arts in Britain: The Augustan Age*.

The main sections of the Appendix relate to the individual chapters of the book, and after The Cultural and Social Setting section, are arranged alphabetically. The place of publication, unless otherwise indicated, is London.

1 The Cultural and Social Setting

Anthologies and collections

Aitken, J. (ed.), *English Letters of the Eighteenth Century* (Harmondsworth, 1946)

Allott, K. (ed.), *The Pelican Book of English Prose*, vols. II-III (Harmondsworth, 1956)

George, M.D. (ed.), *England in Johnson's Day* (1928)

Price, M. (ed.), *The Restoration and Eighteenth Century* (Oxford Anthology of English Literature, vol. I, New York and London, 1973)

Trawick, L.M. (ed.), *Backgrounds of Romanticism: English Philosophical Prose of the Eighteenth Century* (Bloomington, 1967)

Vickers, B. (ed.), *English Science, Bacon to Newton* (Cambridge, 1987)

Bibliographies

Alston, R.C. (ed.), *The Eighteenth-Century Short Title Catalogue* (1983 – in progress)
The Eighteenth Century: A Current Bibliography (Philadelphia and Los Angeles, annually since 1978)

Horne, C.J. in B. Ford (ed.), *The New Pelican Guide to English Literature*, vol. IV, *From Dryden to Johnson* (Harmondsworth, 1957; rev. edn 1991)
Oxford History of English Literature, vols. VI-VIII (Oxford, 1959–79)
The Scriblerian and the Kit-Cats (Philadelphia, Boston Mass. and London, biannually since 1968)

Watson, G. (ed.), *The New Cambridge Bibliography of English Literature*, vol. II (Cambridge, 1971)

General and special studies

Appleton, W.W., *A Cycle of Cathay: The Chinese Vogue in England* (New York, 1951)

Battestin, M.C., *The Providence of Wit: Aspects of Form in Augustan Literature and the Arts* (Oxford, 1974)

Bayne-Powell, R., *The English Child in the Eighteenth Century* (1939)

Beaglehole, J.C., *The Exploration of the Pacific* (1934; rev. edn London and Stanford, 1966)

Black, J., *The British and the Grand Tour* (1985)
The English Press in the Eighteenth Century (Philadelphia, 1987)

Burke, E., *A Philosophical Enquiry into the Origin of our Ideas of the Sublime and Beautiful*, ed. J.T. Boulton (1958)

Burke, J., *English Art, 1714–1800* (Oxford History of Art, vol. IX, Oxford, 1976)

Butt, J. and Carnall, G., *The Mid-Eighteenth Century (Oxford History of English Literature*, vol. VIII, Oxford, 1979)

Cassirer, E., *The Philosophy of the Englightenment* (Princeton, 1951)

Clark, G.N., *The Later Stuarts, 1660–1714* (Oxford, 1934; rev. edn 1956)

Clark, K., *The Gothic Revival* (1928; rev. edn 1950)
The Romantic Rebellion: Romantic versus Classic Art (1973)

Cunnington, C.W. and P., *Handbook of English Costume in the Eighteenth Century* (1957; rev. edn 1972)

Dobrée, B., *English Literature in the Early Eighteenth Century 1700–1740* (Oxford History of English Literature, vol. VII, Oxford, 1959)

Goldgar, B.A., *Walpole and the Wits: The Relation of Politics to Literature* (Lincoln, Neb., 1976)

Hampson, N., *The Enlightenment* (Harmondsworth, 1968)

Hans, N., *New Trends in Education in the Eighteenth Century* (1951)

Hazard, P., *European Thought in the Eighteenth Century* (1954; Harmondsworth, 1965)

Hilles, F.W. and Bloom, H. (eds.), *From Sensibility to Romanticism* (New York, 1965)

Hogarth, W., *The Analysis of Beauty*, ed. J. Burke (Oxford, 1955)

Hole, C., *English Home Life 1500–1800* (1947)

Humphreys, A.R., *The Augustan World* (1954)

Hunt, J.D., *The Figure in the Landscape: Poetry, Painting and Gardening during the Eighteenth Century* (Baltimore, 1976)

Hussey, C., *English Gardens and Landscapes 1700–1750* (1967)

Jones, W.P., *The Rhetoric of Science: A Study of Scientific Ideas and Imagery in Eighteenth-Century Poetry* (Berkeley, 1966)

Kenny, S.S. (ed.), *British Theatre and the Other Arts 1660–1800* (Washington, 1984)

Klingender, F.D., *Art and the Industrial Revolution* (1947; rev. edn 1968)

Kuhn, T.S., *The Structure of Scientific Revolutions* (Chicago, 1960; 1962)

Lipking, L., *The Ordering of the Arts in Eighteenth-Century England* (Princeton, 1970)

Marshall, D., *Eighteenth-Century England* (1962)
English People in the Eighteenth Century (1956)

Paulson, R., *Emblem and Expression: Meaning in English Art of the Eighteenth Century* (Cambridge, Mass. and London, 1975)

Plumb, J.H., *England in the Eighteenth Century* (Harmondsworth, 1950; rev. edn, 1963)

Porter, R., *English Society in the Eighteenth Century* (Harmondsworth, 1982)

Rogers, K.M., *Feminism in Eighteenth-Century England* (Hassocks, 1982)

Rogers, P., *Grub Street* (1972)

Summerson, J.N., *Georgian London* (1945)

Tinker, C.B., *Painter and Poet: Studies in the Literary Relations of English Painting* (Cambridge, Mass., 1938)

Trevelyan, G.M., *England under Queen Anne* (3 vols., 1930–4)

Illustrated English Social History, vols.
II–III (1950–5; Harmondsworth, 1964)
Willey, B., *The Eighteenth-Century
Background* (1940; New York, 1961)

2 Applied and Decorative Arts

Baillie, G.H., Clutton, C. and Ilbert, C.A.,
*Britten's Old Clocks and Watches and
their Makers* (1980)
Baker, J., *English Stained Glass* (1969)
Beard, G. and Gilbert, C. (eds.), *A
Dictionary of English Furniture Makers
1660–1840* (Leeds, 1986)
Charleston, R.J., *English Glass, the Glass
used in England c. 400–1940* (1984)
English Porcelain 1745–1850 (1965)
Cornforth, J. and Fowler, J., *English
Decoration in the 18th Century* (1978,
repr. 1986)
Cotterell, H.H., *Old Pewter, its Makers and
Marks in England, Scotland and Ireland*
Cunnington, C.W., Cunnington, P. and
Beard, C., *A Dictionary of English
Costume* (1976)
Cushion, J. and Honey, W.B., *Handbook of
Pottery and Porcelain Marks* (4th edn,
1980)
Denvir, B. (ed.), *The Eighteenth Century:
Art, Design and Society 1683–1789*
(1983)
Edwards, R., *The Dictionary of English
Furniture . . .* (2nd edn, 3 vols., 1954;
repr. in reduced form 1985; also issued
in a shorter form in one vol., 1979)
Garner, F.H. and Archer, M. *English
Delftware* (1972)
Glanville, P., *Silver in England* (1987)
Godden, G., *Encyclopedia of British Pottery
and Porcelain Marks* (1979)
*An Illustrated Encyclopedia of British
Pottery and Porcelain* (1980)
*Encyclopedia of British Porcelain
Manufacturers* (1988)
Grimwade, A., *London Goldsmiths
1697–1837, their Marks and Lives*
(1976, rev. edn, 1982)
Hammelmann, H.A., *Book Illustrators in
Eighteenth-Century England* (New
Haven, 1975)
Honour, H. and Fleming, J. (eds.), *The
Penguin Dictionary of Decorative Arts*
(2nd edn, rev. 1989)
Newman, H., *An Illustrated Dictionary of
Jewellery* (1982)
Oman, C., *Wallpapers and Wallpaper
Designs in the Victoria and Albert
Museum* (2nd edn, rev. J. Hamilton,
1982)
Osborne, H. (ed.), *The Oxford Companion
to the Decorative Arts* (Oxford, 1975)

Ribeiro, A., *A Visual History of Costume –
the Eighteenth Century* (1988)
Tattersall, C. and Reed, S., *A History of
British Carpets* (1966)
Thomson, W.G., *A History of Tapestry*
(new edn, 1973)
Towner, D., *English Cream-Coloured
Earthenware* (1957)
Creamware (1978)
Williams Wood, C., *English
Transfer-Printed Pottery and Porcelain*
(1981)

Craftsmen

Baskerville, John (1706–75)
Printer at Birmingham, also a japanner.
Began to occupy himself with typefounding,
1750, and after several years of
experimenting produced the elegant
typeface bearing his name. Elected printer
to Cambridge University, 1758

Bennett, J., *John Baskerville* (Birmingham,
1937–9)

Chippendale, Thomas (1718–79)
Born Otley, Yorkshire, Chippendale trained
at York but had settled in London by 1748.
Issued his important pattern-book, *The
Gentleman and Cabinet-Maker's Director* in
1754 (2nd and 3rd edns, 1762–3).
Chippendale established himself as the
leading supplier of rococo furniture and
then adroitly changed his style in the
mid-1760s to incorporate neo-classical
ideas.

Edwards, R. (ed.), *The Gentleman and
Cabinet-Maker's Director* [facsimile edn
(reduced) of the 3rd edn, 1763 (1957)]
Gilbert, C., *The Life and Work of Thomas
Chippendale* (2 vols., 1978; reissued as
one vol., 1983)

Wedgwood, Josiah (1730–95)
Potter, working in Staffordshire from 1739.
Appointed Queen's Potter in 1762. Opened
new works at Etruria, Staffordshire in 1769;
produced his fine jasper wares there, 1773–80.

Meteyard, E., *The Life of Josiah Wedgwood
from the private correspondence and
family papers* (2 vols., 1865; still the
classic biographical study)
Reilly, R., *Wedgwood* (2 vols., 1989)
Reilly, R. and Savage, G., *The Dictionary of
Wedgwood* (Woodbridge, 1986)

3 Architecture

Addleshaw, G. and Etchells, F., *The
Architectural Setting of Anglican
Worship* (1948)

320 *Appendix: Architecture*

Colvin, H., *A Biographical Dictionary of British Architects 1600–1840* (2nd edn, 1978)
Colvin, H., Mordaunt Crook, J., Downes, K. and Newman, J., *The History of the King's Works*, vol. V, 1660–1782 (1977)
Fleming, J., Honour, H. and Pevsner, N., *The Penguin Dictionary of Architecture* (Harmondsworth, 1966 and later)
Pevsner, N., *et al.*, *The Buildings of England* (Harmondsworth, 1951–74 and later revisions)

General studies

Blunt, A. (ed.), *Baroque and Rococo Architecture and Decoration* (1978)
Downes, K., *English Baroque Architecture* (1966)
Harris, J., *The Palladians* (1981)
Hussey, C., *The Picturesque* (1927)
Mordaunt Crook, J., *The Greek Revival* (1972)
Port, M. (ed.), *The Commissioners for Building Fifty New Churches* (1986)
Summerson, J., *Architecture in Britain 1530–1830* (1953 and later)
Georgian London (1945 and later)
The Architecture of the Eighteenth Century (1986)
Wittkower, R., *Palladio and English Palladianism* (1974 and later)

The Country house

Girouard, M., *Life in the English Country House* (1978)
Hussey, C., *English Country Houses: Early Georgian 1715–1760* (1955)
English Country Houses: Mid-Georgian 1760–1800 (1956)
Lees-Milne, J., *English Country Houses: Baroque 1685–1715* (1970)

Interior decoration

Beard, G., *Craftsmen and Interior Decoration in England 1660–1820* (1981)
Fowler, J. and Cornforth, J., *English Decoration in the 18th Century* (1974 and later)
Rococo: Art and Design in Hogarth's England (1984) [exhibition catalogue]
Thornton, P., *Authentic Decor: The Domestic Interior 1620–1920* (1984)

Architects
Adam, Robert (1728–92)
Born Kirkaldy, son of a distinguished Scottish architect. Edinburgh University. Grand Tour 1754–8 to Italy and Dalmatia. Set up practice in London with brothers

James and William which became one of the most influential in the country, designing houses large and small, and particularly interiors. One of the two Architects of the King's Works 1761–9 (with Chambers).

Adam, R. and J., *The Works in Architecture of Robert and James Adam* (1773–9, repr. with introduction by Oresko, R. (ed.), 1975)
Beard, G., *The Work of Robert Adam* (1978)
Rowan, A., *Robert Adam. Catalogue of Architectural Drawings in the Victoria & Albert Museum* (1988)

Archer, Thomas (*c.* 1668–1743)
Younger son of a Warwickshire gentleman. Oxford 1686–9. Travelled abroad 1691–5. Court office of Groom Porter. Member of the 1711 church-building commission. Designed houses, churches and monuments in the baroque style until *c.* 1730.

Marsden, E., 'Thomas Archer's Creative Autumn', *Country Life* (12 May 1983)
Whiffen, M., *Thomas Archer* (1950)

Boyle, Richard, 3rd Earl of Burlington and 4th Earl of Cork (1694–1753)
Patron of the arts and guiding spirit of the Palladio/Jones revival. Grand tour 1714–15 and Italy again in 1719, to study Palladio's work. Began designing in 1717. A series of important buildings followed. Also influential through his protégés (the most important of whom was William Kent), and the publications he promoted.

Hewlings, R., *Chiswick House and Gardens*, (1989) [guide booklet]
Lord Burlington and his Circle (1982) [Georgian Group symposium papers]
Wilton-Ely, J. (ed.), *Apollo of the Arts: Lord Burlington and his Circle* (1973) [exhibition catalogue]

Campbell, Colen (1676–1729)
Scottish lawyer, qualified Edinburgh 1702. Travelled abroad. Probably associated with James Smith, a leading Scottish architect. In England by 1710, and probably planning his influential publications, *Vitruvius Britannicus*. Chief Clerk and Deputy Surveyor at Office of Works 1718–19, Architect to Prince of Wales from 1719, Surveyor of Greenwich Hospital 1726.

Campbell, C., *Vitruvius Britannicus*, vols. I–III (1715, 1717, 1725), continued by Badeslade & Rocque (1739), and Wolfe & Gandon (1767, 1771)
Stutchbury, H., *The Architecture of Colen Campbell* (1967)

Chambers, Sir William (1723–96)
Born Gothenberg, Sweden, son of Scottish
merchant. Educated in England. Began
career with Swedish East Indian Company
1739, and made journeys to Bengal and
China. Studied architecture in Paris 1749.
Italy 1750–5. Returned to London 1755 and
secured patronage of Prince and Princess of
Wales. From 1761 held important posts in
Office of Works; became head in 1782.

Chambers, W., *A Treatise on Civil
 Architecture* (1759)
Harris, J., *Sir William Chambers, Knight of
 the Polar Star* (1970)

Gibbs, James (1682–1754)
Born Aberdeen and brought up a Roman
Catholic. Travelled to Rome 1703; trained
with Carlo Fontana. Returned to England
1709. Surveyor to the 1711 Act
Commissioners 1713–15; post of Architect
of the Ordnance 1727. Large practice in
country-houses. Best remembered as
architect of St Martin-in-the-Fields.

Gibbs, J., *A Book for Architecture* (1728)

Friedman, T., *James Gibbs* (1984)
Harris, J., 'Who Designed Houghton?',
 Country Life, 3 March 1989

Hawksmoor, Nicholas (*c.* 1661–1736)
Born and probably educated in
Nottinghamshire. Two important
architectural partnerships: as clerk to Sir
Christopher Wren from *c.* 1679, and as
assistant to Vanbrugh from 1700. Senior
posts in Office of Works from 1715.
Surveyor to 1711 Act Commissioners,
designing three great East-End churches.

Downes, K., *Hawksmoor* (1959 and later)
 Hawksmoor (1969) [a different book
 although the title is the same as the
 previous one]
Saumurez Smith, C., *The Building of Castle
 Howard* (1990)

Kent, William (1685–1748)
Architect, painter and draughtsman;
furniture, interior and landscape designer;
book illustrator. Born Bridlington,
Yorkshire. Travelled to Italy 1709,
remained there until 1719. Trained as
painter, acted as dealer. Began career in
London as painter, but turned to
architecture and developed other interests
under protection of Lord Burlington, who
procured official posts for him at Office of
Works. For Kent as a landscapist, see
chapter by Michael Symes.

Wilson, M., *William Kent* (1984)

Wilton-Ely, J., *A Tercentenary Tribute to
 William Kent* (1985) [exhibition
 catalogue]

Stuart, James 'Athenian' (1713–88)
Born London, of Scottish descent.
Travelled to Rome 1742 to study
antiquities. Met Nicholas Revett, with
whom he travelled to Greece 1751–5.
Together they published first accurate
survey of classical buildings in Athens.

Stuart, J. and Revett, N., *Antiquities of
 Athens* (vols. I and II, 1762 and 1789,
 3 posthumous vols, with contributions
 from others 1794, 1814, 1830)
Watkins, D., *Athenian Stuart: Pioneer of the
 Greek Revival* (1982)

Vanbrugh, Sir John (1664–1726)
Of Dutch descent, born London. Soldier
from 1686; successful playwright from
1696. Took up architecture *c.* 1699, with a
commission to design Castle Howard
(Yorkshire). Assisted by Hawksmoor there
and at Blenheim. Many independently
designed country houses followed.
Important figure at Office of Works from
1702, and influential member of the 1711
Act Commission. Precocious appreciation of
historic medieval buildings as a source for
new work and as part of landscape.

Downes, K., *Vanbrugh* (1977)
Saumurez Smith, C., *The Building of Castle
 Howard* (1990)

Wood, John the Elder (*c.* 1705–54)
Architect. Born Bath; educated Blue Coat
School there and later referred to as joiner.
Began career as speculative builder in
London, but saw opportunities in
development of Bath and moved there by
1727. Known as 'John Wood of Bath',
initiated the Georgian redevelopment of
Bath, beginning with houses for the Duke
of Chandos. Subsequently leased land and
designed the layout and façades, notably
Queen Square and the Circus, and North
and South Parades. Also designed the
Palladian mansion of Prior Park.

John Wood the Elder, *An Essay Towards a
 Description of Bath* (1742, rev. 1749)

Wood, John the Younger (1732–82)
Architect. Son of John Wood senior, he
completed the building of the Circus in
Bath. Designed the Royal Crescent and
Brock Street; also the Assembly Rooms and
adjoining streets, and the Hot Bath.

4 Bath

Bath History, vols. I, II and III
(Gloucester, 1986, 1988 and 1990)
Buchanan, C. and Partners, *Bath, A Study
in Conservation* (1968)
Cunliffe, B., *Roman Bath Discovered* (1971)
Ferguson, A., *The Sack of Bath* (Salisbury,
1973)
Haddon, J., *Portrait of Bath* (1982)
Ison, W., *The Georgian Buildings of Bath*
(1948; Bath, 1969)
Little, B., *Bath Portrait* (Bristol, 1980, 4th
edn 1988)
Mowl, T. and Earnshaw, B., *John Wood,
Architect of Obsession* (Bath, 1988)
Robertson, C., *Bath: An Architectural
Guide* (1975)
Smith, R.A.L., *Bath* (1944)
For Wood, father and son, see
3 Architecture

5 Folk-Songs and Ballads

An Introduction to English Folk Song by
Maud Karpeles (1973, revised by Peter
Kennedy, 1987). The best introduction
to the subject, and includes extensive
bibliographies and recordings.

Child, F.J., *The English and Scottish
Popular Ballads* (8 parts, Boston,
1882–92)
Collison, F., *The Traditional and National
Music of Scotland* (1966)
Friedman, A.B., *The Penguin Book of Folk
Ballads* (New York 1956;
Harmondsworth, 1976)
Graves, R., *English and Scottish Ballads*
(1957)
Hodgart, M.J.C., *The Ballads* (1950)
Howes, F., *Folk Music of Britain and
Beyond* (1969)
Karpeles, M., *Cecil Sharp, His Life and
Work* (1967)
Lloyd, A.L., *Folk Song in England* (1967)
Muir, W., *Living with Ballads* (1965)
Palmer, R., *Everyman's Book of British
Ballads* (1980)
Renwick, R. de V., *English Folk Poetry:
Structure and Meaning* (1980)
Sharp, C.J., *Eighty English Folk Songs from
the Southern Appalachians*, ed. M.
Karpeles (1968)
English Folk-Song: Some Conclusions
(1907, rev. edn, M. Karpeles, 1965)

Recordings
A selected list of field recordings is given in
Karpeles, *An Introduction to English Folk*
Song. Recordings by modern folk singers of
very varied 'authenticity' are too numerous
to list here, with the notable exception of
recordings by A.L. Lloyd, Ewan MacColl,
and Peggy Seegar:

Lloyd, A.L., and MacColl, E., *English and
Scots Popular Ballads* (4 vols.,
Folkways)
MacColl, E., *The English and Scots Popular
Ballads* (3 vols., Folkways)
The Jacobite Rebellions (Topic) [songs of
1745 and 1775]
MacColl, E. and Seegar, P., *The Long
Harvest* (10 vols., Argo) [recordings of
some traditional ballads in their
English, Scots and North American
variants]
Blood and Roses (5 vols., Blackthorne)

6 Gardens and Landscape

For Hawksmoor, Kent and Vanbrugh, see
3 Architecture.
Hunt, J.D. and Willis, P. (eds), *The Genius
of the Place: the English Landscape
Garden 1660–1820* (1975)
Hussey, C., *English Landscapes and Gardens
1700–1750* (1967)
The Picturesque (1927)
Jacques, D., *Georgian Gardens: The Reign
of Nature (1983)*
Oxford Companion to Gardens (1986)
Symes, M., *The English Rococo Garden*
(1991)
Walpole, H., *Essay on Modern Gardening*
(1785)
Whateley, T., *Observations on Modern
Gardening* (1770)
Individual Biography and Bibliography

Brown, Lancelot ('Capability')
(1716–83)
Born Kirkharle, Northumberland, of
farming family. Learned about laying out
landscape and estate management under Sir
William Loraine at Kirkharle, then under
Lord Cobham at Stowe. After 1749 set up
as freelance garden designer; extensive
commissions included Blenheim, Bowood,
Chatsworth, Corsham Court, Croome
Court, Harewood, Nuneham Courtenay,
Petworth, Sheffield Park. Royal Gardener
1764.

Hinde, T., *Capability Brown* (1986)
Stroud, D., *Capability Brown* (1975)
Turner, R., *Capability Brown and the
Eighteenth Century English Landscape*
(1985)

7 Holkham Hall

For Burlington and Kent see
3 Architecture.
Hartcup, A., *Below Stairs in the Great
Country Houses* (1980)
James, C.W., *Chief Justice Coke, His Family
and Descendants at Holkham Hall*
(1929)
Parker, R.A.C., *Coke of Norfolk* (Oxford,
1975)
Stacy, J., *A General History of the County
of Norfolk, intended to convey all the
information of a Norfolk Tour*, vol. II
(Norwich, 1829)
Wade-Martins, S., *A Great Estate at Work*
(Cambridge, 1980)

8 Literature and Drama

General works

Butt, J. and Carnall, G., 'The
Mid-Eighteenth Century', *Oxford
History of English Literature*, vol. VIII
(Oxford, 1979)
Clifford, J.L., (ed.), *Eighteenth-Century
English Literature: Modern Essays in
Criticism* (New York, 1959)
Damrosch, L. (ed.), *Eighteenth-Century
English Literature* (New York, 1988)
Dobrée, B., 'English Literature in the Early
Eighteenth Century', *Oxford History of
English Literature*, vol. VII (Oxford,
1959)
Ford, B. (ed.), *The New Pelican Guide to
English Literature*, vol. IV, *From
Dryden to Johnson* (Harmondsworth,
1987)
Fussell, P, *The Rhetorical World of
Augustan Humanism* (Oxford, 1965)
Humphreys, A.R., *The Augustan World*
(1954)

Critical theory

Bate, W.J., *From Classic to Romantic*
(Concord, Mass., 1946)
Hagstrum, J.H., *The Sister Arts* (Chicago,
1958)
Johnson, J.W., *The Formation of English
Neo-Classical Thought* (Princeton,
1967)
Monk, S.H., *The Sublime* (New York, 1935)

Genres

DRAMA

Price, C., *Theatre in the Age of Garrick*
(1973)

THE NOVEL

McKeon, M., *The Origins of the English
Novel 1600–1740* (1987)
Spencer, J., *The Rise of the Woman Novelist*
(1986)
Watt, I., *The Rise of the Novel* (1957)

POETRY

Doody, M., *The Daring Muse: Augustan
Poetry Reconsidered* (Cambridge, 1985)
Sutherland, J., *A Preface to
Eighteenth-Century Poetry* (1948)

MISCELLANEOUS PROSE

Spacks, P.M., *Imagining a Self:
Autobiography and the Novel in
Eighteenth-Century England*
(Cambridge, Mass., 1976)

SATIRE

Jack, I., *Augustan Satire 1660–1750*
(Oxford, 1952)
Rawson, C., *Order from Confusion Sprung*
(1985)

ANTHOLOGIES

Lonsdale, R. (ed.), *The New Oxford Book of
Eighteenth-Century Verse* (1984)
Price, M. (ed.), 'The Restoration and the
Eighteenth Century', *Oxford Anthology
of English Literature*, vol. I (1973)

Authors

Addison, Joseph (1672–1719)
Essayist and politician; educated
Charterhouse and Oxford; 1698 Fellow of
Magdalen College; 1699–1703 travelled on
the Continent; 1705 celebrated
Marlborough's victory at Blenheim in poem
The Campaign; 1708 MP; 1709–11
contributed to *The Tatler*; 1711–12
co-author with Steele of *The Spectator*;
1713 spectacular success of play *Cato*;
1717–18 Secretary of State for the Southern
Department.

Smithers, P., *The Life of Joseph Addison*
(rev. edn, 1968)

Boswell, James (1740–95)
Biographer and diarist; born Edinburgh,
son of judge; educated at Edinburgh and
Glasgow universities; 1763 met Johnson on
a visit to London; 1763–6 travelled through
Germany, Switzerland, Italy and France;
met Voltaire and Rousseau; practised at
Scottish bar from 1766, moving his main
base to London in 1789; 1773 made tour of
the Highlands and Hebrides with Johnson;

1785 *Journal of a Tour to the Hebrides* (delayed until after Johnson's death); 1791 *Life of Johnson*; increasing ill-health and depression in last years. Most of his journals and papers discovered in this century. A member of the Club.

Brady, F., *Boswell: The Later Years* (1984) [a composite biography]
Pottle, F.A., *Boswell: The Earlier Years* (1966)

Burke, Edmund (1729–97)
Political philosopher and statesman; born Dublin; educated Trinity College, Dublin and Middle Temple, London; first major work a treatise on aesthetics, *The Sublime and Beautiful* (1757); 1759 founded *The Annual Register* (editor and contributor until 1788); 1765 private secretary to Marquis of Rockingham and MP; opposed government policy on American war; 1787 took leading part in impeachment of Warren Hastings (trial continued until 1794); spoke and wrote against the French Revolution; 1794 retired from Parliament. A member of the Club.

Copeland, T.W., *Edmund Burke: Six Essays* (1950)

Burney, Fanny (1752–1840)
Novelist and diarist; born King's Lynn, where her father, the musician Charles Burney, was an organist; largely self-educated and a compulsive writer from early childhood; achieved huge success with *Evelina* (1778) and became habituée of the Johnson circle; 1782 followed up with another noval *Cecilia*, also successful; later novels less popular; compiled *Memoir* of her father (1832). Her diary, published in part after her death, describes life at court and her marriage to an émigré refugee, General d'Arblay, in England and on the Continent.

Doody, M.A., *Frances Burney: The Life in the Works* (New Brunswick, N.J., 1989)
Hemlow, J., *The History of Fanny Burney* (1954)

Chatterton, Thomas (1752–70)
Poet, born Bristol; publishing poetry by the age of twelve; based a series of fake-medieval poems on originals he claimed to have found among the archives of St Mary Redcliffe Church, Bristol; wrote in the guise of a fictitious fifteenth-century monk, 'Thomas Rowley'; 1770 moved to London, but soon reduced to poverty and despair, and died (probably by self-administered arsenic poisoning). The Rowley poems first published *in extenso* by Thomas Tyrwhitt, who confirmed doubts as to their authenticity as historical poems. Became an emblem of the neglected genius for the Romantics.

Meyerstein, E.H.W., *A Life of Chatterton* (1930)

Cowper, William (1731–1800)
Poet and letter-writer; born Berkhamsted; educated Westminster and Middle Temple; 1754 called to the bar; career anxieties and emotional upset led to severe depression culminating in attempted suicide in 1763; after period in mental hospital went to live with Unwin family at Huntingdon in 1765; 1767 moved to Olney with Mrs Unwin; collaborated with John Newton, the evangelical curate, on the *Olney Hymns* (1779); satires and short poems (published 1782); *The Task* (published 1785); 1791 published translation of Homer by subscription; increasingly incapacitated by melancholia, especially after death of Mrs Unwin in 1796; died in East Dereham, Norfolk.

King, J., *William Cowper: A Biography* (Durham, NC, 1986)
Newey, V., *Cowper's Poetry* (1982)

Defoe, Daniel (*c.* 1660–1731)
Novelist, miscellaneous writer and journalist; born London; intended for career in ministry but abandoned this; 1685 joined Monmouth rebellion, captured and received royal pardon; successively hose-factor, overseas merchant and brick manufacturer; held minor government posts under William III; 1697 first considerable work, *Essay upon Projects*; 1702 satiric pamphlet *Shortest Way with the Dissenters* led to imprisonment and pillory; rescued by Robert Harley, for whom Defoe worked as a spy, agent and publicity officer; 1704–13 ran *The Review*, a newspaper of comment, single-handedly; several times prosecuted and gaoled; 1719 first part of *Robinson Crusoe* initiated successful career as novelist; 1724 first volume of influential *Tour of Great Britain*; produced a stream of works on trade, economics, history, the occult, family life and much else; died in hiding from creditors.

Backscheider, P., *Daniel Defoe: His Life* (Baltimore, 1989)
Earle, P., *The World of Defoe* (1976)
Sutherland, J., *Daniel Defoe: A Critical Study* (1971)

Fielding, Henry (1707–54)
Novelist and playwright,; born near Glastonbury; educated Eton and Leyden; 1728 first play *Love in Several Masques*

successful; earned initially precarious living in London in the theatre, often in 'underground' companies; 1737 Licensing Act blocked career as dramatist; 1740 called to the Bar; thereafter combined career as barrister and magistrate (JP for Westminster, 1748) with journalism and fiction, including *Shamela* (1741), a parody of Richardson; *Joseph Andrews* (1742), *Tom Jones* (1749) and *Amelia* (1751). His *Miscellanies* (1743) include *Jonathan Wild*. His final trip in fruitless search for health recorded in *Journal of a Voyage to Lisbon* (1755); also wrote important works on social and legal issues.

Battestin, M.C., with R. R. Battestin, *Henry Fielding: A Life* (1990)
Rawson, C.J., *Henry Fielding and the Augustan Ideal under Stress* (1972)

Garrick, David (1717–79)
Actor, manager and dramatist; born Hereford; 1736 studied at Samuel Johnson's school near Lichfield; 1737 went to London with Johnson; 1741 made reputation as Richard III in fringe theatre; 1747 joint patentee of Drury Lane; 1763–5 travelled in France and Italy; 1769 organised the great Shakespeare jubilee at Stratford; 1776 retired from stage and management; member of the Literary Club and enjoyed wide circle of friends.

Stone, G.W. and Kahrl, G.M., *David Garrick: A Critical Biography* (Carbondale, Ill., 1979)

Gay, John (1685–1732)
Dramatist and poet; born Barnstaple; started life as apprentice to London silk-mercer; 1713 first important work, *Rural Sports*; 1714 *The Shepherd's Week*, a mock-pastoral; member of the Scriblerus Club, and collaborated with Pope and Arbuthnot in satirical drama; 1715 *Trivia*, a mock-georgic on London street-life; 1717 first series of *Fables*, immensely popular; 1728 *The Beggar's Opera*, the first and greatest of ballad operas (music arr. by J.C. Pepusch); later plays and poems less successful.

Irving, W.H., *John Gay, Favorite of the Wits* (Durham, NC, 1940)

Gibbon, Edward (1737–94)
Historian; born Putney; educated Westminster and Oxford, but in crucial ways self-educated; after conversion to Catholicism at age of sixteen, dispatched by his father to Lausanne; formed attachment to Suzanne Curchod, later Mme Necker, mother of Mme de Staël, but relinquished

her on father's request; 1758 returned to England; 1759–63 served as captain in militia; 1764–5 spent in Italy, conceived *Decline and Fall*; 1772 settled in London; 1774 became MP; 1776 first volume of *Decline and Fall* (later instalments 1781 and 1788), created furore especially over treatment of Christianity; 1783 moved back to Lausanne to complete history and draft his autobiography, later published as *Memoirs* (1796); returned to England but survived only a short time. A member of the Club.

Burrow, J.W., *Gibbon* (Oxford, 1985)
Craddock, P.B., *Young Edward Gibbon: Gentleman of Letters* (Baltimore, 1982) *Edward Gibbon, Luminous Historian* (1989)

Goldsmith, Oliver (1728/30–74)
Poet, essayist, dramatist, novelist; born Co. Longford; educated Trinity College, Dublin; studied medicine at Edinburgh and Leyden but never graduated; 1755–6 wandered through Europe; *c.* 1757 began career as hack writer for periodical press; became acquainted with Johnson circle; 1760–2 major success with essays *The Citizen of the World*; followed with major poem (*The Traveller*, 1764) and novel (*The Vicar of Wakefield*, 1766); 1770 best known poem *The Deserted Village*; 1773 great success with play *She Stoops to Conquer*; continued to write a wide range of miscellaneous works, including *History of the Earth and Animated Nature* (1774). A member of the Club.

Wardle, R.M., *Oliver Goldsmith*: (Lawrence, Kan., 1957)

Gray, Thomas (1716–71)
Poet and letter-writer; born London; educated at Eton and Cambridge, where Horace Walpole was among his close friends; 1739–41 Grand Tour with Walpole, but quarrelled with him and returned separately; 1742 settled at Cambridge; 1747 *Ode on Distant Prospect of Eton College*; 1751 *Elegy in a Country Churchyard* published; 1757 *Odes* published by Walpole to general incomprehension; 1768 professor of modern history at Cambridge; toured in Scotland and the Lake District.

Ketton-Cremer, R.W., *Thomas Gray: A Biography* (1955)

Johnson, Samuel (1709–84)
Lexicographer, critic, biographer, poet, essayist; born Lichfield; 1728–9 studied at Oxford but left university owing to poverty, and suffered first nervous breakdown;

attempted career as schoolmaster without success; 1735 married Elizabeth Porter, a widow twenty years his senior; 1737 moved to London with his former pupil Garrick; 1738 began to write for *Gentleman's Magazine*; first major work satire *London*; 1740 began to write semi-fictionalised accounts of parliamentary debates; 1744 published life of his friend Savage; 1749 *The Vanity of Human Wishes*; 1750–2 twice-weekly paper *The Rambler*; 1752 death of wife; showed great generosity and hospitality to the needy and infirm; 1755 *Dictionary of the English Language* established his position at the forefront of English literature; 1758–60 *The Idler*, weekly paper; 1759 *Rasselas*; 1762 received royal pension of £300 per annum; 1763 meeting with Boswell; 1764 foundation of the Club and became its dominating member; 1765 meeting with the Thrales; 1765 edn of Shakespeare published; 1771 *Thoughts on Falkland's Islands*; 1773 visited Highlands and Hebrides with Boswell; 1774 tour to North Wales with Mrs Thrale; 1775 *Journey of the Western Islands* published; 1779–81 *Lives of Poets* published; increasing ill health in last years.

Bate, W.J., *The Achievement of Samuel Johnson* (New York, 1955)
Boswell, J., *Life of Samuel Johnson*, ed. G.B. Hill and L.F. Powell, 6 vols. (Oxford, 1934–50)
Clifford, J.L., *Young Samuel Johnson* (1955) *Dictionary Johnson* (1979) [up to 1763]
Greene, D.J., *The Politics of Samuel Johnson* (New Haven, 1960)
Piozzi, H.L. [Thrale], *Anecdotes of the late Samuel Johnson*, ed. A. Sherbo (1974)

Pope, Alexander (1688–1744)
Poet; born London, a Roman Catholic; childhood illness, probably Pott's disease, produced curvature of the spine, stunted growth and lifelong invalidism; brought up in Windsor Forest; educated privately; 1709 *Pastorals* (written in teenage years); 1711 *Essay on Criticism*; became friendly with Addison circle and then with Tory group (including Swift and Gay) which formed nucleus of the Scriblerus Club; 1714 revised *Rape of the Lock* in five cantos; 1715 first volume of *Iliad* translation; 1717 published edition of *Works* to date; 1718 moved to Twickenham; 1725–6 translation of *Odyssey* published; 1725 edn of Shakespeare, excited criticism; 1727 volume of Scriblerian miscellanies, including *Peri Bathous*; 1728 first version of *Dunciad*; 1729 *Dunciad Variorum* with notes and additions; 1731–5 *Moral Essays*; 1733–4 *Essay on Man*; 1733–8

Imitations of Horace, with increasing commitment to political opposition to Walpole; 1735 began to publish his own correspondence by clandestine means; 1742 further book added to *Dunciad*; 1743 final version of *Dunciad* in four books.

Erskine-Hill, H., *The Social Milieu of Alexander Pope* (New Haven, 1975)
Mack, M., *Alexander Pope: A Life* (1985) *The Garden and the City* (Toronto, 1969)

Richardson, Samuel (1689–1761)
Novelist and printer; born near Derby; 1706 apprenticed to London printer; 1721 set up own business; 1733 *The Apprentice's Vade Mecum*, a conduct book for the young tradesman; 1740–1 *Pamela* published, great vogue for the book; 1747–8 *Clarissa*, widely admired in Europe; 1753–4 *Sir Charles Grandison*; wide circle of women admirers, also friendly with Johnson and Edward Young.

Doody, M. and Sabor, P. (eds.), *Samuel Richardson: Tercentenary Essays* (Cambridge, 1989)
Eaves, T.C.D. and Kimpel, B., *Samuel Richardson: A Biography* (Oxford, 1971)

Sheridan, Richard Brinsley (1752–1816)
Dramatist and politician; born Dublin; educated Harrow; 1770 moved to Bath, fell in love with singer Elizabeth Linley, with whom he eloped to France and married (1773); 1775 *The Rivals*, first comedy; 1777 *School for Scandal*; 1779 sole proprietor of Drury Lane theatre; produced his own play *The Critic*; 1780 became MP, as ally of C.J. Fox; 1782 first minor government office; 1787 famous speech in prosecution of Warren Hastings; contracted enormous debts in building new playhouse at Drury Lane (destroyed by fire, 1809), and fell into severe poverty. A member of the Club.

Sichel, W., *Sheridan*, (2 vols., 1909)

Smart, Christopher (1722–71)
Poet; born near Tonbridge; educated Durham School and Cambridge; notable classical scholar; 1749 moved to London, where he survived as journalist and entertainer; 1759–63 confined in private madhouse after signs of religious mania; 1763 *A Song to David*; renewed decline into poverty and debt, died within rules of King's Bench prison. Known and liked by Johnson. His major work *Jubilate Agno* not published until 1939.

Sherbo, A., *Christopher Smart, Scholar of the University* (East Lancing, Mass., 1967)

Smollett, Tobias George (1721–71)
Novelist, miscellaneous writer and surgeon;
born near Dunbarton; educated Glasgow
University and apprenticed to surgeon, but
left for London; 1741–3 served as surgeon
in navy during war in West Indies; 1744 set
up practice in London; 1748 *Roderick
Random*; 1751 *Peregrine Pickle*; further
novels together with increasing range of
other writing, especially historical works;
1756 founder-editor of *Critical Review*;
1757–8 *Complete History of England*; 1760
imprisoned for libel; edited government
paper *The Briton*, opposed by Wilkes in
The North Briton; embarked on Continental
travels in search of health; 1766 *Travels
through France and Italy*; 1771 *Humphry
Clinker*; died Leghorn.

Knapp, L.M., *Smollett, Doctor of Men and
Manners* (Princeton, 1949)

Steele, Richard (1672–1729)
Essayist, dramatist and politician; born
Dublin; educated Charterhouse and Oxford;
joined army; 1701 *The Christian Hero*, an
uplifting moral work; began writing for the
stage without very great success; 1707
gazetteer (government information officer);
1709–11 initiated *The Tatler*, huge success;
1711–12 *The Spectator*, with great help
from Addison; 1713 *The Guardian*; 1713
MP; 1714 expelled from parliament; 1715
knighted on Hanoverian accession and
Whig triumph; supervisor of Drury Lane
theatre; 1718 estranged from Addison; 1720
periodical *The Theatre*; 1722 most
successful play *The Conscious Lovers*; retired
to Wales.

Winton, C., *Captain Steele* (1964)
 Sir Richard Steele MP (Baltimore, 1970)

Sterne, Laurence (1713–68)
Novelist; born Clonmel, Co. Tipperary;
childhood spent in various barracks in
England and Ireland where his father
served as a soldier; 1733 went to Cambridge
University; 1737 took holy orders; 1738
vicar of Sutton-in-the-Forest; 1741
prebendary of York; 1741 marriage to
Elizabeth Lumley (later unhappy); 1759
satire on ecclesiastical politics, *A Political
Romance*, after long period of anonymous
provincial living; 1759–67 *Tristram Shandy*
published in five instalments, at first
creating immense vogue; 1760 *Sermons of
Mr Yorick*; 1760 vicar of Coxwold;
consumption gradually advanced, and made
journeys to France and Italy (1762–4,
1765–6) in vain search for health; 1766
further volume of *Sermons*; 1767 fell in love
with Elizabeth Draper (*Journal to Eliza*

published posthumously); 1768 *A
Sentimental Journey*; died heavily indebted.

Cash, A.H., *Laurence Sterne: The Early and
 Middle Years* (1975)
 The Later Years (1986)

Swift, Jonathan (1667–1745)
Satirist, poet, pamphleteer and churchman;
born Dublin; educated Kilkenny School
and Trinity College, Dublin; 1689 became
secretary to Sir William Temple and met
the young Esther Johnson, later known as
'Stella'; 1694 ordained, and briefly held
small incumbency near Belfast; 1696
returned to Temple's household; 1699
returned to Ireland and became vicar of
Laracor, near Trim; successive visits to
England, making acquaintance of Addison,
Steele and late Pope; 1704 *Tale of a Tub*
published with *Battle of the Books*; 1708–9
Bickerstaff papers satirising the astrologer
Partridge; 1710 period of great political
influence begins under Tory administration
of Harley and Bolingbroke; 1710–11 *The
Examiner*, weekly paper; 1711 *The Conduct
of the Allies*, highly successful attack on war
with France; 1711 *Miscellanies* containing
early satires and poems; this phase of his
life recorded in *Journal to Stella* (published
1766–8); 1713 Dean of St Patrick's, Dublin;
took up cause of Irish against English
government; 1724 *Drapier's Letters* help to
rouse the nation against Wood's inferior
coinage; 1726 visited England, *Gulliver's
Travels* published; 1727 beginning of a
series of *Miscellanies* including much of his
work; 1728 death of Stella; 1729 *A Modest
Proposal*; 1735 major collection of *Works*
published by Faulkner; *c.* 1738 began to
show signs of senile dementia, finally
leading to total incapacity; 1739 *Verses on
the Death of Dr Swift*. Legacies included
one to help establish St Patrick's hospital
for insane.

Ehrenpreis, I., *Swift: The Man, his Works
 and the Age* (3 vols., 1962–83)
Rawson, C.J., *Gulliver and the Gentle
 Reader* (1973)
 (ed.), *The Character of Swift's Satire*
 (Newark, Del., 1983)

Thomson, James (1700–48)
Poet and dramatist; born near Kelso;
educated Jedburgh School and Edinburgh
University; abandoned studies for the
Church; 1725 moved to London; 1726
success of *Winter* initiated triumphant series
of poems completed as *The Seasons* (1730);
1731 undertook Grand Tour as tutor to a
young aristocrat; 1735–6 *Liberty* published;
strong Whig patriot verse; produced several

plays with increasing political element, directed against Walpole ministry; 1740 masque *Alfred*, containing 'Rule Britannia' (set by Thomas Arne); 1748 Spenserian imitation *The Castle of Indolence*; friend of Pope, Lord Lyttelton and other literary figures.

Grant, D., *James Thomson: Poet of 'The Seasons'* (1951)
McKillop, A.D., *The Background of Thomson's 'Seasons'* (Minneapolis, Minn., 1942)

Walpole, Horace, 4th Earl of Orford (1717–97)

Letter-writer, connoisseur, miscellaneous writer and politician; born London, son of Sir Robert Walpole; educated Eton and Cambridge; 1739–41 Grand Tour with Gray, cut short by quarrel; 1741 MP; 1747 acquired Strawberry Hill, Twickenham, which he converted into a Gothic shrine filled with objets d'art and curios; 1757 set up printing press; 1758 *Catalogue of Royal and Noble Authors*; 1762 *Anecdotes of Painting in England*; 1764 the first Gothic novel, *The Castle of Otranto*; 1765 began series of visits to Paris; embarked on lengthy memoirs of his times (published in various forms 1822, 1845, 1859; some remain unpublished); 1785 *Essay on Modern Gardening*, one of first serious discussions of landscape-gardening; 1791 inherited earldom from nephew; left at his death an immense trove of superb letters, literary manuscripts and collections of books, pictures, etc.

Ketton-Cremer, R.W., *Horace Walpole: A Biography* (rev. edn, 1946)
Smith, W.H. (ed.), *Horace Walpole: Writer, Politician and Connoisseur* (New Haven, Conn., 1967)

9 Music

An encyclopedic account of all aspects of music is provided by

Sadie, S. (ed.), *The New Grove Dictionary of Music and Musicians* (20 vols., 1980) [includes comprehensive bibliographies]
The New Oxford History of Music: Vol. V, *Opera and Church Music 1630–1750*, ed. Lewis, A. and Fortune, N. (Oxford, 1975); Vol. VI, *Concert Music*, ed. Abraham, G. (Oxford, 1986); Vol. VII, *The Age of Enlightenment 1745–90*, ed. Wellesz, E. and Sternfeld, F. (Oxford, 1973)

Burney, C., *General History of Music* (1789, repr. Dover, NY, 1957)
Hawkins, Sir J., *History of the Science and Practice of Music* (1776, repr. Dover, NY, 1962)
Fiske, R., *English Theatre Music in the Eighteenth Century* (Oxford, 1973)
Foss, M., *The Age of Patronage: The Arts in England 1660–1750* (Ithaca, NY and London, 1971)
Hutchings, A., *The Baroque Concerto* (1961, rev. edn, 1973)
Scholes, P., *The Great Dr Burney* (2 vols., Oxford, 1948)
Wilson, J., *Roger North on Music* (1959)

Composers

Arne, Thomas Augustine (1710–78)

Composer and violinist; educated Eton College; wrote musical settings in Italian style for plays and masques; 1738 wrote score for *Comus*; his *Rule Britannia* became national patriotic song; 1759 Hon. Doc. of Music, Oxford (hence 'Dr A.'). Operas *Thomas and Sally* (1760); *Artaxerxes* (1762) a major success at Covent Garden; visits to Ireland; from 1767 wrote innumerable catches and glees.

Herbage, J. and Parkinson, J.A., in Sadie, *New Grove*

Avison, Charles (1709–70)

Organist and composer; 1736 organist at St Nicholas's Church, Newcastle, where he also organised subscription concerts (among the first such events in Britain); wrote 60 concertos and chamber music; his *Essay on Music Expressions* (1752) a pioneering work of musical criticism.

Horsley, P.M., 'Charles Avison: the Man and his Milieu' (ML, 55, 1974)
Stephens, N.L., in Sadie, *New Grove*

Bach, Johann Christian (1735–82)

Composer and organist; the 'London Bach', the 11th and youngest surviving son of J.S. Bach, studied with his brother Carl Philipp Emanuel in Berlin; 1754 music director to Count Litta in Milan and organist at cathedral, 1760–2. Travelled throughout Italy; 1762 settled in England; 1763 appointed music master to Queen; major success with opera *Orione*; 1765–81 gave Bach–Abel series of London concerts; 1772 and 1774 invited to Mannheim to compose and present operas and cantatas; a prolific and immensely popular composer in light rococo style; influenced Mozart; works include 13 operas, symphonies, concertos, and solo keyboard and chamber music;

gradual decline of popularity; died in serious debt, barely noticed by public.

Geiringer, K., *The Bach Family* (1954)
Terry, C.S., *Johann Christian Bach* (Oxford, 1929; 2nd edn, 1967)
Warburton, E. and Derr, E.S., in Sadie, *New Grove*

Bononcini, Giovanni (1670–1747) Composer; born Bologna; after periods in Rome writing operas, and in Berlin and Vienna as court composer; 1720 joined Royal Academy of Music in London, where Handel was director, but rivalry developed between them; 1724–31 in Duchess of Marlborough's service; 1732 accused of plagiarism and association with an alchemist; left for Paris and Vienna; composed over 40 operas, serenatas, oratorios and instrumental works.

Lindgren, L., in Sadie, *New Grove*

Boyce, William (1711–79) Organist and composer; chorister at St Paul's; appointed composer at Chapel Royal 1736 and organist 1758; conducted Three Choirs Festival 1737; B. and Doc. Mus., Cambridge, 1749; Master of King's Musick 1755; gave up regular musical duties after 1769 owing to deafness; composed operas, symphonies and overtures, songs, music for masques; a distinguished composer of church music; finally turned to musical studies; his 3-volume anthology *Cathedral Music* (1760, 1768 and 1773) preserved the English church choral tradition.

Fiske, R., Platt, R. and Bruce, R.J., in Sadie, *New Grove*

Handel, George Frideric (1685–1759) Composer and organist. Born Halle; began musical studies, especially the organ, at age of 8; 1702 organist at Halle Domkirche; 1703 violinist and harpsichordist to Hamburg opera; 1705 first opera *Almira*; 1706–10 to Italy; composed operas (notably *Agrippina* 1709), oratorios, secular cantatas, chamber sonatas and Latin church music; 1710 appointed *Kapellmeister* to Elector George of Hanover; first visit to England; 1711 wrote *Rinaldo*, a great success in London; 1712 returned to London; on the death of Queen Anne, Elector of Hanover became George I and so Handel settled in England; resident composer to Duke of Chandos, for whom he wrote *Chandos Anthems* (1717–18); 1719 became a director of the new Royal Academy of Music; until 1737 engaged with varying success and amidst much rivalry in running opera companies and composing some 30 Italian operas; 1727 naturalised; wrote 4 coronation anthems for George II, 12 *concerti grossi*, and organ concertos; suffered from paralysis and went for cure to Aachen; 1737 turned to oratorio; composed *Messiah* (1742); last oratorio *Jephtha* (1752). In spite of 3 operations became blind, but continued to direct concerts until his death. Buried in Westminster Abbey.

Dean, W., *Handel's Dramatic Oratorios and Masques* (1959)
Dean, W. and Hicks, A., in Sadie, *New Grove*
Deutsch, O.E., *Handel: a Documentary Biography* (Oxford, 1954)
Hogwood, C., *Handel* (1984)
Simon, J. (ed.), *Handel: a Celebration of his Life and Times* (1985)
Strohm, R., *Essays on Handel and Italian Opera* (Cambridge, 1985)

Stanley, John (1712–86) Organist, violinist and composer; blind from age of 2; organist at All Hallows at age of 11; 1734 organist at Inner Temple; 1779 Master of the King's Band. Directed concerts in City of London; was a friend of Handel and directed several of his oratorios; wrote oratorios (*Zimri, Fall of Egypt*), organ voluntaries, concertos and cantatas.

Boyd, M., in Sadie, *New Grove*

10 Vauxhall Gardens

Coke, D., *The Muse's Bower, Vauxhall Gardens 1728–1786* (Sudbury, 1978)
Edelstein, T.J. and Allen, B., *Vauxhall Gardens* (New Haven, 1983)
Hunt, J.D., *Theatre in Focus: Vauxhall and London's Garden Theatres* (1985)
Scott, W.S., *Green Retreats: The Story of Vauxhall Gardens 1661–1859* (1955)
Southworth, J.G., *Vauxhall Gardens* (New York, 1941)

For Hayman see **3 Architecture**.

11 The Visual Arts

Sir Joshua Reynolds, *Discourses on Art* (1769–90); ed. R. Wark (San Marino, 1959, repr. New Haven and London, 1975).

Bindman, D. (ed.), *Encyclopedia of British Art* (1985)
Burke, J., *English Art 1714–1800* (Oxford, 1976)
Clarke, M., *The Tempting Prospect: A Social History of English Watercolours* (1981)

Cordingly, D., *Marine Painting in England 1700–1900* (1973)

Croft-Murray, E., *Decorative Painting in England 1537–1837*, vol. I (1962), vol. II (1970)

Denvir, B. (ed.), *The 18th century: Art, Design & Society 1689–1789* (1983) (A useful anthology of contemporary writings)

Deuchar, S., *Sporting Art in 18th-century England: a Social and Political History* (New Haven and London, 1988)

Edwards, R., *Early Conversation Pictures* (1954)

Einberg, E., *Manners and Morals: Hogarth and British Painting 1700–1760*, Catalogue of exhibition at the Tate Gallery (1987)

Einberg, E. and Egerton, J., *The Age of Hogarth: British Painters born 1675–1709*, Tate Gallery (1987)

English Caricature 1620 to the Present, introduction by R. Godfrey, Victoria & Albert Museum (1984)

George, M.D., *Social Change & Graphic Satire, from Hogarth to Cruikshank* (1967)

Herrmann, L., *British Landscape Painting of the 18th century* (1973)

Irwin, D. and Irwin, F., *Scottish Painters at Home & Abroad 1700–1900* (1975)

Johnson, E.D.H., *Painting of the British Social Scene from Hogarth to Sickert* (1986)

Kerslake, J., *Early Georgian Portraits in the National Portrait Gallery* (2 vols., 1977)

Manwaring, E.W., *Italian Landscape in 18th-century England* (New York, 1925)

Piper, D., *The English Face* (1957)

Pressly, N.L., *The Fuseli Circle in Rome: Early Romantic Art of the 1770s* (New Haven, 1979)

Ribeiro, A., *The Dress Worn at Masquerades in England 1730–1790 and its Relation to Fancy Dress in Portraiture* (New York, 1984)

Rococo Art & Design in Hogarth's England, ed. M. Snodin, Victoria & Albert Museum (1984)

Waterhouse, E., *Dictionary of British 18th-century Painters* (Woodbridge, 1981)

Painting in Britain 1530–1790, (4th edn, Harmondsworth, 1978)

Whinney, M., *Sculpture in Britain 1530–1830* (Harmondsworth, 1964; rev. edn, 1988)

Artists and sculptors

Gainsborough, Thomas (1727–88)
Landscape and portrait painter, born at Sudbury, Suffolk; studied in London 1740–8 where he learnt the latest rococo style from Hogarth, Hayman, Gravelot and Roubiliac; worked in Ipswich c. 1749–59 and at Bath 1759–74; then settled in London; exhibited at the Society of Artists 1761–8; founder member RA 1768; although a brilliant and successful portrait painter, winning Royal favour, he preferred landscapes and the newly fashionable genre of fancy pictures; his style was unique and is easily recognisable: his handling was light and his colours typically delicate, owing something to Ramsay and a good deal to Van Dyck; a superb draughtsman in pencil or chalk; he scoffed at the Great Style and never went to Italy, yet was the only artist to be made the subject of one of Reynolds's presidential Discourses, the 14th (1788)

Hayes, J., *The Drawings of Thomas Gainsborough* (2 vols., 1970)

Gainsborough as Printmaker (1971)

Gainsborough: Paintings and Drawings (1975)

The Landscape Paintings of Thomas Gainsborough (2 vols., 1982)

Thomas Gainsborough, Catalogue of exhibition at the Tate Gallery (1980)

Letters, ed. M. Woodall (Ipswich, 1963)

Whitley, W.T., *Thomas Gainsborough* (1915)

Gibbons, Grinling (1648–1721)
Woodcarver, born at Rotterdam of English parents; came to England c. 1668; by 1678 was working at Windsor Castle; an outstanding baroque craftsman with a precious talent in woodcarving, specialising in elaborate schemes of fruit, flowers, shells, cherubs' heads, etc., rendered with astonishing naturalism; his workshop also produced sculpture in stone and bronze, but his monuments (e.g. Cloudesley Shovel, Westminster Abbey) were never admired.

Beard, G., *The Work of Grinling Gibbons* (1989)

Green, D., *Grinling Gibbons, His Work as Carver and Statuary* (1964)

Oughton, F., *Grinling Gibbons & the English Woodcarving Tradition* (1979)

Gillray, James (1756–1815)
Caricaturist; studied at the RA Schools but turned to political and social satire about the time of the 'No Popery' riots, 1780; through medium of hand-coloured etching of great power, attacked Pitt, C.J. Fox, the Westminster election, the Royal Family –

especially the Prince of Wales, the French Revolution and numerous other subjects; became insane *c*. 1811.

Hill, D., *Fashionable Contrasts: Caricatures* (1966)
 Mr Gillray the Caricaturist (1965)
 Satirical Etchings of James Gillray (New York, 1976)
Wright, T. and Grego, J., *Works of James Gillray* (1873)

Hayman, Francis (*c*. 1708–76)
History and portrait painter, born Devon; painted sets for Drury Lane, and decorative and historical canvases for Vauxhall Gardens throughout the 1740s; pioneered Shakespearean and other literary subjects, as well as scenes from the stage; taught for many years at the St Martin's Lane Academy.

Allen, B., *Francis Hayman* (New Haven and London, 1987)
See also: Hammelmann, H. in *Book Illustrators in 18th-century England*, ed. T.S.R. Boase (New Haven and London, 1975)

Hogarth, William (1697–1764)
Engraver and painter of portraits and subject pictures; born London; apprenticed 1713 to an engraver of ornamental plate; published first satirical prints *c*. 1720, and enrolled as a student in Cheron and Vanderbank's Academy in St Martin's Lane; his finest portraits are typically of professional or middle-class sitters; most original contribution to British (indeed to European) art was, however, the 'modern moral subject': *A Harlot's Progress*, 1732, *A Rake's Progress*, 1735, *Marriage à la Mode*, 1745 and *The Election, c.* 1754; 1753 published *The Analysis of Beauty*, expounding his theory of the 'Line of Beauty' and the 'Line of Grace'; lifelong ambition to succeed as a History painter but in spite of such original peformances as *Satan, Sin and Death, c.* 1735–40, which anticipated the 'horrific-sublime' of Fuseli and Blake, his attempts were ridiculed and his last years were clouded by his sense of persecution.

Antal, F., *Hogarth & his Place in European Art* (1962)
Cowley, R.L.S., *Marriage à-la-Mode: A Re-view of Hogarth's Narrative Art* (Manchester, 1983)
Dabydeen, D., *Hogarth's Blacks* (1985)
Oppé, A.P., *The Drawings of Hogarth* (1948)

Paulson, R., *Hogarth: His Life, Art & Times* (2 vols., New Haven and London, 1971)
 Hogarth's Graphic Works (2 vols., New Haven and London, 1970; new edn 1989)
Shesgreen, S., *Hogarth & the Times-of-the-Day Tradition* (Ithaca and London, 1983)

Kneller, Sir Godfrey (1646–1723)
Portrait painter, born Lübeck; studied in Rembrandt's circle (under F. Bol) and visited Italy before settling in England 1676. The most successful and prolific painter to work in England between Van Dyck and Reynolds, appointed Principal Painter to William and Mary 1688, and monopolising royal portraiture from that time until his death.

Stewart, J.D., *Sir Godfrey Kneller & the English Baroque Portrait* (Oxford, 1983)

Ramsay, Allan (1713–84)
Portrait painter, born Edinburgh; son of the poet; studied under the Swedish artist Hysing in London 1734, before making the first of four visits to Italy 1736–8 where he acquired an Italian feeling for composition as well as French rococo drawing techniques (he attended life-classes at the French Academy in Rome) rare in a mid-eighteenth-century British artist; Ramsay's delicate colour and careful, craftsmanlike handling are especially evident in his female portraits in which (according to Walpole) he surpassed Reynolds; 1761 appointed Principal Painter to George III.

Irwin, D. and Irwin, F., *Scottish Painters at Home & Abroad 1700–1900* (1975)
Macmillan, D., *Painting in Scotland: The Golden Age* (Edinburgh, 1986)
Smart, A., *Life & Art of Allan Ramsay* (1952)

Reynolds, Sir Joshua (1723–92)
Portrait and history painter, writer and collector; born Plympton, Devon; studied under Hudson 1740–3 and went to Italy 1749–52, where he laid the foundations of his later style, based on study of the Roman and Bolognese painters (for outline and composition) and the Venetians (for light and colour); other major influences upon his style were Rembrandt (already popular in England) and classical sculpture; founder member and first President of the RA 1768; knighted 1769; friend of Dr Johnson, Garrick, Goldsmith and Wilkes; the 15 Discourses which he delivered to students

at the RA 1769–90 are among the most lucid statements ever made of the classical theory of art; they were intended to raise the status of the art, and to underwrite the fledgling British school of history painting.

Leslie, C.R. and Taylor, T., *Life & Times of Sir Joshua Reynolds* (2 vols., 1865)
Penny, N. (ed.), *Reynolds*, Catalogue of exhibition at the RA (1986)
Waterhouse, E.K., *Reynolds* (1941)
Reynolds (1973)
Wind, E., *Hume and the Heroic Portrait* (Oxford, 1986)

Richardson, Jonathan, Senior
(c. 1665–1745)
Portrait painter, collector and writer; born London; studied under John Riley 1688–91 and was in busy practice until he retired in 1740.

Kerslake, J., *Early Georgian Portraits in the National Portrait Gallery* (2 vols., 1977)
Waterhouse, E.K., *Painting in Britain 1530–1790* (4th edn, Harmondsworth, 1978)

Romney, George (1734–1802)
Painter of portraits, fancy pictures and occasionally histories; born Beckside, near Dalton-in-Furness; settled in London 1762; 1773–5 visited Italy; although portraits lack any strong sense of character, they are often attractive and well-composed; was a lesser rival to Reynolds and Gainsborough for a few years.

Chamberlain, A.B., *George Romney* (1910)
Jaffe, P., *Drawings by George Romney* (Cambridge, 1977)
Romney, J., *Memoirs of the Life & Works of George Romney* (1830)
Ward, H. & Roberts, W., *Romney* (2 vols., 1904)
See also: Pressly, N.L., *The Fuseli Circle in Rome: Early Romantic Art of the 1770s* (New Haven, 1979)

Roubiliac, Louis-François (1702/5–62)
Sculptor, born Lyons and trained perhaps under Nicolas Coustou; brilliant European baroque style probably developed through his work on the Zwinger in Dresden; settled in London by 1735 and made his name with his statue of Handel, 1738, for Vauxhall Gardens; this was followed by seven major monuments in Westminster Abbey and numerous realistic portrait busts; from 1745 taught sculpture at the St Martin's Lane Academy.

Bindman, D., 'The Consolation of Death: Roubiliac's Nightingale Tomb' in *Huntington Library Quarterly* 49 (1986)
Esdaile, K.A., *Life & Works of L.-F. Roubiliac* (1928)

Rowlandson, Thomas (1756–1827)
Caricaturist, born London; studied at the RA Schools 1772; visited France c. 1774; etched political satires in the 1780s but his most characteristic works concern social manners and follies; the splendid watercolour of Vauxhall Gardens, 1784, typifies his early style.

Baskett, J. and Snelgrove, D., *Drawings of Thomas Rowlandson in the Paul Mellon Collection* (1977). *See also* catalogue of exhibition at the Yale Center for British Art, and at the Royal Academy, with text by Riely, J. (1978)
Falk, B., *Thomas Rowlandson: his Life & Art* (1949)
Grego, J., *Rowlandson the Caricaturist* (2 vols., 1880; repr., New York, 1970)
Hayes, J., *Rowlandson: Watercolours & Drawings* (1972)

Rysbrack, John Michael (1694–1770)
Sculptor, born Antwerp; studied under Michel van der Voort in Antwerp; early mastery of Augustan classicism exemplified by his *Roman Marriage*, a royal commission c. 1723; made more than sixty busts, and more than eighty monuments including Newton's in Westminster Abbey, and the Marlborough tomb at Blenheim (these two in collaboration with Kent); executed chimneypieces and other architectural details for Palladian houses.

Eustace, K., *Michael Rysbrack Sculptor*, Catalogue of exhibition at Bristol (1982).
Webb, M.I., *Michael Rysbrack* (1954)

Sandby, Paul (1730–1809)
Topographical landscape painter, mainly in watercolour; born Nottingham; went to London 1747, sketched views for the military survey of Scotland 1747–52; founder member of the RA, 1768; his brother Thomas Sandby (1721–98) a skilled topographical draughtsman.

Herrmann, L., *Paul & Thomas Sandby* (1986)
The Art of Paul Sandby, Catalogue of exhibition at Yale Center for British Art (1985)
See also: Herrmann, L., *British Landscape Painting of the 18th century* (1973)

Stubbs, George (1724–1806)
Painter and engraver of animals, scenes of
rural life, and portraits. Born in Liverpool
and apparently self-taught, studying
anatomy in York in 1750. Visited Rome
1754. His masterpiece was a set of engraved
plates, *The Anatomy of the Horse*, 1766,
based on 18 months' intensive study
through dissections precisely recorded in
meticulous drawings of which 42 survive.
This, together with his earlier illustrations
(again based on his own dissections) to
Burton's textbook on midwifery (1751),
earned him his place as a leading
experimental scientist of the Enlightenment.
As a painter, Stubbs exhibited at the
Society of Artists 1761–74, and at the RA
1775–1803.

Egerton, J., *George Stubbs: Anatomist &
Animal Painter*, Catalogue of exhibition
at the Tate Gallery (1976)
Catalogue of exhibition at the Tate
Gallery (1984)
Taylor, B., *Stubbs* (1971)

Thornhill, Sir James (1675/6–1734)
Decorative history painter, born Dorset;
Thornhill, who visited Paris and the
Netherlands in 1711, was the only
British-born artist to compete with Verrio
and Laguerre in baroque mural painting;
works include the Painted Hall at
Greenwich 1708–27, the dome of St Paul's
Cathedral 1714–19, and the ceiling of the
Hall at Blenheim, 1716; knighted 1720, but
his style fell out of favour with the rise of
Burlington and Kent in the years that
followed.

Allen, B., 'Thornhill at Wimpole' in *Apollo*
122 (1985)
Catalogue of tercentenary exhibition at
Dorset County Museum (Dorchester,
1975)

West, Benjamin (1738–1820)
Historical and portrait painter; born
Springfield, Pennsylvania; 1760 went to
Italy where he was influenced by Gavin
Hamilton and began to paint historical
subjects in the new neo-classical style; sent
some of these to the exhibitions of the
Society of Artists in London, and went to
England in 1763; 1768 won the patronage of
George III; founder member of the RA
1768; succeeded Reynolds as President
1792; best-known work was *Death of Wolfe*,
1771, but also attempted grand religious
pictures on an imposing scale.

Abrams, A.U., *The Valiant Hero: Benjamin
West & Grand Style History Painting*
(Washington, 1985)
Erffa, H. von, and Staley, A., *Paintings of
Benjamin West* (New Haven and
London, 1986)
Mitchell, C., 'Benjamin West's "Death of
General Wolfe", and the Popular
History Piece' in *JWCI* 7 (1944)
Pressly, N.L., *Revealed Religion: Benjamin
West's Commissions for Windsor Castle
& Fonthill Abbey* (San Antonio, 1983)

Wilson, Richard (1713–82)
Landscape painter, born at Penegoes,
Wales; son of a clergyman; received a
classical education – unusual for an
eighteenth-century British artist; went to
Venice 1750; Rome 1752–7; visited Naples,
making drawings of sites which were
celebrated in classical literature; back in
England he exhibited at the Society of
Artists 1760–8; founder member of the RA,
1768; painted English, Welsh and Italian
scenery in an elevated style (comparable to
Reynolds's 'great' style in portraiture) based
upon Claude, Gaspard Poussin, and the
Dutch Italianate masters, e.g. Cuyp;
popularity waned early 1770s; retired to
Wales in 1781.

Constable, W.G., *Richard Wilson* (1953)
Ford, B., *The Drawings of Richard Wilson*
(1951)
Solkin, D.H., *Richard Wilson: the
Landscape of Reaction* (1982)
Sutton, D. and Clements, A., *An Italian
Sketchbook* (2 vols., 1968) [facsimile of
drawings made in Rome in 1754]
See also: Herrmann, L., *British Landscape
Painting of the 18th century* (1973)
Howard, D., 'Some 18th-century English
Followers of Claude' in *BM* 111 (1969)

Wright of Derby, Joseph (1734–97)
Portrait and subject painter; born Derby;
studied under Hudson 1751–3 and 1756–7;
worked in Liverpool 1769–71 and in Bath
1775–6 as a portrait painter; visited Italy
1774–5 where he saw an eruption of
Vesuvius – a frequent subject for his later
art; most original pictures were large
candlelight scenes of scientific subjects,
exhibited at the Society of Artists in the
1760s; exhibited at the RA 1778–94; elected
to full membership 1784, but declined;
patrons included Wedgwood, Arkwright
and Brook Boothby.

Egerton, J. *Wright of Derby* Catalogue of
exhibition at the Tate Gallery (1990).
Nicolson, B., *Joseph Wright of Derby* (2
vols, 1968)

Zoffany, Johann (1733–1810)
Painter of portraits and conversation pieces, born near Frankfurt; studied at Regensburg and under Agostino Masucci in Rome; arrived London 1760 and was encouraged by Garrick to develop a new type of theatrical conversation piece, usually representing Garrick himself on stage in a scene from a popular play; exhibited at the Society of Artists 1762–9; a favourite of the King and Queen, for whom he painted several royal portrait groups informally composed yet meticulously detailed; Italy 1772–8, where he painted the remarkable *Tribuna of the Uffizi* for George III; India 1783–9.

Jackson-Stops, G., 'Johan Zoffany & the 18th-century Interior' in *Antiques* 131 (1987)
Webster, M., Catalogue of exhibition at the National Portrait Gallery (1976)

Sources of Illustrations

The publishers gratefully acknowledge the help of the many individuals and organisations who cannot be named in collecting the illustrations for this volume. In particular they would like to thank Callie Crees for picture research. Every effort has been made to obtain permission to use copyright materials; the publishers apologise for any errors and omissions and would welcome these being brought to their attention.

2, 206, 216 Museum of London
48 Leeds City Art Galleries; photograph by Christopher Hutchinson
51, 55, 57, 59, 65, 120, 233, 237 A. F. Kersting
62 By courtesy of LTC International College of English
66 The National Trust Photographic Library/Jeremy Whitaker
68 The Metropolitan Museum of Art, Gift of William C. Jackson, 1968 (68.164). All rights reserved, The Metropolitan Museum of Art
70, 75, 76t, 78, 204 By courtesy of the Board of Trustees of the Victoria & Albert Museum
72 Leeds City Art Galleries; photograph by Richard Littlewood
74 Methuen Collection
76b The National Trust Photographic Library/John Bethall
81 By Courtesy of Lloyd's of London
83 By courtesy of the Wedgwood Museum Trustees, Barlaston, Stoke-on-Trent, Staffordshire
85, 184 Reproduced by permission of the Syndics of the Fitzwilliam Museum, Cambridge
86 Photograph courtesy of the City Museum and Art Gallery, Stoke-on-Trent
89 By courtesy of Cinzano; Derek Balmer, photographer
94 Gr ..wich Local History Library
106, 122, 124 © Warburg Institute
111, 145, 202, 209, 212, 214 Yale Center for British Art, Paul Mellon Collection
113, 115, 139, 141 Reproduced by courtesy of the Trustees of the National Gallery, London
118, 179, 196, 274, 302 Reproduced by courtesy of the Trustees of the British Museum
12f Royal Academy of Arts
127, 146 National Gallery of Scotland
128 National Gallery of Canada, Ottawa; transfer from the Canadian War Memorials, 1921 (Gift of the 2nd duke of Westminster, Eaton Hall, Cheshire, 1918)
131, 132 Derby Museum and Art Gallery
137 Reproduced by kind permission of His Grace the Duke of Marlborough
138 *The Gower Family* by George Romney; Abbot Hall Art Gallery, Kendal, Cumbria, U.K.

143 The Tate Gallery, London
147 Reproduced by permission of The Huntington Library, San Marino, California
148, 154, 156 English Life Publications
150, 152, 153 Viscount Coke and the Trustees of the Holkham Estate
151, 156t Jarrold Publishing
158, 219, 247 By permission of the Syndics of Cambridge University Library
166 London Borough of Richmond-upon-Thames, Libraries and Arts Services; Orleans House Gallery
189 Aberdeen City Arts Department, Art Gallery and Museums
194 Private collection
207 The Beinecke Rare Book and Manuscript Library, Yale University
222, 223, 243, 260, 279 By permission of the British Library
225 English Heritage
228, 239, 307, 313 Royal Commission on the Historical Monuments of England
230 B. T. Batsford Ltd.
238 Devonshire Collection, Chatsworth. Reproduced by permission of the Chatsworth Settlement Trustees
253 The Metropolitan Museum of Art, Harris Brisbane Dick Fund, 1925 (25.19[48])
254 Sally Jeffery
255 Crown copyright; reproduced with the permission of the Controller of HMSO
256 National Trust Photographic Library/Angelo Hornak
257, 258 By courtesy of the Trustees of Sir John Soane's Museum
262 Courtesy of Michael Symes
264, 265 Courtesy of the Hon. Simon Howard
267 M. J. Bevington/Stowe School Photographic Archives
269 C. Cottrell-Dormer Esq., Rousham; photograph by permission of Courtauld Institute of Art, London
270 National Trust Photographic Library/David Noton
272 A–Z Botanical Collection
284 Royal Opera House Archives
296 National Trust Photographic Library
304 Photograph by Unichrome (Bath) Limited
308 Bath Reference Library
309, 312 Victoria Art Gallery, Bath City Council
309b, 310, 311c William Morris

'The Quiet Grave' by U. A. Fanthorpe, quoted on pp. 104–5, was published by Peterloo Poets in *Side Effects* by U. A. Fanthorpe (1978) and again in *Selected Poems* by U. A Fanthorpe (1986).

Index

Major entries are shown in capitals. Individual works of importance are listed under the artist where known. Page numbers of illustrations are shown in italics.